I KNOW WHAT I AM

The Life and Times of
ARTEMISIA GENTILESCHI

GINA SICILIANO

FANTAGRAPHICS BOOKS

Fantagraphics Books
7563 Lake City Way NE
Seattle, WA 98115

Editor: Conrad Groth
Editor, Original Series: Jason Conger
Designers: Keeli McCarthy & Gina Siciliano
Design Assistance: Justin Allan-Spencer
Production: Preston White
Proofreader: Christina Hwang
Publicity: Jacq Cohen
Associate Publisher: Eric Reynolds
Publisher: Gary Groth

ISBN: 978-1-68396-211-3
Library of Congress Control Number: 2018963699
First edition: September 2019
Printed in Korea

I KNOW WHAT I AM
THE LIFE AND TIMES OF ARTEMISIA GENTILESCHI

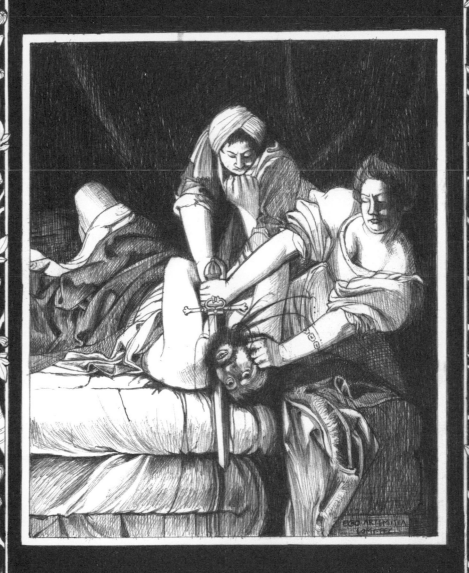

ALL LOWER-CASE LETTERS REPRESENT QUOTES FROM SOURCES LISTED IN THE NOTES SECTION AND BIBLIOGRAPHY IN THE BACK.

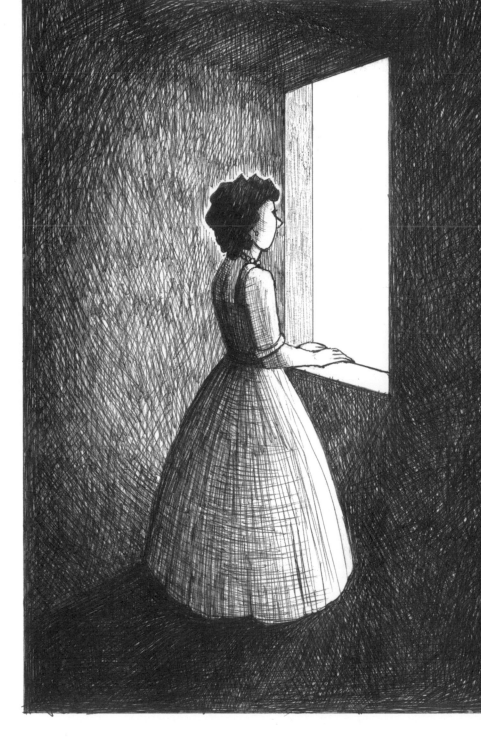

DEDICATED TO:
ISAAC, AVA, AND ALINA.
THE WILL TO CREATE
IS IN OUR BLOOD.

MAKING NEW WORLDS OUT OF OLD WORLDS

A preface by the author

IT ALL STARTED IN 2007 when at the Uffizi I saw *Judith Slaying Holofernes*, the Florentine masterpiece by the painter and rape survivor, Artemisia Gentileschi. The painting struck me so hard, I knew I would never forget it. As Judith pulls the sword through Holofernes' neck, I recognized the look on her face—a determined, vengeful rage, a feeling within many survivors, either suppressed or embraced, or both. Who was this seventeenth-century artist who had the guts to create something so unapologetically violent and raw, an image of organized female aggression that shocked generations of viewers? There were female still-life and portrait painters, but a single mother completing large-scale history paintings for the most prestigious patrons of Europe was, and still is, remarkable.

After years of struggling to heal from my own history of sexual abuse, I wondered if perhaps we have to look back in order to move forward. So much has changed since Artemisia's time, but in some ways very little has changed. It seems as if survivors are facing the same judgments, the same doubts, the same callous questions from authorities. Many people still can't understand how a rape survivor could continue to have sex with the man who raped her, but most survivors will tell you that it is absolutely possible to love the one that hurts you the most. These are the contradictions we live with. Intense financial, emotional, and physical forces have bound women to abusive men from Artemisia's time to the present. A close examination of these parallels with the past can help us put our current struggles into perspective and overcome them.

Some feel that the fixation on Artemisia's personal life has detracted from her art. There's tension between feminist scholarship and general academic scholarship, between art historians and social historians, between personal feelings and neutral analysis. Feminist scholars have been accused of presenting an exaggerated, anachronistic vision of a woman rebel. But history always conforms to whoever is telling it. We are all biased. Artists and writers have "creative license" to weave history into whatever will make a good story, but I didn't want to use Artemisia's life and work as merely a jumping-off point for my own expression. I wanted to actually figure out what happened to her, even though there is so much that we don't know. To address the difficulty of representing history, I decided to be totally transparent.

That is why there's a lengthy notes section at the end, so that readers can trace all my decisions if they want to.

To avoid taking Artemisia out of context, I've attempted to create a world and put her into it. One of the first artists to express the stark reality of that time was Caravaggio. This was no idealized Botticelli's Venus — this was David disdainfully holding the blood-drenched, severed head of Goliath, bandits and tricksters robbing young dandies in taverns, still-lifes with wilting leaves and rotting fruit. At the same time, artists were celebrated and revered, distant lands were explored and colonized, radical new science butted against the old religions, absolute monarchies slowly broke apart as political systems changed, and the world gradually headed toward the Enlightenment. For the past seven years, I've been immersed in this research — piecing together letters, paintings, and historical documents, and using my own storytelling to fill in the blanks. A lot happened to me during those seven years — I was priced out of my apartment, a disc slipped in my spine, I was hit by a car on my bike, a man shot and killed five people at the bar where my weekly drawing group met, and I've juggled multiple day jobs. Through it all, I knew I could escape into this other world, with Artemisia as my lifeline. Artemisia, her art, and her world sustained me.

Since I first starting drawing comics nearly twenty years ago, the medium has flowered and expanded. With comics, I can utilize two different languages at the same time — words and images. Questions that scholars grappled with for years — like why did Artemisia's later Neapolitan paintings look so different from her earlier Caravaggesque style? Or what was the relationship between Artemisia's personal life and her art? — take on new life in the comics format. When we see her work on a page alongside images of events in her life and/or the socio-political landscape, our eyes absorb a more comprehensive picture. The mysteries become a little clearer, leading to new questions. Each painting I copied with my pen into the narrative became easier to understand. During the Renaissance, painters learned from copying the "Old Masters," and I instinctively dove right into this tradition — through copying Artemisia's paintings, all kinds of details I'd overlooked leapt forth.

Artemisia was one of the Old Masters. The more new information surfaces about her life and work, the more I see her as a polymath — a mother, painter, musician, writer, survivor. New discoveries continue to convey Artemisia's humor and wit as well. More and more scholars are discovering and translating early modern women writers and radical thinkers. We are finally beginning to develop a bigger picture of the Western Renaissance, something more than just the ruthlessness of Machiavelli, the slovenly opulence of Henry VIII, or the scandal of the Borgias. Artemisia's struggle to paint and survive and be recognized has paralleled my own journey in many ways. This book is about the determination and will that it takes to live an artist life, no matter what.

Gina Siciliano
Seattle, 2019

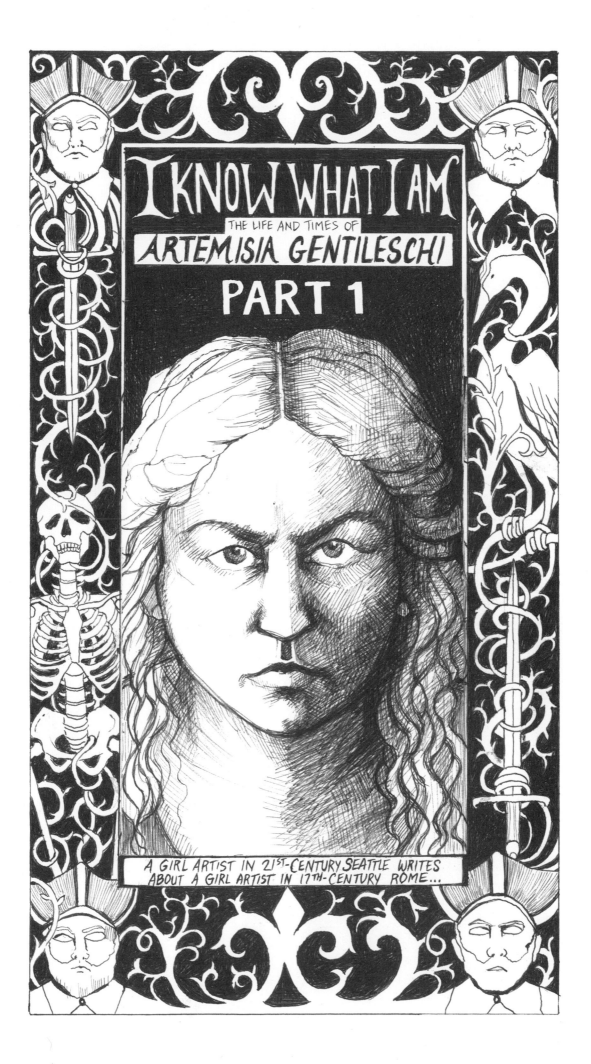

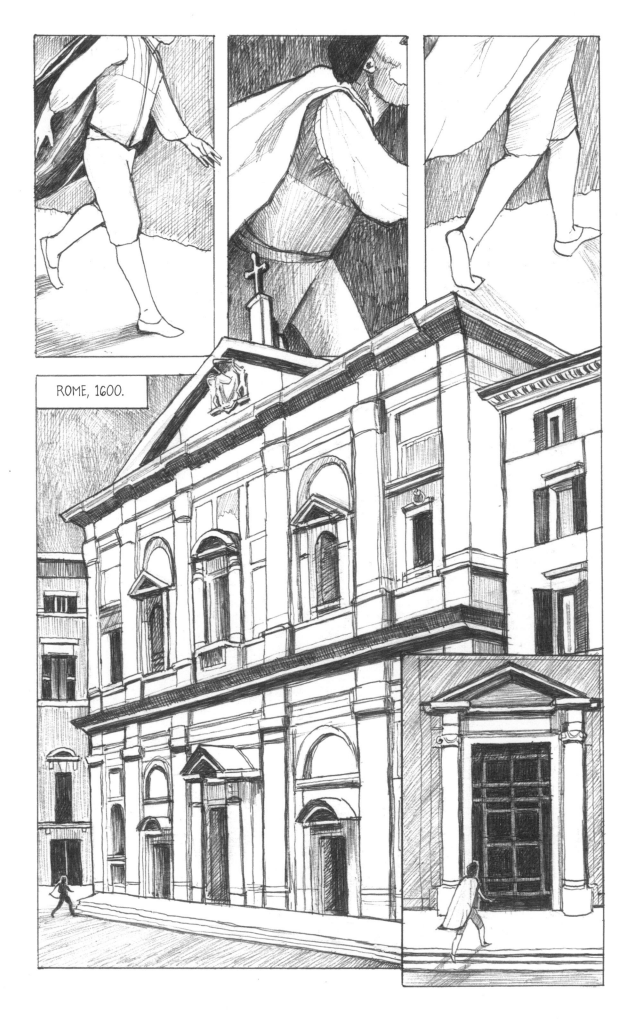

ROME, 1600.

1

ORAZIO GENTILESCHI KNEW HIS LIFE WAS ABOUT TO CHANGE.

THROUGH THE DIM GLOW OF THE CONTARELLI CHAPEL, THE FIGURES OF CARAVAGGIO'S LATEST WORK LOOMED BEFORE HIM, AND HE KNEW HIS CAREER WOULD NEVER BE THE SAME. HE WAS 36 YEARS OLD.

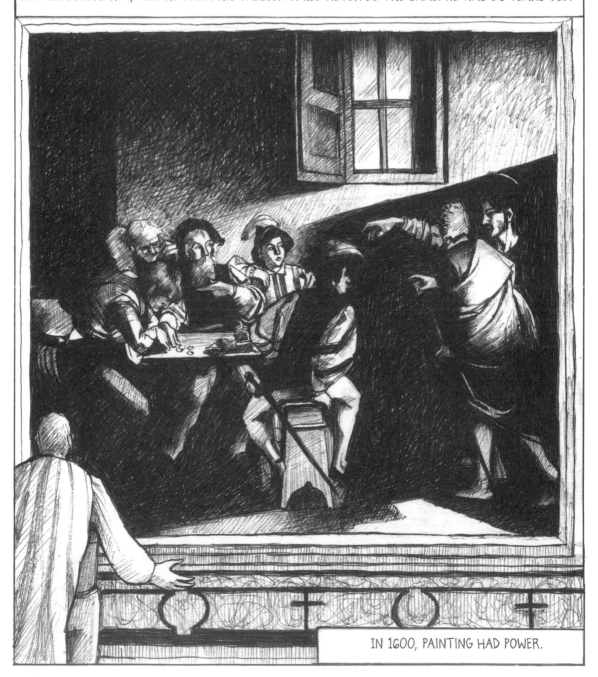

IN 1600, PAINTING HAD POWER.

THE ITALY OF ORAZIO'S ERA WAS A TUMULTUOUS PENINSULA SPLIT INTO INDEPENDENT CITY-STATES. AFTER THE SACK OF ROME IN 1527, IT TOOK YEARS FOR THE ANCIENT CITY TO REGAIN ITS FOOTING. THE COUNCIL OF TRENT WAS FORMED BY CHURCH OFFICIALS WHO REJECTED THE NORTHERN PROTESTANT REFORMATION. THE PAPAL STATES ROSE ANEW WITH A VAST SERIES OF RULES ENFORCING STRICT CATHOLIC DOCTRINE, AND THE COUNTER-REFORMATION WAS BORN.

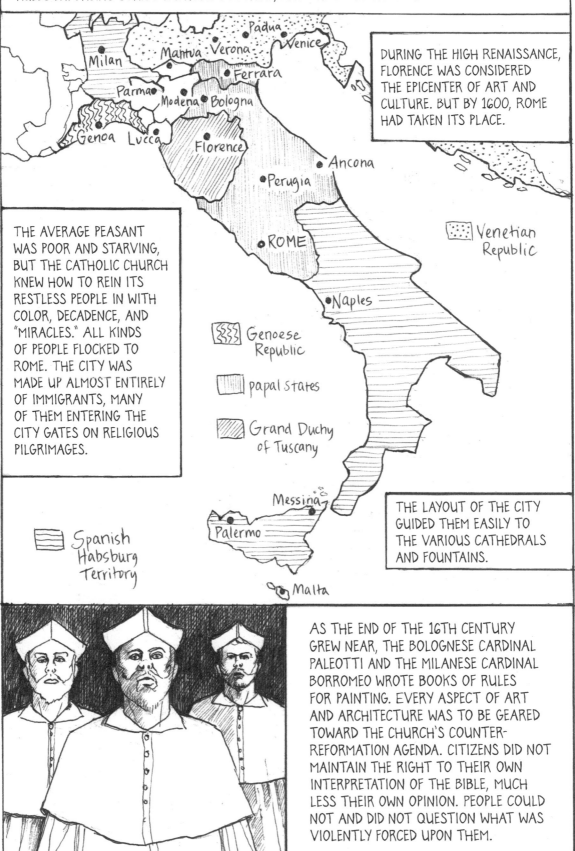

DURING THE HIGH RENAISSANCE, FLORENCE WAS CONSIDERED THE EPICENTER OF ART AND CULTURE. BUT BY 1600, ROME HAD TAKEN ITS PLACE.

THE AVERAGE PEASANT WAS POOR AND STARVING, BUT THE CATHOLIC CHURCH KNEW HOW TO REIN ITS RESTLESS PEOPLE IN WITH COLOR, DECADENCE, AND "MIRACLES." ALL KINDS OF PEOPLE FLOCKED TO ROME. THE CITY WAS MADE UP ALMOST ENTIRELY OF IMMIGRANTS, MANY OF THEM ENTERING THE CITY GATES ON RELIGIOUS PILGRIMAGES.

Venetian Republic

Genoese Republic

papal states

Grand Duchy of Tuscany

Spanish Habsburg Territory

THE LAYOUT OF THE CITY GUIDED THEM EASILY TO THE VARIOUS CATHEDRALS AND FOUNTAINS.

AS THE END OF THE 16TH CENTURY GREW NEAR, THE BOLOGNESE CARDINAL PALEOTTI AND THE MILANESE CARDINAL BORROMEO WROTE BOOKS OF RULES FOR PAINTING. EVERY ASPECT OF ART AND ARCHITECTURE WAS TO BE GEARED TOWARD THE CHURCH'S COUNTER-REFORMATION AGENDA. CITIZENS DID NOT MAINTAIN THE RIGHT TO THEIR OWN INTERPRETATION OF THE BIBLE, MUCH LESS THEIR OWN OPINION. PEOPLE COULD NOT AND DID NOT QUESTION WHAT WAS VIOLENTLY FORCED UPON THEM.

YET THE VOICES OF DISSENT COULD NOT BE SHUT OUT ENTIRELY. ORIGINALLY FROM NOLA, NEAR NAPLES, THE PHILOSOPHER GIORDANO BRUNO SPENT MOST OF HIS LIFE TRAVELING, TEACHING, WRITING, AND THEORIZING, CULTIVATING WHAT HE CALLED THE NOLAN PHILOSOPHY. AS A TEENAGER, HE ENTERED THE MONESTARY OF ST. DOMENICO, BUT IT WASN'T LONG BEFORE HE FLED NORTH UNDER SUSPICION OF HERESY. THE NOLAN PHILOSOPHY GREW INTO A RADICAL BLEND OF COPERNICAN THEORY, ASTRONOMY, COSMOLOGY, AND A REJECTION OF THE STEADFAST PTOLEMAIC AND ARISTOTELIAN VIEWS THAT DOMINATED HIS TIME. HIS PHILOSOPHY PROPOSED AN INFINITE UNIVERSE, LINKING RELIGION, POETRY, SCIENCE, AND ART INTO A COMPLEX MAGICAL WEB. HE STROVE FOR A RESURGENCE OF AN ANCIENT EGYPTIAN, SUN-CENTERED "HERMETIC" RELIGION ROOTED IN DIVINE LOVE AND TOLERANCE. HE WAS PERHAPS MOST FAMOUS DURING HIS LIFETIME FOR HIS GROUNDBREAKING STUDY OF MNEMONICS, THE ANCIENT ART OF MEMORY.

HIS WRITING REVEALS A PASSIONATE, SOMETIMES HUMOROUS TENDENCY TO QUESTION THE CORRUPTION OF MILITANT RELIGIOUS POWER. HIS TRAVELS LED HIM ACROSS A EUROPE TORN APART BY RELIGIOUS WARS, WHERE HE OBTAINED PATRONAGE FROM SUCH INFLUENTIAL AND POWERFUL FIGURES AS HENRY III OF FRANCE AND QUEEN ELIZABETH OF ENGLAND.

AROUND 1522, GIOVANNI MOCENIGO LURED GIORDANO TO VENICE. GIOVANNI CLAIMED HE WANTED TO BE HIS APPRENTICE AND LEARN THE MAGIC ART OF MEMORY. BUT AFTER A FEW MONTHS OF TEACHING AT THE UNIVERSITY OF PADUA, GIORDANO WAS TURNED OVER TO THE VENETIAN INQUISITION. GIOVANNI MOCENIGO AND GIORDANO'S PRISONMATES SERVED AS WITNESSES AGAINST GIORDANO, WHO WAS EVIDENTLY TRANSFERRED TO THE INFAMOUS ROMAN INQUISITION. HE SPENT EIGHT YEARS IN PRISON TRYING TO DEFEND HIS POSITION.

We hereby in these documents publish, announce, pronounce, sentence, and declare thee, Brother Giordano Bruno, to be an impenitent and pertinacious heretic, and therefore to have incurred all the ecclesiastical censures and pains of the Holy Canon.

These works are purely philosophical and I who hold the intellect should be free to inquire, provided it does not dispute divine authority, but submits to it.

IN THE END, THE PENALTY WAS DEATH.

You may be more afraid of pronouncing this sentence against me than I feel receiving it.

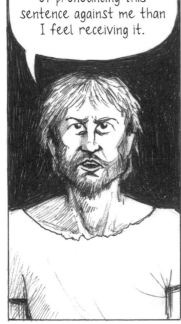

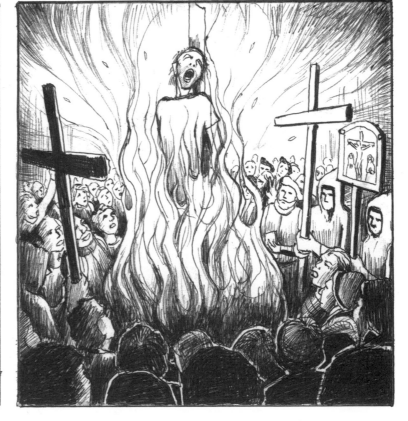

5

AND IN THE MIDST OF THIS STIFLING REPRESSION, HOW DID WOMEN LIVE? IT HAD BEEN ABOUT 200 YEARS SINCE CHRISTINE DE PIZAN LAUNCHED AN IDEA INTO THE DARK VOICE OF MEDIEVAL PATRIARCHY—THAT WOMEN WERE PERHAPS MORE THAN BIRTHING MACHINES AND BABY RECEPTACLES, THAT THEY COULD THINK AND LEARN JUST LIKE THEIR MALE COUNTERPARTS, THAT THEY DID NOT DESERVE OR ENJOY BEING RAPED AND ABUSED. WITH HUMANISM CAME SOME RENEWED RESPECT FOR WOMEN, BUT THEY WERE LEGALLY CONSIDERED MINORS, OWNED BY FATHERS AND HUSBANDS, OR ELSE DESTINED TO SPEND THEIR LIVES IN CONVENTS. ONLY PROSTITUTES AND COURTESANS HAD THE ABILITY TO SUPPORT THEMSELVES FINANCIALLY.

BARELY SIX MONTHS PRIOR TO GIORDANO BRUNO'S DEATH, A POPULAR HEROINE EMERGED NAMED BEATRICE CENCI. HER STORY SPREAD QUICKLY AMIDST A COUNTER-REFORMATION SOCIETY THAT POPULARIZED NOTIONS OF FANTASTIC SUFFERING AND TRIUMPHANT MARTYRDOM.

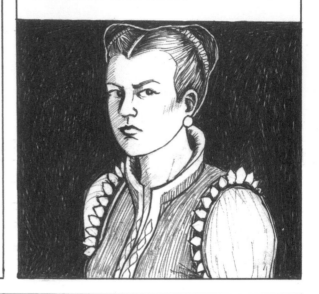

HER FATHER FRANCESCO WAS ONE OF THE WEALTHIEST MEN IN ROME. MOST OF FRANCESCO'S FORTUNE WAS INHERITED FROM HIS FATHER, WHO HAD SERVED AS PAPAL TREASURER. BUT FRANCESCO WAS BURIED IN LAWSUITS AND DEBTS.

HE WANTED TO SAVE MONEY ON THE LARGE DOWRY THAT WOULD BE REQUIRED IF BEATRICE WERE MARRIED, SO HE LOCKED HIS DAUGHTER AND SECOND WIFE IN A TOWER ON THE OUTSKIRTS OF ROME FOR THREE YEARS.

FRANCESCO WAS SAVAGELY ABUSIVE, WITH A LONG HISTORY OF VIOLENCE TOWARD HIS FAMILY AND SERVANTS. HIS SON BERNARDO ONCE JUMPED FROM A HIGH BALCONY JUST TO ESCAPE HIS WRATH. TWO OF HIS OTHER SONS DIED IN STREET FIGHTS.

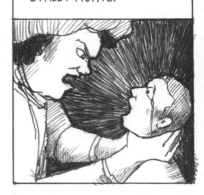

HE REFUSED TO EXTEND ANY OF HIS WEALTH TO HIS STEP-SONS, AND TRIED TO RAPE ONE OF THEM. HE WAS CHARGED WITH SODOMIZING MULTIPLE BOYS.

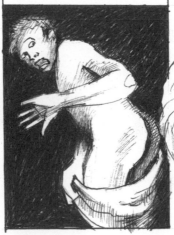

WHILE LOCKED AWAY IN THE CASTLE, BEATRICE DESPERATELY WROTE TO HER BROTHER GIACOMO FOR HELP. BUT FRANCESCO INTERCEPTED THE LETTER AND BEAT HER TO THE GROUND.

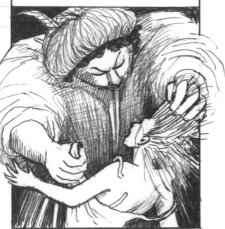

GIACOMO TRIED SENDING POISON BUT FRANCESCO MADE BEATRICE TEST ALL HIS FOOD BEFORE HE ATE. SHE EVEN TRIED TO HIRE THE BANDITS IN THE SURROUNDING COUNTRYSIDE TO CARRY OUT HER REVENGE.

HE WILL PAY.

OLIMPIO, PLEASE TAKE THIS TO THE BANDITS. PLEASE BARGAIN WITH THEM ON MY BEHALF.

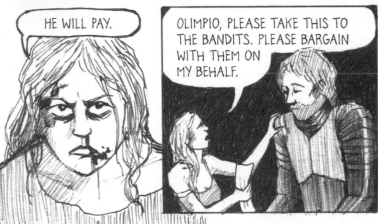

BUT ALL EFFORTS TO ALLEVIATE HER SUFFERING WERE FUTILE UNTIL SHE BEGAN AN AFFAIR WITH THE CASTLE GUARD OLIMPIO CALVETTI.

HE WAS BELOW HER STATUS IN EVERY WAY, FOR, DESPITE THE TATTERED RAGS AND BLACK EYES HER FATHER LEFT HER WITH, SHE WAS STILL A WEALTHY PRINCESS, BARELY 20 YEARS OLD.

TOMORROW EVENING YOU'LL KNOCK HIM OUT AND PUSH HIM OVER THE BALCONY. IT'LL JUST LOOK LIKE HE FELL.

NO ONE WILL EVER KNOW. AND THEN WE'LL BE FREE FROM THIS TERROR.

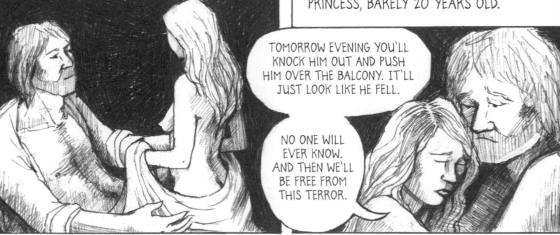

OLIMPIO AND AN ACCOMPLICE CARRIED OUT HER WISHES.

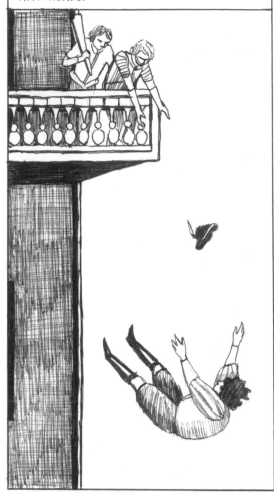

BUT SOME LOCAL PRIESTS GREW SUSPICIOUS AND THE CENCI FAMILY WAS PUT UNDER HOUSE ARREST IN ROME WHILE THE POPE INVESTIGATED. MANY WEALTHY FRIENDS AND RELATIVES PLEADED AND PETITIONED FOR THEIR FREEDOM, BUT TO NO AVAIL. MEANWHILE, GIACOMO HIRED SOMEONE TO MURDER HIS SISTER'S RUNAWAY LOVER, OLIMPIO CALVETTI, WHICH ONLY UNEARTHED MORE WITNESSES AGAINST THE CENCI.

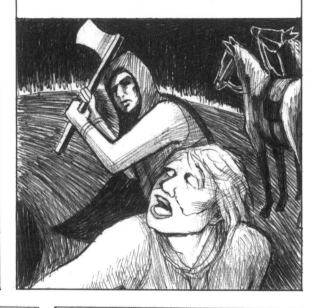

PEOPLE SPECULATED THAT THE POPE WAS AFTER THE CENCI FORTUNE, AND HE ORDERED THAT THE FAMILY BE TORTURED. VARYING DEGREES OF TORTURE WERE COMMONLY USED, BUT RARELY ON AN UPPER-CLASS FAMILY. ONE BY ONE, THE CENCIS WERE HOISTED INTO THE AIR WITH THEIR ARMS TIED BEHIND THEIR BACKS, DISLOCATING THEIR SHOULDERS. THEY WERE LOWERED AND LIFTED AGAIN REPEATEDLY. GIACOMO AND THE STEPMOTHER, LUCREZIA, CONFESSED QUICKLY.

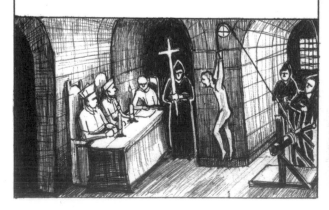

THERE WERE RUMORS THAT BEATRICE ENDURED HOURS OF TORTURE. AFTER A LONG AND TIRESOME TRIAL, POPE CLEMENT VIII DECLARED THAT THE CENCIS WOULD BE PUBLICLY EXECUTED AT THE PIAZZA DI PONTE SANT'ANGELO.

LUCREZIA FAINTED BEFORE SHE REACHED THE CHOPPING BLOCK. GIACOMO WAS RIPPED APART WITH HOT POKERS AND THEN HACKED INTO PIECES.

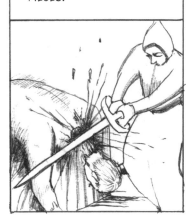

EVEN UP TO HER LAST MOMENTS, BEATRICE MAINTAINED HER PRIDE. SHE DEFIANTLY PLACED HER HEAD ONTO THE CHOPPING BLOCK, CURSING THE INJUSTICE.

THE 17-YEAR-OLD BERNARDO'S LIFE WAS SPARED, BUT HE WAS FORCED TO WATCH THE EXECUTIONS AND THEN SPEND THE REST OF HIS LIFE AS A GALLEY SLAVE.

THE CENCI FAMILY'S REMAINS HUNG ON DISPLAY, PERHAPS ALONGSIDE THE HEADS OF OTHER BANDITS AND CRIMINALS. SUCH A GORY SHOWCASE WAS NOT UNUSUAL, BUT THE WEALTH AND PRESTIGE OF THE VICTIMS SHOCKED EVERYONE. THE PUBLIC WAS OUTRAGED, AND BEATRICE SOON BECAME THE CENTRAL MARTYR.

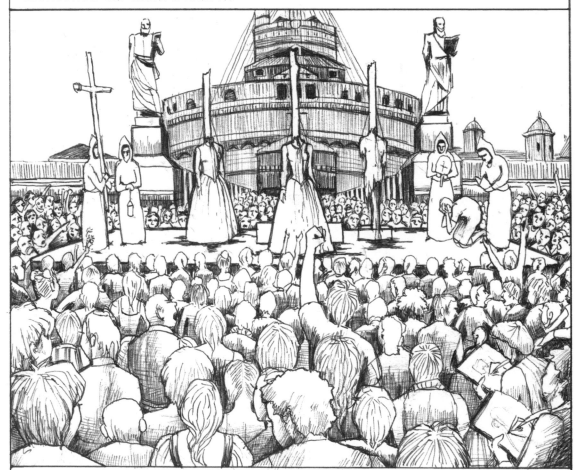

IT IS LIKELY THAT MANY ARTISTS GATHERED AT THE CENCI BEHEADING, INCLUDING CARAVAGGIO AND ORAZIO. AFTER THIS 1599 EXECUTION, DECAPITATION BECAME AN IMPORTANT ELEMENT OF CARAVAGGIO'S PAINTING REPERTOIRE.

IF PUBLIC MURDER WAS THE MOST APPALLING METHOD THE CHURCH USED TO CONTROL PEOPLE, ART WAS THE MOST SPECTACULAR.

ORAZIO COULD FEEL THE POWER OF CARAVAGGIO'S MASTERPIECE AS HE EXAMINED ALL ITS NUANCES. HE AND CARAVAGGIO WERE TENTATIVE FRIENDS.

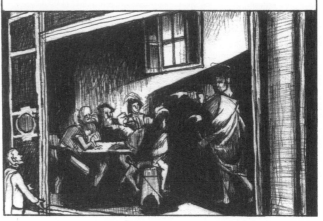

THE MARTYRDOM OF ST. MATTHEW HUNG DIRECTLY ACROSS FROM *THE CALLING OF ST. MATTHEW.* THERE WAS ALMOST NO PUBLIC ART, SO THE ONLY PLACE TO SEE SUCH MAGIC WAS AT CHURCH—AND TO THE PEOPLE, IT REALLY WAS MAGIC! HOW DID CARAVAGGIO DO IT?

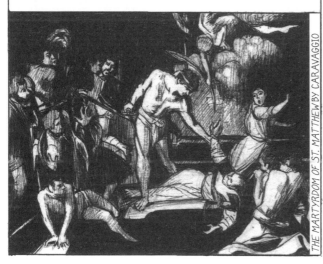

THE MARTYRDOM OF ST. MATTHEW BY CARAVAGGIO

THE FIGURES ACTUALLY LOOKED LIKE ORDINARY PEOPLE THAT THE AUDIENCES COULD RELATE TO. A RELIGIOUS SCENE HAD NEVER BEEN PAINTED THIS WAY BEFORE. IT LOOKED LIKE A FAMILIAR TAVERN WITH A GROUP OF GAMBLERS.

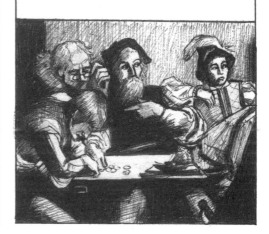

ON THE OTHER SIDE OF THE CANVAS, JESUS SUMMONED ST. MATTHEW WITH A GENTLE BEAM OF LIGHT FOLLOWING HIS GESTURE, EMPHASIZED BY THE LIGHT FROM THE CONTARELLI CHAPEL'S SINGLE WINDOW.

OPPOSITE OF *THE CALLING,* *THE MARTYRDOM* FAST-FORWARDS TO ST. MATTHEW'S VIOLENT DEATH. IT MAY AS WELL HAVE BEEN A STREET GANG MURDER...

...COMPLETE WITH CARAVAGGIO'S OWN FACE DEPICTED IN THE BACK, FLEEING THE SCENE.

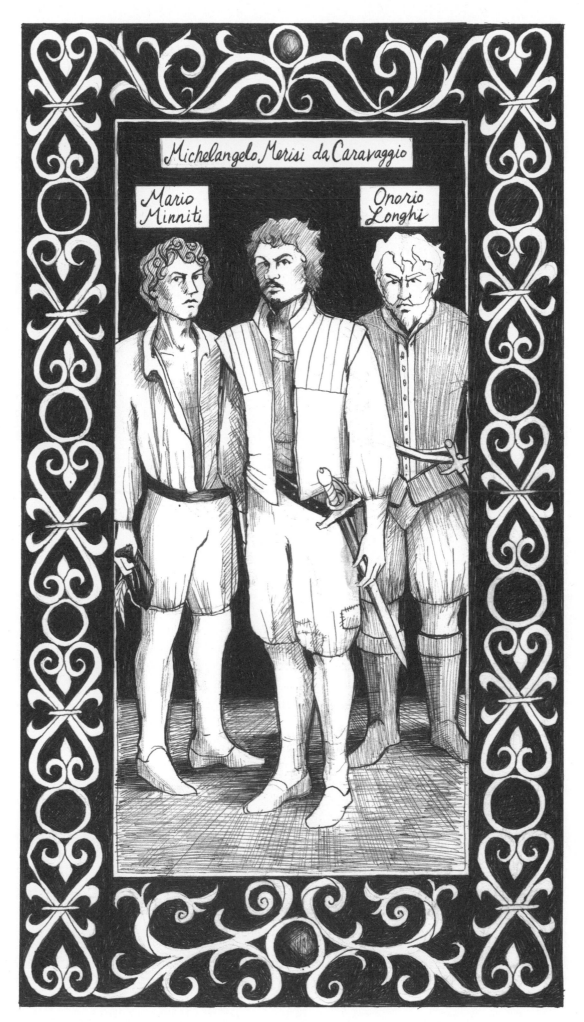

THE ST. MATTHEW PAINTINGS AT THE SAN LUIGI DE FRANCESI BEGAN CARAVAGGIO'S CLIMB TO FAME. HE HAD JUST MOVED INTO THE HOME OF DEL MONTE, THE FIRST OF THE GREAT PATRONS TO TAKE THIS UNRULY CHARACTER UNDER HIS WING. DURING THE 16TH AND 17TH CENTURIES, ARTISTS TRIED TO PROVE THEY WERE MORE THAN MERE CRAFTSMEN. SINCE THE RENAISSANCE INTRODUCED THE CONCEPT OF THE INTELLECTUAL GENIUS, ARTISTS COMPETED WITH ONE ANOTHER, HOPING TO RAISE THE STATUS OF THEIR PROFESSION. ART AND THEATRE WERE THE MAIN SOURCES OF ENTERTAINMENT. THE GREATEST ARTISTS BECAME CELEBRITIES, AS PATRONS PITTED THEM AGAINST ONE ANOTHER, TESTING THEIR SKILL AND ENDURANCE.

SO WHO WAS CARAVAGGIO, THE EMERGING STAR?

MOST OF WHAT IS KNOWN ABOUT HIM COMES FROM POLICE REPORTS. HIS NAME WAS ACTUALLY MICHELANGELO MERISI. CARAVAGGIO WAS THE NAME OF THE TOWN HE WAS BORN IN, AND IT GRADUALLY BECAME HIS NICKNAME. HE WAS ALSO CALLED SIMPLY MICHELE. ALTHOUGH HE CAME FROM HUMBLE ORIGINS, HIS FAMILY WAS BY NO MEANS POOR. HIS FATHER, FERMO, WAS A STONE MASON UNDER THE POWERFUL SFORZA FAMILY OF MILAN. CARAVAGGIO'S TIES WITH THIS FAMILY REMAINED STRONG THROUGHOUT HIS LIFE, ESPECIALLY WITH THE MARCHESA COSTANZA SFORZA COLONNA, WHO RAN THE ESTATE AFTER HER HUSBAND DIED.

WHEN MICHELE WAS STILL A CHILD THE PLAGUE HIT, KILLING THOUSANDS, INCLUDING HIS FATHER AND GRANDFATHER. HIS MOTHER RAISED ALL FOUR MERISI CHILDREN ON HER OWN.

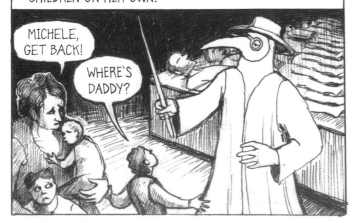

MICHELE, GET BACK!

WHERE'S DADDY?

MICHELE RECEIVED HIS EARLIEST ART EDUCATION IN MILAN WITH SIMONE PETERZANO, A STUDENT OF TITIAN.

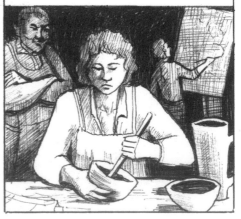

AROUND 1592, HE MOVED TO ROME, WHERE HE WORKED UNDERNEATH THE INCREASINGLY BUSY AND FAMOUS GIUSEPPE CESARE, ALSO KNOWN AS THE CAVALIER D'ARPINO. DURING HIS FIRST YEARS IN ROME, CARAVAGGIO LIVED IN EXTREME POVERTY, LIMITED TO COMPLETING FRIVOLOUS STILL-LIFE PAINTINGS FOR HIS EMPLOYER.

YOU IDIOT! WHY DID YOU PAINT THE BRUISES ON THOSE FIGS?

BECAUSE THAT'S WHAT THEY REALLY LOOK LIKE!

HE BEGAN FIGHTING AND GETTING INTO TROUBLE. WHO KNOWS WHAT WOULD'VE HAPPENED IF DEL MONTE HADN'T PICKED HIM UP OFF THE STREET?

HOLD IT RIGHT THERE. HIS SUPREME HOLINESS HAS FORBIDDEN ANYONE TO CARRY WEAPONS.

FUCK YOU! I'M WITH DEL MONTE.

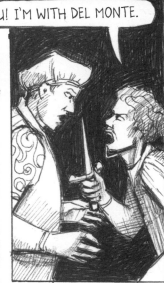

THESE WERE THE DARK AND DANGEROUS ALLEYWAYS FLOODED WITH CRIME, THE INSPIRATION FOR SHAKESPEARE'S TRAGEDIES. THE POPES CONSTANTLY TRIED TO CONTROL THIS MAYHEM, AND THEY ALWAYS FAILED. CARAVAGGIO WAS RUTHLESS.

HE BECAME NOTORIOUS FOR NEVER MAKING PRELIMINARY DRAWINGS, PAINTING RIGHT ONTO THE CANVAS, AND ALWAYS WORKING FROM DIRECT OBSERVATION. HE DILIGENTLY PAINTED WHAT HE SAW.

THE FORTUNE TELLER BY CARAVAGGIO

HE NEVER DID FRESCOES. HE REJECTED THE RENAISSANCE OBSESSION WITH CLASSICAL GRANDEUR AND THE IDEAL FORM. HE REJECTED THE TRANQUIL, FORMULAIC MANNERISM THAT DOMINATED THE ART SCENE. HE REJECTED ANY ARTIST THAT TRIED TO COMPETE WITH HIM, AND HE REJECTED ALL THE CARAVAGGESQUE FOLLOWERS WHO COPIED HIS WORK.

CARAVAGGIO'S FIRST PIECES FOR DEL MONTE HAVE BEEN THE SUBJECT OF MUCH DEBATE—YOUTHFUL, SEDUCTIVE BOYS, ADOLESCENTS JUST ON THE CUSP OF MANHOOD. THE MODEL FOR MANY OF THESE SENSUAL PIECES WAS EITHER THE ARTIST HIMSELF OR HIS YOUNG SICILIAN SIDEKICK, MARIO MINNITI. IT IS DIFFICULT TO GAUGE HOW THE IDEA OF HOMOSEXUALITY MANIFESTED IN THE COUNTER-REFORMATION SOCIETY.

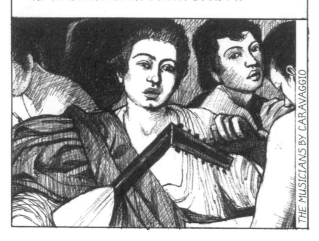

THE MUSICIANS BY CARAVAGGIO

SEX BETWEEN TWO ADULT MEN COULD BE PUNISHABLE BY DEATH. WHILE STILL UNLAWFUL, AN OLDER MAN'S SEXUAL ADVANCES TOWARD A YOUNG BOY WERE MORE ACCEPTED AND CERTAINLY DID NOT NULLIFY HIS MASCULINITY OR HIS SOCIAL STATUS. CARAVAGGIO CONTINUED TO PAINT EROTIC ADOLESCENT BOYS FOR WEALTHY PATRONS SUCH AS BANKER CARDINAL GIUSTINIANI AND FOR THE MATTEI CLAN.

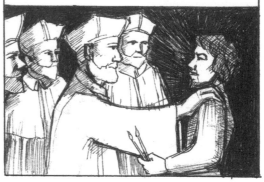

IT WAS WOMEN'S SEXUALITY THAT WAS MOST TABOO. MEN'S ARTISTIC DISPLAYS OF FEMALE FLESH WERE SUBJECT TO INTENSE SCRUTINY. MANY ARTISTS USED THE THEME OF MARY MAGDALENE AS A VEHICLE FOR SEXUAL EXPRESSION, AN EXCUSE TO PAINT A SCANTILY CLAD WOMAN POSED AS THE LEGENDARY PROSTITUTE THAT CONVERTED. BUT UNLIKE HIS CONTEMPORARIES, CARAVAGGIO DIDN'T PAINT IDEALIZED BEAUTIES. INSTEAD, HE PORTRAYED THE STURDY PROSTITUTES AND HARDWORKING COURTESANS OF HIS DAY. THE MOST FAMOUS WAS FILLIDE MELANDRONI, POSED AS THIS SQUEAMISH JUDITH OF 1599, THE SAME YEAR BEATRICE WAS BEHEADED. WAS THIS CARAVAGGIO'S RESPONSE?

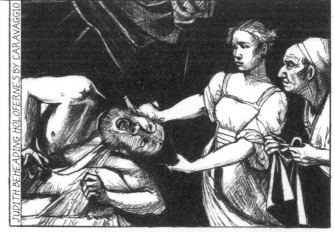

JUDITH BEHEADING HOLOFERNES BY CARAVAGGIO

ORAZIO CONTINUED STARING AT THE ST. MATTHEW SAGA BEFORE HIM.

HE RECOGNIZED MINNITI'S HANDSOME CHARM, ALTHOUGH HERE WAS NOT HIS USUAL SEXY GAZE.

THROUGHOUT HIS CAREER, CARAVAGGIO STRADDLED THE LINE BETWEEN PLEASING HIS PATRONS AND CHALLENGING THEM. WHILE HIS EPIC REALISM WAS AT TIMES TOO EXTREME FOR THE WEALTHY ELITE WHO BOUGHT HIS ART, IT ALSO FIT RIGHT INTO THE COUNTER-REFORMATION'S GOAL OF USING RAW, TANGIBLE HUMANITY TO DRAW PEOPLE INTO THE CATHOLIC FAITH.

ORAZIO GENTILESCHI WAS, NO DOUBT, JEALOUS AND FASCINATED.

HE WANTED SO DESPERATELY TO CAPTURE SOME OF CARAVAGGIO'S POWER.

LIKE CARAVAGGIO, HE HAD PREVIOUSLY WORKED FOR THE CAVALIER D'ARPINO AND WAS PAINTING FROM LIFE NOW, TOO, MORE FREQUENTLY THAN EVER.

IN THE SUMMER OF 1600, HE FINISHED AN APOSTLE THAT ADORNED THE FRESCOED DECORATION OF THE TRANSEPT IN SAN GIOVANNI IN LATERANO. HE ALSO DID FRESCO WORK FOR THE APSE OF SAN NICOLA IN CARCERE FOR THE POPE'S NEPHEW, CARDINAL PIETRO ALDOBRANDINI.

YES, ORAZIO RECEIVED SOME IMPORTANT COMMISSIONS, BUT HIS NAME WOULD NOT GO DOWN IN HISTORY LIKE CARAVAGGIO'S.

THERE WAS ONE BIG DIFFERENCE BETWEEN ORAZIO AND HIS YOUNGER COMPANIONS—CARAVAGGIO, MARIO MINNITI, ARCHITECT ONORIO LONGHI, AND THE OTHERS—

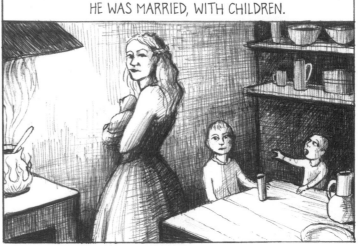

HE WAS MARRIED, WITH CHILDREN.

HE WAS KNOWN AS A GRUFF AND SULLEN MAN WHO SPENT MORE THAN HE COULD MAKE.

HE DESCENDED FROM A LONG LINE OF PAINTERS, BUT HIS PAINTINGS HAVE ALWAYS BEEN OVERLOOKED.

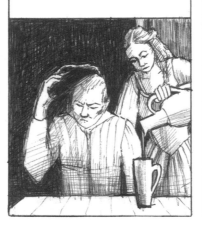

ORAZIO STRUGGLED. HE TOILED OVER HIS PRECIOUS WORK. HE TOOK HIS ANGER OUT ON OTHERS.

BUT DESPITE HIS TROUBLES, HE HAD HIS PAINTING SECRETS TOO. MANY OF HIS IMAGES ARE SURPRISINGLY TENDER. THE WOMEN IN HIS PAINTINGS ARE NOT GRITTY HARLOTS OR SEXY MAIDENS.

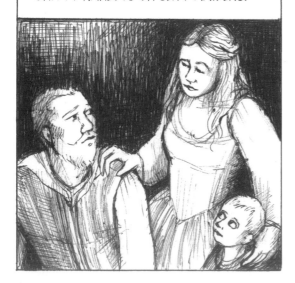

THEY ARE SWEET YOUNG MOTHERS, EARTHY ANGELS, CONCENTRATING LUTE PLAYERS. THEY ARE HIS FAMILY.

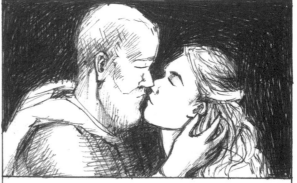

THROUGHOUT HIS LIFE, HIS PAINTINGS SHOWED A HUMBLE FONDNESS FOR WOMEN AND CHILDREN, IN CONTRAST WITH THE SEEDY NIGHTLIFE HE TOOK PART IN AND THE DESPERATION HE FELT.

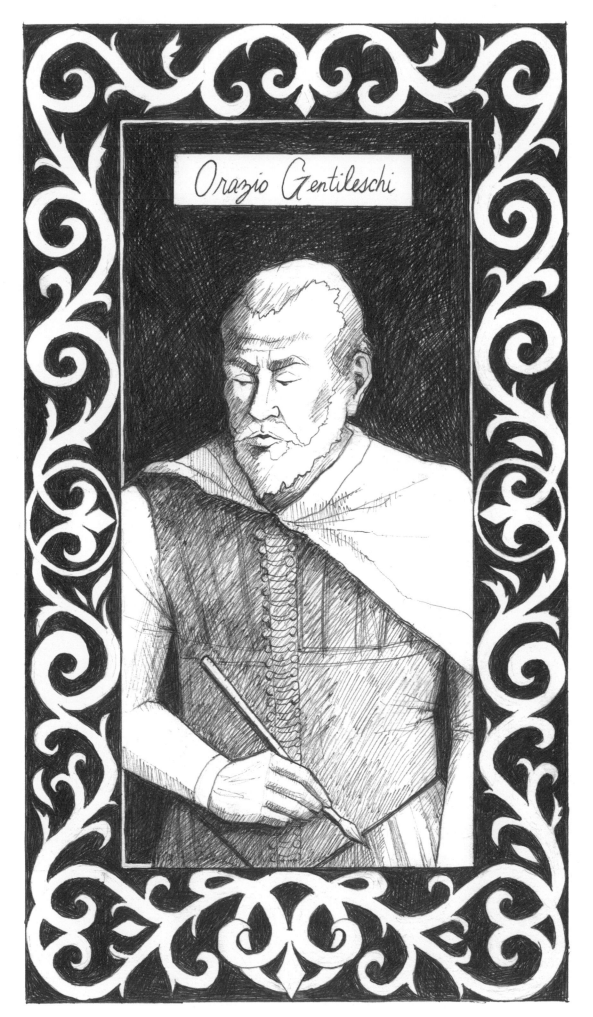

Orazio Gentileschi

WHILE CARAVAGGIO FERVENTLY PUSHED THE BOUNDARIES OF ART AND REVOLUTIONIZED NEW TECHNIQUES, ORAZIO TRAILED BEHIND, STRUGGLING TO FEED HIS FAMILY AND RISE ABOVE MEDIOCRITY. ORAZIO TURNED HIS HOUSEHOLD INTO A WORKING STUDIO. THERE IS LITTLE DOUBT THAT THE CHILDREN GROUND PIGMENTS AND PREPARED COLORS FOR THEIR FATHER AS HE STRUGGLED TO KEEP UP WITH TRENDS AND DEMANDS.

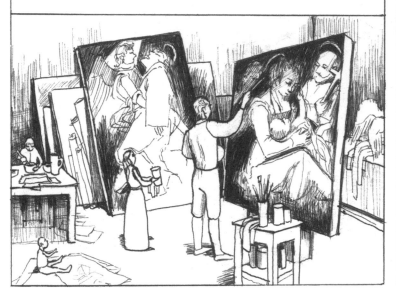

IN 1600, ORAZIO'S HOUSEHOLD CONSISTED OF HIS WIFE PRUDENZIA, AGE 25;

THEIR THREE SONS— GIOVANNI BATTISTA, AGE SIX; FRANCESCO, AGE THREE; GIULIO, STILL AN INFANT;

AND THE OLDEST CHILD, ARTEMISIA, AGE SEVEN.

HOW HAPPY WAS THIS HOUSEHOLD? WHAT WAS IT THAT DROVE ORAZIO OUT INTO THE NIGHT?

DID HE CARRY A SWORD OR DAGGER LIKE SO MANY OF HIS FRIENDS, EVEN THOUGH IT WAS ILLEGAL?

AFTER THE DEATH OF BEATRICE CENCI, HOSTILE AND ACCUSATORY VERSE AIMED AT THE POPE CIRCULATED THROUGH THE CITY. IN RESPONSE, CLEMENT VIII ENACTED SEVERE LAWS AGAINST SLANDER. ANYONE WHO WAS CAUGHT WRITING NASTY POEMS OR LETTERS, SPREADING BLASPHEMOUS GOSSIP, OR INTENTIONALLY RUINING SOMEONE'S REPUTATION COULD BE PUT TO DEATH.

YET THREE YEARS LATER IN 1603, RIVALRY IN THE ARTIST QUARTER REACHED NEW LEVELS OF MALICIOUSNESS, AS GIOVANNI BAGLIONE EMERGED PROMINENTLY. BOTH HE AND ORAZIO WERE PAINTING IN CARAVAGGIO'S STYLE—

A DRAMATIC HIGH CONTRAST REALISM ROOTED IN PASSIONATE CATHOLICISM. ALL THREE ARTISTS HAD RECENTLY COMPLETED SIMILAR ST. FRANCIS PAINTINGS.

ST. FRANCIS SUPPORTED BY ANGEL BY O. G.

ALTHOUGH GIOVANNI BAGLIONE'S WORK WAS LESS POPULAR AND OBVIOUSLY DERIVATIVE OF CARAVAGGIO'S, CARDINAL BENEDETTO GIUSTINIANI REWARDED HIM WITH A VALUABLE GOLD CHAIN.

CARAVAGGIO HAD ALREADY ATTACKED BAGLIONE'S SIDEKICK, MAO SALINI, FOR TRYING TO COPY HIS PAINTINGS. THIS DIZZYING COMPETITION ESCALATED DUE TO AN IMPORTANT COMMISSION GIOVANNI RECEIVED FROM THE JESUITS—ONE OF THE MOST POWERFUL FACTIONS OF THE POPE'S CATHOLIC ORDER—A HUGE *RESURRECTION OF CHRIST*. NOW, WITH THE HELP OF ORAZIO AND ONORIO LONGHI, CARAVAGGIO TARGETED GIOVANNI BAGLIONE. IT WASN'T LONG BEFORE ANOTHER FOLLOWER, FILIPPO TRISEGNI, EXPOSED A SERIES OF SCANDALOUS POEMS ABOUT BAGLIONE AND SALINI.

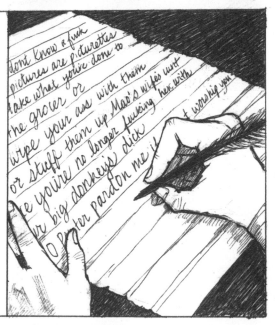

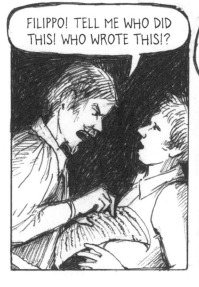

FILIPPO! TELL ME WHO DID THIS! WHO WROTE THIS!?

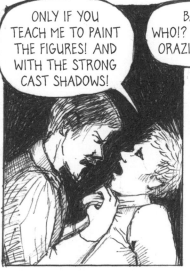

ONLY IF YOU TEACH ME TO PAINT THE FIGURES! AND WITH THE STRONG CAST SHADOWS!

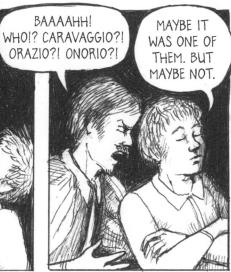

BAAAAHH! WHO!? CARAVAGGIO?! ORAZIO?! ONORIO?!

MAYBE IT WAS ONE OF THEM. BUT MAYBE NOT.

GIOVANNI BAGLIONE TOOK CARAVAGGIO, ORAZIO, AND FILIPPO TRISEGNI TO COURT FOR CRIMINAL LIBEL. ONORIO LONGHI LEFT TOWN AND WAS NOWHERE TO BE FOUND. CARAVAGGIO DEFENDED HIMSELF SIMPLY AND ELOQUENTLY.

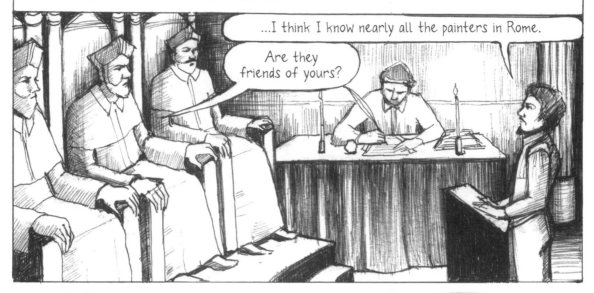

...I think I know nearly all the painters in Rome.

Are they friends of yours?

Nearly all of them are my friends, though they aren't all good men.

And what do you mean by "good man?"

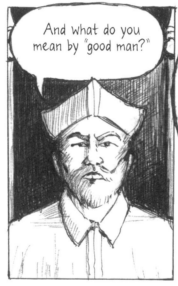

To me, the term "good man" means someone who knows how to do things well—that is, how to do his art well. So in painting, a good man knows how to paint well and imitate natural things well.

CARAVAGGIO EXPLAINED THAT NO ONE LIKED BAGLIONE'S *RESURRECTION OF CHRIST*. HE VAGUELY DESCRIBED HIS RELATIONSHIP WITH THE OTHER PAINTERS AND CONCLUDED HIS CASE FIRMLY.

What do people think of Giovanni Baglione?

I have never heard in verse or prose, in latin or the vulgar toungue, anything of any kind whatsoever that made any mention of the said Giovanni Baglione or the said Mao Salini.

Who are your friends among these painters?

They are all my friends. Though obviously there is some rivalry between us.

Can you write, Mr. Gentileschi?

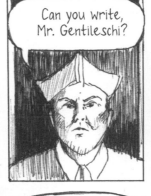

I can write... but not without errors.

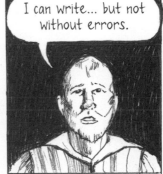

If you were to see your handwriting, would you recognize it?

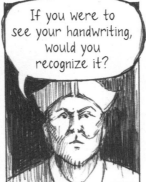

I... I think so.

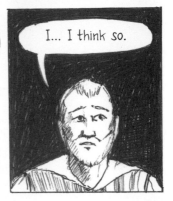

So do you recognize this as yours?

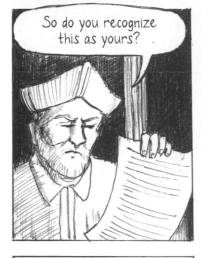

I... I saw it, but I don't remember it anymore.

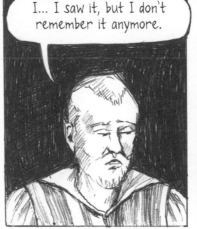

Do you recognize your handwriting in this poem and in this letter?

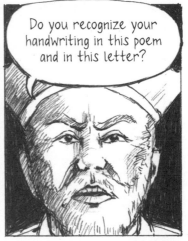

ORAZIO GOT CAUGHT UP IN TOO MANY DETAILS.

M-maybe yes. But maybe not. I write in different hands. Sometimes I write in ink, sometimes pencil.

...you see, Giovanni only painted this *Divine Love* to compete with Caravaggio, who just finished an *Earthly Love* for Cardinal Giustiniani. The Cardinal liked Giovanni Baglione's *Divine Love* less than Caravaggio's *Earthly Love*, but despite that, Giovanni got a gold chain for his painting. I myself told him that his painting struck me as being very imperfect. *Divine Love* ought to be an angelic little naked boy. He made him a great hefty thing dressed as a warrior.

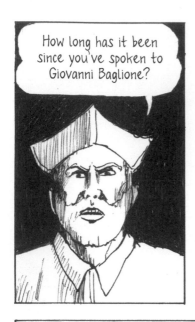

How long has it been since you've spoken to Giovanni Baglione?

I haven't spoken to Giovanni since that dispute, because whenever we meet in Rome he expects me to greet him first. He expects me to raise my hat to him and I expect him to raise his hat to me. Even Caravaggio, a friend of mine, expects me to raise my hat first. It's been six or seven months since I spoke to Caravaggio. But I recently lent him a Capuchin habit and some angel wings he asked to borrow for a painting. He returned the habit about ten days ago.

THE OUTCOME OF THE LIBEL SUIT IS NOT RECORDED. THROUGHOUT THE TRIAL, THE CONVICTED MEN WERE LOCKED IN THE CORTE SAVELLA PRISON, WHICH WAS DIVIDED UP BY CLASS AND SOCIAL STATUS. THEY WEREN'T IN THE POOREST SECTION, SO FRIENDS AND FAMILY COULD BRING FOOD AND OTHER NECESSITIES TO THEM. ALTHOUGH THEY MIGHT BE IMPRISONED FOR CONSIDERABLE LENGTHS OF TIME, JAIL WAS ONLY A HOLDING PLACE FOR CONVICTED MEN. THE ACTUAL SENTENCE WAS USUALLY BANISHMENT OR DEATH.

BUT SHORTLY AFTER THE TRIAL, CARAVAGGIO WAS RESCUED BY THE FRENCH AMBASSADOR. THE TENSION BETWEEN SPANISH AND FRENCH INFLUENCE PERMEATED THE WAY THE PEOPLE OF THE PAPAL STATES LIVED, DRESSED, AND SPOKE. CARAVAGGIO WAS OFTEN BAILED OUT OF JAIL BY POWERFUL PEOPLE WHO WANTED HIS PAINTINGS, USUALLY DEL MONTE, WHO WAS PRO-FRENCH. THIS TIME THERE MAY HAVE BEEN A HANDFUL OF OTHERS AIDING HIS RELEASE. IT WASN'T LONG BEFORE ORAZIO WAS BACK IN HIS STUDIO TOO. HE MUST'VE BEEN RELEASED WITH CARAVAGGIO.

NOT LONG AFTER, THE RED-BEARDED ONORIO LONGHI RETURNED TO ROME AND THREW A BRICK AT MAO SALINI. THE TENSION BETWEEN THE ARTIST GANGS PROVED TO BE AN ONGOING AFFAIR.

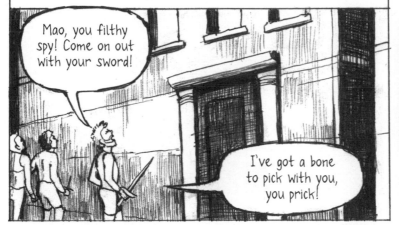

Mao, you filthy spy! Come on out with your sword!

I've got a bone to pick with you, you prick!

BUT ORAZIO TRIED TO STAY OUT OF TROUBLE. HE NEVER RETURNED TO PRISON.

IN 1604 HIS SON MARCO WAS BORN. BY THEN, TWO OF HIS OTHER SONS WERE DEAD. DURING THE RENAISSANCE, SIX OUT OF TEN CHILDREN DIED BEFORE REACHING ADULTHOOD.

IN 1605 ORAZIO'S WIFE, PRUDENZIA, DIED AT THE AGE OF THIRTY WHILE GIVING BIRTH.

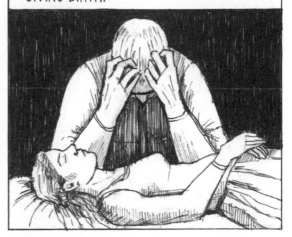

EVEN THOUGH ORAZIO COULD NOT AFFORD A BURIAL OR A TOMB, HE DID PROVIDE A FUNERAL AT THE CHURCH OF SANTA MARIA DEL POPOLO.

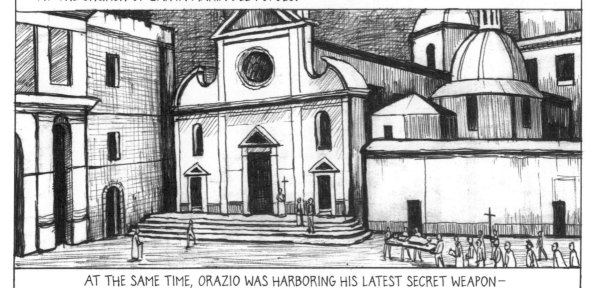

AT THE SAME TIME, ORAZIO WAS HARBORING HIS LATEST SECRET WEAPON—

HIS DAUGHTER, ARTEMISIA GENTILESCHI.

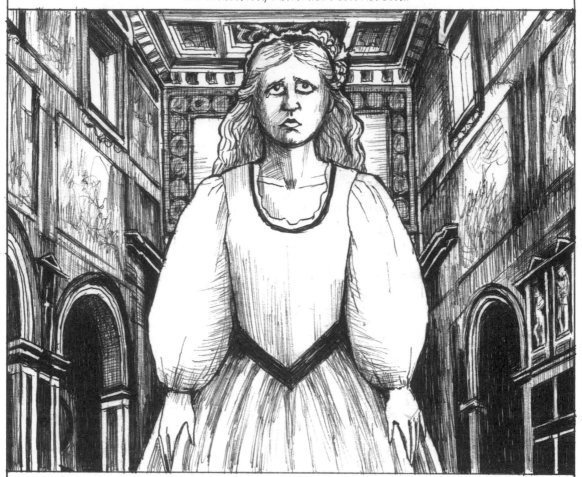

IN 1605, THE YEAR HER MOTHER DIED, SHE WAS CONFIRMED IN THE CHURCH OF SAN GIOVANNI IN LATERANO AT AGE ELEVEN. SOON AFTER, SHE BEGAN HER TRAINING AS A PAINTER.

WHY?

WHY WOULD ORAZIO TEACH HIS ONLY DAUGHTER THE SECRETS OF HIS TRADE? HE HAD THREE STARVING SONS, BUT NONE OF THEM PURSUED A CAREER IN PAINTING.

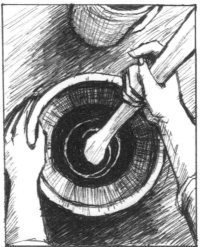

WAS IT BECAUSE HIS SONS SIMPLY DID NOT SHOW THE TECHNICAL ABILITY, CREATIVE DRIVE, AND COMMITMENT THAT SHE DID?

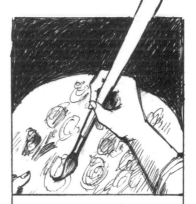

GIOVANNI BAGLIONE'S VENDETTA AGAINST ORAZIO LIKELY TARNISHED HIS REPUTATION. WAS IT HIS STATUS AS AN OUTSIDER THAT PRODUCED AN OUTSIDER DAUGHTER?

OR WAS IT CONNECTED TO THE DEATH OF HIS BELOVED WIFE? PERHAPS ALL HE COULD DO TO CHANNEL HIS LOVE FOR THE ONLY WOMAN LEFT IN HIS LIFE WAS TO OFFER HER THE GIFT OF HIS KNOWLEDGE.

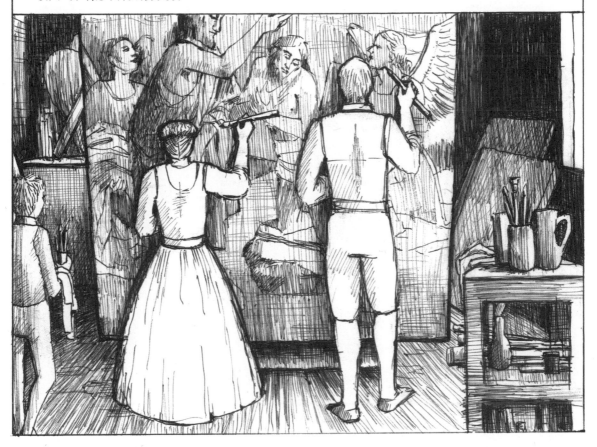

HE WAS EXTREMELY PROTECTIVE OF ARTEMISIA. LIKE MOST YOUNG UNMARRIED WOMEN, SHE WAS KEPT HIDDEN AWAY, NEVER TO BE SEEN OR HEARD.

HOWEVER, SHE MUST HAVE BEEN EXPOSED TO SOME OF THE GREAT MASTERS OF HER DAY. HER FATHER'S ENTHUSIASM FOR HIS OCCUPATION TRICKLED DOWN TO HER.

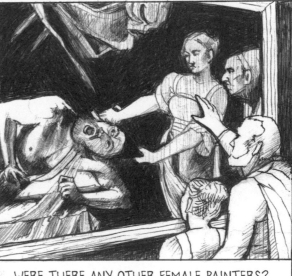

WERE THERE ANY OTHER FEMALE PAINTERS? AND DID THE GENTILESCHI FAMILY KNOW ABOUT THEM?

WOMEN PAINTERS WERE CONSIDERED QUITE THE SPECTACLE—MIRACULOUS FREAKS OF NATURE. THEY WERE NEVER ALLOWED TO JOIN GUILDS OR ATTEND CLASSES OR STUDY FROM LIVE MODELS. THE HANDFUL OF FEMALE ARTISTS WERE TRAINED BY OTHER FAMILY MEMBERS, USUALLY FATHERS, WITHIN THEIR HOMES. ONE OF THE MOST WELL-KNOWN OF THESE WOMEN WAS SOFONISBA ANGUISSOLA (1532–1625).

SOFONISBA'S FATHER WAS NOT A PAINTER, BUT HE WAS SO CONCERNED ABOUT THE FUTURE OF HIS SIX DAUGHTERS AND THE PROGRESSION OF THE FAMILY NAME THAT HE PROVIDED ART TRAINING FOR THEM TO SUPPLEMENT THEIR DOWRIES. SOFONISBA WAS EVENTUALLY INVITED TO THE SPANISH COURT AS PAINTER AND LADY-IN-WAITING FOR ELIZABETH DE VALOIS.

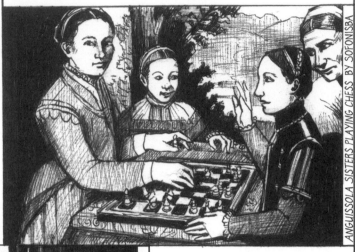

ANGUISSOLA SISTERS PLAYING CHESS BY SOFONISBA

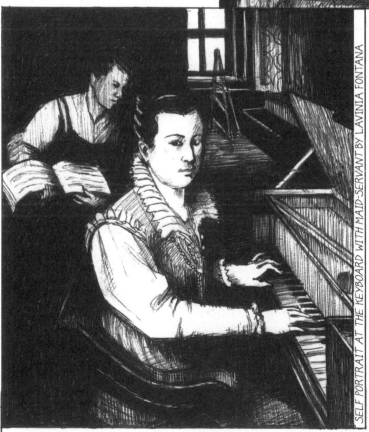

SELF PORTRAIT AT THE KEYBOARD WITH MAID-SERVANT BY LAVINIA FONTANA

LAVINIA FONTANA (1552–1614) OF BOLOGNA WAS ANOTHER SUCCESSFUL WOMAN PAINTER. IN HER EARLY TWENTIES, SHE PAINTED THIS SELF-PORTRAIT FOR HER FUTURE HUSBAND SO THAT HE COULD GET AN IDEA OF WHO SHE WAS AND WHAT SHE LOOKED LIKE BEFORE THEIR ARRANGED MARRIAGE. LAVINIA WAS AN AVID FOLLOWER OF CARDINAL PALEOTTI'S CONVENTIONAL RULES FOR PAINTING. HER SUBJECT MATTER OBEDIENTLY CONFORMED TO THE EXPECTATIONS OF HER GENDER—MAINLY PORTRAITS OF BOLOGNESE NOBILITY. YET HER DETAILED PORTRAYALS OF THE NOBLEWOMEN (FROM YOUNG BRIDES TO OLD WIDOWS CARRYING THEIR HUSBANDS' LEGACIES) CONVEY HER STRONG RELATIONSHIP WITH THEM AND HER ALLIANCE WITH THEIR FIGHT. LAVINIA WAS EXCEPTIONALLY WELL-EDUCATED. DESPITE LIVING IN A CONSTANT STATE OF PREGNANCY, SHE PROVIDED THE MAJORITY OF HER FAMILY'S INCOME THROUGHOUT HER CAREER.

THE YEAR 1605 MARKED THE ELECTION OF A NEW POPE—PAUL V BORGHESE. HIS NEPHEW, CARDINAL SCIPIONE BORGHESE, BECAME ONE OF THE MOST RELENTLESSLY DEVOTED ART COLLECTORS. AS THE YEARS WENT ON, ORAZIO MOVED HIS FAMILY SEVERAL TIMES, BUT HIS STUDIO FULL OF CHILD ASSISTANTS ALWAYS CHURNED OUT PAINTINGS. HE HIRED AN ADDITIONAL ASSISTANT, FRANCESCO SCALPELINO, WHO SERVED AS A MODEL AS WELL.

ORAZIO WAS OFTEN ABSENT, OUT DRINKING WITH HIS NEW NIGHT CROWD. ONE OF THEM WAS AN OLD FRIEND WHO HAD PREVIOUSLY ARRANGED THE MARRIAGE OF ORAZIO AND PRUDENZIA.

GOOD EVENING, YOUNG FRANCESCO!

PERHAPS PRUDENZIA'S RECENT DEATH REAFFIRMED ORAZIO'S FRIENDSHIP WITH COSIMO QUORLI, A POMPOUS RENEGADE WHO SERVED AS THE GRAND PAPAL STEWARD. HE WAS IN CHARGE OF THE HOUSEHOLD INVENTORY OF THE VATICAN AND QUIRINAL PALACES.

COSIMO WAS A POWERFUL AND IMPORTANT FRIEND BECAUSE HE WAS ABLE TO INFLUENCE THE POPE'S DECISIONS FOR COMMISSIONS AND PARTAKE IN SOME OF HIS WEALTH AND GLORY.

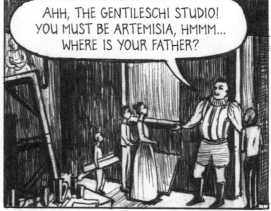

AHH, THE GENTILESCHI STUDIO! YOU MUST BE ARTEMISIA, HMMM... WHERE IS YOUR FATHER?

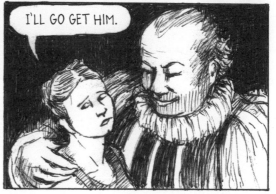

I'LL GO GET HIM.

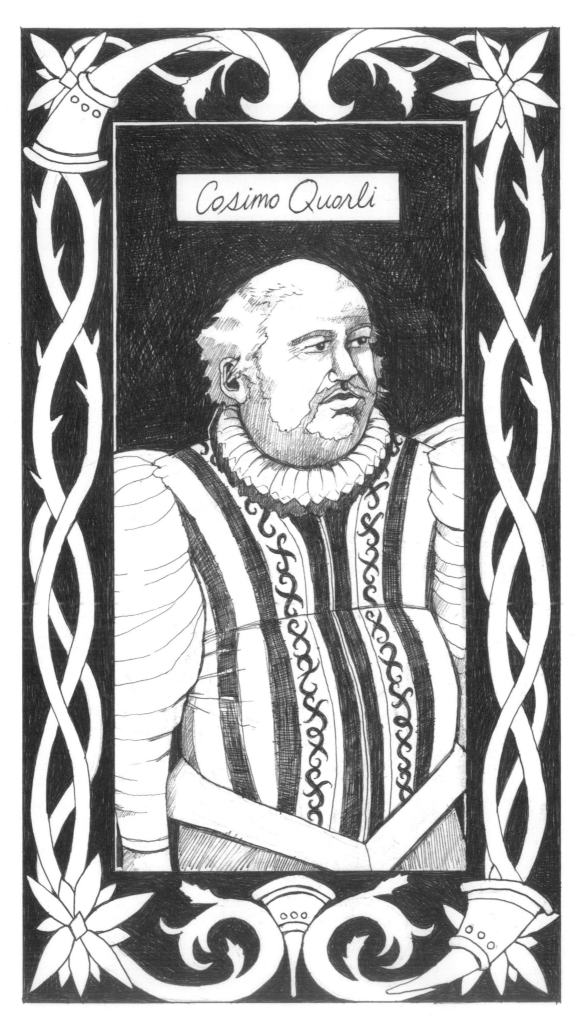

Cosimo Quarli

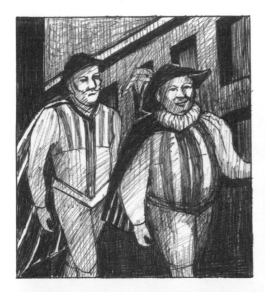

THE OTHER NEW FIXTURE IN ORAZIO'S LIFE WAS THE FRESCO PAINTER AGOSTINO TASSI.

THAT SUMMER OF 1610, AGOSTINO ARRIVED FROM LIVORNO AFTER MUCH STRUGGLE AND SCANDAL. NONETHELESS, HE WAS BUSY MAKING A NAME FOR HIMSELF AS A PHENOMENAL DRAFTSMAN, SPECIALIZING IN ARCHITECTURE AND LANDSCAPE PAINTING.

ORAZIO WELCOMED HIM BACK TO ROME AND THEY MADE PLANS TO COLLABORATE IN THE NEAR FUTURE. BUT FIRST THEY SPOKE OF WHAT HAD BEEN THE TALK OF THE TOWN...

29

MICHELANGELO MERISI DA CARAVAGGIO, WHO HAD BEEN ON THE RUN FOR FOUR YEARS AFTER KILLING RANUCCIO TOMASSONI.

RANUCCIO WAS NOT JUST ANY HOODLUM, BUT THE YOUNGEST OF THE FIVE EX-MILITARY TOMASSONI BROTHERS, FRESH FROM SERVING THE POWERFUL PRO-SPANISH FARNESE DYNASTY. NOW IN ROME, RANUCCIO'S OCCUPATION WAS THAT OF A PIMP AND A THUG.

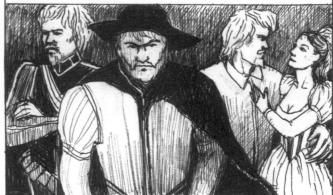

ONORIO LONGHI WAS INVOLVED AGAIN. THE FIGHT BROKE OUT OVER A TENNIS MATCH, BUT A DEEP TENSION BETWEEN RANUCCIO'S GANG AND ONORIO AND CARAVAGGIO'S GANG HAD BEEN BUILDING FOR YEARS.

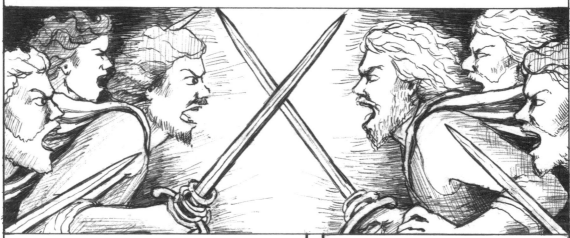

IMMEDIATELY AFTER RANUCCIO LAY BLEEDING TO DEATH, THE SEVERELY INJURED CARAVAGGIO FLED, WITH AID FROM HIS USUAL POWERFUL ALLIES. THE MARCHESA COSTANZA SFORZA COLLONA STEPPED IN, AS WELL AS DEL MONTE.

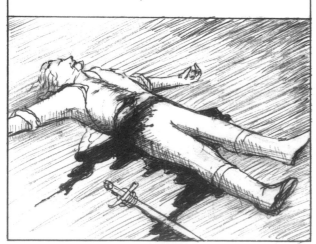

CARAVAGGIO SPENT TIME IN NAPLES AND THEN MOVED TO MALTA, WHERE HE BECAME A KNIGHT OF THE ORDER OF ST. JOHN, A PRESTIGIOUS HONOR THAT OFFERED HIM HOPE FOR A PARDON TO RETURN TO ROME...

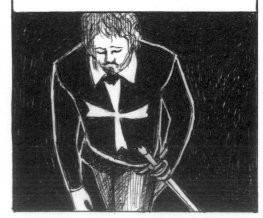

...UNTIL SOMETHING HAPPENED... PRESUMABLY SOME SORT OF RIFT BETWEEN SOLDIERS. BY THE SUMMER OF 1608, HE WAS STRIPPED OF HIS KNIGHT'S UNIFORM, EXPELLED FROM THE ORDER, AND THROWN INTO THE GUVA, A DUNGEON MADE FROM A HOLE TUNNELED DEEP INTO THE GROUND.

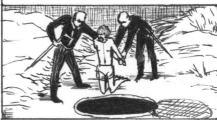

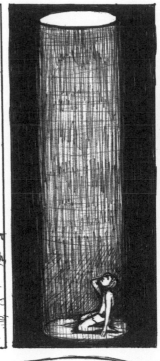

AND IF THAT WEREN'T MYSTERIOUS ENOUGH, SOMEHOW HE ESCAPED!

THERE WOULD BE NO WAY TO ESCAPE UNLESS A ROPE WERE THROWN DOWN.

BY SOMEONE...

HE THEN FLED TO SYRACUSE IN SICILY, WHERE HE MET UP WITH HIS OLD FRIEND, MARIO—

MINNITI! AHH, YES.

HE NOW HAS A FAMILY AND HIS OWN PAINTING STUDIO.

OF COURSE, AT THAT POINT, CARAVAGGIO WAS WRACKED WITH PARANOIA AND FEAR, FOR HE WAS TRULY A WANTED MAN.

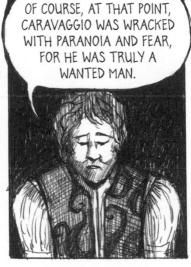

HE FLED AGAIN TO MESSINA, THEN TO PALERMO, THEN BACK TO NAPLES, WHERE HIS FACE WAS SLASHED.

MOST LIKELY BY ONE OF THOSE KNIGHTS HE OFFENDED IN MALTA!

YES... OR MAYBE IT WAS ONE OF RANUCCIO'S MEN, OUT FOR REVENGE?

HIS FAME HAD ONLY INCREASED AS RICH PATRONS FOUGHT TO GET AHOLD OF HIS WORK, INCLUDING THE POPE'S NEPHEW, CARDINAL SCIPIONE BORGHESE. FINALLY, THE GREAT PARDON CAME. AFTER FOUR LONG YEARS, CARAVAGGIO WAS ON HIS WAY BACK TO ROME!

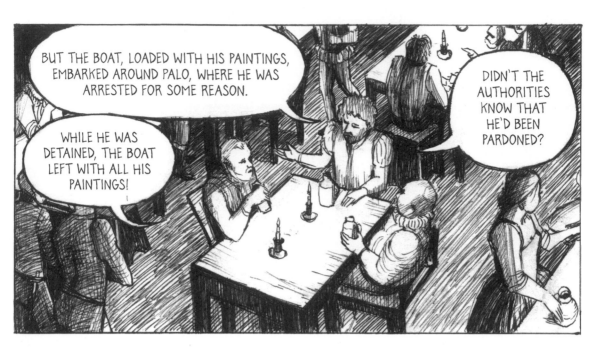

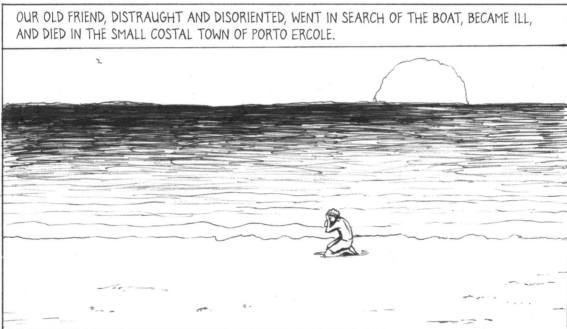

OUR OLD FRIEND, DISTRAUGHT AND DISORIENTED, WENT IN SEARCH OF THE BOAT, BECAME ILL, AND DIED IN THE SMALL COSTAL TOWN OF PORTO ERCOLE.

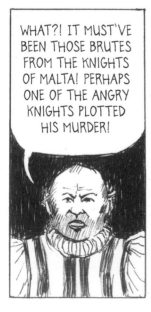

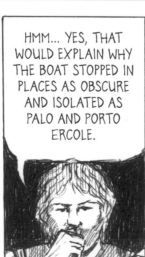

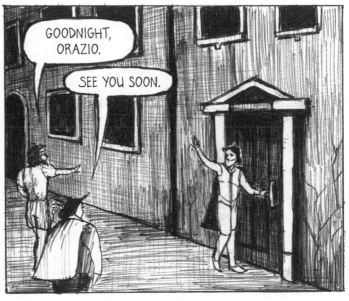

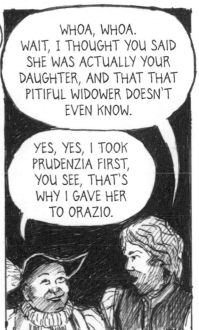
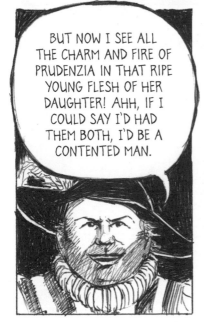

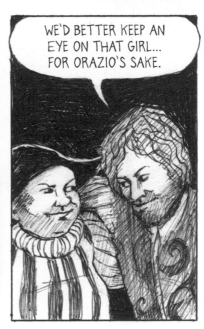

THE SIXTEEN-YEAR-OLD ARTEMISIA WAS LEFT ALONE.

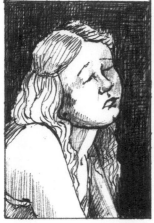

SHE LIVED IN THE GENTILESCHI STUDIO WHILE HER BROTHERS CAME AND WENT. SHE COULD NOT READ OR WRITE. THERE WAS NO MOTHER TO COACH HER IN COOKING AND CLEANING. ORAZIO SPOKE OF SENDING HER TO A CONVENT, BUT HE WAS ABSENT, CONSUMED BY HIS COMMISSIONS. HE NEGLECTED HIS DUTY. THEREFORE, THERE WAS NEITHER DOWRY NOR HUSBAND FOR HER.

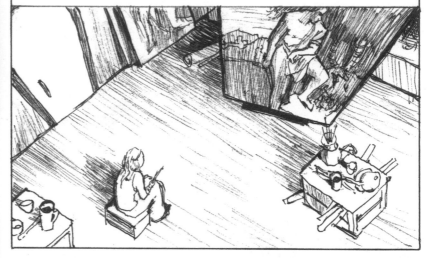

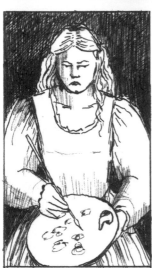

THERE WAS NOTHING FOR ARTEMISIA TO DO EXCEPT DEDICATE HERSELF FULLY TO PAINTING.

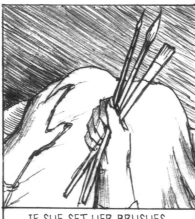

IF SHE SET HER BRUSHES DOWN FOR A MOMENT—

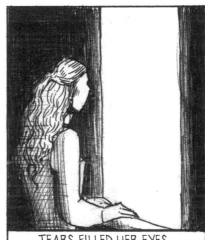

TEARS FILLED HER EYES.

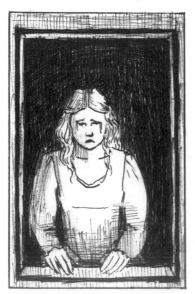

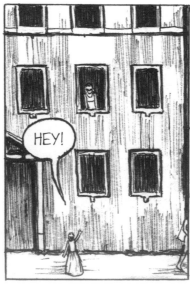

HEY!

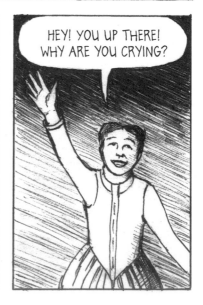

HEY! YOU UP THERE! WHY ARE YOU CRYING?

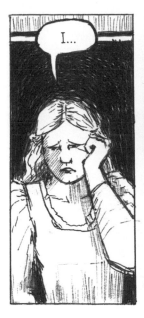

I...

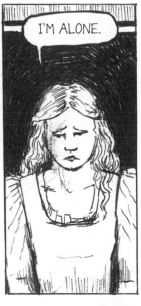

I'M ALONE.

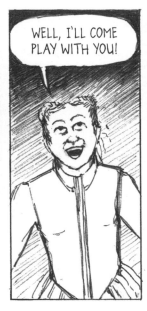

WELL, I'LL COME PLAY WITH YOU!

MOM! MOM! COME HERE!

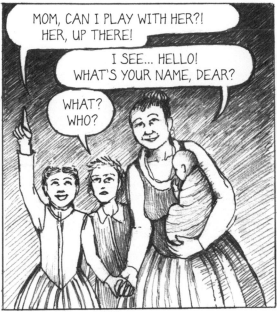

MOM, CAN I PLAY WITH HER?! HER, UP THERE!

I SEE... HELLO! WHAT'S YOUR NAME, DEAR?

WHAT? WHO?

LITTLE IS KNOWN ABOUT TUZIA MEDAGLIA EXCEPT THAT HER HUSBAND WAS OFTEN OUT OF TOWN AND SHE HAD MANY CHILDREN.

THE MEDAGLIA AND GENTILESCHI FAMILIES GOT ALONG SO WELL THAT ORAZIO WELCOMED THEM INTO THE NEIGHBORING APARTMENT. HE CONSTRUCTED A DOOR AND STAIRWAY THAT CONNECTED THE TWO HOUSEHOLDS.

IN TURN, ARTEMISIA HAD A NEW FAMILY OF MODELS TO PAINT AND A NEW MOTHER FIGURE TO SOOTHE HER.

FRANCESCO, THE OLDEST SON, GOT PERMISSION FROM ORAZIO FOR BOTH FAMILIES TO VISIT MONTE CAVALLO, WHERE ORAZIO AND AGOSTINO HAD BEGUN WORKING AT THE QUIRINAL PALACE. AFTERWARDS, DINNER WAS TO BE SERVED AT ONE OF COSIMO'S LUXURIOUS HOUSES.

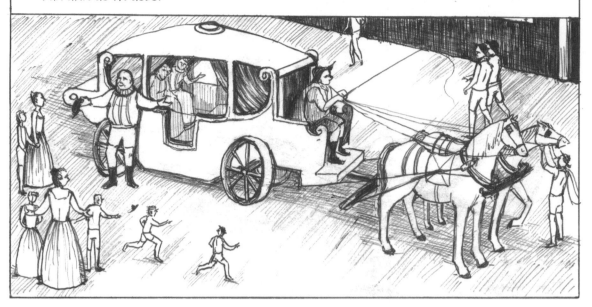

WELCOME, WELCOME. HAVE A LOOK, BUT WE CAN'T HANG AROUND HERE FOR TOO LONG...

AND WHAT DO WE HAVE HERE?

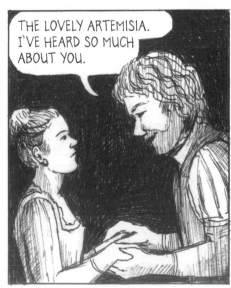
THE LOVELY ARTEMISIA. I'VE HEARD SO MUCH ABOUT YOU.

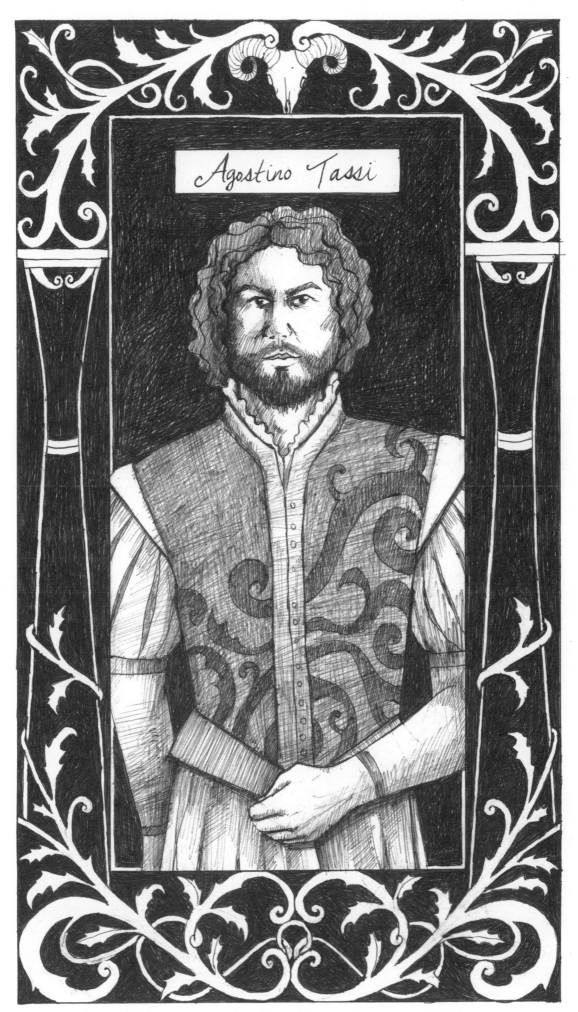

AGOSTINO WAS DASHING AND BOASTFUL, ROMANTIC WHEN HE WANTED TO BE, AND PRONE TO LASHING OUT AGGRESSIVELY.

ARTEMISIA WAS FULLY AWARE OF THE PROBING, LECHEROUS EYES OF HER FATHER'S FRIENDS.

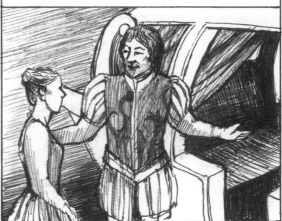

BUT SHE DIDN'T KNOW THE EXTENT OF AGOSTINO'S MESSY HISTORY.

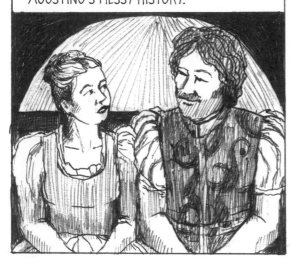

HIS SISTER, OLIMPIA, WAS MARRIED TO SALVATORE BAGELLIS. SALVATORE HAS PREVIOUSLY BORROWED MONEY FROM AGOSTINO, WHO WAS MARRIED TO MARIA CONNODOLI.

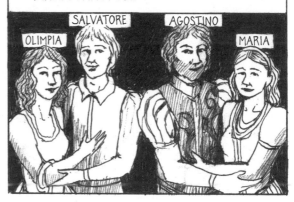

OLIMPIA SALVATORE AGOSTINO MARIA

BUT AGOSTINO HAD A HISTORY OF WOMANIZING. HE HAD BEEN TAKEN TO COURT FOR HANGING AROUND PROSTITUTES, AND HE HELPED HIMSELF TO HIS WIFE'S FOURTEEN-YEAR-OLD SISTER, COSTANZA.

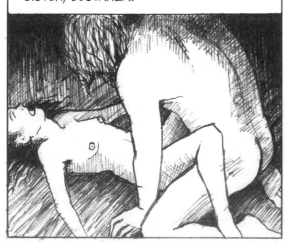

A LADY'S PURITY AND VIRGINITY WERE THE MAIN QUALITIES THAT WOULD ENSURE AN HONORABLE MARRIAGE FOR HER, AND THUS UPHOLD THE FAMILY NAME AND SOCIAL STATUS. IF HER CHASTITY WERE BROKEN OUT OF WEDLOCK, MARRIAGE WAS THE ONLY WAY TO SALVAGE WHAT LITTLE DIGNITY SHE HAD LEFT. SO AGOSTINO ARRANGED FOR THE NEWLY PREGNANT COSTANZA TO BE MARRIED TO HIS ASSISTANT, FILIPPO FRANCHINI.

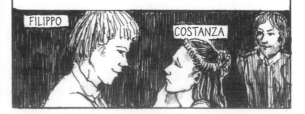

FILIPPO COSTANZA

BUT THAT DIDN'T HALT AGOSTINO'S POWER OVER HER, OR OVER FILIPPO, A YOUNG AND IMPRESSIONABLE APPRENTICE.

I'LL TAKE A TURN WITH COSTANZA NOW. FILIPPO, MY FRIEND, YOU WAIT HERE...

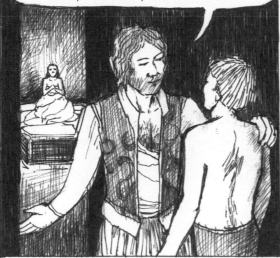

MEANWHILE, HIS WIFE, MARIA, BEGAN HER OWN AFFAIR WITH SOMEONE ELSE. AFTER SHE WAS CAUGHT, SHE RAN AWAY AND TOOK WITH HER A LARGE SUM OF MONEY AND JEWELRY. AGOSTINO EXPLODED IN ANGER AND JEALOUSY.

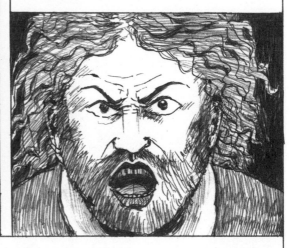

HE SENT COSTANZA AND FILIPPO TO ROME WHILE HE SPENT MONTHS SEARCHING FOR MARIA AND ALL THE MONEY SHE'D STOLEN. BUT IT WAS NO USE. SHE WAS GONE. FINALLY, EXHAUSTED AND INFURIATED, HE HIRED HITMEN TO MURDER MARIA, AND MET WITH COSTANZA AND FILIPPO IN ROME.

STILL HURTING FINANCIALLY UPON HIS ARRIVAL, AGOSTINO HUNTED DOWN HIS BROTHER-IN-LAW, SALVATORE, HOPING TO BE REIMBURSED FOR THE MONEY HE'D LOANED HIM PREVIOUSLY.

WE KNOW YOU'RE UPSET, AGOSTINO, BUT WE JUST DON'T HAVE THE MONEY YET.

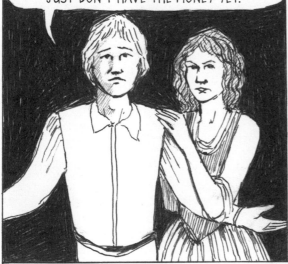

SALVATORE AND OLIMPIA KNEW ABOUT AGOSTINO'S SCANDALOUS LOVE TRIANGLE. HAVING SEX WITH ONE'S SISTER-IN-LAW WAS CONSIDERED INCEST, A SERIOUS OFFENSE.

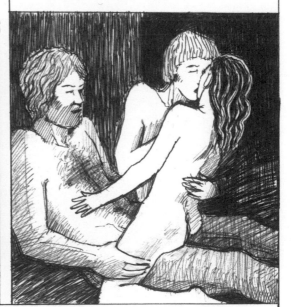

SO SALVATORE BLACKMAILED AGOSTINO, FORCING HIM TO MOVE AWAY FROM COSTANZA AND FILIPPO. BUT AGOSTINO, ALWAYS CRAFTY AND DETERMINED, MOVED ACROSS THE STREET, JUST FAR ENOUGH TO PROVE THAT SALVATORE'S ACCUSATIONS WERE FALSE. AGOSTINO THEN SUED HIM AND HAD HIM JAILED FOR DEBT.

OLIMPIA, ABANDONED AND DEVASTATED, FROM THEN ON HARBORED A DEEP RESENTMENT TOWARD HER BROTHER. SHE CONTINUED TO REVEAL AGOSTINO'S GREED AND CONTEMPT FOR WOMEN AS SHE TRIED TO FREE HER BELOVED SALVATORE.

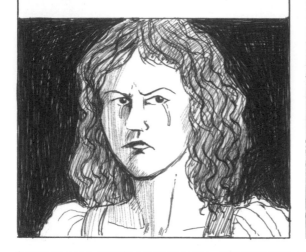

AS FOR MARIA, HER ASSASSINS BROUGHT BACK PAPERS ASSURING AGOSTINO THAT SHE'D BEEN STABBED NUMEROUS TIMES AND WAS SURELY DEAD. AGOSTINO WAS NOT ENTIRELY CONVINCED. HE KEPT THE PAPERS WITH HIM ALWAYS, HE WANTED SO BAD TO BELIEVE THAT HIS REVENGE WAS SUCCESSFUL.

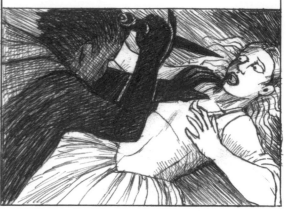

LOOKING AT AGOSTINO NOW ACROSS THE TABLE AT COSIMO'S, WHAT WERE ARTEMISIA'S FIRST IMPRESSIONS OF THIS MYSTERIOUS CHARACTER?

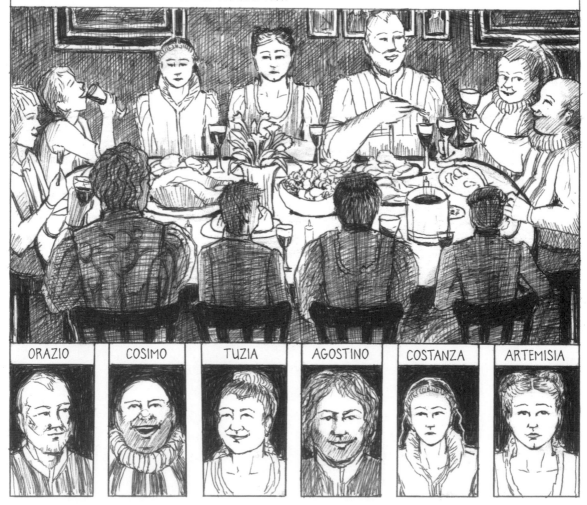

ORAZIO | COSIMO | TUZIA | AGOSTINO | COSTANZA | ARTEMISIA

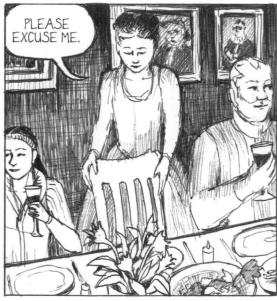

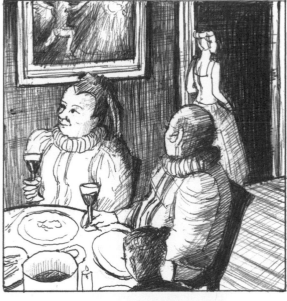

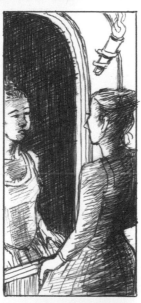

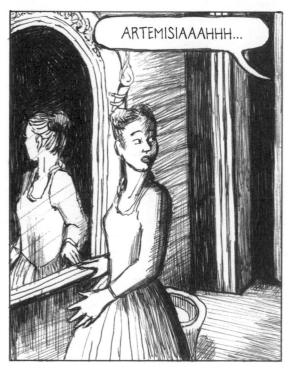

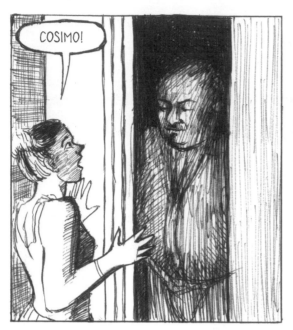
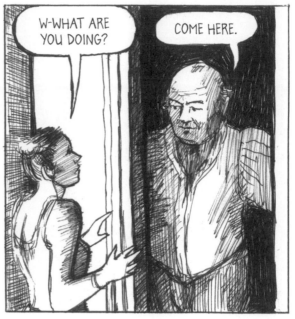
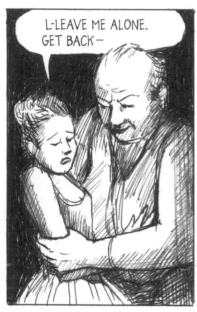
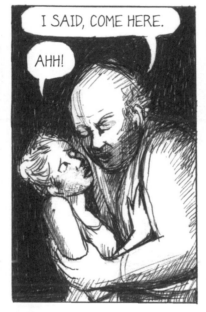
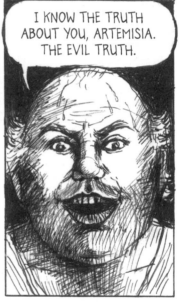
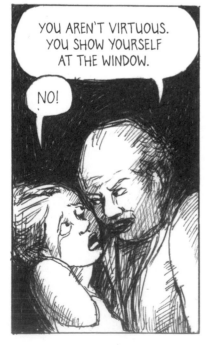
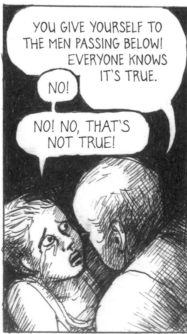
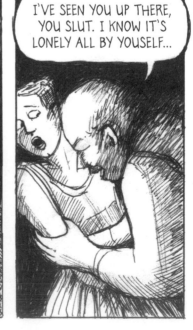

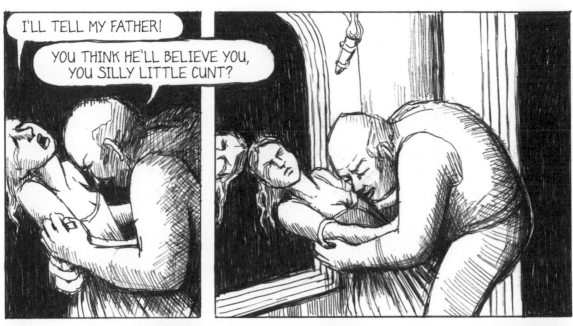

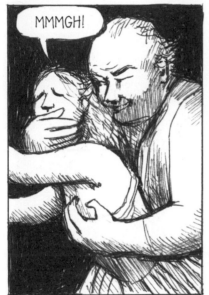

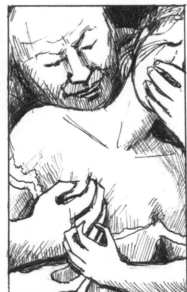

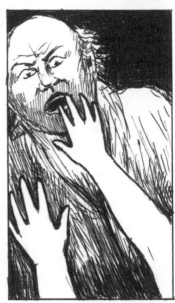

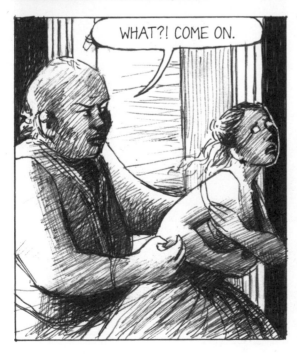

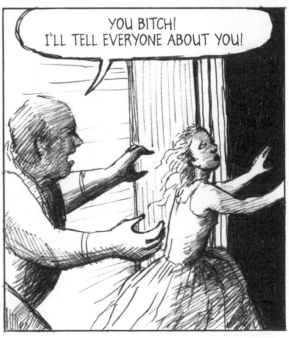

THIS WAS NOT THE ONLY TIME COSIMO TRIED TO FORCE HIMSELF ONTO ARTEMISIA.

SOMETHING DEEP INSIDE HER WAS GIVING WAY...

TRANSFORMING, HARDENING, DARKENING...

COSIMO'S DEMANDING HANDS EXTENDED BEYOND REALITY AND FOUND HER EVEN IN HER DREAMS.

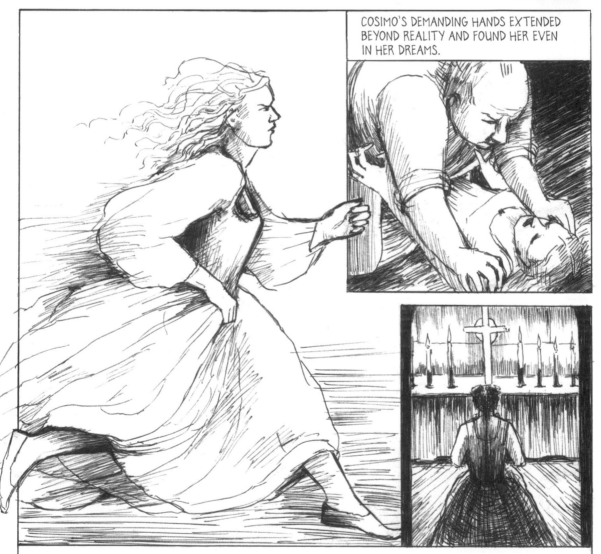

HER BODY DID NOT BELONG TO HER, AND UNDER ORAZIO'S CARE THE DANGER INCREASED. WHEN A HUSBAND WAS CHOSEN FOR HER, ONLY THEN WOULD HER BODY FIND ITS RIGHTFUL PLACE. LEFT ALONE, SHE TURNED TO THE CHURCH, SEARCHING FOR SALVATION. COSIMO'S ADVANCES THREATENED HER HONOR. SHE WOULD HAVE TO CONSTRUCT A NEW ARMOR.

Artemisia Gentileschi

MEANWHILE, COSIMO, SURPRISED BY HER STRENGTH AND RESILIENCE, REALIZED THAT HE COULD NOT ALWAYS GET WHAT HE WANTED. THE CONCEPT OF RAPE ONLY APPLIED TO WOMEN WHO WERE VIRGINS BEFOREHAND. THEREFORE, RAPE WAS KNOWN AS DEFLOWERING. COSIMO KNEW THAT AS SOON AS A WOMAN WAS DEFLOWERED, HER RUINED STATUS MADE HER MORE VULNERABLE. IF HE COULD NOT HAVE ARTEMISIA FIRST, HE KNEW SOMEONE WHO COULD—

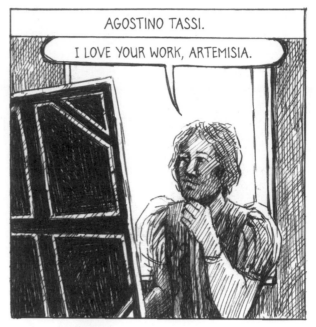

AGOSTINO TASSI.

I LOVE YOUR WORK, ARTEMISIA.

WHAT? WHAT ARE YOU DOING HERE?

I LET HIM IN.

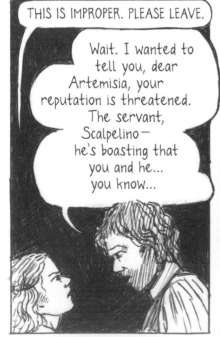

THIS IS IMPROPER. PLEASE LEAVE.

Wait. I wanted to tell you, dear Artemisia, your reputation is threatened. The servant, Scalpelino— he's boasting that you and he... you know...

It doesn't matter what anyone says about me, because I know what I am. Now please leave.

Very well. But I want you to know how it upsets me that he says such things. I value your honor and my friendship with your father very much.

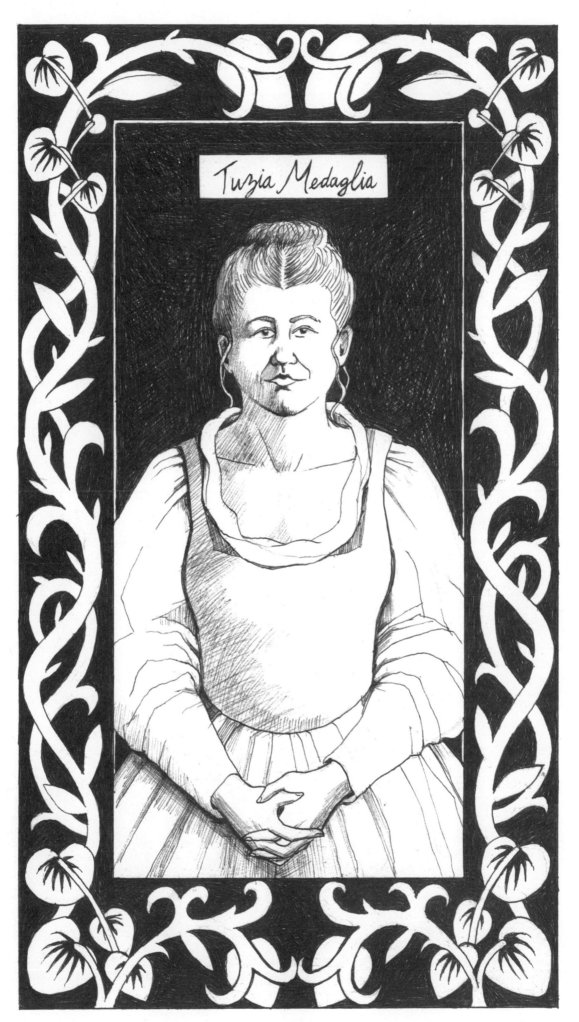

MY DEAR, YOU REALLY OUGHT TO CONSIDER THAT AGOSTI—

HOLD STILL.

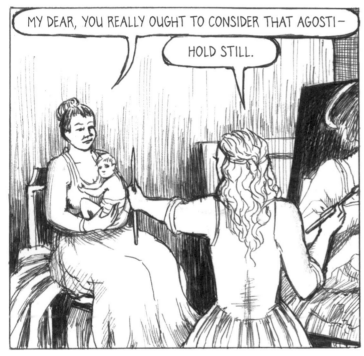

I'M ONLY LOOKING OUT FOR YOUR BEST INTERESTS. AGOSTINO IS FRIENDS WITH YOUR FATHER. THEY'VE EVEN BEGUN WORKING TOGETHER!

IT WOULD MAKE SENSE FOR YOU TO CONSIDER HIS HAND IN—

TUZIA, PLEASE.

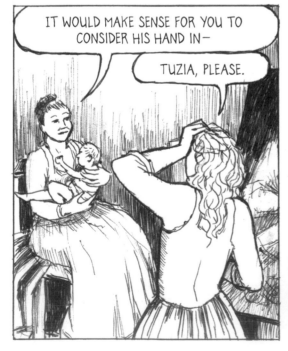

RIGHT NOW I ONLY HAVE EYES FOR PAINTING.

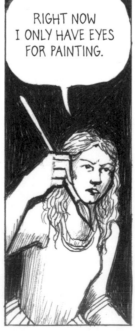

WHAT? ONLY EYES FOR PAINTING? MUST BE A WOMAN CUT FROM THE SAME CLOTH AS ME!

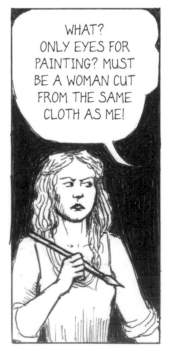

HELLO! HELLO!

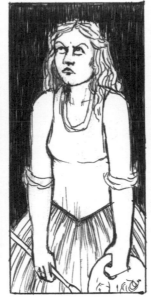

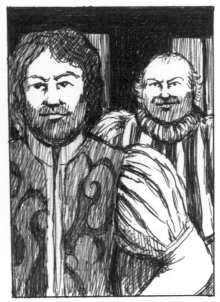

You even want to bring that man in here?

Be quiet.

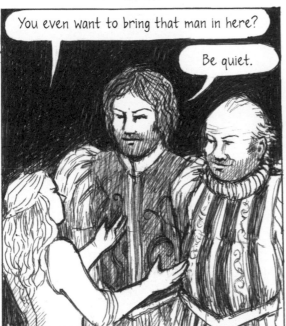

You have given it to so many, you can give it to him too! He's a well-mannered gentleman.

I have no respect for the words of scoundrels like you!

Oh, come on now. I was only joking. How can you disrespect the friends of your father this way?

Please relieve me of your presence.

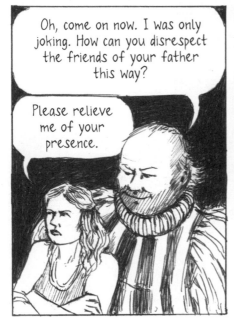

AHH, THE LITTLE WHORE HAS A REQUEST.

LET GO!

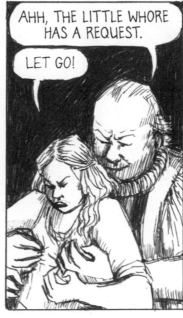

ARTEMISIA!

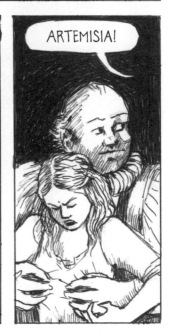

49

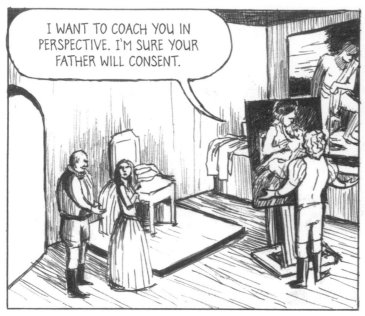

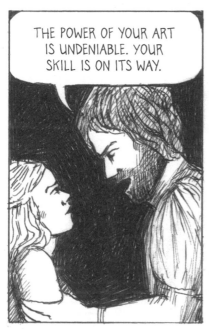

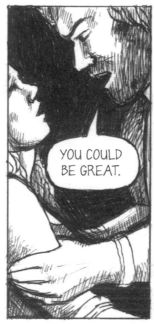

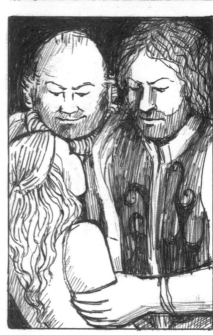

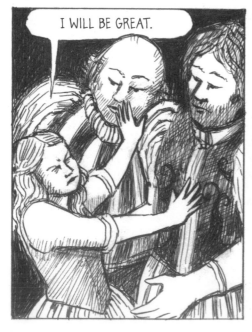

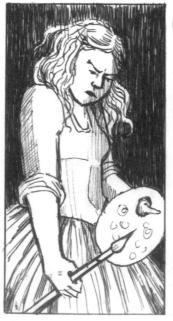

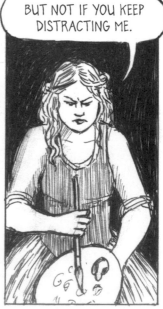

ARTISTS OF THE COUNTER-REFORMATION CHURNED OUT RENDERINGS OF BIBLICAL SCENES SUCH AS DAVID AND GOLIATH, ISAAC AND ABRAHAM, AND VARIOUS CRUCIFIXIONS, ANNUNCIATIONS, AND MADONNAS. THE USE OF FEMALE MODELS WAS TABOO, ESPECIALLY IF THERE WAS TOO MUCH SKIN SHOWING.

THE PREFERABLE METHOD WAS TO USE YOUNG BOYS OR CLASSICAL STATUES IN PLACE OF REAL FEMALE BODIES. BUT ARTEMISIA HAD ACCESS TO HER OWN BODY! THERE WERE RUMORS THAT SHE POSED NUDE FOR HER FATHER'S PAINTINGS, JUST AS SHE MUST'VE POSED FOR HER OWN.

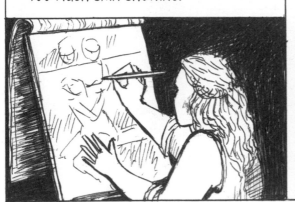

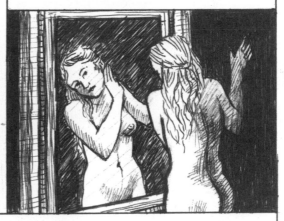

IN 1610 ARTEMISIA TURNED TO THE BIBLICAL LEGEND OF SUSANNA. ACCORDING TO THE APOCRYPHA, SUSANNA WAS THE DAUGHTER OF A WEALTHY JEWISH LORD OF BABYLON DURING THE SIXTH CENTURY B.C. WHILE SHE WAS BATHING IN THE GARDEN, TWO OLDER MEN—THE ELDERS OF THE COMMUNITY—WERE SMITTEN WITH HER BEAUTY. THEY ATTACKED HER, THREATENING TO TELL EVERYONE THAT SHE'D HAD AN AFFAIR IF SHE DIDN'T FULFILL THEIR SEXUAL DESIRES. SUSANNA RESISTED AND THE ELDERS CARRIED OUT THEIR THREATS. SHE WAS BROUGHT TO TRIAL AND SENTENCED TO DEATH. AT THE LAST MINUTE, ANOTHER MAN NAMED DANIEL BROUGHT THE TRUTH TO LIGHT BY CROSS-EXAMINING THE ELDERS. THEIR STORIES DIDN'T MATCH. SUSANNA WAS SAVED, AND HER INNOCENCE RESTORED.

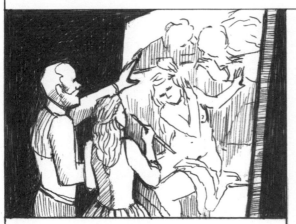

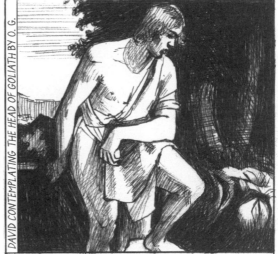

DAVID CONTEMPLATING THE HEAD OF GOLIATH BY O. G.

ORAZIO RETURNED TO THE STUDIO TO SEE THE STORY OF SUSANNA UNFOLDING BENEATH HIS DAUGHTER'S BRUSH. WHAT WAS ORAZIO'S ROLE IN THE EXECUTION OF HIS DAUGHTER'S EMERGING DEBUT? HE MUST'VE AT LEAST HELPED HER. SIMILARITIES ARE ALWAYS PRESENT IN THEIR PAINTINGS.

ORAZIO'S DAVID CONTEMPLATING THE HEAD OF GOLIATH STOOD IN THE SAME STUDIO, BEARING A SIMILAR SKY, THE SAME WHITE CLOTH DRAPED AROUND THE FIGURE, AND EVEN SOME OF THE SAME GREY STONE.

JUST LIKE MARY MAGDALENE, SUSANNA WAS OFTEN AN EXCUSE TO PAINT A PARTIALLY NAKED LADY IN A LUSH, SUGGESTIVE GARDEN OF EDEN. THE MOST BLATANT EXAMPLE IS THIS 1607 VERSION BY CAVALIER D'ARPINO, CARAVAGGIO AND ORAZIO'S FORMER EMPLOYER.

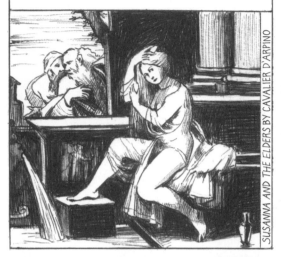

SUSANNA AND THE ELDERS BY CAVALIER D'ARPINO

ALTHOUGH SOME ARTISTS CREATED MORE SYMPATHETIC OR NUANCED DEPICTIONS OF THE STORY, ARTEMISIA'S VISION WAS UNIQUE.

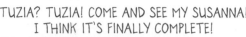
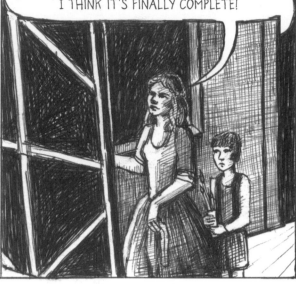

TUZIA? TUZIA! COME AND SEE MY SUSANNA! I THINK IT'S FINALLY COMPLETE!

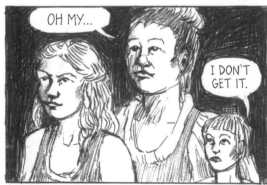

OH MY...

I DON'T GET IT.

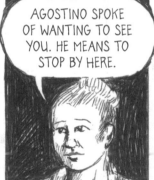

AGOSTINO SPOKE OF WANTING TO SEE YOU. HE MEANS TO STOP BY HERE.

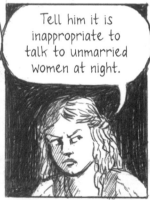

Tell him it is inappropriate to talk to unmarried women at night.

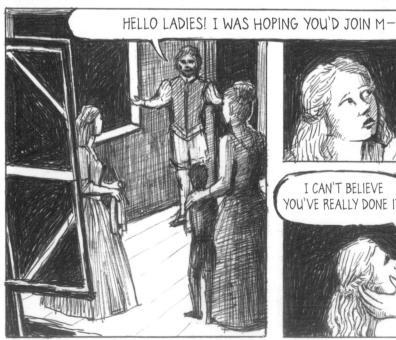

HELLO LADIES! I WAS HOPING YOU'D JOIN M—

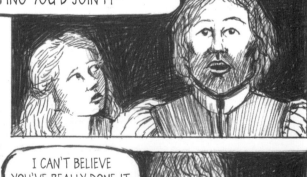

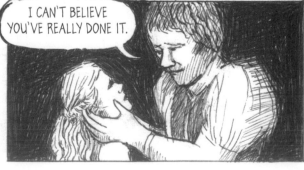

I CAN'T BELIEVE YOU'VE REALLY DONE IT.

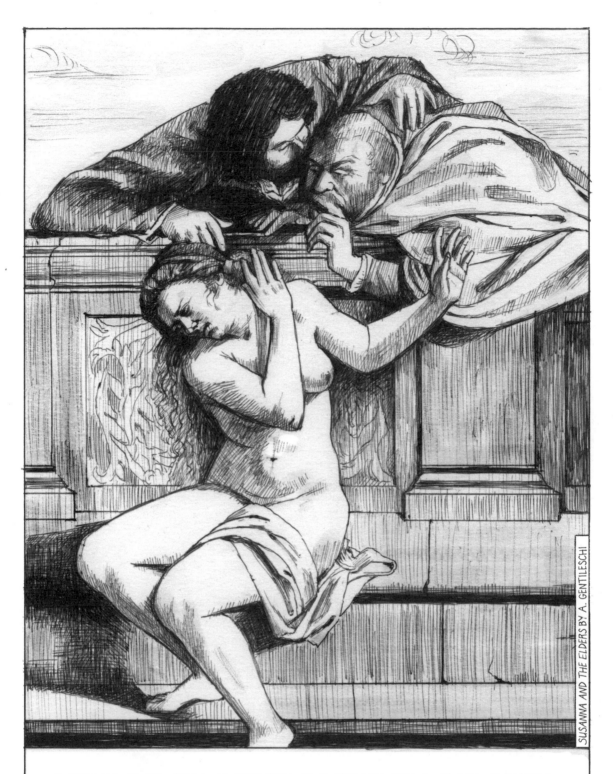

SUSANNA AND THE ELDERS BY A. GENTILESCHI

THERE WAS NO FOUNTAIN, NO GREENERY, NO SWEET SEDUCTION, NO COY LOVELINESS.
SUSANNA SAT ON A HARD, GREY CEMENT FIXTURE AS THE ELDERS LOOMED ABOVE
HER, CALLOUSLY WHISPERING. HER FACE—TOTAL ANGUISH. HER GESTURE—AWKWARD
PAIN. THE TWO ELDERS BORE THE DARK CURLS OF AGOSTINO TASSI AND THE BALDING
SLEAZINESS OF COSIMO QUORLI. ORAZIO'S COLORS APPEARED IN HIS PROGENY'S FIRST
MASTERPIECE: THE BLUE SKY, WHITE CLOTH, RED CLOAK, AND THE SUBTLE DEPTH OF
SUSANNA'S PALE COMPLEXION. IN THE YEAR OF HIS DEATH, CARAVAGGIO'S TRADITION
OF FUSING REAL-LIFE STRUGGLES WITH POPULAR BIBLICAL SCENES WAS PASSIONATELY
ADOPTED BY ARTEMISIA GENTILESCHI, HIS YOUNGEST, MOST DARING FOLLOWER.

AS 1611 BEGAN, AGOSTINO FOUND HIMSELF EMBEDDED EVEN DEEPER IN FINANCIAL TROUBLE. HIS SISTER OLIMPIA SUMMONED HIM TO COURT FOR INCEST, AND HE CONTINUED TO PRESS SALVATORE (AND ANOTHER PAINTER, VALERIO URSINO) FOR OLD DEBTS. AS HE GROPED FOR EXTRA FUNDS, HE EVEN TRIED TO TAKE BACK THE DOWRY MONEY HE HAD DONATED RECENTLY TO HIS NIECE, THE DAUGHTER OF OLIMPIA AND SALVATORE. AGOSTINO OWED THE COLOR SELLER. HE DESPERATELY NEEDED COLORS BECAUSE HE AND ORAZIO WERE STILL WORKING ON THE SALA DEL CONCISTORO IN THE QUIRINAL PALACE, AND ALSO STARTING THE DECORATION OF CARDINAL SCIPIONE BORGHESE'S *CASINO OF THE MUSES*. THESE WERE MASSIVE COMMISSIONS DESTINED TO COMBINE ORAZIO'S FIGURATIVE FINESSE WITH AGOSTINO'S ARCHITECTURAL MASTERY.

AS OLIMPIA'S CHARGES LED AGOSTINO BACK INTO PRISON, HIS FRIENDS RALLIED TOGETHER TO GET HIM OUT OF PRISON. COSIMO HAD POWER AND INFLUENCE.

ORAZIO HAD ONLY TO WRITE LETTERS AND SPREAD THE WORD THAT AGOSTINO SHOULD NOT BE PREVENTED FROM PAINTING—HIS TALENT WAS CRUCIAL.

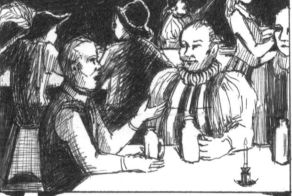

ORAZIO, I WANT YOU TO MEET MY COUSIN, GIOVANNI BATTISTA STIATTESI. HE'S WORKED AS A NOTARY IN TUSCANY, BUT HE'S HERE ON ACCOUNT OF SOME FINANCIAL TROUBLES.

PLEASED TO MEET YOU. I'VE HEARD OF YOUR GREAT PAINTING. I'VE ALSO HEARD THAT YOU HAVE A MOST UNUSUAL AND TALENTED DAUGHTER AS WELL.

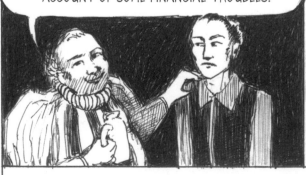

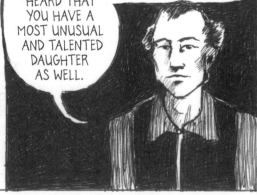

GIOVANNI BATTISTA WAS BACK IN ROME TO RECLAIM MONEY THAT HIS MISCHIEVOUS COUSIN OWED HIM. HE SECRETLY RESENTED COSIMO AND VOWED TO KEEP AN EYE ON THIS SEEDY ART SCENE.

Giovanni Battista Stiattesi

MEANWHILE, ARTEMISIA ATTEMPTED TO TAKE MATTERS INTO HER OWN HANDS AND FIND A HUSBAND FOR HERSELF. SHE MET GIROLAMO MODENESE, A TWENTY-YEAR-OLD HOUSE PAINTER LIVING IN THE HOUSEHOLD OF CARDINAL BANDINO.

AT SEVENTEEN, SHE WAS ALMOST PAST THE DESIRED MARRIAGEABLE AGE. THE NEED TO SECURE HER NAME AND HONOR WITH THE RIGHTEOUS PLEDGE OF MATRIMONY DROVE HER TO INVITE GIROLAMO INSIDE.

BUT AGOSTINO WAS OUT OF JAIL AFTER BARELY TWO MONTHS. HE AND ORAZIO SWEPT IN.

AGOSTINO! COME QUICK! I SAW A MAN! IN MY HOUSE! WITH MY DAUGHTER!

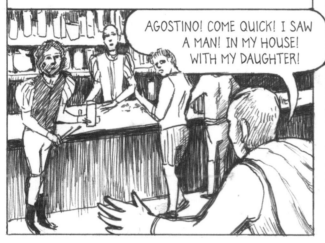

THEY KILLED HER HOPE.

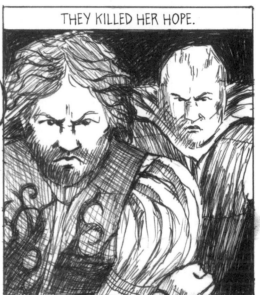

YOU.

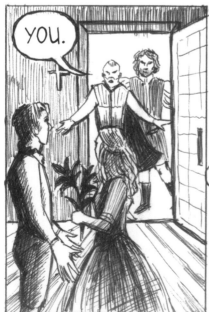

GET OUT OF HERE.

IT'S NOT WHAT YOU THINK.

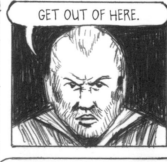

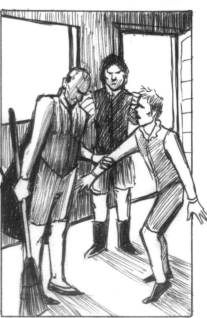

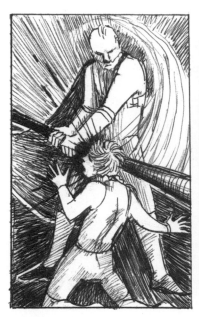

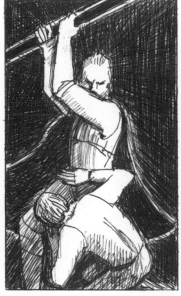

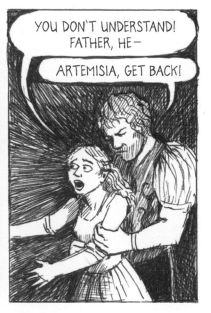

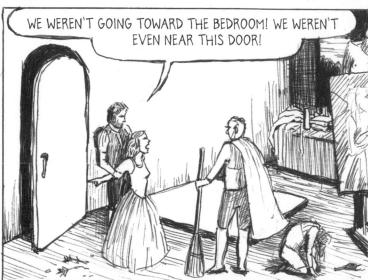

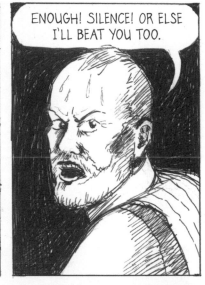

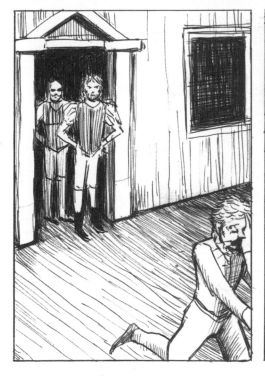

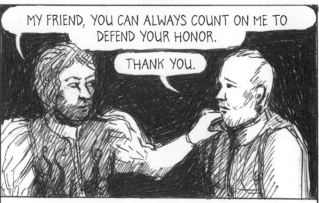

LITTLE DID ORAZIO KNOW THAT AGOSTINO'S DESIRE FOR ARTEMISIA WAS GROWING. MORE AND MORE FREQUENTLY HE TURNED AWAY FROM COSTANZA, CONSUMED BY THOUGHTS OF POSSESSING THE GIRL PAINTER. HE PREVENTED ANY OTHER MALE VISITORS FROM ENTERING THE GENTILESCHI HOME.

PAINTING WAS THE ONLY THING THAT BROUGHT FATHER AND DAUGHTER TOGETHER AGAIN. THEY CHOSE JUDITH AS THEIR NEW SUBJECT. WHY DID ORAZIO PAINT WITH HIS DAUGHTER INSTEAD OF FINDING HER A HUSBAND? PERHAPS BY NOW HER TALENT WAS SO GREAT THAT HE COULDN'T AFFORD TO LET HER GO.

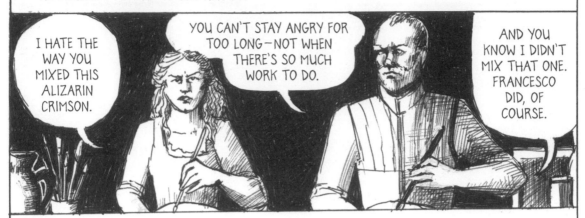

I HATE THE WAY YOU MIXED THIS ALIZARIN CRIMSON.

YOU CAN'T STAY ANGRY FOR TOO LONG—NOT WHEN THERE'S SO MUCH WORK TO DO.

AND YOU KNOW I DIDN'T MIX THAT ONE. FRANCESCO DID, OF COURSE.

THE OLD TESTAMENT APOCRYPHAL BOOK OF JUDITH BEGINS WITH A BLOODTHIRSTY ASSYRIAN GENERAL, HOLOFERNES, WHO PLANS TO DESTROY THE ISRAELITE CITY OF BETHULIA ON HIS WAY TO JERUSALEM. BUT A WIDOW NAMED JUDITH DRESSES UP IN HER FINEST, MOST SEDUCTIVE ATTIRE AND, ALONG WITH HER MAIDSERVANT, ABRA, SNEAKS INTO THE ENEMY CAMP. HOLOFERNES IS AMAZED BY HER BEAUTY AND INVITES HER INTO HIS BEDCHAMBER. HE BECOMES SO AROUSED AND ENCHANTED THAT HE DRINKS HIMSELF INTO A STUPOR, WHEREUPON JUDITH CHOPS HIS HEAD OFF AND SNEAKS OUT AGAIN WITH ABRA. SHE PRESENTS THE SEVERED HEAD TO THE PEOPLE OF BETHULIA AND THEY HANG IT OUTSIDE THE CITY GATES, WHICH INTIMIDATES AND DISPERSES THE ENEMY. DURING THE COUNTER-REFORMATION, THE TALE OF JUDITH WAS OFTEN USED TO SYMBOLIZE THE TRIUMPH OF THE CATHOLIC CHURCH OVER HERESY.

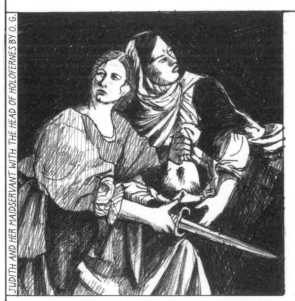

JUDITH AND HER MAIDSERVANT WITH THE HEAD OF HOLOFERNES BY O. G.

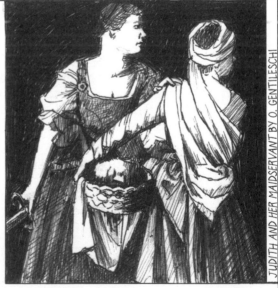

JUDITH AND HER MAIDSERVANT BY O. GENTILESCHI

DESPITE THEIR REMEMBRANCE OF CARAVAGGIO'S BLOODY RENDITION FROM 1599, ORAZIO AND ARTEMISIA FOCUSED ON THE BOND BETWEEN ABRA AND JUDITH. INSTEAD OF ABRA ASSUMING HER USUAL ROLE OF WITHERED OLD HAG IN THE BACKGROUND, ORAZIO AND ARTEMISIA MADE THE TWO WOMEN CLOSER IN AGE, THEIR DIFFERING SOCIAL STATUS CONVEYED BY THEIR CLOTHING.

MOST OF THESE EARLY JUDITHS ARE ATTRIBUTED TO ORAZIO, BUT ARTEMISIA WOULD SOON DRAW INSPIRATION FROM JUDITH'S POWERFUL STORY.

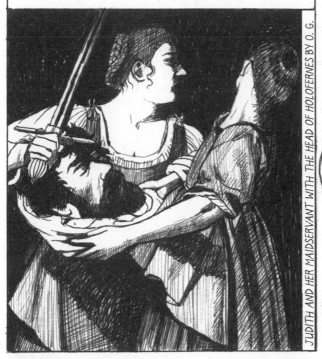

JUDITH AND HER MAIDSERVANT WITH THE HEAD OF HOLOFERNES BY O. G.

I LOVE THIS PAINTING! THIS LOOKS JUST LIKE YOU, ARTEMISIA

I LOVE TO SEE A PAINTING OF A BEAUTIFUL WOMAN BY A BEAUTIFUL WOMAN. HA! I MUST HAVE IT! I MUST OWN IT FOR ONE OF MY BEDROOMS.

GET BACK, YOU'RE BLOCKING THE LIGHT.

I HEAR ORAZIO RETURNING.

WHAT ARE YOU ADDING TO THAT PAINTING?

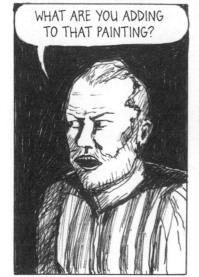

ORAZIO, THIS CHILD HAS BECOME SO FRAIL, SHE NEEDS TO GET OUT! LET US GO FOR A WALK.

ALRIGHT, ALRIGHT. TOMORROW YOU MAY TAKE HER OUT. BUT NO FURTHER THAN SAN GIOVANNI.

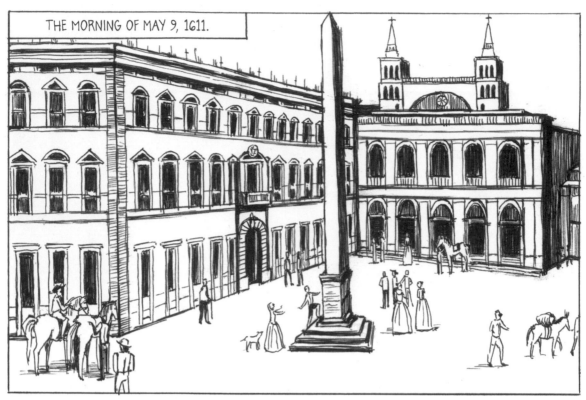

THE MORNING OF MAY 9, 1611.

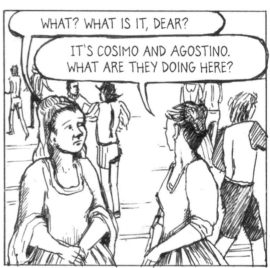

WHAT? WHAT IS IT, DEAR?

IT'S COSIMO AND AGOSTINO. WHAT ARE THEY DOING HERE?

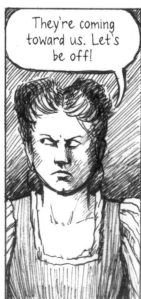

They're coming toward us. Let's be off!

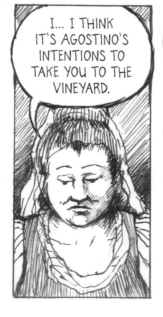

I... I THINK IT'S AGOSTINO'S INTENTIONS TO TAKE YOU TO THE VINEYARD.

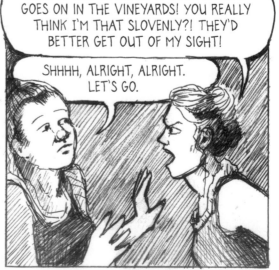

WHAT?! THE VINEYARD?! I KNOW WHAT GOES ON IN THE VINEYARDS! YOU REALLY THINK I'M THAT SLOVENLY?! THEY'D BETTER GET OUT OF MY SIGHT!

SHHHH, ALRIGHT, ALRIGHT. LET'S GO.

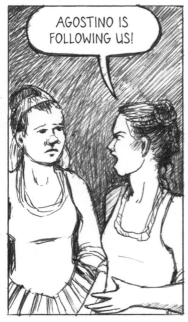
AGOSTINO IS FOLLOWING US!

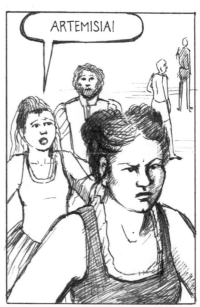
ARTEMISIA!

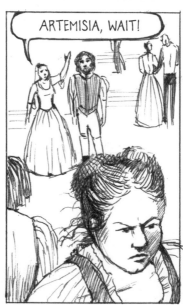
ARTEMISIA, WAIT!

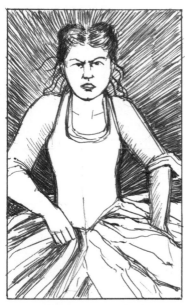

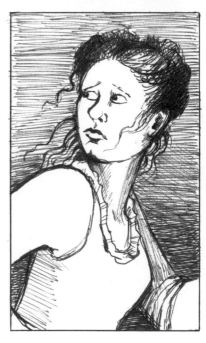

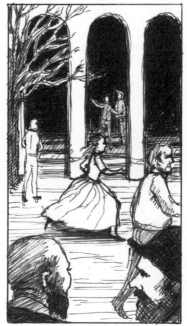

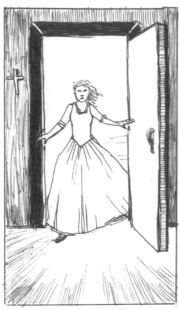

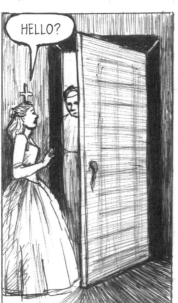
HELLO?

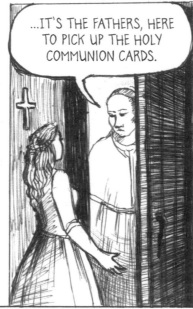
...IT'S THE FATHERS, HERE TO PICK UP THE HOLY COMMUNION CARDS.

OH, YES. YES, HERE THEY ARE.

THE PARISH FATHERS HANDED OUT CARDS TO THOSE WHO RECEIVED THE HOLY COMMUNION ON EASTER SUNDAY. THEN, THEY COLLECTED THEM LATER AS PROOF OF THE GOOD CATHOLICS' ATTENDANCE.

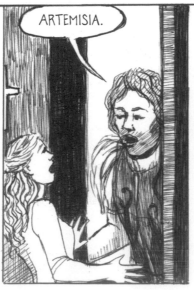
ARTEMISIA.

SO YOU *WERE* FOLLOWING ME. WHAT DO YOU WANT?

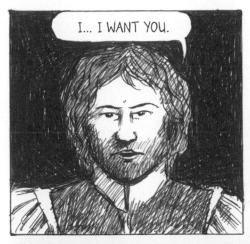

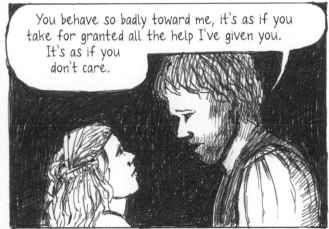

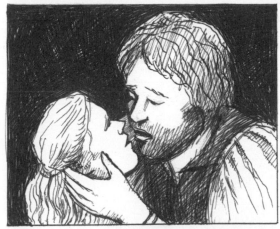

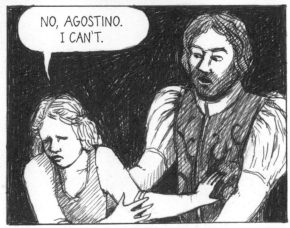

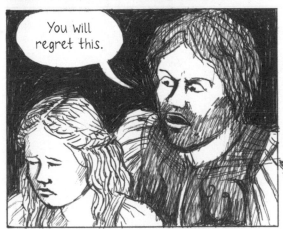

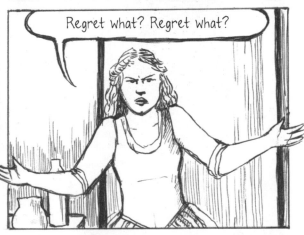

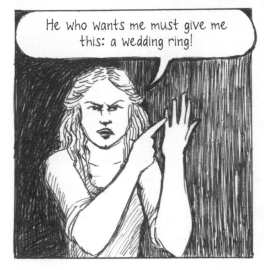

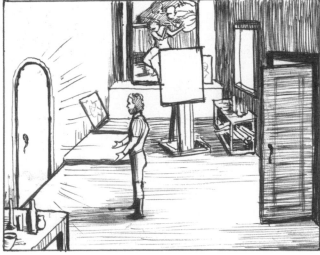

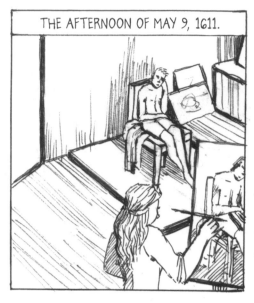

THE AFTERNOON OF MAY 9, 1611.

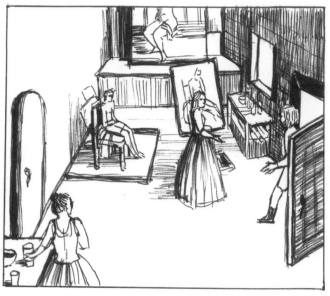

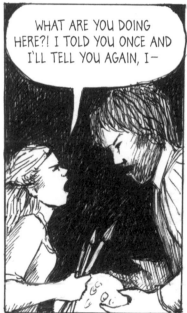

WHAT ARE YOU DOING HERE?! I TOLD YOU ONCE AND I'LL TELL YOU AGAIN, I—

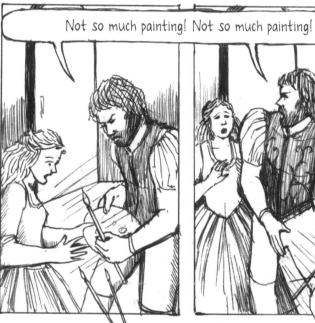

Not so much painting! Not so much painting!

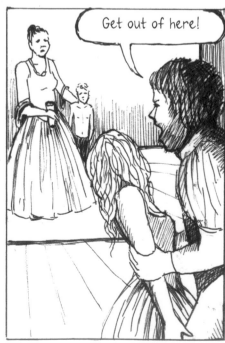

Get out of here!

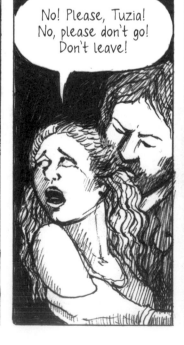

No! Please, Tuzia! No, please don't go! Don't leave!

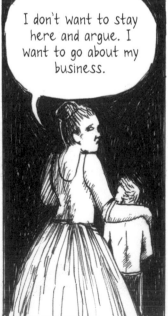

I don't want to stay here and argue. I want to go about my business.

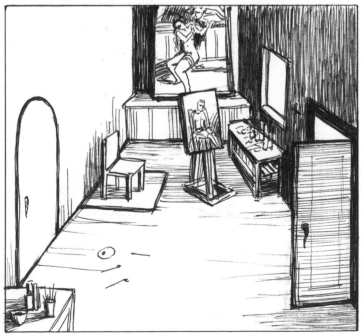
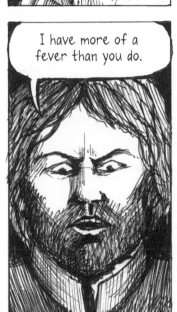
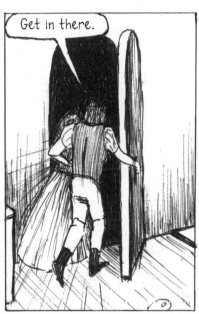
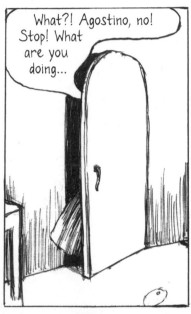
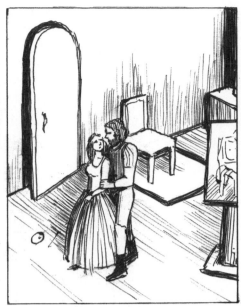
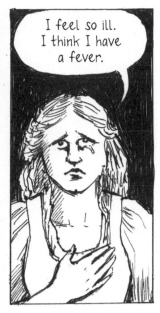

I KNOW WHAT I AM

THE LIFE AND TIMES OF ARTEMISIA GENTILESCHI

PART 2

THE TRIAL OF 1612

MARCH 18, 1612.

...I can imagine the reason Your Lordship wants to question me. For the past few days I have watched my father's activities. He has had the tenant, Tuzia, imprisoned. She lives in the apartment upstairs, and has betrayed me by plotting to disgrace me.

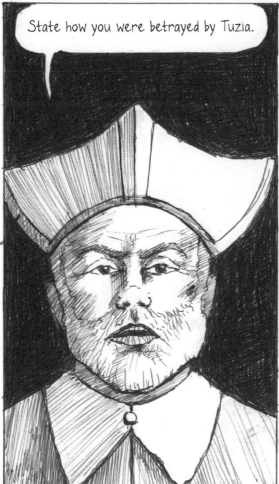

State how you were betrayed by Tuzia.

She acted as procuress to have me deflowered by Agostino Tassi, a painter. In order that you shall be fully informed, I shall relate in detail the facts, as they happened.

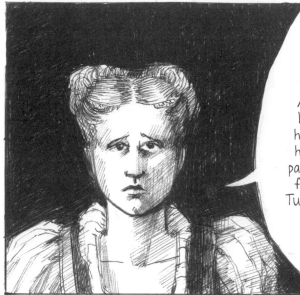

One day last May, after I had eaten lunch, I was painting one of Tuzia's boys for my own pleasure, and Agostino stopped by. He managed to get in because the masons working on the house had left the door open. When he found me, he said, "Not so much painting, not so much painting." He grabbed the palette and brushes from me and threw them around, saying to Tuzia, "Get out of here." When I told her not to leave me, she said, "I don't want to stay here and argue. I want to go about my business."

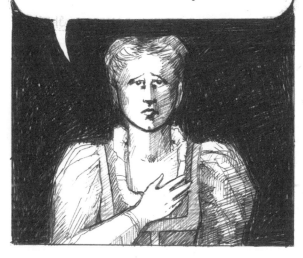

Agostino put his head on my breast. As soon as Tuzia was gone, he took my hand and said, "Let's walk together a while, I hate sitting down."

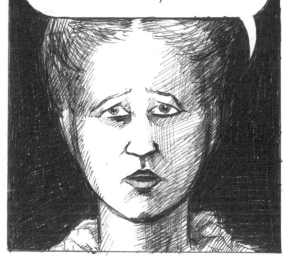

I told him that I was feeling ill and that I thought I had a fever. He replied, "I have more of a fever than you do."

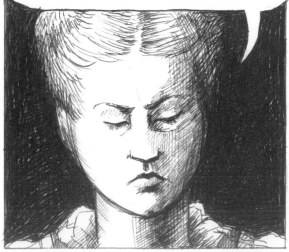

We walked around the room two or three times, each time going by the bedroom door.

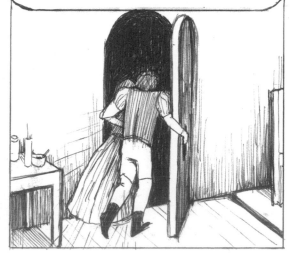

Once we were in front of the bedroom, he pushed me in and locked the door behind him...

He threw me onto the edge of the bed, pushing me with a hand on my breast, and put his knee between my thighs to prevent me from closing them. He had a great deal of trouble lifting my clothes. Then he placed a hand with a handkerchief at my throat and mouth, to keep me from screaming.

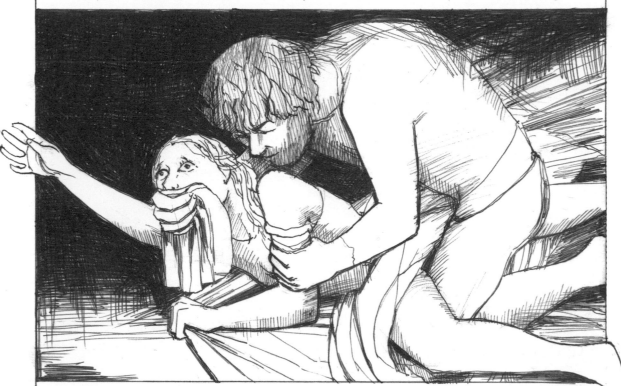

He let go of my hands, which he had been holding with his other hand and, having previously put both knees between my legs with his penis pointed at my vagina, he pushed it inside. I felt a strong burning and it hurt very much, but because he held my mouth I couldn't cry out. I tried to scream as best I could, calling for Tuzia.

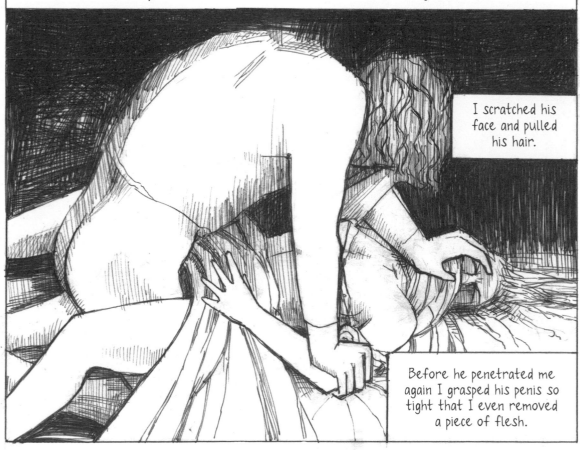

I scratched his face and pulled his hair.

Before he penetrated me again I grasped his penis so tight that I even removed a piece of flesh.

None of this bothered him at all, and he continued his business, which kept him on top of me for a while, holding his penis inside my vagina.

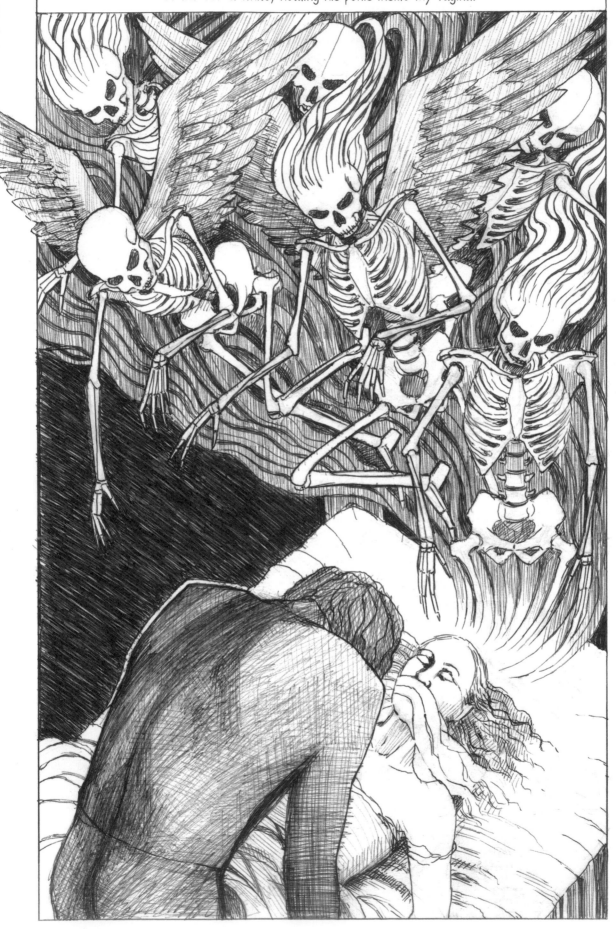

After he had done his business, he got off of me.

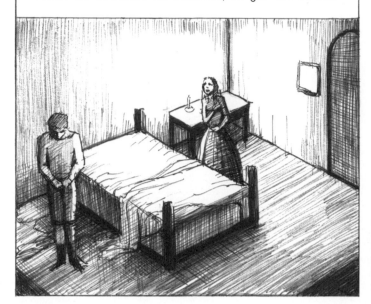

When I saw myself free, I went to the table drawer and took a knife.

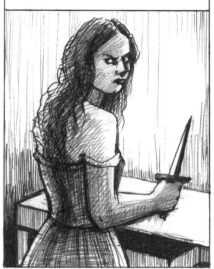

I moved toward Agostino...

I'd like to kill you with this knife because you have dishonored me!

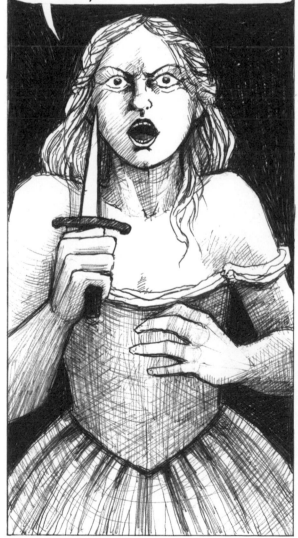

He opened his coat...

Here I am.

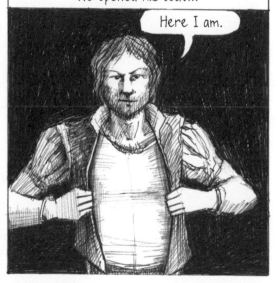

And I threw the knife at him.

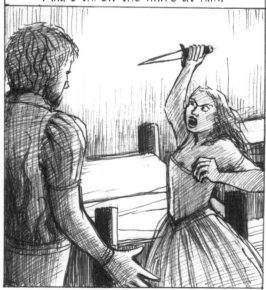

He shielded himself, otherwise I would have hurt him and might easily have killed him. Instead, I wounded him slightly on the chest and blood came out, but only a little since I'd barely touched him with the point of the knife.

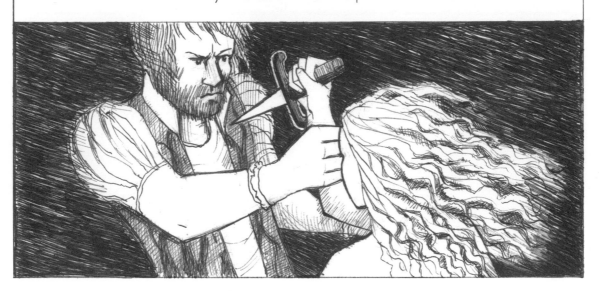

Agostino fastened his coat. I was crying and suffering over the wrong he had done to me.

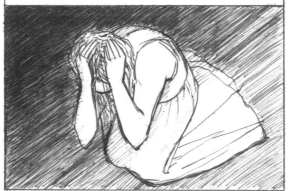

To pacify me, he said:

Give me your hand. I promise to marry you as soon as I get out of the labyrinth I am in.

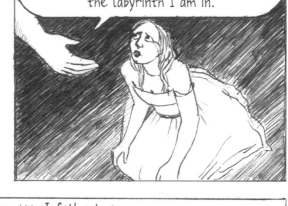

And with this good promise, I felt calmer.

I warn you that when I take you as my wife, I don't want any foolishness.

I think you will see if there is any foolishness.

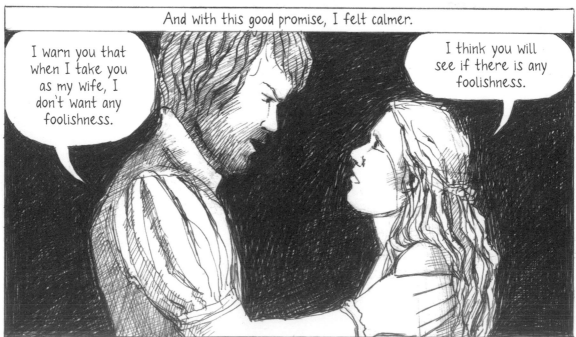

Many times he reconfirmed this promise to me and induced me
to yield lovingly to his desires.

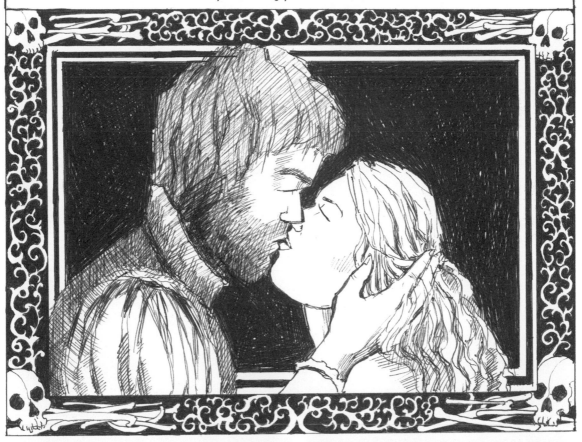

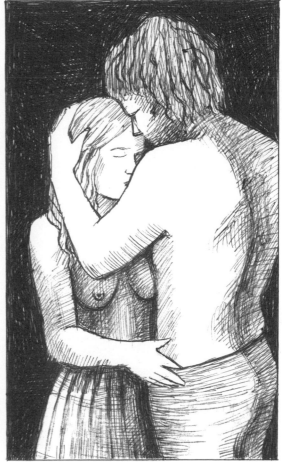

HIS PROMISE OF MARRIAGE WAS THE PROMISE OF THE CHURCH—OBEY NOW AND YOU WILL BE TAKEN CARE OF.

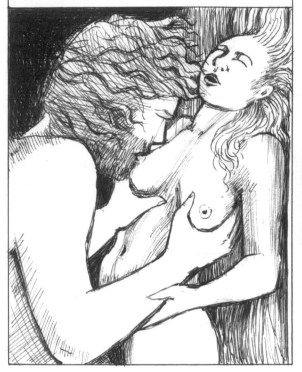

THIS WAS THE AGE OF WITCH HUNTS, AND THE LEGEND OF EVE'S SINFUL BITE OF THE FORBIDDEN APPLE CAST A SHADOW OVER THE FEMALE SEX. TO THE SEVENTEENTH-CENTURY MAN, A WOMAN'S BODY WAS FULL OF MYSTERIOUS SECRETS. WOMEN WERE THOUGHT TO BE MORE LUSTFUL AND MORE PRONE TO SIN THAN MEN.

AGOSTINO PROVIDED THE EMBRACE THAT THIS LONELY YOUNG PERSON SO DESPERATELY NEEDED.

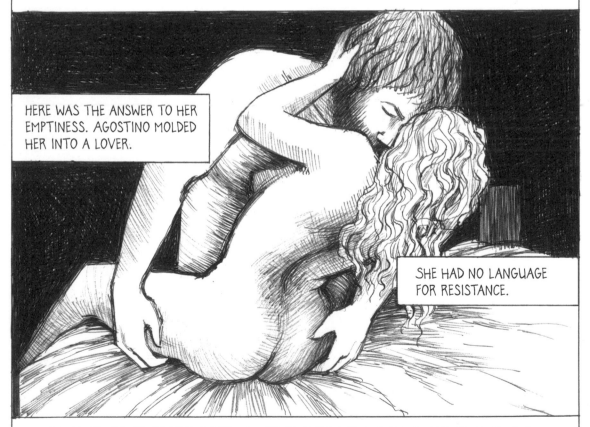

HERE WAS THE ANSWER TO HER EMPTINESS. AGOSTINO MOLDED HER INTO A LOVER.

SHE HAD NO LANGUAGE FOR RESISTANCE.

SHE WAS COMPELLED TO RETURN TO HIM, TO THIS FEELING SHE COULD NOT NAME, TO THE SECRET THAT WAS SEX. AGOSTINO HAD NEVER MET ANYONE LIKE HER. THROUGHOUT THE FALL AND WINTER, HE BEGAN TO LOVE HER DEEPLY.

AND AS THE NEW YEAR OF 1612 ROLLED IN, CARNIVAL TIME GAVE ROME THE OPPORTUNITY TO PARTY BEFORE LENT. DURING CARNIVAL, THE CITY TURNED INTO A DRUNKEN, RECKLESS WORLD OF THEATRE, PARADES, GAMES, HORSE RACES, COSTUMES, AND MASKS. SOME CARDINALS, ROME'S MEN OF WEALTH, SAVED AND PLANNED FOR CARNIVAL FESTIVITIES ALL YEAR ROUND, WAITING FOR THOSE DAYS LEADING UP TO LENT WHEN ROME EXPLODED WITH HUMOR AND DEBAUCHERY.

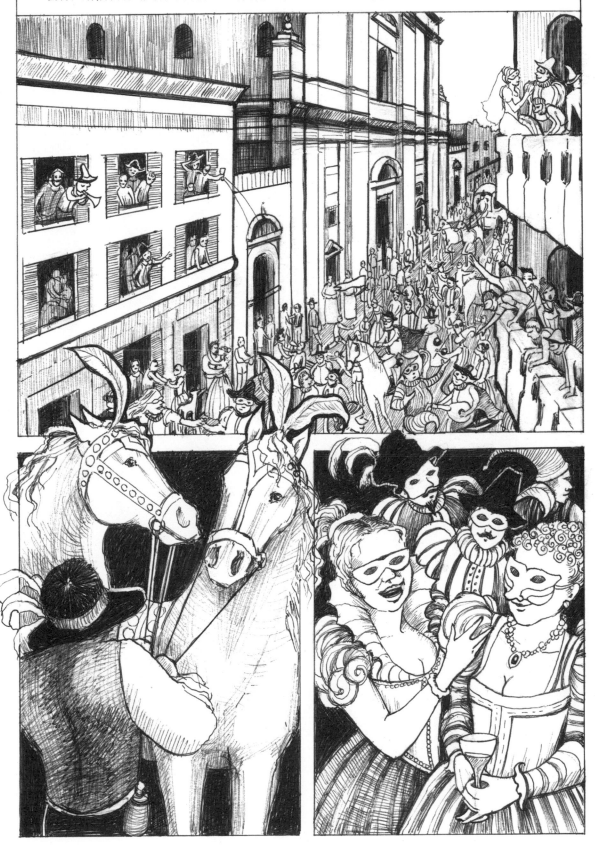

THUS, ROMAN CATHOLIC LIFE WAS DIVIDED INTO OPPOSITES—GOOD AND EVIL, PRAYER AND SIN, DARK AND LIGHT, RICH AND POOR, HONOR AND SHAME, LENT AND CARNIVAL. YET, AS THE AUTHORITIES ENFORCED THESE BINARIES, THE REALITY OF PEOPLE'S LIVES ENCOMPASSED MORE COMPLEXITY.

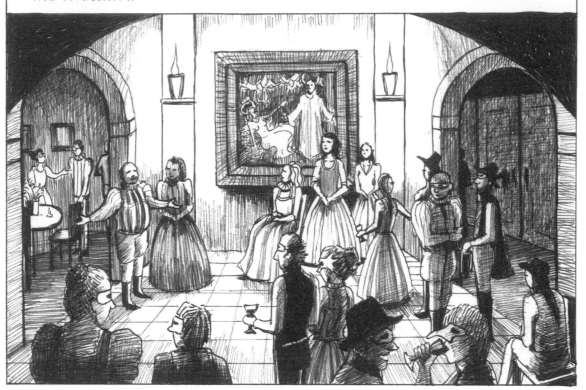

ONE MOMENT, FRIENDS.

HELLOOO? COME ON OUT, YOU TWO! If you haven't done your business yet, it's your own loss!

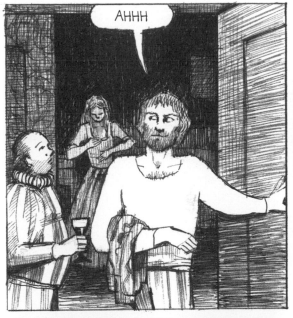

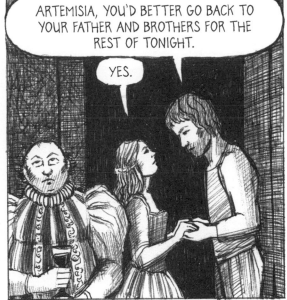

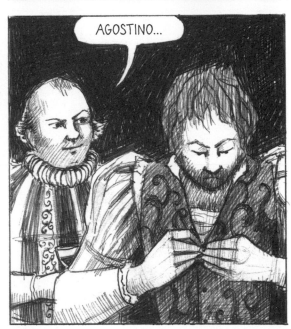

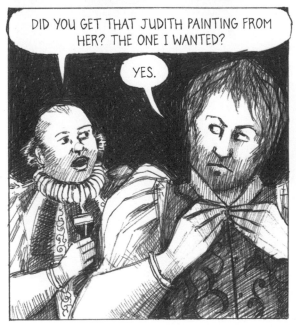

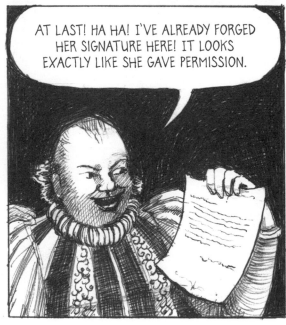

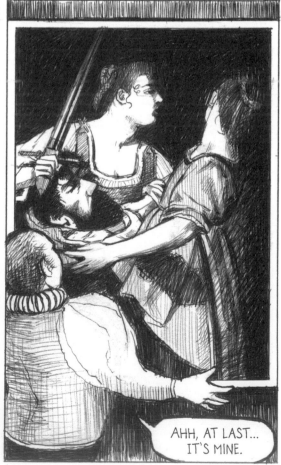

IT WAS ONLY ORAZIO'S SPIRIT THAT DID NOT LIFT FOR CARNIVAL.

HE FOUND HIMSELF BURIED EVEN DEEPER IN HIS WORK.

AH, THERE YOU ARE.

I'VE BEEN WAITING FOR YOU ALL MORNING!

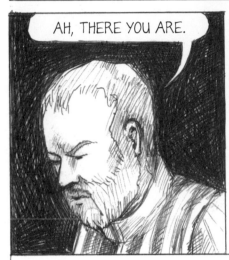

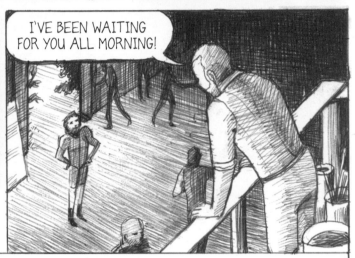

HE AND AGOSTINO WERE BACK NEAR THE QUIRINAL PALACE COMPLETING THE FAMOUS *CASINO OF THE MUSES* FRESCO. AGOSTINO PAINTED THE ARCHITECTURE, AND ORAZIO PAINTED THE FIGURES WITHIN IT. THEY WERE TWO ARTISTS STRIVING TO PROVE THEIR ABILITIES TO THE MOST POWERFUL PATRON OF ROME, CARDINAL NEPHEW SCIPIONE BORGHESE, AS HE MERCILESSLY CLIMBED THE LADDER OF EXCESSIVE WEALTH AND POWER.

OH, CALM DOWN, ORAZIO. I'VE ALREADY FINISHED MY PART AND YOU KNOW IT.

WELL, SHUT UP THEN AND GO FIND MY DAMN ASSISTANT, NICOLO, TO LEND ME A HAND.

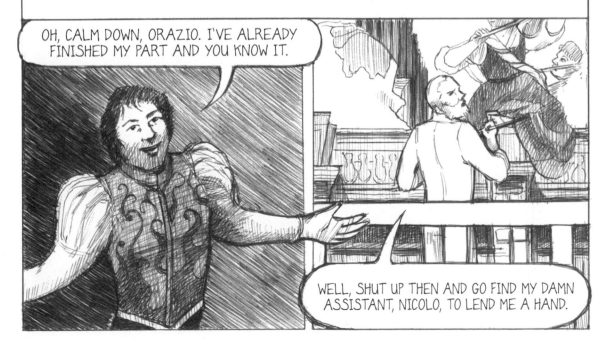

THE FRESCO WAS A METICULOUSLY CONSTRUCTED ILLUSION OF DEPTH AND PERSPECTIVE. ITS UNVEILING MUST HAVE BEEN A TRIUMPH FOR AGOSTINO'S AND ORAZIO'S CAREERS...

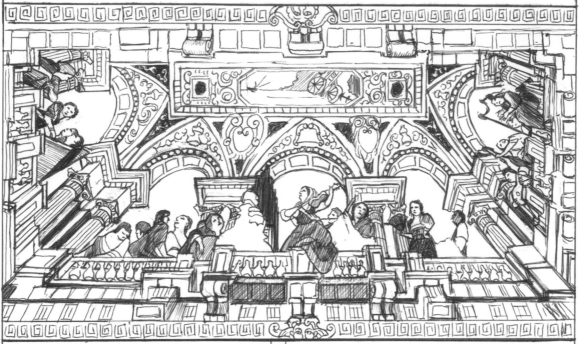

AND THEIR FRIENDSHIP.

AH, YES! A JOB WELL DONE. THE GREAT SCIPIONE WILL HAVE NOTHING TO COMPLAIN ABOUT.

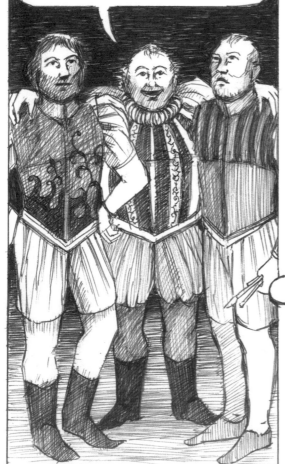

AND WAS THAT ARTEMISIA PAINTED THERE ON THE RIGHT, LEANING IMPATIENTLY WITH THE FAN, HER WATCHFUL GAZE CEMENTED FOREVER AMONG THE MUSICIANS AND PARTYGOERS OF THE BORGHESE'S LAVISH GARDEN VILLA CEILING?

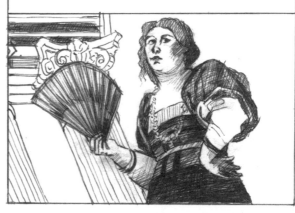

COME WALK WITH ME FOR A MOMENT, MY FRIEND...

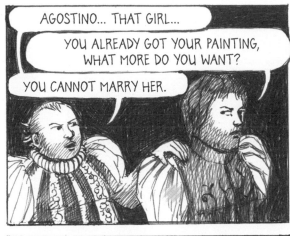

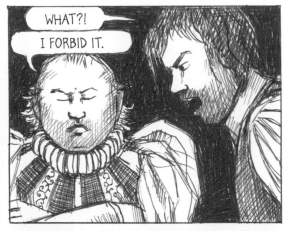

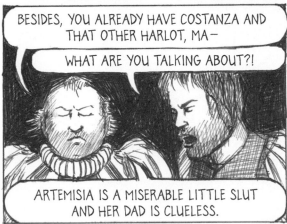

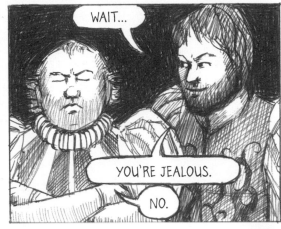

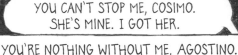

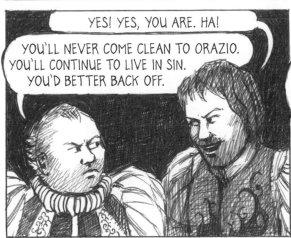

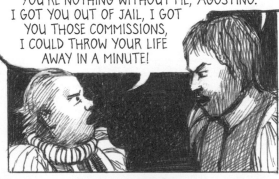

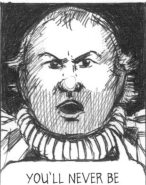

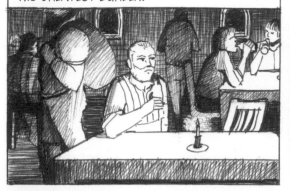

ORAZIO'S GREATEST TREASURE WAS ALSO HIS GREATEST BURDEN.

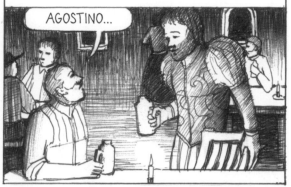

WHAT DID HE KNOW AND HOW DID HE FIND OUT?

AGOSTINO...

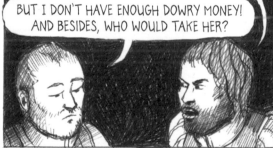

YOU STILL OWE ME FOR MY PORTION OF THE *CASINO OF THE MUSES!*

OHHH... LET'S NOT GET INTO THAT AGAIN. I WANT TO TALK TO YOU ABOUT... WELL... ABOUT ARTEMISIA. MY FRIEND, IT'S TIME YOU COME UP WITH A PLAN.

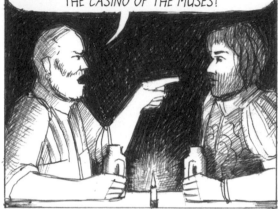

HMMM, YOU'RE RIGHT. A CONVENT WOULD BE BEST FOR HER.

ORAZIO, YOU'RE CRAZY! SHE'LL NEVER GO IN THERE!

BUT I DON'T HAVE ENOUGH DOWRY MONEY! AND BESIDES, WHO WOULD TAKE HER?

YOU...?

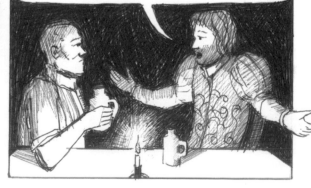

SHE'S A SEDUCTRESS! A SNEAKY LITTLE NYMPH! I CAN'T DENY IT! LET ME HELP. PLEASE, I MUST ASK FOR HER HAND.

BUT THERE WAS ONE OBSTACLE THAT COSIMO AND AGOSTINO HAD TAKEN FOR GRANTED: GIOVANNI BATTISTA STIATTESI. THIS MYSTERIOUS MAN WAS ALWAYS WATCHING.

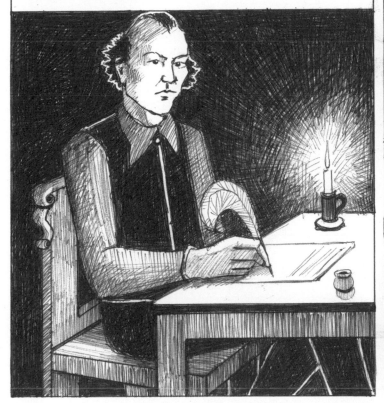

WAS HE A SPY FOR ORAZIO?

SO WHAT DO YOU THINK?

AMAZING, AS USUAL.

OR A SPY FOR COSIMO AND AGOSTINO?

DEAR ARTEMISIA, SOMEDAY YOU WILL BE FAMOUS.

HE BORE A DEEP GRUDGE AGAINST HIS COUSIN COSIMO, EVEN BEFORE HIS ALLIANCE WITH ORAZIO WAS SOLIDIFIED. HE COULD NOT STAY SILENT ANYMORE.

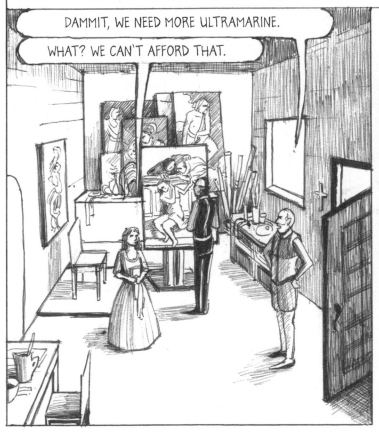

DAMMIT, WE NEED MORE ULTRAMARINE.

WHAT? WE CAN'T AFFORD THAT.

WELL, WE MUST. GO FIND FRANCESCO AND MARCO SO THEY CAN GET SOME. GO!

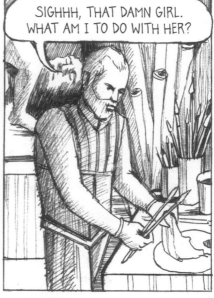

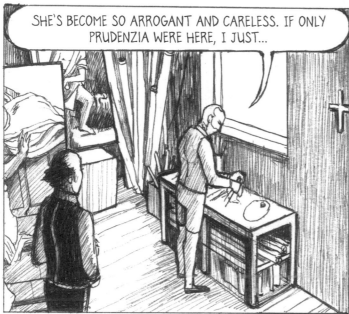

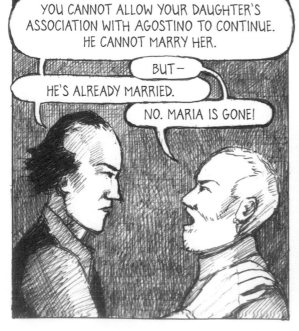

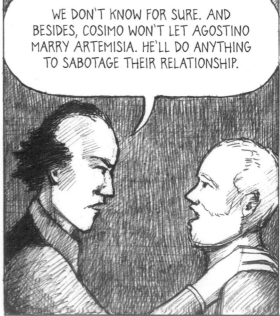

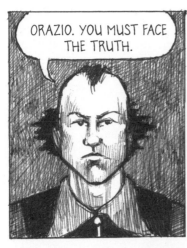

ORAZIO. YOU MUST FACE THE TRUTH.

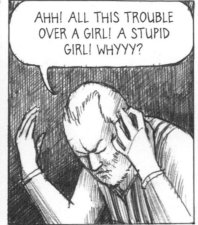

AHH! ALL THIS TROUBLE OVER A GIRL! A STUPID GIRL! WHYYY?

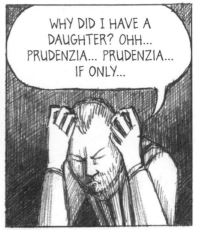

WHY DID I HAVE A DAUGHTER? OHH... PRUDENZIA... PRUDENZIA... IF ONLY...

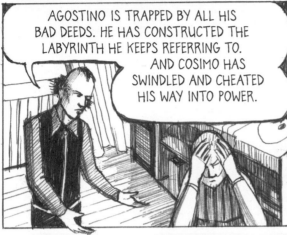

AGOSTINO IS TRAPPED BY ALL HIS BAD DEEDS. HE HAS CONSTRUCTED THE LABYRINTH HE KEEPS REFERRING TO. AND COSIMO HAS SWINDLED AND CHEATED HIS WAY INTO POWER.

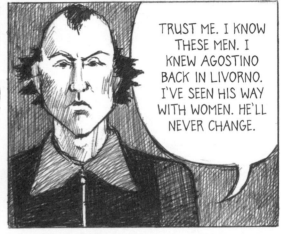

TRUST ME. I KNOW THESE MEN. I KNEW AGOSTINO BACK IN LIVORNO. I'VE SEEN HIS WAY WITH WOMEN. HE'LL NEVER CHANGE.

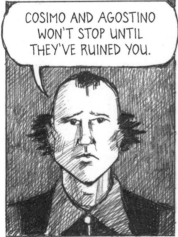

COSIMO AND AGOSTINO WON'T STOP UNTIL THEY'VE RUINED YOU.

MY GOD...

YOU'RE RIGHT... BUT...

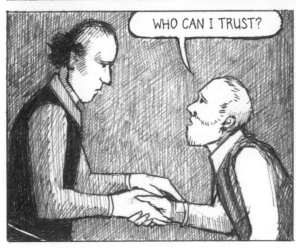

WHO CAN I TRUST?

UM... WHAT'S GOING ON?

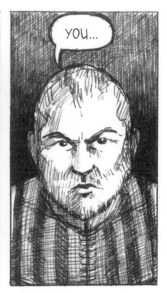

YOU...

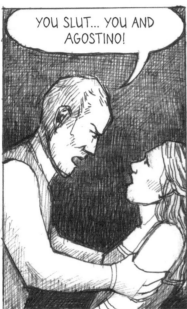

YOU SLUT... YOU AND AGOSTINO!

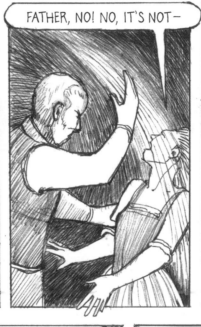

FATHER, NO! NO, IT'S NOT—

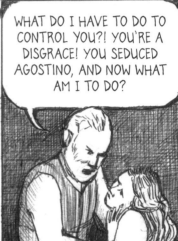

WHAT DO I HAVE TO DO TO CONTROL YOU?! YOU'RE A DISGRACE! YOU SEDUCED AGOSTINO, AND NOW WHAT AM I TO DO?

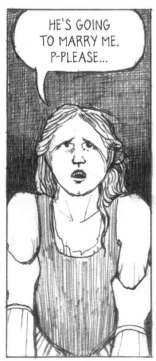

HE'S GOING TO MARRY ME. P-PLEASE...

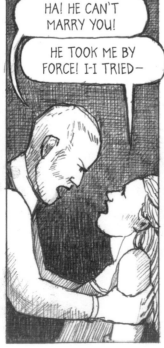

HA! HE CAN'T MARRY YOU!

HE TOOK ME BY FORCE! I-I TRIED—

BY FORCE! AND WHERE DOES THAT LEAVE ME? WHERE DOES THAT LEAVE THE GENTILESCHI? ALL DAY AND NIGHT I WORK AND WORK TO UPHOLD OUR HONOR! I'VE RAISED OUR GOOD NAME UP! I'VE PROVIDED FOR YOU AND TRAINED YOU!

AND THIS IS THE THANKS I GET— YOU PARADING AROUND WITH THIS SCOUNDREL LIKE A FUCKING PROSTITUTE?!

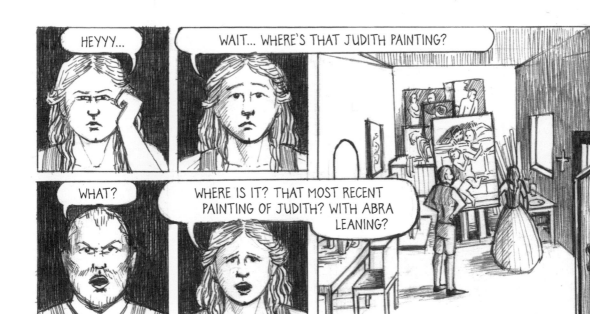

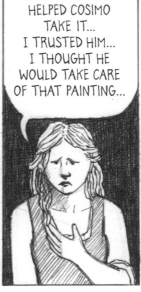

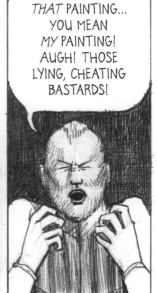

89

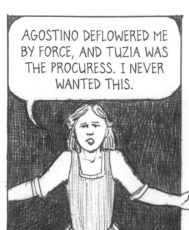

AGOSTINO DEFLOWERED ME BY FORCE, AND TUZIA WAS THE PROCURESS. I NEVER WANTED THIS.

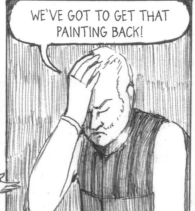

WE'VE GOT TO GET THAT PAINTING BACK!

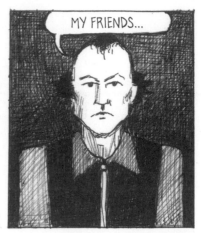

MY FRIENDS...

YOU CAN GET YOUR PAINTING BACK. I KNOW WHERE IT IS. AND YOU CAN RESTORE YOUR HONOR AS WELL. THE ONLY WAY TO STOP AGOSTINO IS TO BRING HIM TO TRIAL.

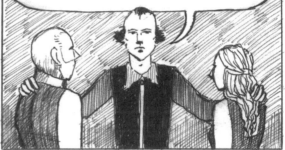

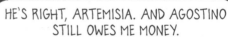

AND MAKE MY SHAME PUBLIC? NO!

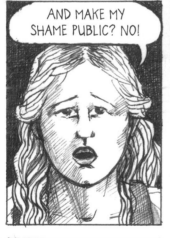

SIGHHHH

HE'S RIGHT, ARTEMISIA. AND AGOSTINO STILL OWES ME MONEY.

AND NOW HE OWES ME DOWRY MONEY TO MAKE UP FOR WHAT HE'S DONE. SHIT!

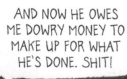

AND THE PAINTING... OHHH, THE PAINTING.

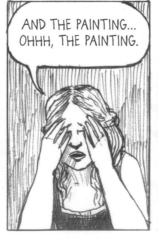

I'LL NEVER FORGIVE YOU FOR WHAT YOU'VE DONE TO ME.

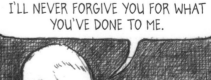

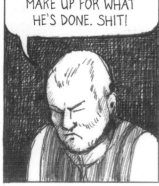

90

IT'S NOT TOO LATE. IT WILL BE A DIFFICULT BATTLE, BUT WE MUST CHOOSE TO FIGHT AGAINST THESE MEN. YOU MUST COME TOGETHER TO PRESERVE THE GENTILESCHI NAME. AGOSTINO MUST BE BROUGHT TO JUSTICE.

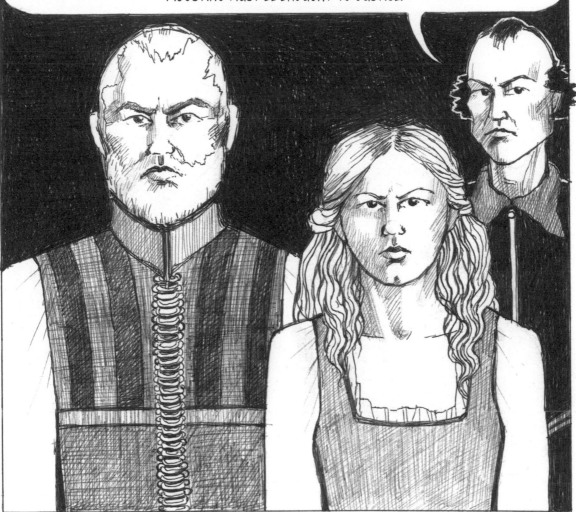

Most Holy Father, Pope Paul V Borghese,
Orazio Gentileschi, painter, most humble servant of Your Highness, respectfully reports to you that, through the complicity of his tenant, Madam Tuzia, a daughter of the plaintiff was forcefully deflowered by Agostino Tassi, painter and close friend of the plaintiff. Your orderly, Cosimo Quorli, also took part in this obscene business. Cosimo Quorli also took from the hands of the same young woman some paintings by her father, the plaintiff, in particular a Judith, large in size. Holy Father, this is such a nasty deed, causing such great injury and damage to the poor plaintiff (especially since it was done under the trust of friendship) that it is like a murder. Thus, kneeling at your Holy feet, I implore you in the name of Christ, to take action against this ugly impertinence by bringing Agostino Tassi to justice. Besides granting a very great favor, your action will keep the poor plaintiff from disgracing his other children. And he will always pray to God for your most just reward.

THE TRIAL OF ARTEMISIA AND ORAZIO GENTILESCHI AGAINST AGOSTINO TASSI LASTED EIGHT MONTHS, FROM MARCH THROUGH OCTOBER OF 1612. MOST OF THE INTERROGATIONS TOOK PLACE IN CORTE SAVELLA AND TOR DI NONA PRISONS. MANY WITNESSES WERE IMPRISONED AND QUESTIONED PRIVATELY, WITH NO PRIOR KNOWLEDGE OF WHY THEY WERE ON TRIAL.

MARCH 16, 1612.

...when I heard that Agostino had a wife, I reproached him for this betrayal but he always denied it.

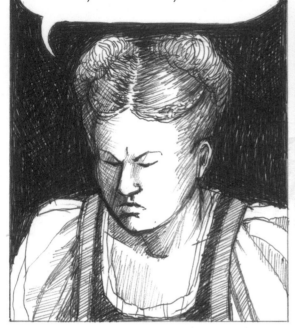

And I was even more certain that Agostino was going to marry me because any time there was any possibility of a marriage to someone else, he prevented it from developing.

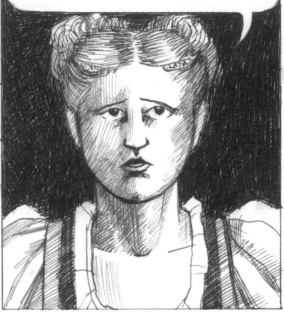

If you were as violently deflowered as you claim, did you discover afterwards that your pudenda was bleeding?

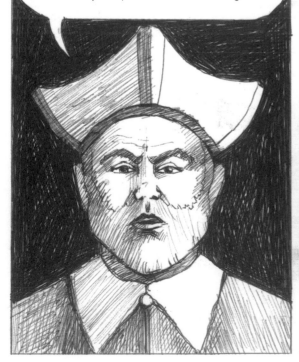

At the time that Agostino violated me, I was having my menstrual period, and I cannot tell Your Lordship for certain whether I was bleeding because of what Agostino had done. I didn't know much about these things. It is true that the blood was redder than usual...

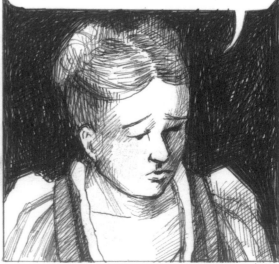

INDEED, ON MANY OTHER OCCASIONS I BLED WHEN AGOSTINO HAD CARNAL RELATIONS WITH ME. WHEN I ASKED HIM WHAT THIS BLOOD MEANT, HE SAID IT CAME BECAUSE I HAD A WEAK CONSTITUTION.

Have you had carnal relations with any other person than Agostino?

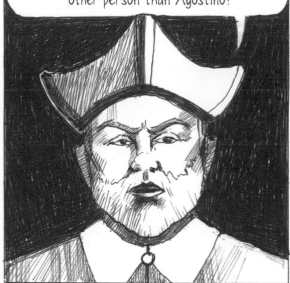

Oh no, Sir. I never had sexual relations with anyone besides Agostino. Cosimo made all sorts of efforts to have me, but I never consented. One time he came to my house after I had been with Agostino and tried to force me, but he did not succeed.

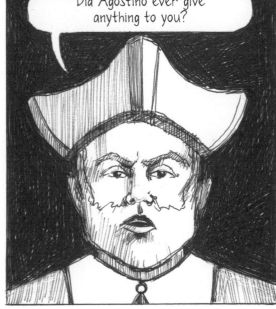

Because I did not consent, Cosimo said he was going to tell everyone that I gave myself to him anyway. He told numerous people, including his cousin, Giovanni Battista, as well as Agostino.

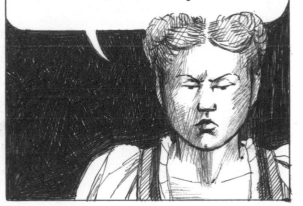

Did Agostino ever give anything to you?

Agostino never gave me anything. Since he dishonored me, I only had sexual relations with him so that he would marry me... except, well... last Christmas he gave me a pair of earrings as a present, and I gave him twelve handkerchiefs.

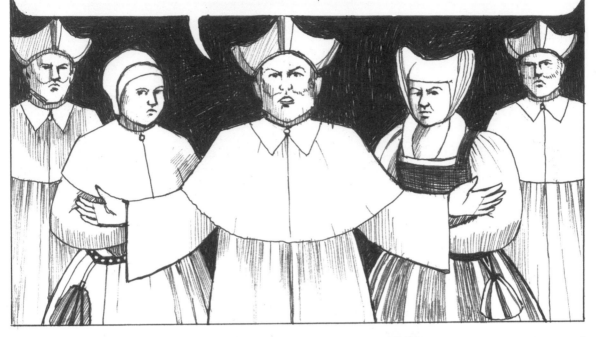

In order to ascertain whether the examinee has been deflowered as she claims, I've summoned two midwives. They are Diambra, daughter of the late Blasio from Capo di Monte, and Donna Caterina, daughter of the late Menicho Mordichi. They will inspect the examinee's pudenda.

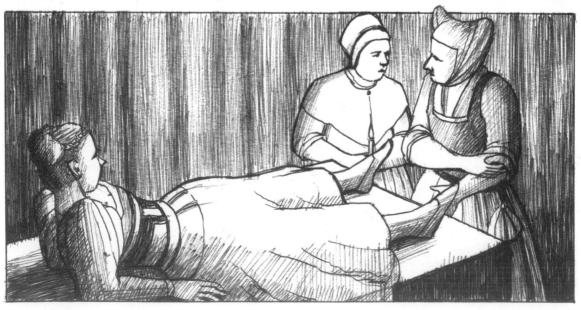

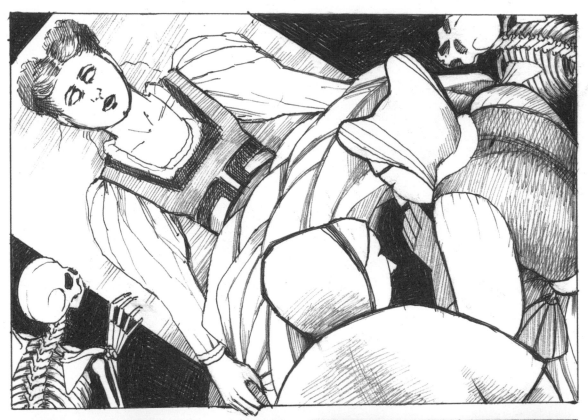

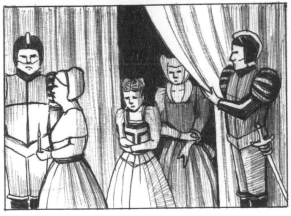

I have touched and examined the vagina of Signora Artemisia, Orazio Gentileschi's daughter, and I can say that she is not a virgin. I know this because, having placed my finger inside her vagina, I found that the hymen is broken. I can say this because of my experience as a midwife for ten or eleven years.

I have looked at and examined this young woman by the name of Artemisia, as Your Lordship has ordered me. I touched her vagina. I even put a finger in it, and I found that she has been deflowered since the hymen is broken. This happened a while ago. If it were recent, one would recognize it. I can say this because of my experience as a midwife for fifteen years.

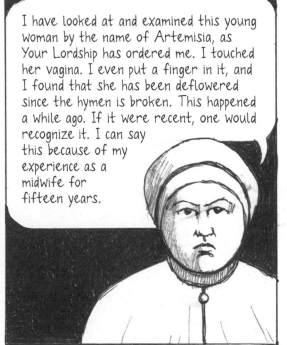

MARCH 6, 1612.

Signora Tuzia, wife of Stephano Medaglia.

Your Lordship, whenever Signor Orazio left, he always entrusted his daughter to me to take care of. He warned me not to speak about husbands, and that I should persuade her to become a nun, which I tried to do several times. But she always told me that her father did not need to waste his time because when he spoke of her becoming a nun, he alienated her.

When Agostino and Cosimo come to Orazio's house in his absence, was Artemisia present? Did she speak with them?

Yes, Sir. Many times when Agostino and Cosimo came to the house, Artemisia spoke with them. Agostino came more than Cosimo. In fact, for the past few months, Agostino has been coming to my place.

He seemed suspicious. His words clearly demonstrated that he suspected people were coming to Artemisia's home.

When Artemisia was downstairs, Agostino would come in to see what she and her father were doing. He showed great affection for Artemisia. He loved her very much. He would have given his life for her and her father.

Why did Agostino care so much for Artemisia and pursue her with so much love? What motive induced him to find out whether anyone else frequented her house?

Agostino said that he cared so much for Artemisia because he loved her father very much. They were good friends, so I always opened the door to Agostino whenever he came.

MARCH 23, 1612.

Tuzia, was Agostino at Orazio's house in his absence when Artemisia was painting?

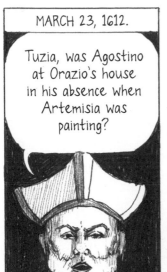

Yes, Sir. Agostino sometimes pushed his way into the house while Signor Orazio was out. One time he came in while Artemisia was painting a portrait of my son, and right after he came in Artemisia stopped painting. I left and went upstairs to my apartment.

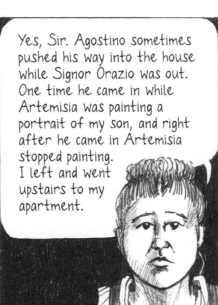

Have you ever seen Agostino with scratches or bruises on his face, and, if so, on what occasion?

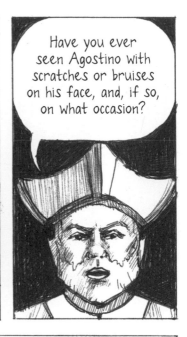

Yes, Sir. I saw Agostino's face scratched and his eyes bruised, but I don't remember when that was.

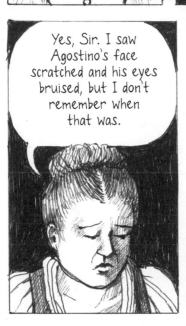

Many times I've seen Agostino alone in the room with Artemisia when I had to go downstairs. I found them joking together. Sometimes Agostino would throw himself onto the bed.

Many times I would reprove her, and she would say:

What is it that you want? Mind your own business and don't meddle in what doesn't concern you!

Do you know if Artemisia and Agostino had sexual relations?

No, Sir. I don't know because they both denied it.

Have you ever seen any other person alone with Artemisia?

I never saw Artemisia alone with anyone except Agostino. I told her I did not like this hot pursuit of Agostino's, but she replied that he promised to marry her.

MARCH 24, 1612.

Signor Giovanni Battista Stiattesi

...Your Lordship, Cosimo Quorli introduced Artemisia and Agostino to each other. Thereafter, Agostino went to her house whenever he knew that her father was gone. He deflowered her and came to know her carnally. When Agostino discussed this matter with me, he told me that he was obliged to marry her but that Cosimo was preventing this arrangement. I prodded Agostino and urged him to tell me why he should not or could not marry her. At last, one night while I slept next to him at his house on the slope of S. Onofrio, Agostino made up his mind:

Stiattesi, I owe you so much that I cannot avoid telling you the whole story, but give me your gentleman's word that you will not mention it to Cosimo.

Then we took each other's hands, and I promised not to mention it to Cosimo.

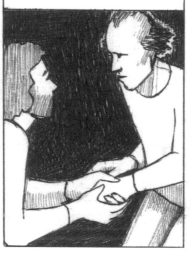

You should know, Stiattesi, that it was Cosimo who decided to introduce me to Artemisia... and it is because of him that I have gotten into this great labyrinth!

I am so entangled that I really must resolve to go to Tuscany. Otherwise, something distinctly unpleasant is likely to arise between Cosimo and me. Since he knows how much I love Artemisia and he knows the promise I made to God and to her, he had better not attempt to take her sexually anymore. Besides trying to force her twice, he has said whatever he pleased about me and generated a lot of misunderstanding between us.

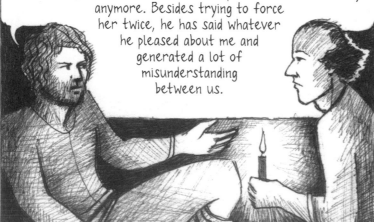

Cosimo told me firmly that I shouldn't encumber myself with this because she is a capricious woman who will cause me trouble for as long as I live.

In short, because of my debt to Signor Cosimo, to whom I owe my life, I cannot do anything without his approval.

Now you see what a state I have fallen into!

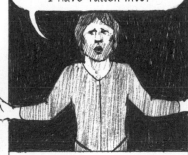

Lamenting thus all night long, Agostino told me he was in love with Artemisia and related what had taken place between them in detail.

Then Cosimo and I discussed this matter of Agostino and Artemisia. Cosimo sometimes said good things and sometimes bad, but he was trying to prove to me that Agostino should not marry her.

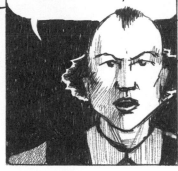

Since I had the impression that Cosimo was in love with Artemisia, I prodded him so much that he said:

Stiattesi, don't concern yourself with this matter anymore, because ultimately Agostino is a virtuous young man who, when he wants to get married, will not lack other possibilities. Artemisia is a shameless sluggard without any brains, the kind of woman who will bring him bad luck.

When I told him he was speaking out of jealousy, Cosimo answered:

It's not the way it used to be when I wanted to screw her and tried with the strength of Hercules. She never consented to give me even the tiniest morsel! Let her just go to hell! And you... if you want to do me a favor, leave that house and let them disentangle themselves.

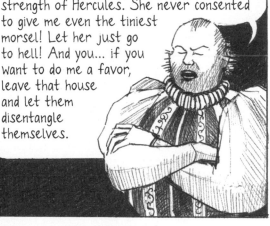

I had these conversations with both Cosimo and Agostino innumerable times and in various places—at the Palace on Monte Cavallo, in Cardinal Borghese's gardens, at Agostino's house, at the Palace of St. Peter's, in church, in taverns... everywhere! We haven't talked of anything but this for the past eight or ten months!

Do you know if Agostino had, or has, a wife?

Agostino had a wife named Maria. I met both of them in Livorno several years ago when I lived there.

99

I know that she ran away with a lover. When Agostino couldn't find her, feeling desperate and disgraced by her flight, he came this way by sea with his wife's sister and her husband. They brought along all their goods and set up here in Rome, living together as a family.

Because of this cohabitation, last year Agostino was sued by his sister, Olimpia, for incest with his sister-in-law, Costanza.

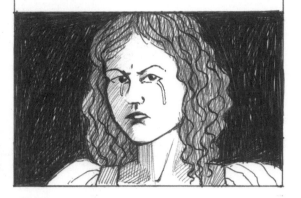

For several months he attempted to have Maria stabbed, but he did not succeed in killing her. Later, within the letters of reply from the merchants of Lucca, Pisa, and Livorno, I saw for myself the notice that his wife had finally been killed.

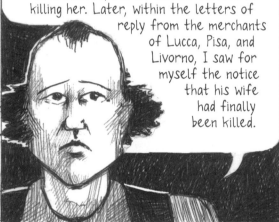

When, where, and by whom was Maria killed? Where did you see the letters and what is their present disposition?

I don't know who did it, but Maria was murdered according to what Agostino said, in the state of Matua about three months ago. He also told me that those who performed the service came to Rome to collect payment from him and left right away. Agostino told me he paid them, but he didn't say how much. He showed me the letters at his home and elsewhere in Rome.

I think he has them with him. I also know that he showed those letters to Artemisia.

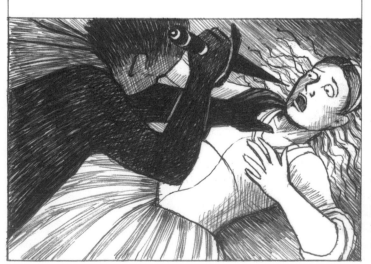

I can tell you that many times Cosimo asked me confidentially whether Artemisia resembled him. He always claimed that Artemisia was his daughter for certain and that other people had said she resembled him in certain facial features, particularly her eyes. I found it strange that he would brag about such a thing.

You brag that she's your daughter and yet you want to fuck her?!

Be quiet, you prick! This is the way one increases one's family.

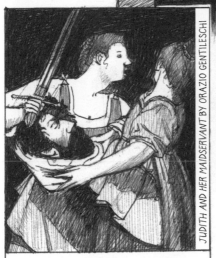

JUDITH AND HER MAIDSERVANT BY ORAZIO GENTILESCHI

Artemisia had a painting of Judith which she had sent to Agostino's house.

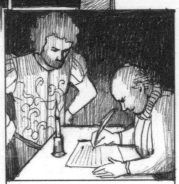

On the last day of Carnival, Cosimo forged an order to obtain the painting from Agostino, as though on her instructions.

Cosimo wrote the note with his own hand in the name of Artemisia. I reprimanded him and told him he should not take a painting of that sort away from a young lady.

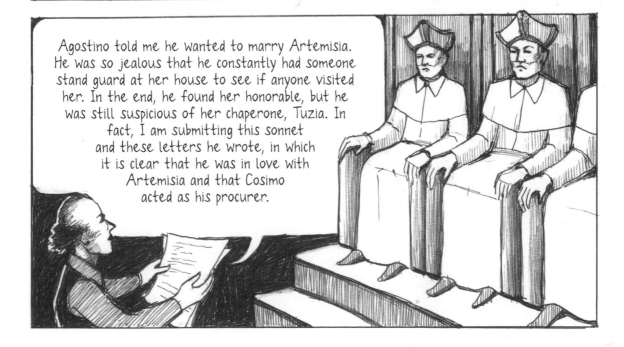

Agostino told me he wanted to marry Artemisia. He was so jealous that he constantly had someone stand guard at her house to see if anyone visited her. In the end, he found her honorable, but he was still suspicious of her chaperone, Tuzia. In fact, I am submitting this sonnet and these letters he wrote, in which it is clear that he was in love with Artemisia and that Cosimo acted as his procurer.

MARCH 26, 1612.

Agostino Tassi of Rome.

Have you been arrested, interrogated, or tried on any other occasions? And were you acquitted or convicted?

I've been in prison two or three times—once, in Borgo, under the pretext that I had carnal relations with my sister-in-law, Costanza.

I stayed in prison for two days and was then released and acquitted. Another time I was in prison in Tor di Nona for a triviality. Your Lordship was the judge, and I was released immediately.

I was also questioned and tried in Livorno for beating someone, but I was acquitted.

Have you always lived in Rome, or did you leave for some time?

I left Rome as a young man. I was about twelve years old when I went to Florence, in Tuscany. There, as I already had support in my profession as a painter, I got into the service of his Highness of Florence.

I perfected my skills and completed many paintings. I served the old Duke until he died. Also, by the Grand Duke's orders, I sailed on his galleys and saw the world with him.

And how long ago did your wife die? Did she die a natural death?

I cannot tell Your Lordship how long it's been since my wife died, because I left her and went away.

How long were you married to your wife? And where did you leave her when you came to Rome?

I was married for about eight years. Fifteen days before I left Tuscany, I was in Lucca with my wife. And unbeknownst to me, she stole seven or eight hundred scudi from me!

She also took some gold and silver and ran away. I let her go to hell and I went to Rome. Later, I heard that she had died.

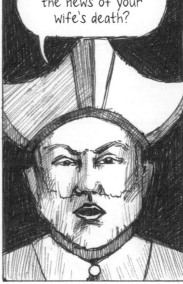

How did you hear the news of your wife's death?

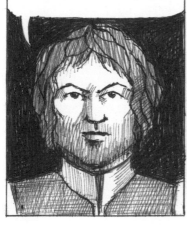

Some friends of mine from Lucca wrote to congratulate me that she was dead, but I don't remember how long ago.

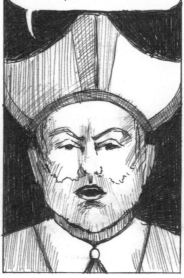

Were you informed of how your wife died?

No, Sir. I was not. They only wrote to me to say that she was dead. I did not inquire about anything else.

103

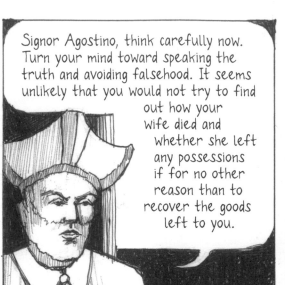
Signor Agostino, think carefully now. Turn your mind toward speaking the truth and avoiding falsehood. It seems unlikely that you would not try to find out how your wife died and whether she left any possessions if for no other reason than to recover the goods left to you.

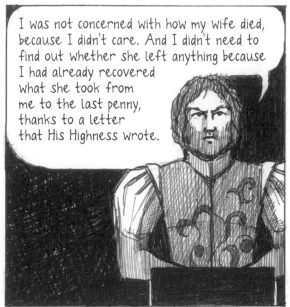
I was not concerned with how my wife died, because I didn't care. And I didn't need to find out whether she left anything because I had already recovered what she took from me to the last penny, thanks to a letter that His Highness wrote.

If she left anything of her own, I didn't care to have it because I am not a slave to money.

Did your sister-in-law and brother-in-law come to this city on your behalf?

Costanza's husband was sorry to lose my instruction. He hadn't finished his study and he valued my advice on the matter. I told him that if he wanted to be near me, he should come to Rome, and that I would help him as I had in the past.

Do you have any close friends or partners in this city?

Yes, Sir. I do have friends in Rome with whom I keep company... but now I'm not sure which ones are my real friends...

Your Lordship should know that I wish to state which ones are NOT my friends now. They are Orazio Gentileschi and Giovanni Battista Stiattesi. I declare these two to be my enemies.

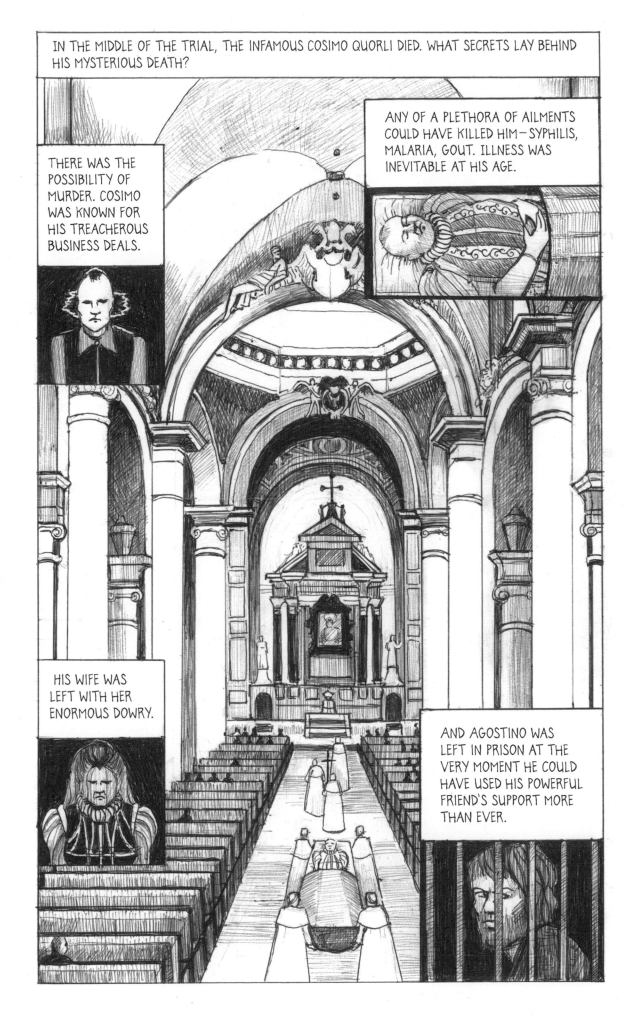

IN THE MIDDLE OF THE TRIAL, THE INFAMOUS COSIMO QUORLI DIED. WHAT SECRETS LAY BEHIND HIS MYSTERIOUS DEATH?

ANY OF A PLETHORA OF AILMENTS COULD HAVE KILLED HIM—SYPHILIS, MALARIA, GOUT. ILLNESS WAS INEVITABLE AT HIS AGE.

THERE WAS THE POSSIBILITY OF MURDER. COSIMO WAS KNOWN FOR HIS TREACHEROUS BUSINESS DEALS.

HIS WIFE WAS LEFT WITH HER ENORMOUS DOWRY.

AND AGOSTINO WAS LEFT IN PRISON AT THE VERY MOMENT HE COULD HAVE USED HIS POWERFUL FRIEND'S SUPPORT MORE THAN EVER.

APRIL 6, 1612.

Agostino Tassi of Rome.

When Giovanni Battista Stiattesi spent the night with you at your home did you have any conversations? If so, what about?

Giovanni Battista told me that he was going to go begging with his children, and that he would be desolate. He also told me he was in love with Gentileschi's daughter and that they were fucking each other.

He told me that wherever he worked, he deflowered virgins and impregnated women, and that he even impregnated a woman almost fifty years old and had a son by her!

On what occasions did you discuss Orazio's daughter?

We talked about Orazio's daughter because he was sighing and wailing that he was in great pain. When I asked him why he complained so much, he told me that he was madly in love with Orazio's daughter.

When I told him that he was harming both their friendship and himself, he said, "I don't know what's wrong with that. I can fuck and eat in Orazio's house."

When you spoke to Artemisia at her house, were other people there besides her brothers?

This I don't remember, Sir.

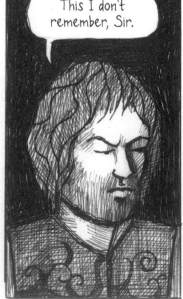

106

 Answer the preceding question precisely, not with ambiguous words.

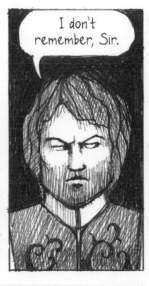 I don't remember, Sir.

 That is not a precise answer.

 I don't remember! I have no memory of it!

Enough! Answer the question exactly.

I don't remember, Sir, since I have other worries besides these!

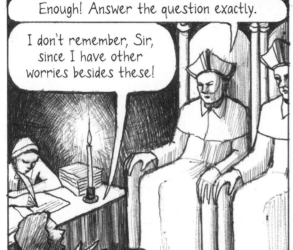

And what, in fact, are these other worries, because of which you cannot answer the question accurately?

The worries, Your Lordship, are the study of my profession and the amount of work I have to do for our Lord and most illustrious Cardinal Borghese.

On what occasion did you go into the upstairs rooms that Tuzia occupied?

I saw someone with whom the girl was flirting coming out of Orazio's house, so I went up to Tuzia's rooms and said, "Madam Tuzia, you know very well that Orazio brought you here so that you could look after Artemisia...

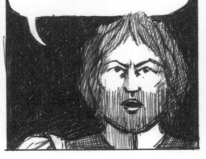

...yet you tolerate people coming upstairs in this house?!" And she said she didn't know what to do, that she had admonished her several times, but Artemisia wanted to do as she pleased.

107

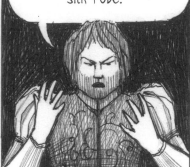

Who were these men that came out of Orazio's house? Do you know their reasons for going there?

I don't know their names, but I would recognize them if I saw them. One of them was a tall, young man with a small, red beard. He wore a long, silk robe.

The others wore secular clothes, but I didn't pay close attention to their features.

I believe they went for Artemisia, to screw her! Once, while I was passing by, I raised my eyes toward the window and saw Artemisia with her arm on the shoulder of the man with the long robe.

She called me that evening from her window and asked me not to mention it to her father.

Have you ever attempted to have carnal intercourse with Artemisia?

No. I have never had carnal intercourse with Artemisia, nor have I tried to.

...Orazio! That wretched scoundrel ought to be killed! Ten times he made me stay with him to wait for people to come out of his house! And now he does this to me because he doesn't want to give me back my money!

He wants to usurp my share of the profit from the loggia at Monte Cavallo! But he will not succeed because I am an honest man! I am here!

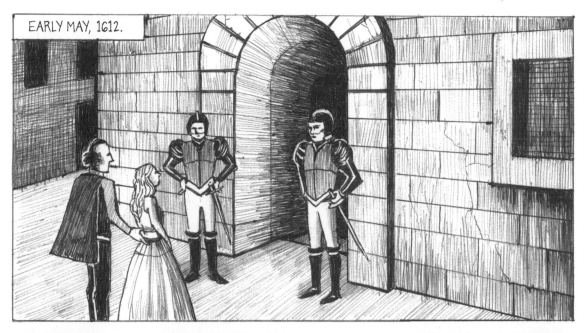

EARLY MAY, 1612.

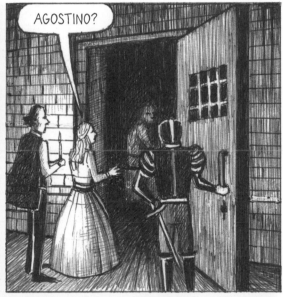

AGOSTINO?

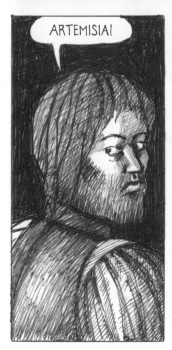

ARTEMISIA!

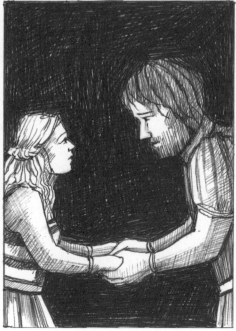

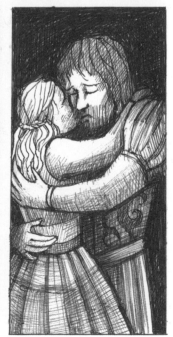

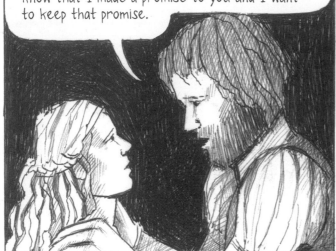

Oh, my Signora Artemisia, you know that you must belong to me and no one else. And you know that I made a promise to you and I want to keep that promise.

If I don't take you as my wife, then let as many devils take me as there are hairs in my beard! Let us exchange marriage vows.

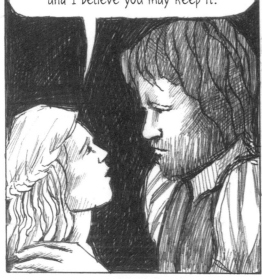

I accept your promise, and I believe you may keep it.

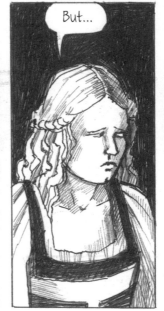

But...

Agostino, If you have a wife already, please tell me.

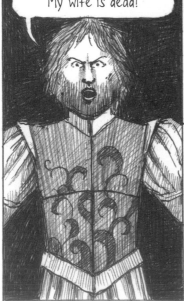

My wife is dead!

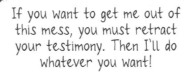

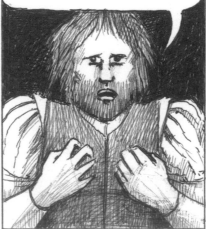

If you want to get me out of this mess, you must retract your testimony. Then I'll do whatever you want!

I don't want to do that.

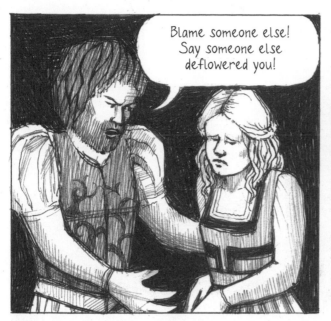

Blame someone else! Say someone else deflowered you!

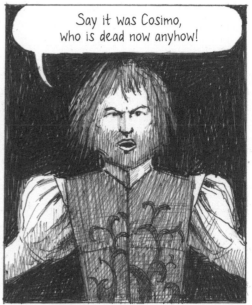

Say it was Cosimo, who is dead now anyhow!

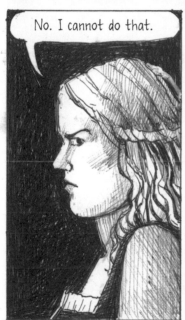

No. I cannot do that.

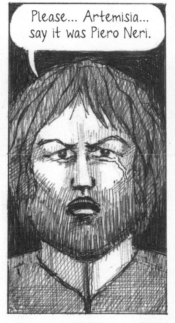

Please... Artemisia... say it was Piero Neri.

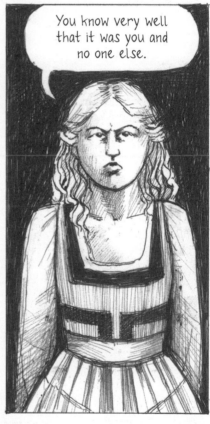

You know very well that it was you and no one else.

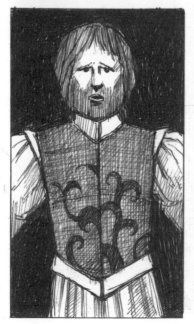

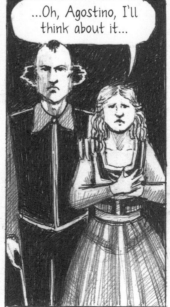

...Oh, Agostino, I'll think about it...

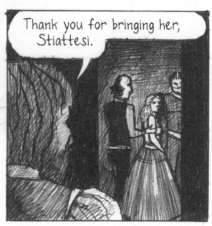

Thank you for bringing her, Stiattesi.

MAY 11, 1612.

Agostino Tassi. Do you need to say anything else in addition to your testimony in the earlier depositions?

I don't need to say anything more than what I've already said.

Are you ready to tell the truth about whether you've had carnal relations with Artemisia, the daughter of Orazio Gentileschi?

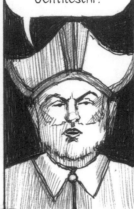

I have nothing else to say, and I have not had carnal relations with Artemisia. I have spoken the truth and no one will be able to prove otherwise.

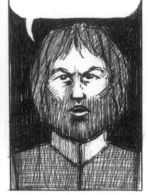

You should speak openly before God. The Curia is well informed. We know for certain that you not only had carnal relations with Artemisia more than once, but that you also violently deflowered her, as it clearly appears in her testimony.

The Curia also considers the frequency with which you visited Orazio's house in his absence, the spying you did, the confessions you made outside the court, and, finally, that you were seen in bed alone with Artemisia.

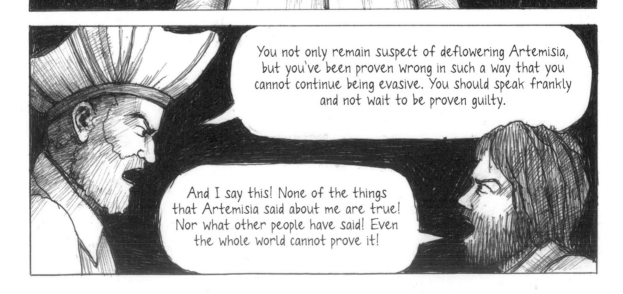

You not only remain suspect of deflowering Artemisia, but you've been proven wrong in such a way that you cannot continue being evasive. You should speak frankly and not wait to be proven guilty.

And I say this! None of the things that Artemisia said about me are true! Nor what other people have said! Even the whole world cannot prove it!

112

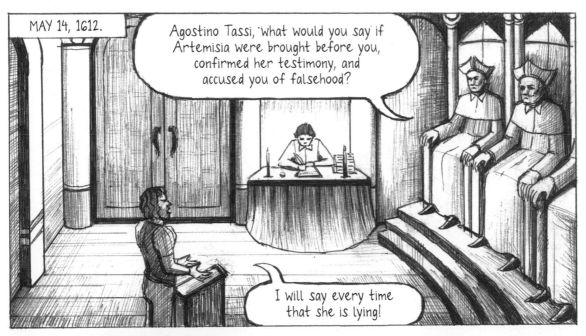

MAY 14, 1612.

Agostino Tassi, what would you say if Artemisia were brought before you, confirmed her testimony, and accused you of falsehood?

I will say every time that she is lying!

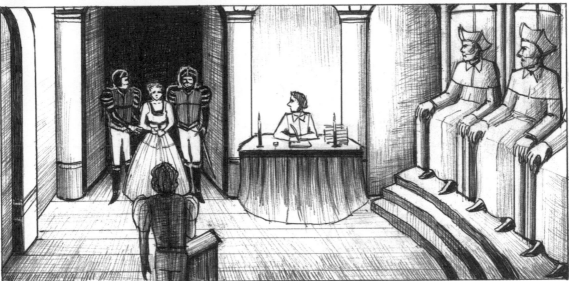

Artemisia, is your testimony regarding Agostino Tassi, here present, true? Do you intend to confirm and substantiate it now in front of him?

Yes, Sir. What I said before about Signor Agostino is the truth. And for the sake of truth, I am ready to confirm and substantiate it in front of him.

Relate the aforementioned deeds in their essence now.

I have told Your Lordship on other occasions that last year, during the month of May, Agostino frequented my father's house. He came as a friend, and both my father and I trusted him. One day he came to the house under certain pretexts. He grabbed me by the waist, threw me onto the bed, closed the door, and took my virginity, even though I struggled.

Everything Signora Artemisia said is a lie! In her house there was a stonecutter named Francesco, with whom you couldn't trust a female cat! He was alone with her both day and night! And there was Pasquino from Florence, who boasted publicly that he'd had her! I visited her with the honor and respect which one must show in a friend's house. I have not deceived her or my friend! I have avoided going there because they always involve me in fights!

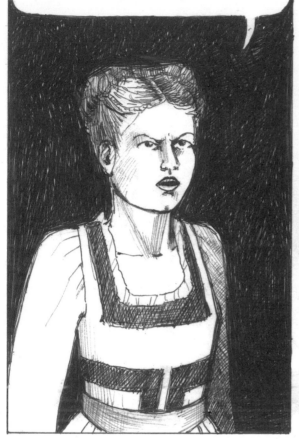

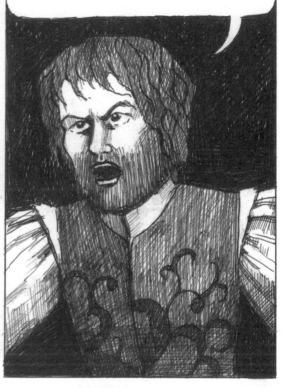

No! Everything I have said is true. If it were not, I would not have said it.

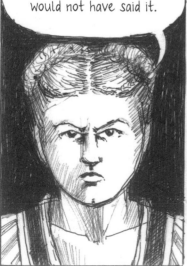

Signora Artemisia, are you prepared to confirm your testimony...

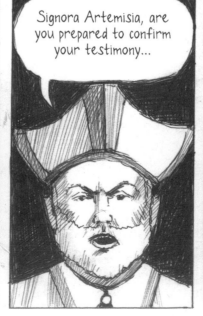

...even under torture?

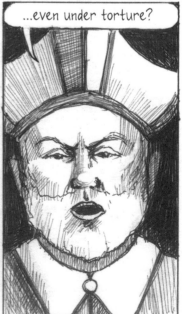

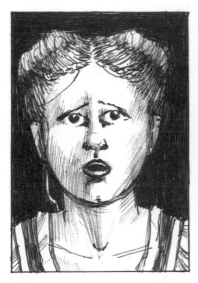

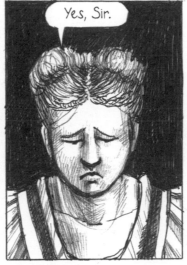

Yes, Sir.

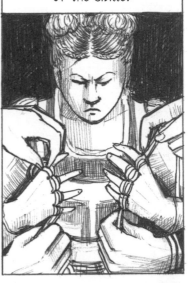

I am ready to confirm my testimony, even under torture and whatever is necessary.

Artemisia, be aware of unjustly accusing Agostino...

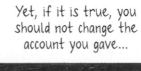

Yet, if it is true, you should not change the account you gave...

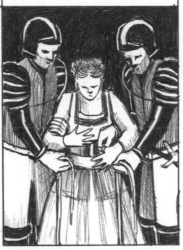

...even under the torture of the sibille.

I have told the truth and I always will.

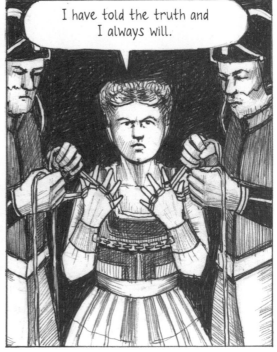

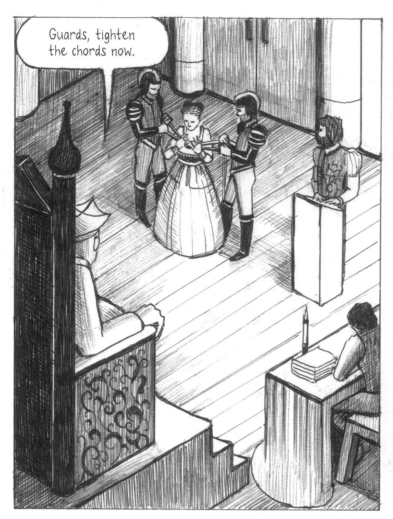

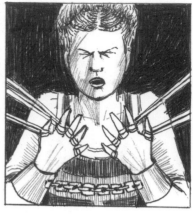

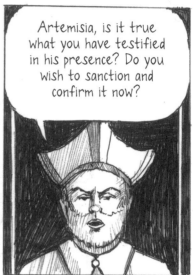

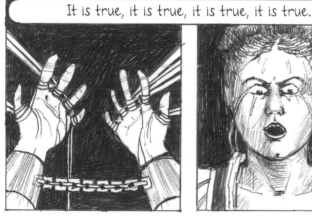

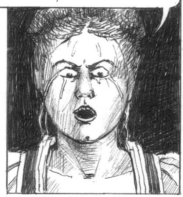

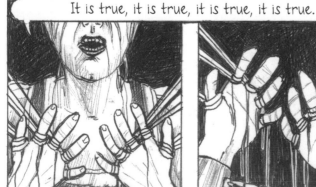

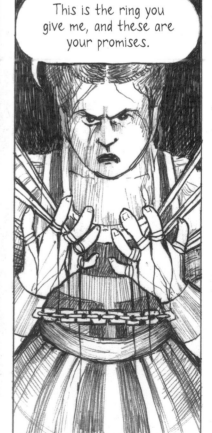

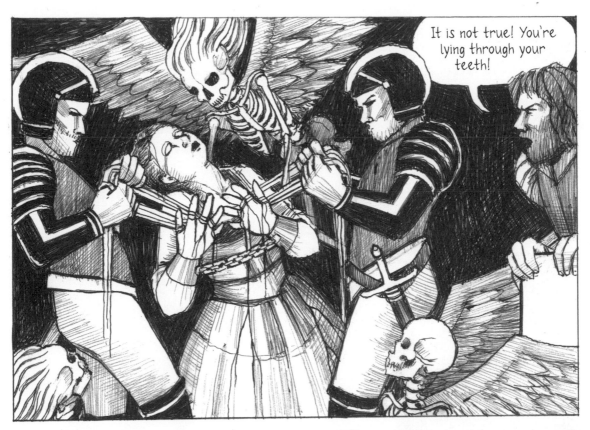

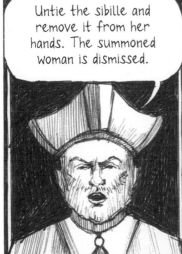

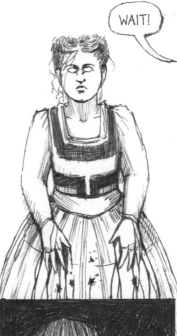

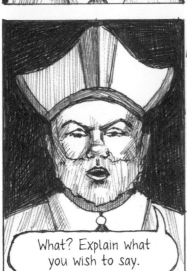

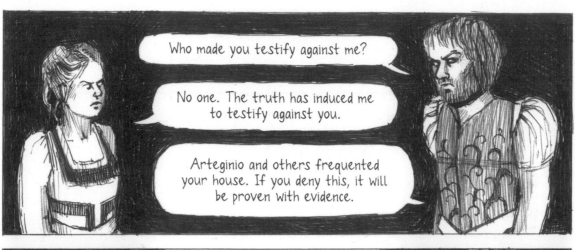

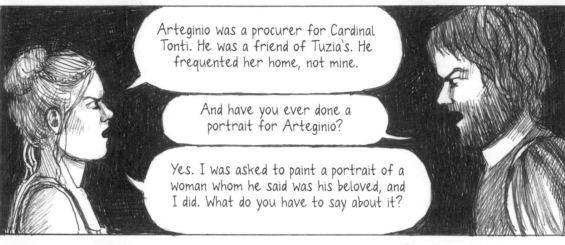

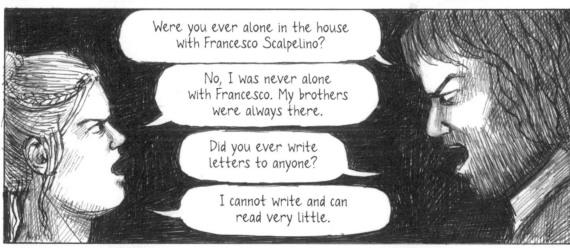

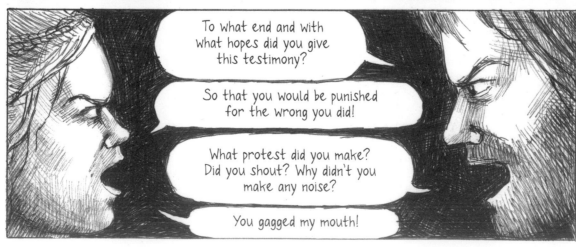

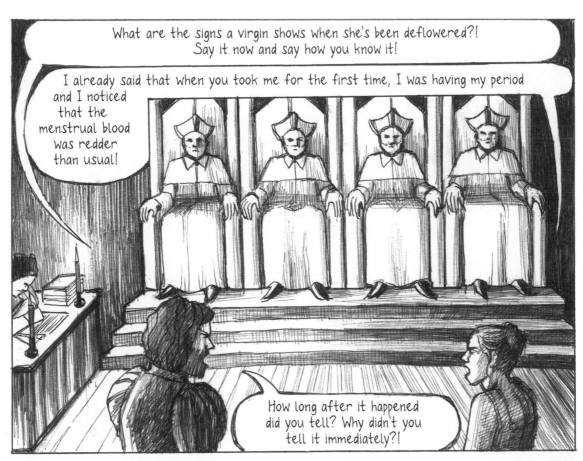

What are the signs a virgin shows when she's been deflowered?!
Say it now and say how you know it!

I already said that when you took me for the first time, I was having my period and I noticed that the menstrual blood was redder than usual!

How long after it happened did you tell? Why didn't you tell it immediately?!

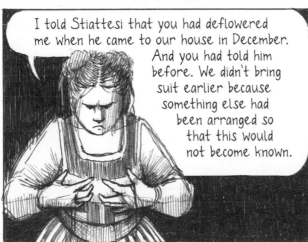

I told Stiattesi that you had deflowered me when he came to our house in December. And you had told him before. We didn't bring suit earlier because something else had been arranged so that this would not become known.

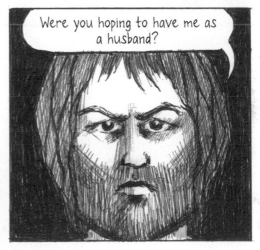

Were you hoping to have me as a husband?

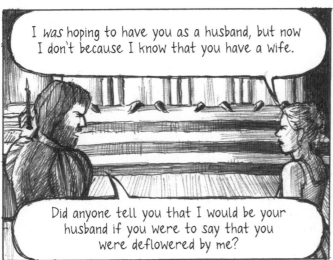

I *was* hoping to have you as a husband, but now I don't because I know that you have a wife.

Did anyone tell you that I would be your husband if you were to say that you were deflowered by me?

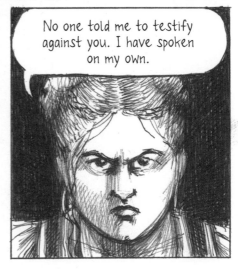

No one told me to testify against you. I have spoken on my own.

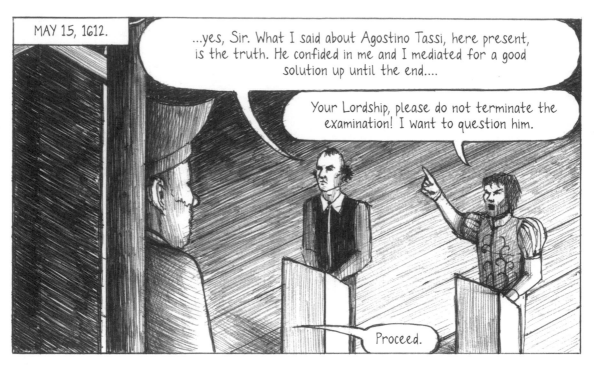

MAY 15, 1612.

...yes, Sir. What I said about Agostino Tassi, here present, is the truth. He confided in me and I mediated for a good solution up until the end....

Your Lordship, please do not terminate the examination! I want to question him.

Proceed.

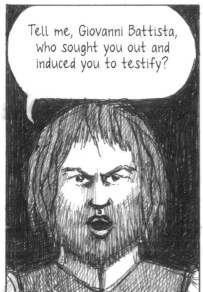

Tell me, Giovanni Battista, who sought you out and induced you to testify?

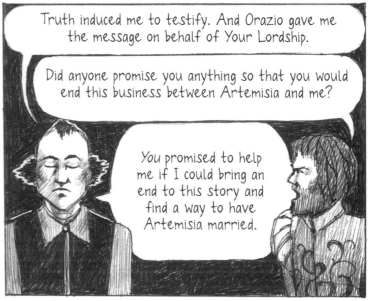

Truth induced me to testify. And Orazio gave me the message on behalf of Your Lordship.

Did anyone promise you anything so that you would end this business between Artemisia and me?

You promised to help me if I could bring an end to this story and find a way to have Artemisia married.

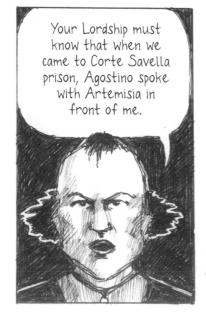

Your Lordship must know that when we came to Corte Savella prison, Agostino spoke with Artemisia in front of me.

He said he had never broken his word and that he was ready to renew his pledge and marry her as promised. Artemisia even said, "Agostino, if you have a wife already, please tell me so we can take care of this some other way."

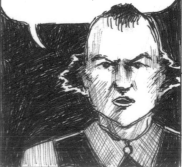

Agostino answered, "My wife is dead," and added further, "If you want to get me out of this mess, you must retract your testimony. Then I'll do whatever you want."

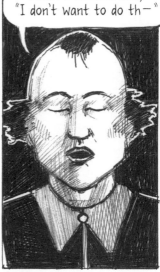

And Artemisia said, "I don't want to do th—"

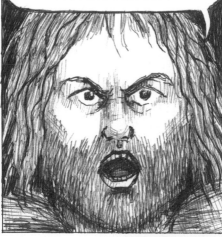

You are lying through your teeth and you are a FUCKING CUCKOLD!

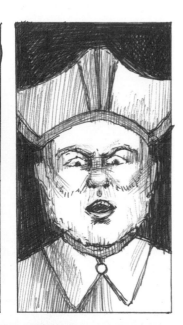

Agostino Tassi! How dare you assault the summoned man with such scandalous, disrespectful words. In order to restrain your effrontery and insolence, I order the prison guards to handcuff you immediately.

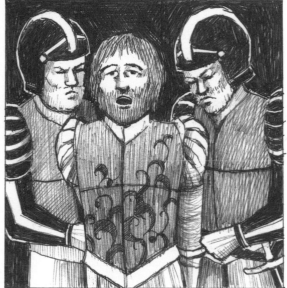

A-hem. After he heard Artemisia say that she wouldn't retract her testimony, Agostino told her, "At least blame someone else. Say it was Cosimo, who is dead anyhow." Artemisia answered, "I especially don't want to do that."

Sir! I ask you not to be offended by the lack of respect I have shown by uttering those insulting words against Giovanni Battista. I did not say them to offend or show contempt toward Your Lordship or the court. I honor all of you and bow before you. Neither do I wish to offend Giovanni Battista, since I regard his wife as an honorable woman. I blurted out those words in anger, forgetting where I was. And as for what he says, he is lying. He brought Artemisia to Corte Savella of his own accord—not because I asked him.

THE MAGISTRATES WERE SKEPTICAL OF AGOSTINO'S STANCE, AND ROME WAS BUZZING WITH GOSSIP.

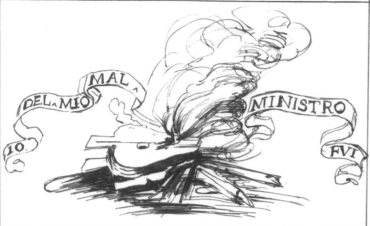

THIS IS A DRAWING BY AGOSTINO TASSI FROM 1612— "I WAS THE MAKER OF MY OWN MISFORTUNE."

IN DESPERATION, AGOSTINO SUMMONED HIS ALLIES TO SUPPORT HIM IN COURT.

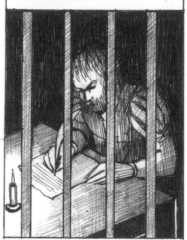

HIS PRIMARY WITNESS WAS THE ASSISTANT AND SERVANT—NICOLO BEDINO.

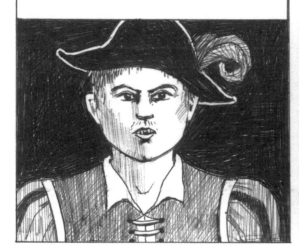

JUNE 8, 1612.

...As I said, I stayed in Signor Orazio's house because I was with him as an apprentice.

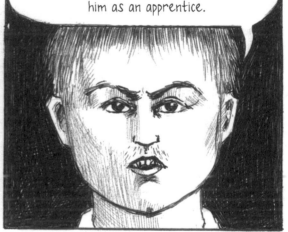

I have seen Artemisia read letters that were both printed and handwritten, but she cannot write. However, I can read and write.

I left Signor Orazio because Artemisia made me deliver letters all over the place. I left on my own and moved in with Signor Pasquale, a painter.

To whom did you deliver the letters that Artemisia gave you?

I delivered letters to Girolamo Modenese, a painter, and to Arteginio, a man in a long robe who lives at Monte d'Orso.

I delivered three or four letters to each of them. Artemisia's brothers, Giulio and Francesco, also delivered some. The letters were sealed, so I don't know what was in them.

Do you know why Agostino went alone to Signor Orazio's house?

Agostino came alone to Signor Orazio's house because he taught perspective to Artemisia.

Was anyone present when Agostino was teaching Artemisia perspective?

In the house there was myself and Artemisia's brothers, and sometimes also Tuzia.

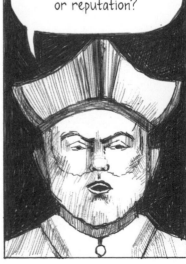

Have you heard anything about Artemisia's status or reputation?

I didn't consider Artemisia an honest woman, because men used to come to the house—that is, Girolamo and Arteginio.

Both of them used to kiss and touch Artemisia in my presence.

123

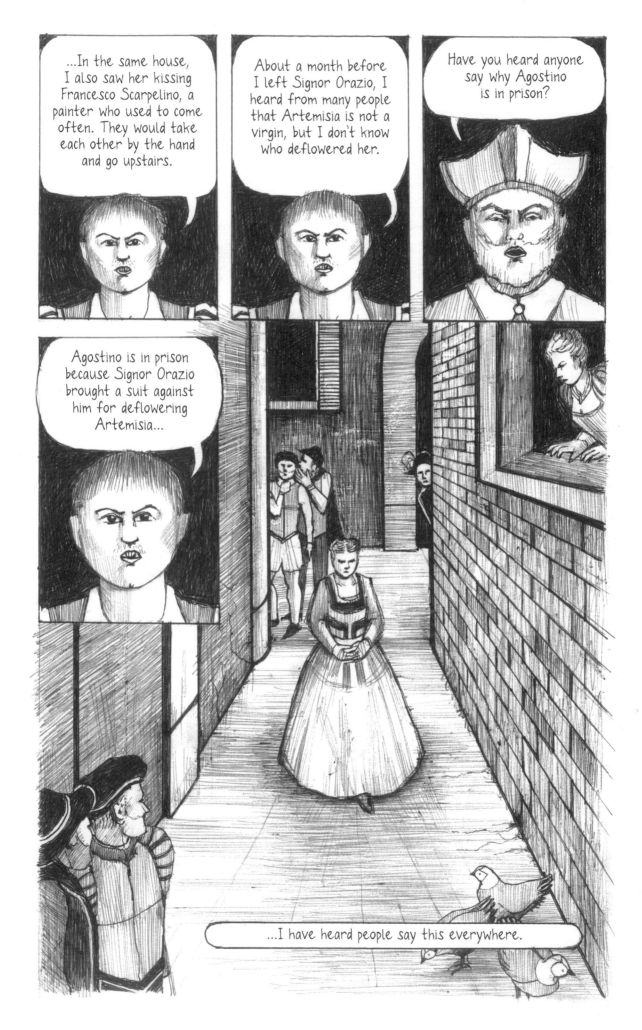

JUNE 9, 1612.
Guiliano Formicino of Rome.

...I've known Giovanni Battista Stiattesi for five years.

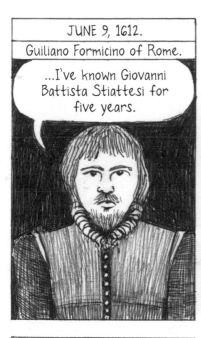

I overheard Stiattesi promise Agostino that the girl, Artemisia, would retract her accusation.

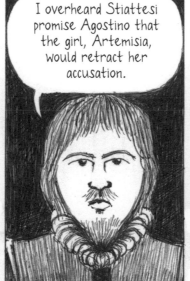

Stiattesi confided in me that Pasquino Fiorentino deflowered her about four years ago.

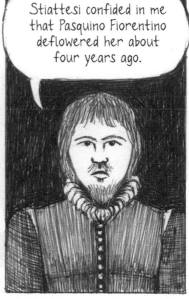

June 15, 1612.
Luca, son of Aloisio Penti of Rome, tailor.

...Oh yes, Sir, I see Signora Artemisia at her window very often.

It was my friend, Pasquino, that deflowered her. He's been visiting her for a long time. I believe they are in love... but everyone knows that she is a prostitute...

Cosimo Quorli and many others said about a year ago that Agostino was in love with her, but no one said that they had carnal relations.

JUNE 18, 1612.
Donna Fausta, daughter of Domenico Cicerone, laundress.

I have been doing Agostino Tassi's laundry for about a year while living on the Lungara.

Around the beginning of Lent, I overheard Tuzia arguing with Agostino. I'm not sure what they were arguing about exactly.

Tuzia left with insulting words. She called him a scoundrel.

JUNE 20, 1612. Mario, son of Filipo Trotta, painter. ...No, Sir, I don't know Artemisia, but I've heard people talk about her often.	...especially when I lived with Antinoro Bertucci, the man who sells paints. In his house the painters gather together.	They said good things about her... she's reputed to be a virgin and an honest woman... except once, Carlo Veneziano said that he saw her shamelessly at her window.
JUNE 20, 1612. Marco Antonio Copino of Florence. ...I have lived in Rome for twenty years mixing ultramarine color for the painters.	I visited Agostino in prison and heard that Artemisia was deflowered long ago. She has gone with many men. I've heard it said in many places, particularly at Antinoro's shop, but also at the shop of Angelo the sculptor.	They say that Artemisia is a beautiful woman, that her father didn't want her to marry, and that she even posed nude for his paintings!
JUNE 29, 1612. Father Pietro Giordano of the Order of the Hermits of St. Augustine. I met Stiattesi in Corte Savella. He told me that Agostino Tassi deflowered a young woman and tried to force Stiattesi to help him.	Stiattesi quarreled with Agostino and ended up in prison. I was asked to intervene. When I approached Agostino, he explained that he had to marry the girl because he had taken her virginity, but he was concerned that his wife was still alive.	...Nicolo Bedino? He used to come to prison with meals for Agostino. I often saw the two of them eating together. Nicolo Bedino and several others offered their services as witnesses for Agostino to put Orazio to shame.

JULY 5, 1612.
Your Lordship, Father Giordano is lying! And Nicolo has never been to Corte Savella, a fact that can be proven by three or four witnesses! Artemisia is a whore! And this whole thing is a plot designed by Orazio and Stiattesi!

ORAZIO RESPONDED WITH HIS OWN GROUP OF WITNESSES.

Love letters?! Preposterous! She can barely read or write! And that idiot Nicolo has been working for Agostino all along!

JULY 27, 1612.
Giovanni Pietro, son of Andrea Molli of Palermo, age 73.

...I worked as a model for Signor Orazio during Lent of the previous year...

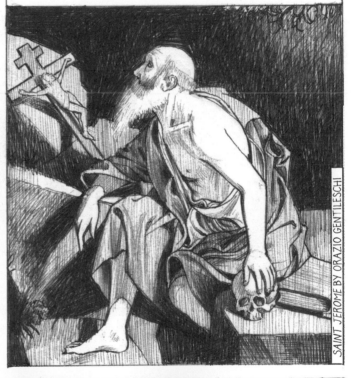

...I posed for some head studies, as well as for whole figure of St. Jerome, for which I was asked to undress from the waist up...

SAINT JEROME BY ORAZIO GENTILESCHI

...In Orazio's house I saw his daughter and three sons, the oldest of whom used to grind the colors. Orazio did not have an apprentice. I don't know who Nicolo Bedino is.

...Now if you'll excuse me, Your Lordship, I must get to confession and take communion, as I fear I am about to faint.

127

JULY 31, 1612.

Bernardino, Son of Francesco de Franceschi of Lucina.

...I've been Orazio's barber and sometimes model for eighteen or twenty years.

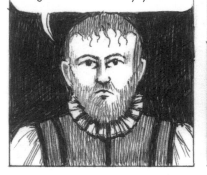

I've seen people at Orazio's house—Francesco Scarpelino, Pasquino Fiorentino, and the washer woman, Margherita... I do not know Nicolo, nor have I met anyone by that name in Orazio's house.

...I did see a young man, about thirteen or fourteen, there a few times. He was learning to draw. I think the Cavalier D'Arpino recommended him, but I don't remember his name.

AUGUST 4, 1612.

Pietro Hernandes, a Spaniard.

...I've only known Orazio since October, and Artemisia is godmother to my son.

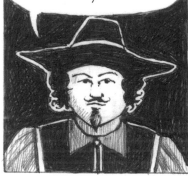

I never saw Nicolo there, but I heard from a neighbor that Orazio had taken a young man to do chores around the house. Later, I saw him there learning to draw.

Artemisia was teaching him to paint too. I heard that this Nicolo has been with Agostino, who placed him with Orazio.

AUGUST 8, 1612.

Caterina, daughter of Jacopo Zuccarini.

...I helped the Gentileschi family with housework between July and August, and during November of last year.

At that time, Signor Orazio took in a young man named Nicolo who helped with house chores and studied drawing.

I heard that before staying with Orazio, Nicolo used to live with Agostino Tassi. In fact, when Orazio scolded Nicolo, he threatened to send him back to Agostino.

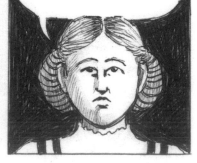

SEPT. 12, 1612.

Antinoro Bertucci, paint seller on Via del Corso.

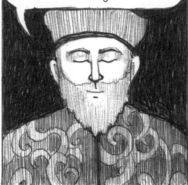

I've known Orazio for six or seven years... I know he has a daughter...

I saw her once when Orazio asked me to come upstairs to see some paintings... I've never heard anyone talk about Orazio or his daughter in my shop.

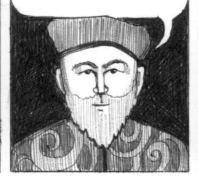

...Once, however, Orazio's nephew came in complaining that Orazio had kicked him out of the house because he had reproached the daughter for being at the window. But I never heard anyone say she was a loose or dishonest woman.

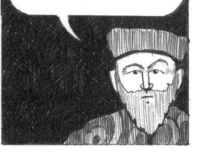

AMONG THE TESTIMONIES OF NUMEROUS PEOPLE WHO CAME INTO CONTACT WITH THE GENTILESCHI CIRCLE, AGOSTINO'S SISTER, OLIMPIA BAGELLIS, RE-EMERGED. SHE TESTIFIED ON AUGUST 24 AND SEPTEMBER 17, 1612:

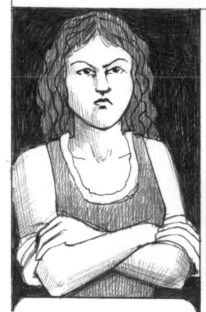

...About two years ago my brother, Agostino, was looking for a boy to do household chores. I talked to Giulio Felice's maid, who recommended Giulio's nephew, Nicolo.

Nicolo moved in because he was interested in learning to draw. Agostino agreed to teach him. He stayed with Agostino for around a year. Afterward, he went to Orazio.

Nicolo left Orazio during the preceding Lenten year and returned to Agostino's place while Agostino was in prison in Corte Savella. Thus, it was impossible that Nicolo was with Orazio during Lent.

I did previously bring suit against Agostino for incest with his sister-in-law. It is true that my brother and I are sometimes on bad terms...

But we've made up... I think...

NICOLO BEDINO REMAINED LOYAL TO AGOSTINO AND STUCK TO HIS STORY. HE WAS INTERROGATED AGAIN ON AUGUST 14 AND AUGUST 26, 1612. ANOTHER WITNESS, LUCA FINICOLI, WAS SUMMONED ON SEPTEMBER 30, 1612, TO ASSIST NICOLO IN DEFENDING AGOSTINO.

Yes, Sir. I will confirm that I lived with Orazio on Via Margutta and that there I saw Artemisia perform those dishonest acts.

BUT DESPITE AGOSTINO'S BEST ATTEMPTS, ONE BY ONE HIS OLD ENEMIES AND RIVALS CLOSED IN ON HIM, INCLUDING VALERIO URSINO ON OCTOBER 5, 2612.

...Your lordship, I must tell you that Agostino and I were close friends. I even lived with him for eight months. While I lived there, there was also a man named Nicolo. He was still there when I left last Summer after some disagreements with Agostino. When I saw Nicolo later, I asked him why he had lied about having lived with Orazio on Via Margutta... Nicolo said that Agostino had forced him to testify against Orazio.

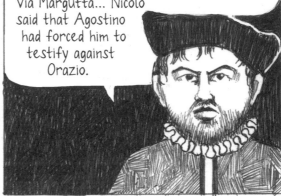

THE MAGISTRATES OF THE PAPAL STATES RESERVED THEIR MOST BRUTAL TACTICS FOR THE LOWER SERVANT CLASSES.

Nicolo Bedino, your testimony has been contradicted by several witnesses. The Curia strongly urges you to tell the truth, otherwise you will be subjected to torture.

Your Lordship, I always speak the truth.

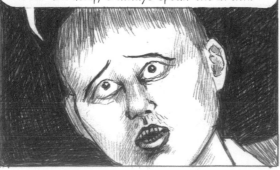

ON OCTOBER 29, 1612, NICOLO BEDINO WAS TORTURED. THEY REMOVED HIS CLOTHES, TIED HIS WRISTS TOGETHER BEHIND HIM, AND LIFTED HIM OFF THE GROUND REPEATEDLY. THE FAMOUS RAPE TRIAL OF 1612 WAS NEARING ITS END.

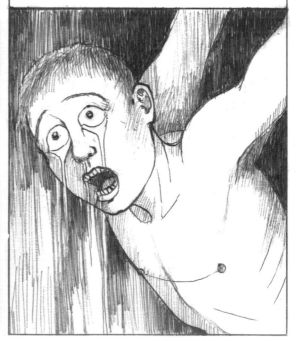

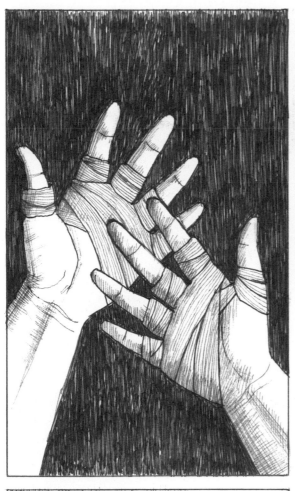

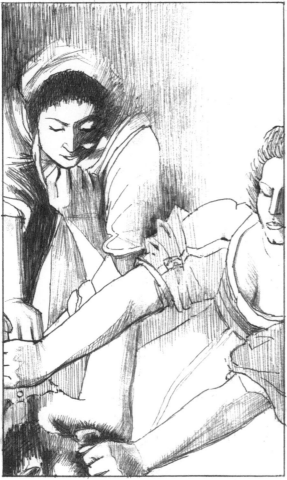

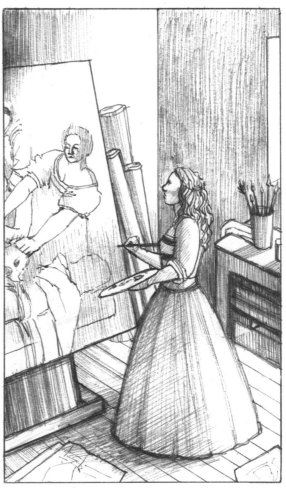

A VIRGIN WAS A VALUABLE COMMODITY. IF A WOMAN WAS DISHONORED, THE HUSBAND OR FATHER WHO OWNED HER WAS DISHONORED.

RAPE WAS NOT CONSIDERED A VIOLATION OF THE BODY AND SPIRIT, BUT ONLY A DISRUPTION OF THE FAMILY NAME AND SOCIAL STATUS.

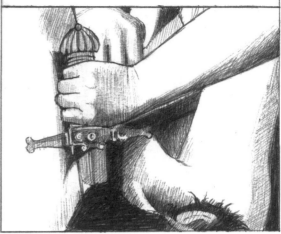

AND YET, IN THE FIFTEENTH CENTURY, THE FAMOUS MEDIEVAL WRITER CHRISTINE DE PIZAN WROTE THAT RAPE "CAUSES THE GREATEST POSSIBLE SUFFERING."

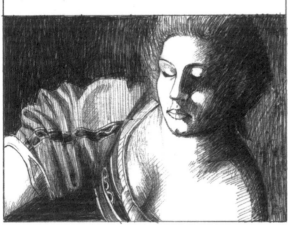

THROUGHOUT HISTORY, WOMEN HAVE INSTINCTIVELY RESISTED SEXUAL ASSAULT.

RAPE HAS ALWAYS WOUNDED WOMEN, PERPETUATING GRIEF AND SHAME.

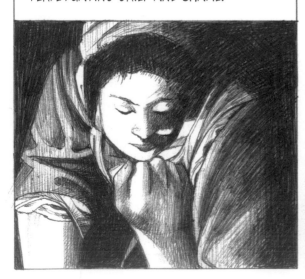

TO PREVENT THE GRIEF FROM KILLING HER, THE SURVIVOR MUST SUMMON ALL OF HER STRENGTH AND POWER.

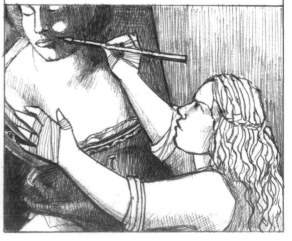

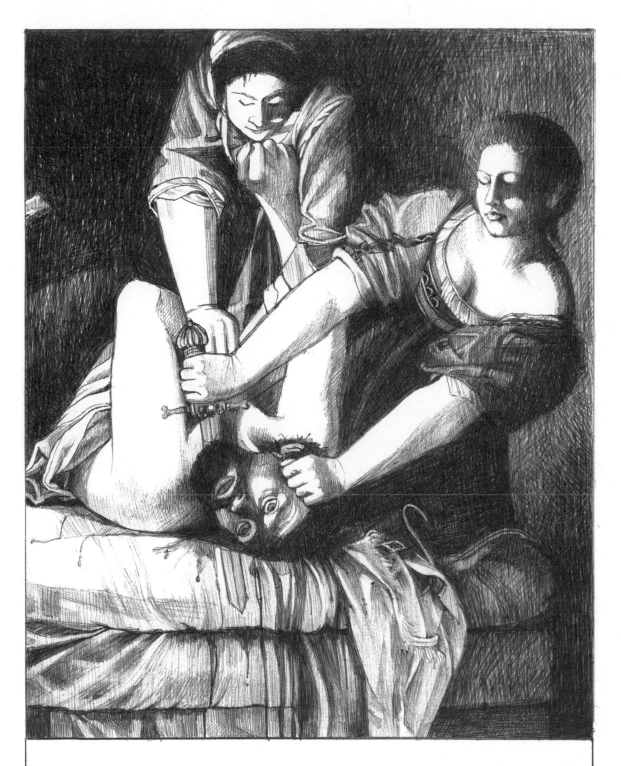

AS ORAZIO AND ARTEMISIA WAITED FOR THE OUTCOME OF THE TRIAL, ARTEMISIA'S RENDITION OF JUDITH SLAYING HOLOFERNES EMERGED. HERE JUDITH AND ABRA ARE EMPOWERED, THEIR STRONG ARMS WORKING TOGETHER IN A TRIUMPHANT, BLOODY MOMENT. THIS PAINTING HAS HORRIFIED VIEWERS FOR HUNDREDS OF YEARS. WE CAN ASSUME THAT IT WAS COMMISSIONED, BUT THE PATRON REMAINS UNKNOWN. EVEN CARAVAGGIO'S JUDITH SLAYING HOLOFERNES OF TWELVE YEARS EARLIER DID NOT OFFER THIS MUCH BELIEVABLE ACTION AND EMOTIONAL INTENSITY. DID ORAZIO ASSIST HIS DAUGHTER IN CREATING THIS MASTERPIECE? OR DID ARTEMISIA WORK ALONE, DRIVEN BY A NEED FOR CATHARTIC RELEASE THROUGH ART? IS THIS HER REVENGE?

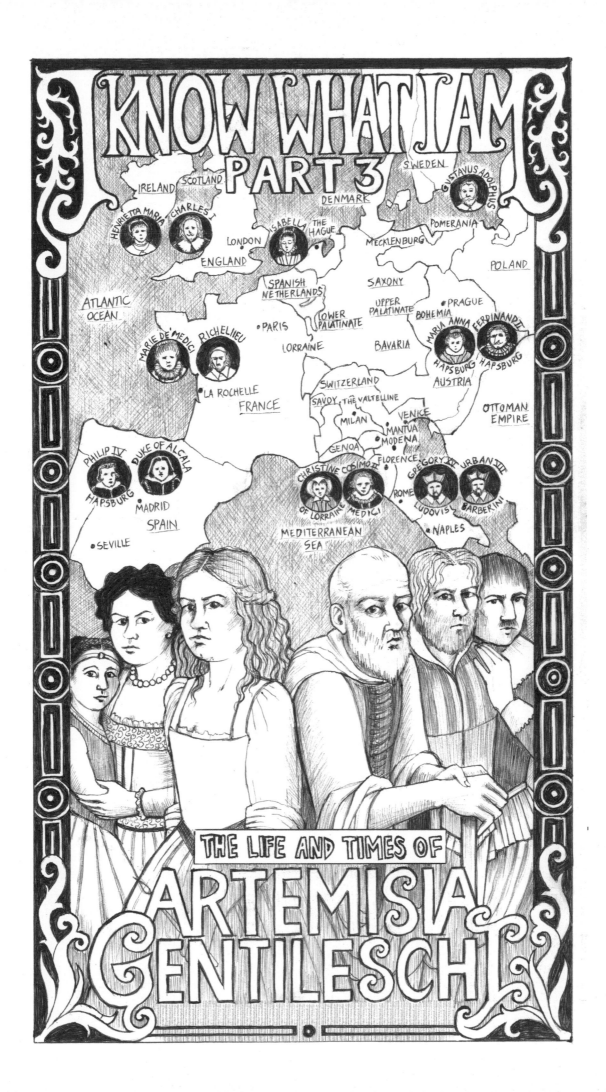

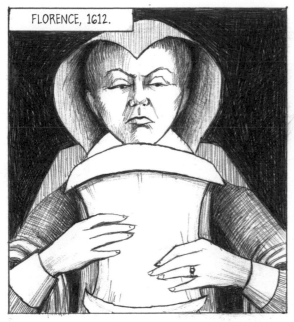

FLORENCE, 1612.

...find myself with one daughter and three sons. This daughter, as it pleases God, having been trained in the profession of painting, in three years has become so skilled that I dare say she has no equal today. She has created works that demonstrate a level of understanding that perhaps even the leading masters of the profession have not attained. In the proper time and place

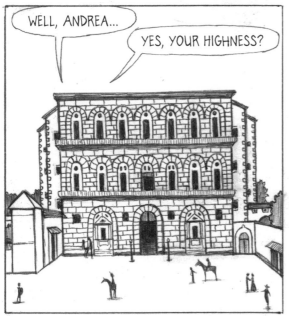

WELL, ANDREA...

YES, YOUR HIGHNESS?

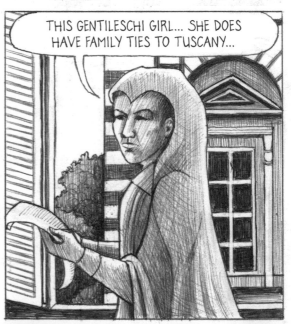

THIS GENTILESCHI GIRL... SHE DOES HAVE FAMILY TIES TO TUSCANY...

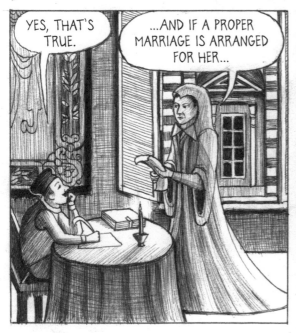

YES, THAT'S TRUE.

...AND IF A PROPER MARRIAGE IS ARRANGED FOR HER...

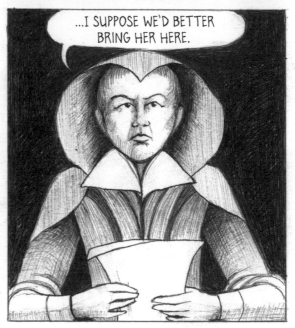

...I SUPPOSE WE'D BETTER BRING HER HERE.

Galileo Galilei

AFTER THE EIGHT-MONTH TRIAL, AGOSTINO TASSI WAS DECLARED GUILTY OF FORCIBLY DEFLOWERING ARTEMISIA GENTILESCHI. ON NOVEMBER 28, 1612, HE WAS COMMANDED TO CHOOSE HIS PUNISHMENT—FIVE YEARS AS A GALLEY SLAVE OR BANISHMENT FROM ROME. HE CHOSE BANISHMENT.

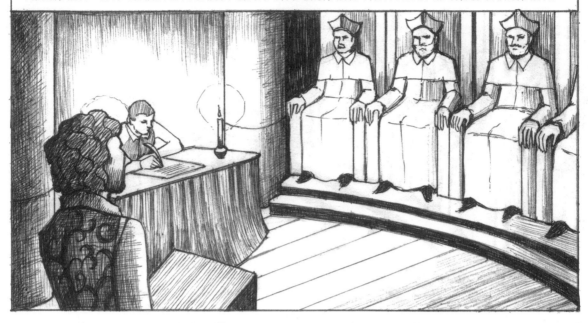

ON THE VERY NEXT DAY ARTEMISIA WAS MARRIED TO GIOVANNI BATTISTA STIATTESI'S YOUNGER BROTHER, PIERANTONIO, A MAN SHE HAD NEVER MET.

BUT HE WAS A PAINTER AND HIS BROTHER SPOKE HIGHLY OF HIM.

THROUGH THIS MARRIAGE ARTEMISIA HOPED TO SALVAGE HER HONOR ONCE AND FOR ALL.

AFTER THE WEDDING ARTEMISIA PACKED HER BELONGINGS, SAID GOODBYE TO HER FATHER AND BROTHERS, AND LEFT FOR FLORENCE WITH HER NEW HUSBAND.

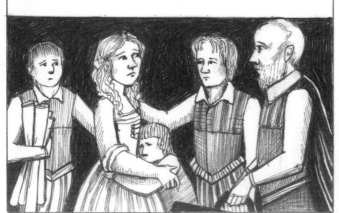

SINCE THE FIFTEENTH CENTURY, FLORENCE HAD BEEN DOMINATED BY THE GREAT MEDICI. BUT BY THE TIME ARTEMISIA ARRIVED, THE DUCHY WAS STRUGGLING TO MAINTAIN THE POWER AND PRESTIGE OF ITS HIGH RENAISSANCE GLORY DAYS.

IN THE EARLY MODERN WORLD, THE GREAT MONARCHS OF EUROPE WERE CONSTANTLY EMBROILED IN RELIGIOUS WARFARE, STRATEGIC MARRIAGE ALLIANCES, POLITICAL INTRIGUE, AND COMPETITIVE DISPLAYS OF WEALTH. IN 1612 FLORENCE WAS RULED BY TWENTY-TWO-YEAR-OLD GRAND DUKE COSIMO II DE' MEDICI, WHO HAD ASSUMED THE THRONE AFTER HIS FATHER'S DEATH IN 1609.

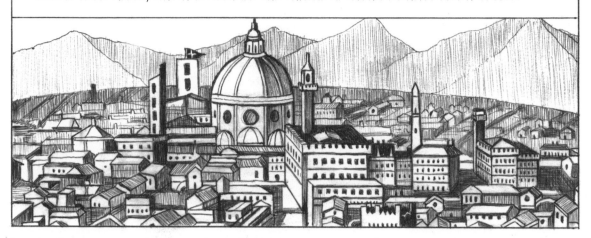

IT WAS HIS JOB TO CARRY ON THE MEDICI LEGACY, BUT COSIMO II NEVER ACHIEVED THE POPULARITY AND SIGNIFICANCE OF HIS DISTANT RELATIVES LIKE LORENZO THE MAGNIFICENT (1449-1492) OR COSIMO I (1519-1574). HE WAS OFTEN SO ILL THAT MANY OF HIS DUTIES WERE RELEGATED TO HIS WIFE AND MOTHER.

HE WAS MARRIED TO MARIA MADDALENA OF AUSTRIA, A MEMBER OF THE INCREASINGLY POWERFUL HAPSBURG EMPIRE. SHE WAS ATHLETIC AND STRONG-WILLED. SHE PREFERRED HUNTING AND HORSEBACK RIDING OVER THE USUAL SUBDUED LIFE OF A NOBLEWOMAN.

AND NO ONE COULD DENY THE AUTHORITY OF COSIMO II'S MOTHER, CHRISTINE OF LORRAINE. LIKE ARTEMISIA, HER MOTHER HAD DIED DURING CHILDBIRTH, LEAVING CHRISTINE IN THE CARE OF HER GRANDMOTHER, CATHERINE DE' MEDICI, A NOTORIOUS WIDOW WHO RULED FRANCE FOR NEARLY THIRTY YEARS.

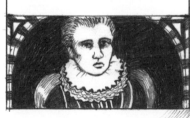

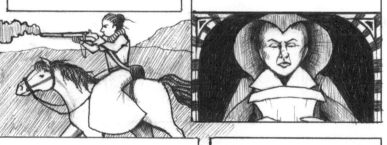

BOTH CHRISTINE OF LORRAINE AND MARIA MADDALENA MAINTAINED A DISTINCT INTEREST IN THE WELL-BEING OF WOMEN. THEY ENSURED THAT EACH WOMAN OF THE COURT WAS PLACED IN A MARRIAGE OR CONVENT WHICH NOT ONLY SUITED HER STATUS BUT ALSO HER DESIRES. THERE ARE NUMEROUS EXAMPLES OF CHRISTINE AND MARIA MADDALENA'S STRICT VIGILANCE AGAINST VIOLENCE TOWARD WOMEN, EVEN WOMEN OF THE LOWER CLASSES.

...Make it clear to Signor Bolgherini that if the beating of Ippolita does not stop, we will make him aware of his error...

...and in such a way that he will remember it forever and serve as an example to others...

THUS, IT IS NOT SURPRISING THAT ORAZIO WAS INCLINED TO REACH OUT TO CHRISTINE ON BEHALF OF HIS OWN DISHONORED DAUGHTER.

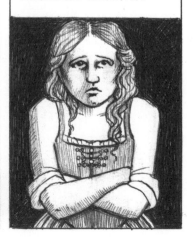

PERHAPS THE MOST IMPORTANT HISTORICAL LANDMARK OF COSIMO II'S REIN WAS HIS PATRONAGE OF GALILEO GALILEI. GALILEO WAS BORN IN PISA IN 1564. HIS FATHER WAS A MUSICIAN WITH TIES TO THE MEDICI.

AFTER STUDYING MEDICINE AND MATHEMATICS, GALILEO TAUGHT AT THE UNIVERSITY OF PISA, AND THEN THE UNIVERSITY OF PADUA (THE SAME LIBERAL HAVEN WHERE THE DOOMED GIORDANO BRUNO TAUGHT BEFORE THE INQUISITION LOCKED HIM UP). GALILEO QUICKLY GAINED FAME FOR HIS INVENTIONS, GADGETS, MILITARY EQUIPMENT, AND SCIENTIFIC EXPERIMENTS.

GALILEO SKILLFULLY OBTAINED THE FAVOR OF THE MEDICI BY BECOMING COSIMO II'S MATH TUTOR IN 1605. IN 1609 HE RESTRUCTURED AND IMPROVED THE TELESCOPE, WHICH ENABLED HIM TO SEE THE STARS MORE CLEARLY THAN EVER BEFORE. HE DEDICATED HIS TREATISE "THE STARRY MESSENGER" TO COSIMO II, AND IN IT HE NAMED THE NEWLY DISCOVERED MOONS OF JUPITER THE MEDICEAN STARS.

HE CLAIMED THAT HIS DISCOVERIES WERE A NATURAL TRIBUTE TO THE MEDICI, AND THEY IN TURN GRANTED HIM THE POSITION OF COURT PHILOSOPHER AND MATHEMATICIAN. THIS GAVE HIS SCIENTIFIC IDEAS A LEGITIMACY AND CREDIBILITY THAT WOULD NOT HAVE BEEN POSSIBLE IF HE HAD REMAINED A UNIVERSITY PROFESSOR.

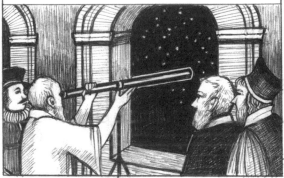

WHEN ARTEMISIA ARRIVED IN FLORENCE, GALILEO WAS OBSERVING AND RECORDING SUN SPOTS, AND DEBATING WITH HIS COLLEAGUES ABOUT HOW OBJECTS FLOAT OR DO NOT FLOAT IN WATER.

...IT IS THE SHAPE OF THE OBJECT THAT DETERMINES WHETHER IT FLOATS. AS YOU CAN SEE, THIS SPHERE OF EBONY SINKS, WHEREAS THE THIN PLATE OF EBONY FLOATS.

NO NO, IT HAS NOTHING TO DO WITH ITS SHAPE!

HE WAS ALSO PREPARING TO PLACE HIS TWO DAUGHTERS INTO THE CONVENT OF SAN MATTEO IN ARCETRI. ALTHOUGH THE MEDICI PROVIDED A LARGE SALARY, GALILEO MAY HAVE FEARED THAT HE COULD NOT EQUIP HIS DAUGHTERS WITH DOWRIES BIG ENOUGH TO MATCH HIS NEWLY ACQUIRED STATUS. GALILEO HIMSELF NEVER MARRIED.

GALILEO WAS ALSO A LIFELONG LOVER OF ART AND A MEMBER OF THE ACCADEMIA DEL DISEGNO, FLORENCE'S STATE-SPONSORED ART ACADEMY, ERECTED BY COSIMO I IN 1563. LIKE MOST INSTITUTIONS UNDER AN ABSOLUTE MONARCHY, IT WAS DESIGNED TO PROMOTE THE RULING HOUSE—THE MEDICI—AND THEY IN TURN HAD A LONG HISTORY OF SUPPORTING ARTISTS.

IT WAS PERHAPS HERE THAT GALILEO RAN INTO A PECULIAR ODDITY—A TWENTY-YEAR-OLD FEMALE PAINTER RECENTLY ARRIVED FROM ROME, DETERMINED TO FIT IN AND FIND WORK.

I WOULD LIKE TO JOIN.

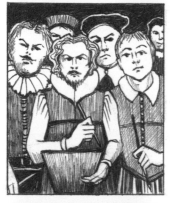

AAAHHH HA HA HA HA HA!!

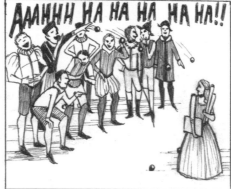

ARTEMISIA?

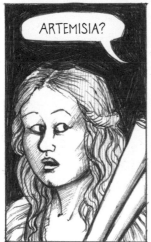

IT WAS LIKELY AROUND THE ACADEMY THAT SHE ALSO MET THE COURT PAINTER—CRISTOFANO ALLORI...

IS YOUR FATHER ORAZIO?

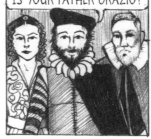

YES!

MY FRIEND GALILEO HERE TOLD ME ABOUT YOU.

I JUST SAW YOUR FATHER IN ROME.

AND I'VE MET YOUR UNCLE, AURELIO LOMI. HE WORKED ALONGSIDE MY FATHER, ALESSANDRO ALLORI.

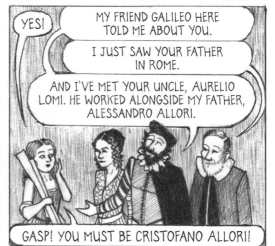

GASP! YOU MUST BE CRISTOFANO ALLORI!

...AND HIS MISTRESS, LA MAZZAFIRRA.

POOR GIRL. PAY NO ATTENTION TO THOSE BRUTES AT THE ACADEMY. WE WILL SHOW YOU THE WAY.

I ALWAYS WANTED TO BE AN ARTIST WHEN I WAS YOUNG, BUT IT IS A DIFFICULT PATH. YOU MUST WORK YOUR WAY UP TO THE ACADEMY.

YOU MUST BE CLEVER AND CHARMING AS WELL AS SKILLED. CAN YOU WRITE?

WELL, NOT REALLY.

YOU MUST LEARN.

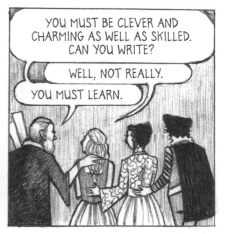

SOON ARTEMISIA WAS CONNECTED TO A GROUP OF ALLIES IN FLORENCE.

ARTEMISIA, LET ME INTRODUCE YOU TO THE POET MICHELANGELO THE YOUNGER. HE IS THE GREAT NEPHEW OF THE FAMOUS PAINTER MICHELANGELO BUONARROTI.

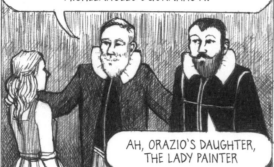

AH, ORAZIO'S DAUGHTER, THE LADY PAINTER

MICHELANGELO THE YOUNGER INTRODUCED ARTEMISIA TO ANOTHER EXCEPTIONAL WOMAN IN HIS CIRCLE—THE SINGER AND COMPOSER FRANCESCA CACCINI. FRANCESCA AND ARTEMISIA HAD A LOT IN COMMON, INCLUDING THE FACT THAT THEY WERE BOTH TRAINED BY THEIR FATHERS.

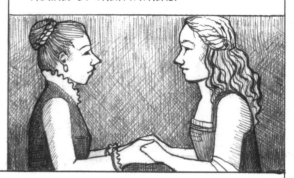

FRANCESCA'S FATHER, GIULIO, WAS A FAMOUS COMPOSER. HE AND HIS MUSICAL FAMILY BEGAN SERVING THE MEDICI IN THE 1560s. BUT JUST AFTER FRANCESCA WAS BORN IN 1588, THE GRAND DUKE FIRED EVERYONE IN A FUTILE ATTEMPT TO PURGE THE COURT OF FRIVOLOUS LUXURIES. HOWEVER, THE MEDICI REALIZED THE VALUE OF THE CACCINIS, AND BY 1600 THEY WERE BACK ON THE MEDICI PAYROLL, WORKING ON THE FESTIVITIES FOR THE MARRIAGE OF MARIE DE' MEDICI AND HENRY IV.

WHEN CHRISTINE OF LORRAINE FACILITATED FRANCESCA'S MARRIAGE IN 1607, THE YOUNG SINGER BECAME ONE OF THE MEDICI'S MOST IMPORTANT COMPOSERS. MICHELANGELO THE YOUNGER WROTE POETRY THAT FRANCESCA PUT TO MUSIC. SHE SPENT MORE TIME WITH HIM THAN WITH HER HUSBAND, AS THEY COLLABORATED ON THE GRAND THEATRICAL SPECTACLES THAT ENTERTAINED THE MEDICI AND FUELED THEIR POWER.

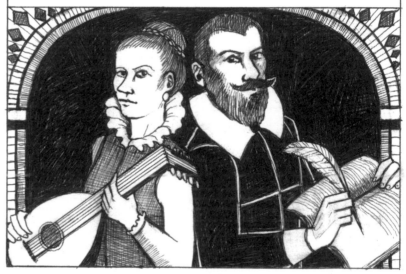

NO, NOT THAT WAY! I WANT TO HEAR BETTER! YOU'RE OFF A HALF STEP!

THE MEDICI KEPT THEIR EMPLOYEES VERY BUSY. NOT ONLY WAS FRANCESCA SUBJECT TO THEIR EVERY COMMAND, SHE ALSO TAUGHT VOCAL LESSONS TO THE LADIES OF THE COURT.

GIOVANNI, WILL YOU ANSWER THE DOOR?

YES, DEAR.

FRANCESCA DEMONSTRATED TO ARTEMISIA THAT IT WAS POSSIBLE FOR A CREATIVE WOMAN TO BE THE PRIMARY PROVIDER FOR A FAMILY.

AHH, GALILEO, CRISTOFANO, ARTEMISIA—WELCOME!

ARTEMISIA, DID YOU FINALLY BRING US A SAMPLE OF YOUR WORK?

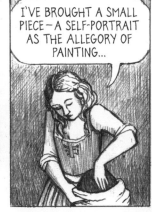

I'VE BROUGHT A SMALL PIECE—A SELF-PORTRAIT AS THE ALLEGORY OF PAINTING...

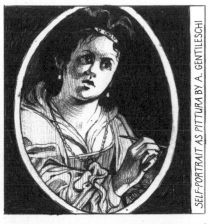

SELF-PORTRAIT AS PITTURA BY A. GENTILESCHI

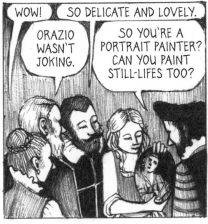

WOW!

SO DELICATE AND LOVELY.

ORAZIO WASN'T JOKING.

SO YOU'RE A PORTRAIT PAINTER? CAN YOU PAINT STILL-LIFES TOO?

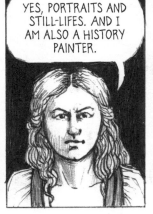

YES, PORTRAITS AND STILL-LIFES. AND I AM ALSO A HISTORY PAINTER.

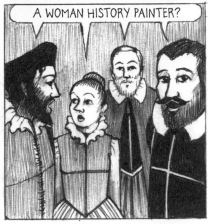

A WOMAN HISTORY PAINTER?

ARTEMISIA, I HAVE A VISION, A GRAND IDEA! I'M IN THE PROCESS OF RENOVATING THE CASA BUONARROTI, THE BUILDING DEDICATED TO MY GREAT UNCLE MICHELANGELO. MAYBE YOU'VE HEARD OF IT?

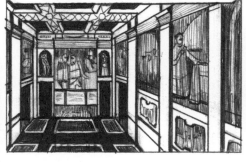

I WANT TO ADD TO THE CASA BUONARROTI A GALLERIA FULL OF PAINTINGS DEPICTING SCENES FROM MICHELANGELO'S LIFE. ON THE CEILING THERE WILL BE PAINTINGS OF HIS NOBLE DEATH AND FUNERAL.

AND ON THE CEILING CORNERS—ALLEGORICAL FIGURES THAT REPRESENT ALL OF HIS VIRTUES: INSPIRATION, INCLINATION, STUDY, TOLERANCE, LOVE OF COUNTRY, PIETY, MODERATION, AND HONOR.

THE SMALLER CORNER ALLEGORIES ARE PERFECT FOR LESSER-KNOWN ARTISTS, EVEN THOSE STILL ATTACHED TO THEIR MASTERS' STUDIOS. WOULD YOU LIKE TO PAINT ONE OF THE ALLEGORIES?

HOW ABOUT... INCLINATION? IT COULD BE SORT OF LIKE THIS... BUT LARGER OF COURSE, A SINGLE FIGURE, PREFERABLY FEMALE...

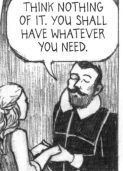

OH, SIGNOR MICHELANGELO, I'D LOVE TO! BUT I'LL NEED SUPPLIES.

THINK NOTHING OF IT. YOU SHALL HAVE WHATEVER YOU NEED.

HMMM... YOU CAN STILL USE THE ACCADEMIA DEL DISEGNO EVEN IF YOU AREN'T AN OFFICIAL MEMBER YET. PERHAPS I CAN GET YOU IN SOMEHOW...

145

ARTEMISIA PLUNGED INTO HER FIRST COMMISSION FOR MICHELANGELO THE YOUNGER— *THE ALLEGORY OF INCLINATION*, A NUDE FIGURE WITH A STRIKING RESEMBLANCE TO HERSELF.

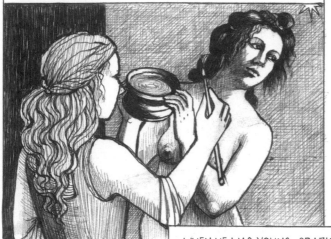

SHE PAINTED MANY SELF-PORTRAITS, MOST OF THEM PORTRAYING AN EARNEST YOUNG WOMAN IN COSTUME.

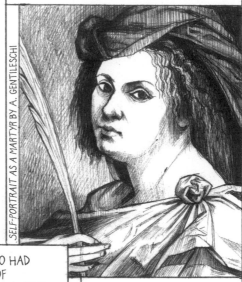

SELF-PORTRAIT AS A MARTYR BY A. GENTILESCHI

SHE ALSO GOT TO WORK LEARNING HOW TO READ AND WRITE.

WHEN HE WAS YOUNG, ORAZIO HAD TAKEN HIS MOTHER'S NAME OF GENTILESCHI TO DISTINGUISH HIMSELF FROM HIS BROTHER, THE FAMOUS TUSCAN PAINTER, AURELIO LOMI. BUT NOW ARTEMISIA DROPPED THE NAME GENTILESCHI AND CHOSE TO GO BY ARTEMISIA LOMI TO CAPITALIZE ON HER CONNECTION TO HER UNCLE.

THIS PAINTING IS SIGNED ARTEMISIA LOMI, BUT YOU'RE A STIATTESI NOW.

LOMI IS BETTER FOR BUSINESS.

SIGHHH, YOU'RE RIGHT...

UNLIKE ORAZIO, ARTEMISIA EMBRACED HER LOMI HERITAGE. SHE LEFT BEHIND BOTH HER SORDID ROMAN PAST AND THE AUTHORITY OF HER FATHER.

...BUT OUR CHILDREN WILL TAKE THE NAME OF STIATTESI, RIGHT?

OF COURSE.

IN SEPTEMBER 1613, HER FIRST SON WAS BORN.

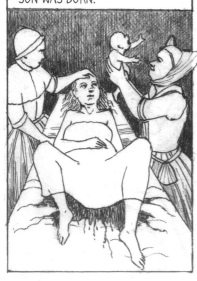

HE WAS NAMED GIOVANNI BATTISTA.

HIS UNCLE WILL BE SO PROUD.

IN NOVEMBER 1615, HER SECOND SON, CRISTOFANO, WAS BORN.

146

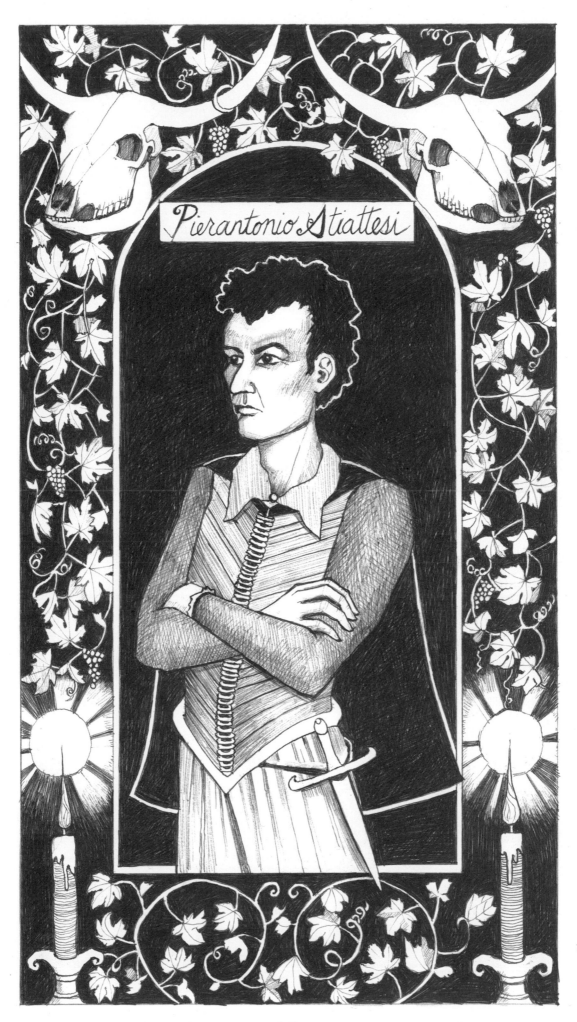

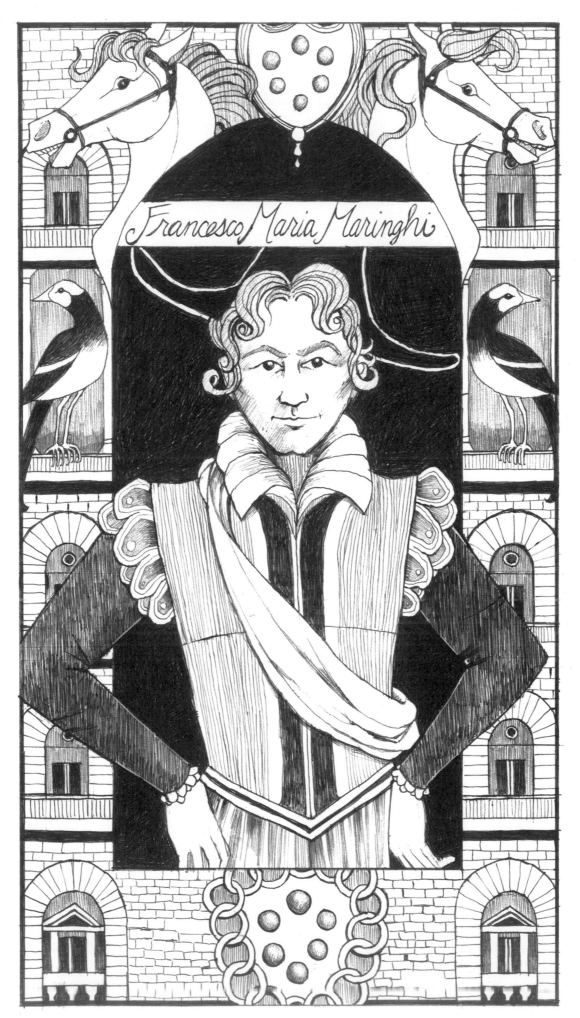

Francesco Maria Maringhi

THE ERA OF THE ITALIAN BAROQUE FEATURED INCREASINGLY LARGE ORNATE THEATRICAL PERFORMANCES. FRANCESCA CACCINI AND HER CIRCLE WERE THE FORERUNNERS OF OPERA, AND THE COURT SPECTACLES THEY CREATED INCORPORATED MUSIC, DANCE, COSTUMES, COMPETITIONS, EXOTIC ANIMALS, CHOREOGRAPHED BATTLES, AND AUTOMATONS. MANY OF THESE SHOWS WERE PRIVATE AFFAIRS FOR THE WEALTHY ELITE, BUT SOME WERE OPEN TO THE PUBLIC. IN 1616 THE MEDICI SPONSORED AN EQUESTRIAN BALLET CALLED "LA GUERRA D'AMORE" (LOVE IS WAR) AT THE PIAZZA SANTA CROCE, FEATURING AN EXTENSIVE STAGED BATTLE WITH ARMED WARRIORS, HORSES, AND PARADE FLOATS. THE "FIGHT" WAS BETWEEN THE ASIATIC INDAMORO, KING OF NARSINGA, AND THE AFRICAN GRADAMETO, KING OF MELINDA, OVER THE HAND OF THE INDIAN QUEEN LUCINDA. KING GRADAMETO WAS PLAYED BY COSIMO II'S BROTHER AND HIS FLOAT WAS DRAWN BY MECHANICAL ELEPHANTS.

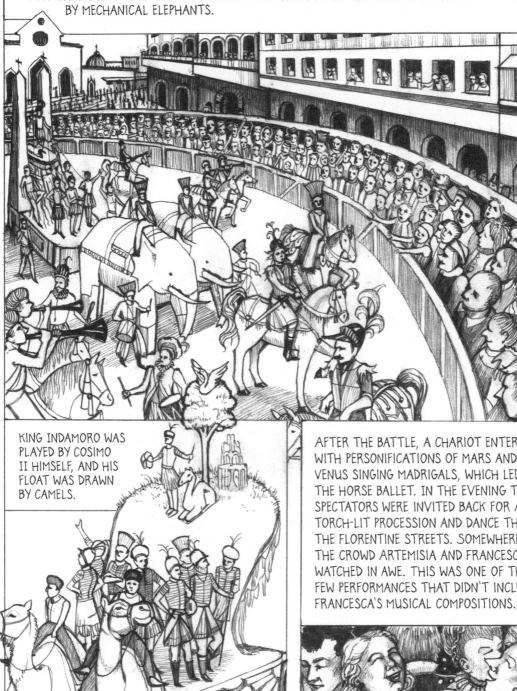

KING INDAMORO WAS PLAYED BY COSIMO II HIMSELF, AND HIS FLOAT WAS DRAWN BY CAMELS.

AFTER THE BATTLE, A CHARIOT ENTERED WITH PERSONIFICATIONS OF MARS AND VENUS SINGING MADRIGALS, WHICH LED TO THE HORSE BALLET. IN THE EVENING THE SPECTATORS WERE INVITED BACK FOR A TORCH-LIT PROCESSION AND DANCE THROUGH THE FLORENTINE STREETS. SOMEWHERE IN THE CROWD ARTEMISIA AND FRANCESCA WATCHED IN AWE. THIS WAS ONE OF THE FEW PERFORMANCES THAT DIDN'T INCLUDE FRANCESCA'S MUSICAL COMPOSITIONS.

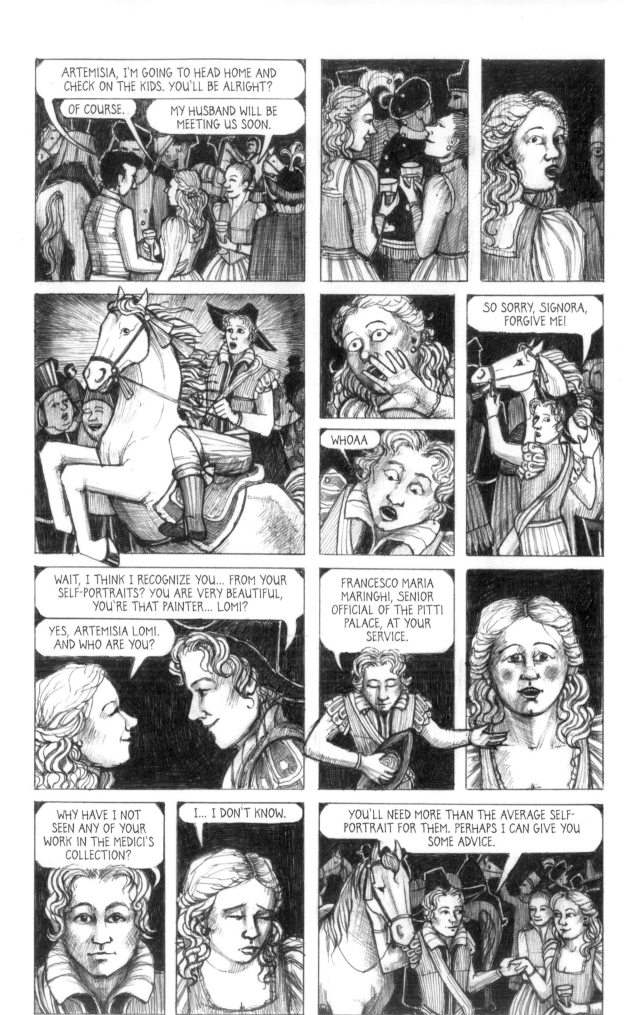

FRANCESCO MARIA MARINGHI WAS A WEALTHY NOBLE LANDOWNER EXACTLY ARTEMISIA'S AGE.

AS SHE SPENT MORE TIME WITH HIM, HE BROUGHT HER CLOSER TO THE MEDICI.

ARTEMISIA...

...YOU MUST SET ASIDE THAT CARAVAGGESQUE GLOOM. THINK OF A STAGE WITH BEAUTIFUL SCENERY AND LUSH FABRICS. NOW PUT YOUR SKILL WITH COLOR TO THE TEST.

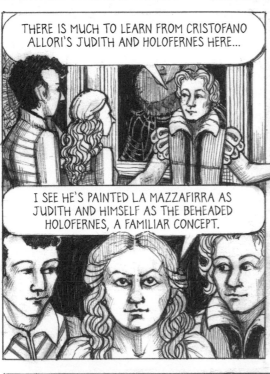

THERE IS MUCH TO LEARN FROM CRISTOFANO ALLORI'S JUDITH AND HOLOFERNES HERE...

I SEE HE'S PAINTED LA MAZZAFIRRA AS JUDITH AND HIMSELF AS THE BEHEADED HOLOFERNES, A FAMILIAR CONCEPT.

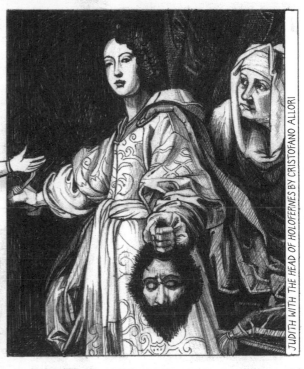

JUDITH WITH THE HEAD OF HOLOFERNES BY CRISTOFANO ALLORI

AROUND 1616 ARTEMISIA PAINTED THIS SELF-PORTRAIT AS A GYPSY, ALONG WITH ANOTHER SELF-PORTRAIT AS AN AMAZON (NOW LOST).

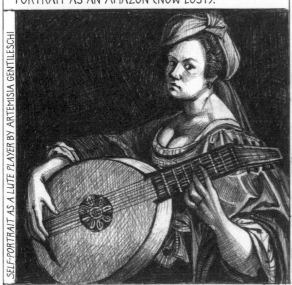

SELF-PORTRAIT AS A LUTE PLAYER BY ARTEMISIA GENTILESCHI

SHE USED THESE IMAGES TO PRESENT HERSELF AS A LEARNED WOMAN—MUSICAL, THEATRICAL, CLEVER, AND SEDUCTIVE. BUT ALTHOUGH THE GYPSY WAS TRADITIONALLY SEEN AS A TRICKSTER, THERE WAS NO MISCHIEF IN HER GAZE HERE. INSTEAD, SOMETHING TIRED AND WEARY WAS EXPRESSED IN HER EYES, ONLY VISIBLE TO THOSE WHO COULD SEE BEYOND THE DAZZLING DRESS AND CLEAVAGE.

ARTEMISIA?

FRANCESCO MARIA IS HERE. HE'S JUST BEEN TO SEE COSIMO II... WITH YOUR TWO SELF-PORTRAITS!

GOOD NEWS—HE LIKES THEM! HE'S QUITE IMPRESSED. HE'S AGREED TO PAY FOR THEM. CONGRATULATIONS!

YES!

FINALLY!

EVEN AS HIS ATTRACTION TO ARTEMISIA INCREASED, FRANCESCO MARIA MAINTAINED HIS FRIENDSHIP WITH HER HUSBAND.

ARTEMISIA AND PIERANTONIO WERE SO GRATEFUL FOR FRANCESCO MARIA'S ASSISTANCE WITH MEDICI PATRONAGE THAT IT SEEMED IMPOSSIBLE FOR PIERANTONIO TO PROTEST AGAINST THE NOBLEMAN'S ROMANTIC INTEREST IN HIS WIFE.

LATER THAT EVENING...

...IT'S OKAY, LET HIM SLEEP IT OFF...

ARTEMISIA...

MMM?

THIS HUSBAND OF YOURS... HE'S...

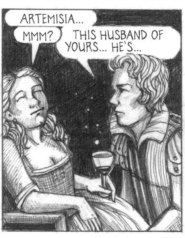

HE'S... WELL... HE'S SUPPOSEDLY A PAINTER, BUT WHERE IS HIS WORK? HE SPENDS THE MONEY YOU EARN BEHIND YOUR BACK. WHAT IS HE DOING TO SUPPORT YOU AND THESE CHILDREN?

YOU KNOW I HAD NO CHOICE. YOU KNOW WHAT HAPPENED.

YES. AND I HATE IT. YOU ARE SO GOOD, SO BEAUTIFUL. I'LL HELP YOU AS MUCH AS I CAN, BUT YOU DESERVE BETTER THAN THIS SIMPLETON.

BUT... PIERANTONIO DOES LOVE ME.

WELL... I LOVE YOU TOO. I CAN'T HELP IT.

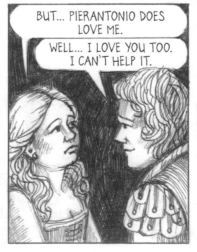

ARTEMISIA'S TRIBUTE TO COSIMO II'S WIFE, MARIA MADDALENA, FEATURED HER NAMESAKE, MARY MAGDALENE, A POPULAR RENAISSANCE SUBJECT. IN THE BIBLE MARY MAGDALENE WAS A PROSTITUTE WHO REJECTED HER PROFESSION FOR A QUIET, CHASTE, AND DEVOUT LIFE AS A HERMIT. IN ARTEMISIA'S PAINTING, MARY MAGDALENE CONTEMPLATES HER CONVERSION, DRESSED IN SHIMMERING GOLD FABRIC THAT RIVALED THE THEATRICAL DECOR OF CRISTOFANO ALLORI'S PAINTINGS. IN ADDITION TO THE DRESS, THE CHAIR ALSO SHOWCASES THE FINERY, ADORNED WITH ARTEMISIA'S SIGNATURE IN SWIRLING GOLD. THE MAGDALENE PUSHES ASIDE THE MIRROR OF VANITY WITH THE INSCRIPTION "OPTIMAM PARTEM ELEGIT" — "SHE CHOOSES THE BETTER PART."

AT THE SAME TIME THAT ARTEMISIA BEGAN TO GAIN THE MEDICI'S FAVOR, GALILEO BEGAN TO LOSE IT. DURING A FORMAL DEBATE, CHRISTINE OF LORRAINE ASKED ABOUT THE CONTRADICTIONS BETWEEN THE HOLY SCRIPTURES AND GALILEO'S DISCOVERIES ABOUT THE COSMOS. HE WROTE HER A SCATHING REPLY DEFENDING THE COPERNICAN WORLD SYSTEM AND CHASTISING HIS OPPONENTS.

CONVERSION OF THE MAGDALENE BY ARTEMISIA GENTILESCHI

...the increase of known truths stimulates investigation, establishment, and growth of the arts; not their diminution or destruction...

ARTEMISIA, I AM GOING TO ROME TO FACE THE PAPACY. I FEAR THAT THEY SEEK TO OUTLAW THE TEACHINGS OF COPERNICUS, AND I MUST DO ALL THAT I CAN TO PREVENT THAT FROM HAPPENING.

MY DEAR, YOU ARE TRULY A MARVEL OF NATURE. I THINK I CAN FINALLY SECURE YOUR MEMBERSHIP INTO THE ACCADEMIA DEL DISEGNO, BUT YOUR FATHER MUST SIGN FOR YOUR ADMISSION. WHEN I AM IN ROME I'LL TELL HIM HE MUST COME TO FLORENCE AT ONCE.

OH THANK YOU, GALILEO, AND PLEASE BE CAREFUL.

I WILL. NATURAL PHILOSOPHY AND CATHOLICISM NEED NOT BE IN OPPOSITION TO EACH OTHER. I AM NO HERETIC.

AFTER ARTEMISIA HAD LEFT ROME, ORAZIO AND HIS SONS BEGAN A LIFE OF TRAVEL AND HARDSHIP. SINCE 1613 THEY HAD MOVED BACK AND FORTH BETWEEN ROME AND THE MARCHES, WHERE ORAZIO WORKED FOR THE SAVELLI (RELATIVES OF CARAVAGGIO'S FORMER PATRON DEL MONTE).

ORAZIO ALSO CONSIDERED GOING TO FLORENCE TO SEEK THE MEDICI'S FAVOR, BUT THE FLORENTINE AMBASSADOR REPORTED TO THE MEDICI SECRETARY (ANDREA CIOLI) THAT ORAZIO'S DRAWING AND COMPOSITION SKILLS WERE WEAK.

...don't bother with that Orazio, he has such strange manners and way of life, and such a temper, that one can neither get along with him nor deal with him...

THESE INSULTING WORDS WERE A NASTY BLOW. WAS THE AFTERMATH OF THE RAPE TRIAL HINDERING ORAZIO'S PROSPECTS? WHILE ARTEMISIA PAINTED THE GLAMOROUS MAGDALENE FOR THE MEDICI, ORAZIO PAINTED A VERY DIFFERENT MAGDALENE FOR A SMALL CHURCH IN FABRIANO.

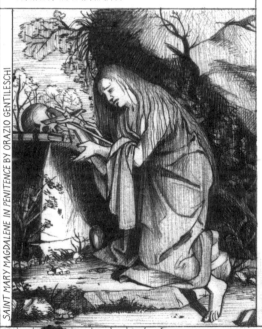

SAINT MARY MAGDALENE IN PENITENCE BY ORAZIO GENTILESCHI

DID AGOSTINO TASSI INFLUENCE THE FLORENTINE AMBASSADOR'S NEGATIVE JUDGMENTS ABOUT ORAZIO? BACK IN ROME, AGOSTINO HAD EARNED THE NICKNAME "IL SMARGIASSO"—THE BRAGGART OR BULLY. VALERIO URSINO CONTINUED TO TESTIFY AGAINST HIM, EXPANDING HIS SENTENCE TO BANISHMENT FROM ALL THE PAPAL STATES, NOT JUST ROME. BUT AGOSTINO WAS A WELL-ESTABLISHED ARTIST WITH IMPORTANT PATRONS WHOSE INFLUENCE ELIMINATED THE SENTENCE. HE WAS ALLOWED TO REMAIN IN ROME AFTER ALL. BY 1616 HE WAS WORKING ON THE QUIRINAL PALACE AGAIN WITH ANOTHER UP-AND-COMING PAINTER, GIOVANNI LANFRANCO.

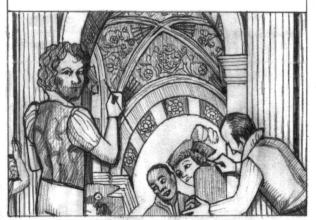

THAT SAME YEAR, ORAZIO GRANTED ARTEMISIA ADMISSION INTO THE ACCADEMIA DEL DISEGNO. HE TRAVELED TO FLORENCE WITH HIS SONS AND THE OLD FAMILY FRIEND GIOVANNI BATTISTA STIATTESI. ARTEMISIA WAS THE FIRST FEMALE MEMBER OF THE ACADEMY. NO OTHER WOMEN WERE ADMITTED UNTIL THE END OF THE SEVENTEENTH CENTURY.

AROUND THE TIME OF ARTEMISIA'S TRIUMPHANT ENTRY INTO THE ACADEMY, SHE PAINTED ANOTHER FAMOUS CATHOLIC HEROINE—SAINT CATHERINE, POSSIBLY A REFERENCE TO CATERINA DE' MEDICI (COSIMO II'S SISTER). ACCORDING TO THE LEGEND, SAINT CATHERINE WAS THE DAUGHTER OF KING COSTUS OF ALEXANDRIA. IN THE FOURTH CENTURY SHE CONVERTED TO CATHOLICISM, SKILLFULLY DEBATING AGAINST THE PAGAN EMPEROR MAXENTIUS AND HIS PHILOSOPHERS. EVENTUALLY MAXENTIUS ORDERED THAT SHE BE TORTURED WITH A SPIKED WHEEL. AN ANGEL INTERCEDED AND BROKE THE WHEEL, BUT MAXENTIUS HAD CATHERINE BEHEADED. IN HER PAINTING, ARTEMISIA INCLUDED THE PALM FROND, A TRADITIONAL SYMBOL OF MARTYRDOM, AS WELL AS THE EDGE OF THE TORTURE WHEEL.

SAINT CATHERINE OF ALEXANDRIA BY ARTEMISIA GENTILESCHI

IN AUGUST 1617, ARTEMISIA GAVE BIRTH TO A THIRD CHILD, A DAUGHTER. SHE WAS NAMED PRUDENZIA AFTER ARTEMISIA'S MOTHER.

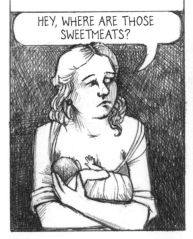

HEY, WHERE ARE THOSE SWEETMEATS?

HER HOUSEHOLD WAS BECOMING MORE STRESSFUL.

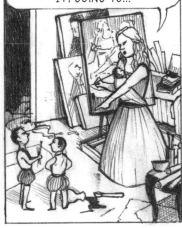

GIOVANNI BATTISTA! YOU PUT THAT DOWN NOW! OR ELSE I'M GOING TO...

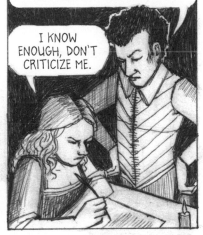

WHO ARE YOU WRITING TO? FRANCESCO MARIA? IS THAT A REFERENCE TO PETRARCH? YOU'VE NEVER READ ANY OF THAT.

I KNOW ENOUGH, DON'T CRITICIZE ME.

WE NEED FRANCESCO MARIA TO MAKE ARRANGEMENTS FOR THESE PAINTINGS...

BWAAAAAAHHHHHHH

I KNOW, I KNOW.

WHERE DID THAT FABRIC COME FROM? DID YOU BUY THAT WITHOUT TELLING ME? WE HAVEN'T EVEN COME CLOSE TO PAYING BACK THE MONEY THAT MICHELANGELO THE YOUNGER LENT US.

GAAAA BWAAA

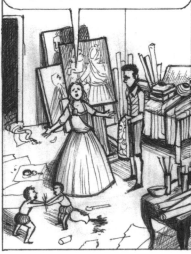

HOW ARE WE GOING TO PAY THAT CARPENTER FOR ALL THE FURNISHINGS IN THIS STUDIO?

AROUND 1618 ARTEMISIA TURNED AGAIN TO JUDITH AND ABRA, THE TWO WOMEN THAT SHE HELPED ORAZIO PORTRAY OVER FIVE YEARS BEFORE. DID SHE MISS WORKING ALONGSIDE HER FATHER? HIS REQUESTS TO WORK IN VENICE, AND ON THE CATHEDRAL OF ST. PETERS IN ROME, WERE BOTH DENIED. HE BEGAN TO RECEIVE ANONYMOUS LETTERS AND HOSTILE SONNETS REGARDING HIS DAUGHTER'S SEXUALITY. IN ROME HE FELT EYES ON HIM AT EVERY TURN, SO HE REMAINED IN THE MARCHES MOST OF THE TIME.

ARTEMISIA POSITIONED JUDITH AND ABRA CLOSER TOGETHER, AND REPLACED ORAZIO'S RED AND BLUE WITH THE WHITE, YELLOW OCHRE, AND DARK BLOOD RED THAT DOMINATED HER FLORENTINE CANVASES. THERE IS SOMETHING RUSTIC ABOUT JUDITH DESPITE HER BEJEWELED ATTIRE, AND THERE IS A SCREAMING FACE ON THE POMMEL OF HER SWORD.

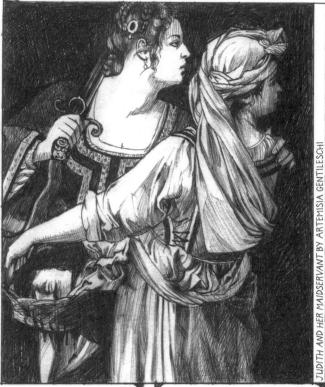

JUDITH AND HER MAIDSERVANT BY ARTEMISIA GENTILESCHI

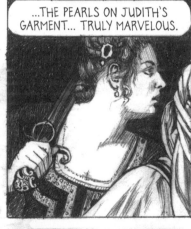

YES, YES, YOU'VE DONE IT AGAIN, MY LOVE. THE DETAILS IN THE LACE...

...THE PEARLS ON JUDITH'S GARMENT... TRULY MARVELOUS.

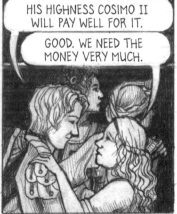

HIS HIGHNESS COSIMO II WILL PAY WELL FOR IT.

GOOD. WE NEED THE MONEY VERY MUCH.

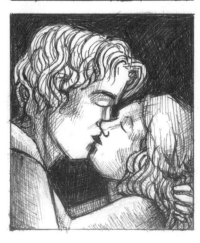

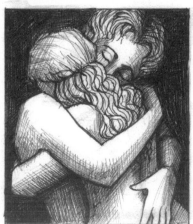

156

MANY MILES NORTH, TENSION BETWEEN CATHOLICS AND PROTESTANTS CAME TO A HEAD IN PRAGUE ON MAY 23, 1618. A GROUP OF PROTESTANT REBELS THREW TWO REPRESENTATIVES OF THE CATHOLIC KING OF BOHEMIA (FERDINAND II) OUT OF A WINDOW OF THE ROYAL PALACE.

THE VICTIMS PLUMMETED DOWN ABOUT SEVENTY FEET, MARKING THE OFFICIAL BEGINNING OF THE THIRTY YEARS' WAR. THIS COMPLICATED STRUGGLE FOR POWER, FUELED BY RELIGIOUS CONFLICTS, CONSUMED NORTHERN EUROPE DURING ARTEMISIA'S TIME. FERDINAND II WAS REPLACED BY THE PROTESTANT FREDERICK V OF THE PALATINATE. BUT ONLY ONE YEAR LATER, FERDINAND II BECAME THE HOLY ROMAN EMPEROR, GRANTING HIM THE POWER TO STRIKE AGAINST PROTESTANTS WITH AID FROM BAVARIA, SAXONY, AND ESPECIALLY FROM HIS OWN FAMILY—THE CATHOLIC HAPSBURGS WHO RULED SPAIN AND AUSTRIA.

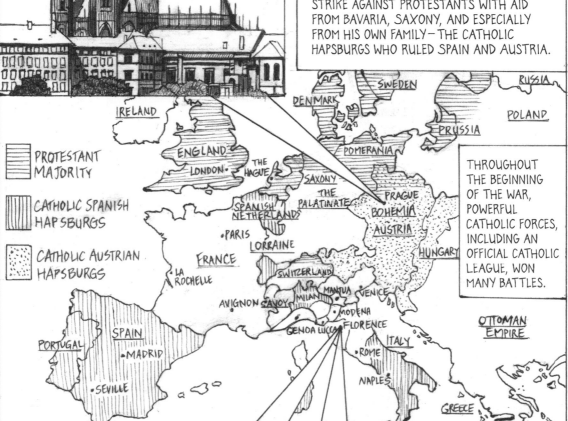

PROTESTANT MAJORITY

CATHOLIC SPANISH HAPSBURGS

CATHOLIC AUSTRIAN HAPSBURGS

THROUGHOUT THE BEGINNING OF THE WAR, POWERFUL CATHOLIC FORCES, INCLUDING AN OFFICIAL CATHOLIC LEAGUE, WON MANY BATTLES.

IN FLORENCE, THE CENTER OF TUSCANY, COSIMO II'S WIFE, MARIA MADDALENA OF AUSTRIA (FERDINAND II'S SISTER), AND HIS MOTHER, CHRISTINE OF LORRAINE, FULLY SUPPORTED THE CATHOLIC LEAGUE. THE WOMEN'S POWER AND INFLUENCE GREW, AS COSIMO II LANGUISHED IN BED WITH TUBERCULOSIS. YET, HIS ILLNESS DIDN'T STOP HIM FROM GRANTING ARTEMISIA THE BIGGEST COMMISSION SHE'D EVER HAD, COMPLETE WITH A LARGE ADVANCE OF FIFTY SCUDI.

BUT ARTEMISIA'S CHILDREN WERE BECOMING ILL, TOO, AND SHE WAS INCREASINGLY BUSY WITH HER FAMILY. PLUS, SHE WAS PREGNANT AGAIN.

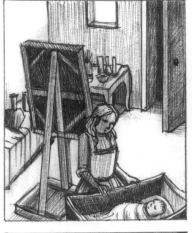

IN OCTOBER 1618 SHE GAVE BIRTH TO HER FOURTH CHILD—A DAUGHTER CALLED LISABELLA.

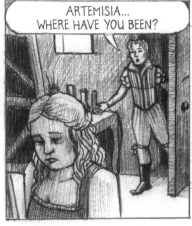

ARTEMISIA... WHERE HAVE YOU BEEN?

SHHH, I JUST GOT HER TO STOP CRYING AND SLEEP.

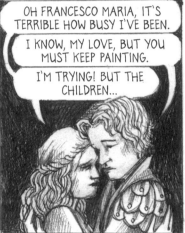

OH FRANCESCO MARIA, IT'S TERRIBLE HOW BUSY I'VE BEEN.

I KNOW, MY LOVE, BUT YOU MUST KEEP PAINTING.

I'M TRYING! BUT THE CHILDREN...

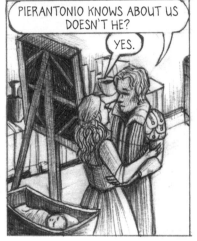

PIERANTONIO KNOWS ABOUT US DOESN'T HE?

YES.

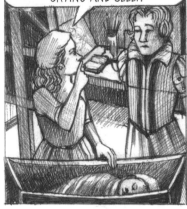

ARTEMISIA, YOU TWO ARE RACKING UP TOO MUCH DEBT. THE ACADEMY, YOUR GUILD, CAN ONLY SUPPORT YOU SO MUCH.

I MYSELF CAN ONLY SUPPORT YOU TO A CERTAIN EXTENT.

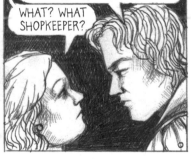

YOU MEAN THE DEBT TO THE PHARMACIST? AND FOR THE SWEETMEATS?

NOT ONLY THAT, THE DEBT TO THE SHOPKEEPER TOO.

WHAT? WHAT SHOPKEEPER?

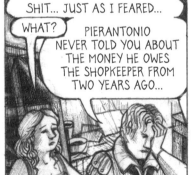

SHIT... JUST AS I FEARED...

WHAT?

PIERANTONIO NEVER TOLD YOU ABOUT THE MONEY HE OWES THE SHOPKEEPER FROM TWO YEARS AGO...

AND NOW THE ACCADEMIA DEL DISEGNO IS HOLDING YOU ACCOUNTABLE.

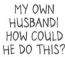

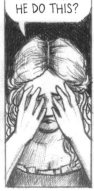

MY OWN HUSBAND! HOW COULD HE DO THIS?

I WILL WRITE TO COSIMO II. HE WILL DEFEND ME. HE MUST!

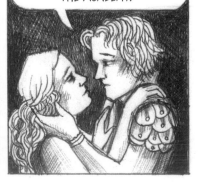

YOU KNOW I'LL DEFEND YOU TOO. BUT YOU MAY HAVE TO FACE THE OFFICIAL CONSUL OF THE ACADEMY.

ON JUNE 5, 1619, ARTEMISIA TESTIFIED TO THE COURT OF THE ACCADEMIA DEL DISEGNO AND REPRESENTATIVES OF COSIMO II.

...my husband never told me about this debt, nor this indictment, which is now two years old...

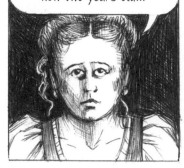

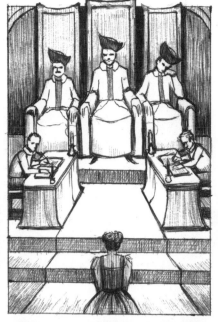

Please, I've already suffered enough and my husband has all of my dowry. I beg you to waive this sentence against me. A married woman cannot be held responsible for debt when her husband is still alive.

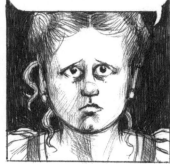

ON JUNE 26, 1619, ARTEMISIA APPEARED BEFORE THE COURT OF THE ARTE DEI SPEZIALI, A DIFFERENT GUILD, AFTER THE SON OF A JEWELER ACCUSED HER OF BEING IN DEBT TO HIM TOO.

...YES, YOUR LORDSHIP, THIS IS THE WOMAN WHO OWES ME.

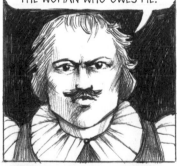

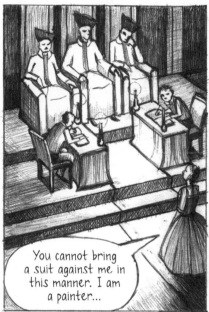

You cannot bring a suit against me in this manner. I am a painter...

...and painters are subject only to the court of the Accademia del Disegno. This man does not have special permission to accuse me outside of the guild I belong to.

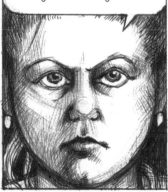

WELL DONE, YOU!

I'M ALMOST GETTING USED TO BEING ON TRIAL, HA HA!

DESPITE ARTEMISIA'S VALIANT DEFENSE, HER TROUBLES IN FLORENCE WERE NOT OVER. RUMORS ABOUT THE ROMANTIC TRIANGLE OF PIERANTONIO, FRANCESCO MARIA, AND ARTEMISIA WERE SPREADING FAST.

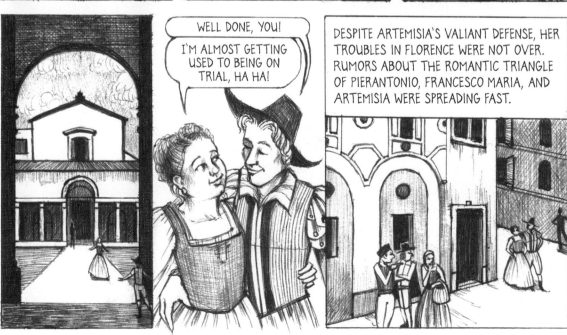

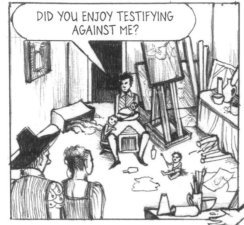 DID YOU ENJOY TESTIFYING AGAINST ME?

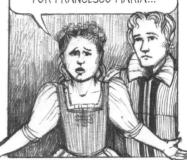 I HAD TO! THE ACADEMY AGREED TO WAIVE SOME OF THE DEBT. AND IF IT WEREN'T FOR FRANCESCO MARIA...

 I KNOW, I KNOW.

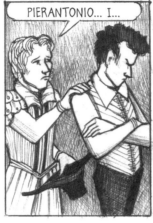 PIERANTONIO... I...

 SHUT UP! YOU'VE MADE ME A CUCKOLD AND THERE'S NOTHING I CAN DO ABOUT IT. NOW YOUR INSOLENT FRIEND, MARGHERITA, HAS ACCUSED US OF THEFT!

WHAT?

 OF COURSE, NOW WE NEED YOUR HELP AGAIN, MORE THAN EVER.

 THAT FUCKING LIAR! WE NEVER STOLE ANYTHING! WHY WOULD SHE SAY THAT? I SWEAR I'M GOING TO CORNER HER IN THE ALLEY AND—

 ARTEMISIA. WHAT IF SHE'S FOUND OUT ABOUT US? THIS COULD BE VERY BAD, VERY DANGEROUS... IF COSIMO II FINDS OUT...

WE COULD LOSE OUR PATRON IN AN INSTANT.

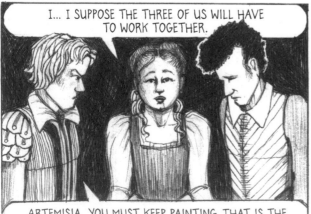 I... I SUPPOSE THE THREE OF US WILL HAVE TO WORK TOGETHER.

ARTEMISIA, YOU MUST KEEP PAINTING. THAT IS THE MOST IMPORTANT THING.

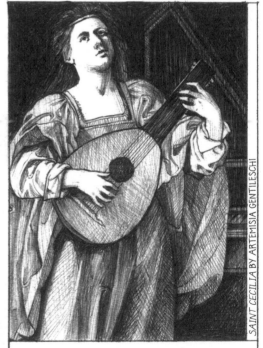

SAINT CECILIA BY ARTEMISIA GENTILESCHI

ARTEMISIA PAINTED SAINT CECILIA, ANOTHER POPULAR CATHOLIC MARTYR. WHEN CECILIA REFUSED TO PARTICIPATE IN PAGAN RITUALS, THE ANCIENT ROMAN PREFECT ORDERED THAT SHE BE SUFFOCATED. SHE MIRACULOUSLY SURVIVED, BUT THEN HE HAD HER BEHEADED. SHE WAS ALSO ASSOCIATED WITH MUSICAL INSTRUMENTS.

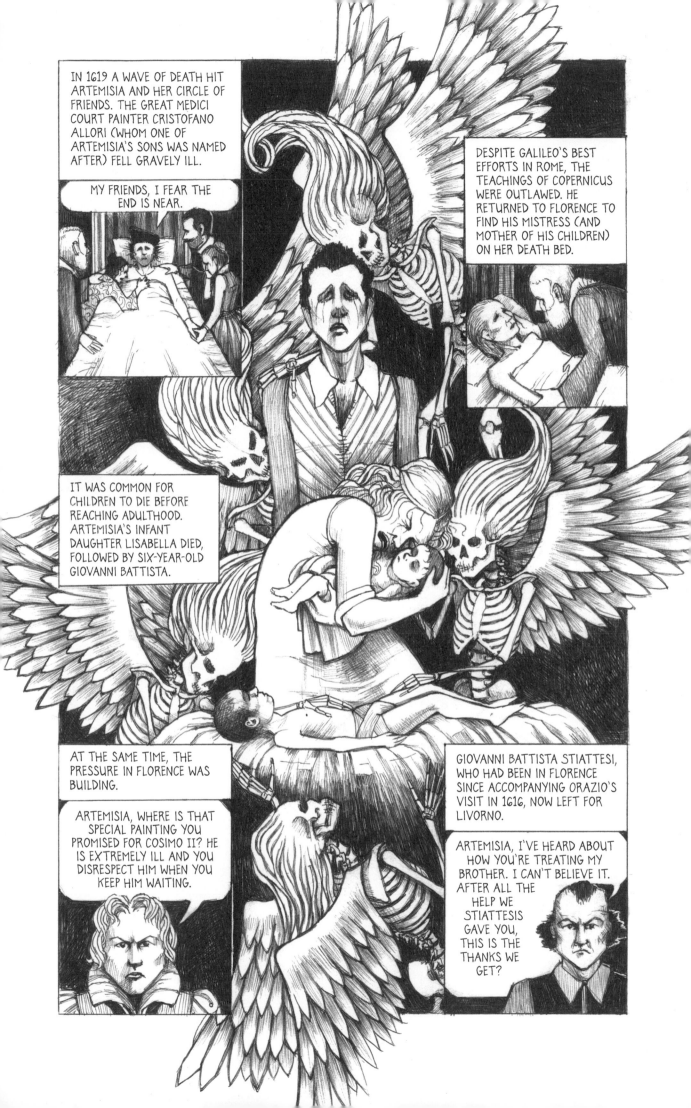

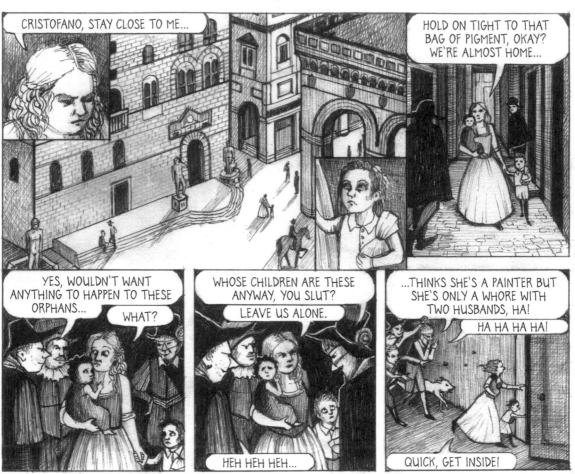

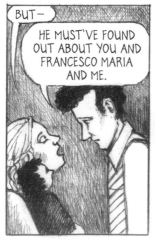

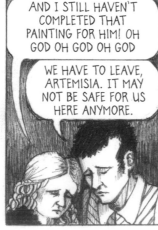

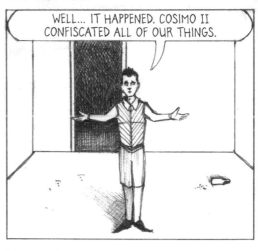

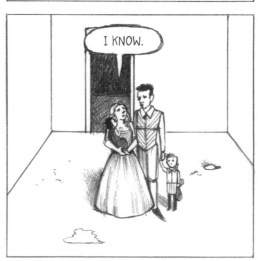

162

IN FEBRUARY 1620, ARTEMISIA AND PIERANTONIO RETURNED TO ROME. THEIR TWO REMAINING CHILDREN, CRISTOFANO AND PRUDENZIA, WERE SENT TO JOIN THEM TWO WEEKS LATER.

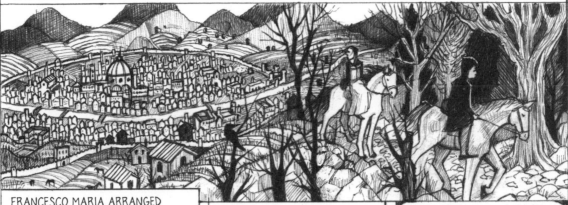

FRANCESCO MARIA ARRANGED A PLACE FOR THEM TO STAY IN ROME. HE TRIED TO RECOVER THEIR BELONGINGS AND SETTLE THEIR AFFAIRS IN FLORENCE. A FLURRY OF LETTERS FROM ARTEMISIA AND PIERANTONIO ANXIOUSLY URGED HIM TO KEEP THEM INFORMED.

YOU'RE QUOTING OVID NOW?

YES.

ARTEMISIA'S FATHER AND BROTHERS DID NOT WELCOME HER BACK TO ROME.

ARTEMISIA, WHAT HAVE YOU DONE?

AS IF THAT TERRIBLE TRIAL WASN'T ENOUGH, YOU GO AROUND WITH MEN LIKE A PROSTITUTE!

YOU COULD BE ARRESTED FOR ADULTERY!

FATHER, PLEASE—

DISGRACEFUL! WE MAY HAVE TO LEAVE ROME BECAUSE OF YOU!

NO!

YOU'VE DEVASTATED THIS FAMILY. LOOK AT THESE SLANDEROUS LETTERS I'VE BEEN GETTING.

FATHER, LISTEN TO ME. WE LOST EVERYTHING. IF YOU GIVE ME A CHANCE TO REBUILD, I'LL SHOW Y—

HA! YOU'D BETTER NOT BE ASKING FOR MONEY!

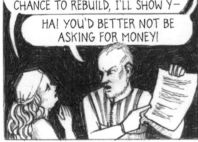

I LET YOUR BROTHER SELL SOME OF YOUR BELONGINGS IN FLORENCE.

AND THAT FRANCESCO MARIA COULDN'T STOP ME! HEH HEH

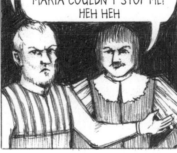

WHAT? BEHIND MY BACK? YOU KNOW HE'LL SPEND THE MONEY ON GAMBLING AND WHORES!

IT'S TOO LATE, ARTEMISIA. GET OUT OF HERE AND LEAVE US ALONE.

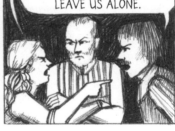

DON'T LISTEN TO THEM, ARTEMISIA. LET'S GO. IT'S OBVIOUS THAT THEY DON'T UNDERSTAND HOW PATRONAGE WORKS IN THIS COUNTRY.

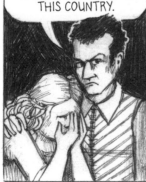

FRANCESCO MARIA GRADUALLY SENT THE CONFISCATED ITEMS BACK TO THEM. BUT AS ARTEMISIA'S LETTERS BECAME MORE DESPERATE FOR HIS LOVE AND REASSURANCE, HE GREW DISTANT AND WROTE LESS.

SCOOT OVER, LET ME WRITE TO HIM THIS TIME.

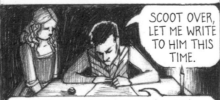

...will you please help us to quiet Artemisia's unruly family? In Florence she was no ordinary woman, and here in Rome she doesn't need these mad dogs barking at her heels.

AND THEN LITTLE CRISTOFANO GOT SICK.

NO! NO, NO, NOT YOU TOO! NO! WAKE UP, SOB, WAKE UP... GOD... DAMMIT! WAKE UP! WAKE UP! WAKE UP! WAKE UP!! NOW! CRIS WAKE UP!

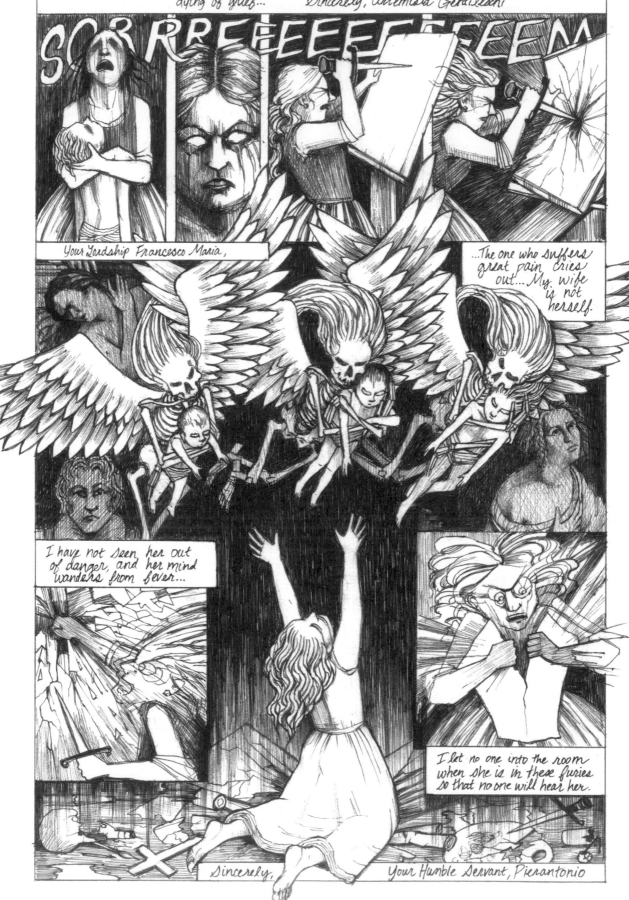

164

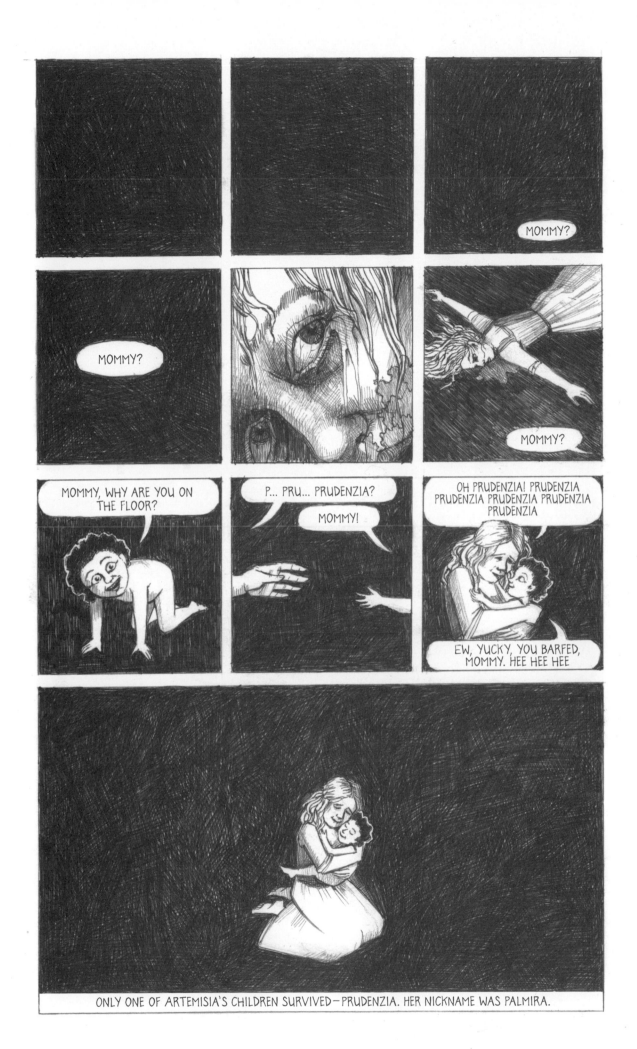

GRADUALLY, MORE AND MORE CARDINALS AND MEN OF WEALTH CAME LOOKING FOR WORK BY ARTEMISIA GENTILESCHI, DESPITE HER PRECARIOUS REPUTATION.

PALMIRA, HOW WOULD YOU LIKE TO LEARN HOW TO PREPARE COLORS FOR ME? I HOPE YOU'LL SAY YES.

UMMM...

YES!

SHE BEGAN TO REALIZE THAT SHE COULDN'T RETURN TO FLORENCE, AND THAT SHE COULD HAVE A CAREER IN ROME.

EXCELLENT!

YOUR MOTHER IS A FAMOUS PAINTER...

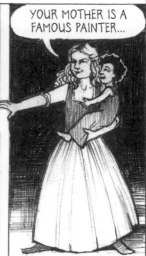

SHE FINALLY BEGAN TO MAKE PROGRESS ON THE GRAND DUKE COSIMO II'S SPECIAL PAINTING.

...AND PAINTING IS SACRED.

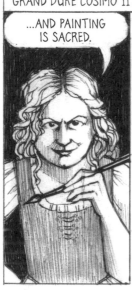

BUT... PALMIRA...

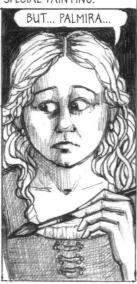

A LONG TIME AGO A MAN HURT YOUR MOTHER VERY MUCH. HE TOOK SOMETHING VERY IMPORTANT FROM ME.

BUT WHY?

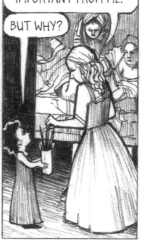

BECAUSE HE WAS VERY BAD. AND SOME OTHER MEN WANTED TO MAKE SURE I WAS TELLING THE TRUTH ABOUT IT, SO THEY HURT MY HANDS.

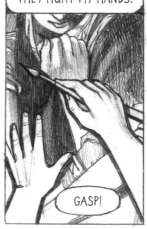

GASP!

BUT THEN I PAINTED JUDITH.

WHO IS JUDITH?

HA! WHO IS JUDITH. YOU'LL LEARN SOME- DAY. I'M PAINTING HER AGAIN FOR THE GRAND DUKE OF TUSCANY.

IN THIS VERSION A SLIGHTLY OLDER JUDITH DOESN'T MIND HOLOFERNES'S BLOOD SQUIRTING ONTO HER.

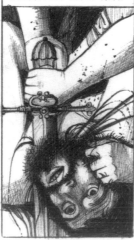

SHE IS STRONGER AND MORE DETERMINED THAN BEFORE, DRESSED IN YELLOW GOLD WITH SHINING JEWELRY.

ARTEMISIA SIGNED THE PAINTING AT THE BOTTOM OF HOLOFERNES'S BED— "EGO ARTEMITIA LOMI FEC." THIS BOLDLY PROCLAIMS, "I, ARTEMISIA LOMI, MADE THIS."

AT LAST, SHE SENT THE FINISHED PAINTING BACK TO FLORENCE.

BUT THE RULER OF FLORENCE, GRAND DUKE COSIMO II, WAS DYING AT THE AGE OF THIRTY. FRANCESCA CACCINI SANG AT HIS BEDSIDE UNTIL THE END. IN HIS WILL HE INSISTED THAT HIS WIFE AND MOTHER ASSUME THE THRONE UNTIL HIS SON TURNED EIGHTEEN. THUS, FOR THE FIRST AND ONLY TIME IN HISTORY, TUSCANY WAS RULED BY WOMEN.

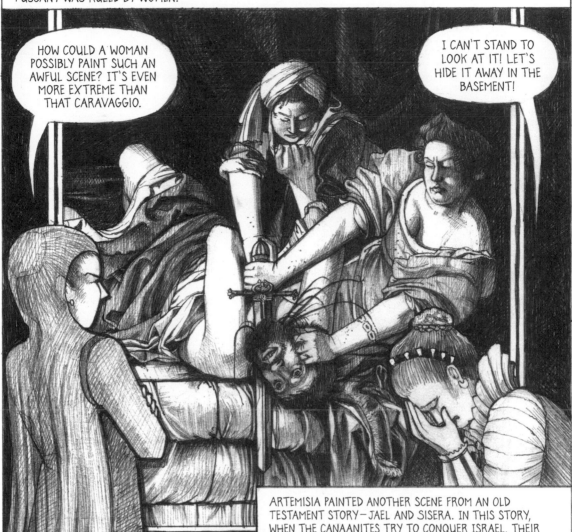

HOW COULD A WOMAN POSSIBLY PAINT SUCH AN AWFUL SCENE? IT'S EVEN MORE EXTREME THAN THAT CARAVAGGIO.

I CAN'T STAND TO LOOK AT IT! LET'S HIDE IT AWAY IN THE BASEMENT!

ARTEMISIA PAINTED ANOTHER SCENE FROM AN OLD TESTAMENT STORY—JAEL AND SISERA. IN THIS STORY, WHEN THE CANAANITES TRY TO CONQUER ISRAEL, THEIR COMMANDER SISERA TAKES REFUGE IN THE TENT OF THE ISRAELITE JAEL. WHEN HE FALLS ASLEEP, JAEL HAMMERS A TENT PEG INTO HIS HEAD, LEADING TO ISRAEL'S VICTORY. ARTEMISIA REPLACED THE TRADITIONAL DECORATIVE FOLIAGE WITH A FORBIDDING PILLAR ADORNED WITH ANOTHER CONFIDENT SIGNATURE.

REGARDLESS OF THE MEDICI SUPPORT ARTEMISIA HAD OBTAINED PREVIOUSLY, IT IS DOUBTFUL THAT THE WOMEN REGENTS APPRECIATED SUCH A GRUESOME RENDITION OF THE OLD TESTAMENT STORY. THE TYPE OF JUDITH THAT MARIA MADDALENA OF AUSTRIA PREFERRED WAS PAINTED BY GIOVANNI BATTISTA VANNI ON ONE OF THE LUNETTES IN HER ANTECHAMBER IN THE POGGIO IMPERIALE.

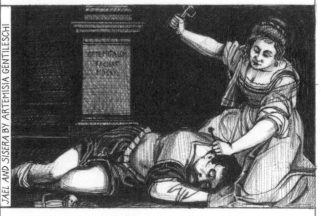

JAEL AND SISERA BY ARTEMISIA GENTILESCHI

THE ELECTION OF A NEW POPE IN 1621—THE BOLOGNESE ALESSANDRO LUDOVISI, KNOWN AS GREGORY XV—PROVIDED A FLOOD OF NEW OPPORTUNITIES FOR ARTISTS IN ROME, SO ARTEMISIA LEFT FLORENCE BEHIND FOR GOOD.

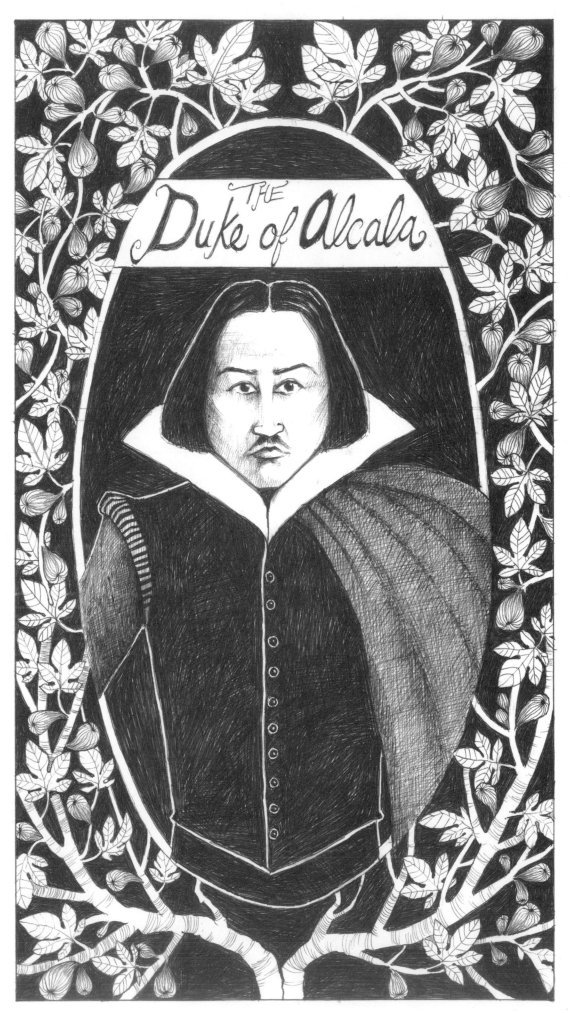

The Duke of Alcala

MANY OF ARTEMISIA'S POPULAR CONTEMPORARIES IN ROME HAD STUDIED AT THE BOLOGNESE SCHOOL FOUNDED BY THE CARACCI. GUIDO RENI WAS THE MOST FAMOUS AND INFLUENTIAL, BUT HE HAD RETURNED TO BOLOGNA BY THE TIME ARTEMISIA ARRIVED.

DOMENICHINO (ANOTHER BOLOGNESE ARTIST WHO HAD STUDIED WITH THE CARACCI ALONGSIDE GUIDO RENI) TOOK HIS SECOND TRIP TO ROME IN 1621 TO WORK FOR THE LUDOVISI. HE WAS KNOWN FOR HIS SMALL STATURE.

THE SLIGHTLY CROSS-EYED GUERCINO—"THE SQUINTER"—ARRIVED IN ROME IN 1621 TO WORK FOR THE LUDOVISI ALSO.

GIOVANNI LANFRANCO FROM PARMA WAS IN ROME TOO. HE AND DOMENICHINO STARTED WORKING ON THE FRESCOES OF THE SANT' ANDREA DELLE VALLE IN 1623.

LANFRANCO WAS IN CHARGE OF THE DOME, WHILE DOMENICHINO HAD THE CHOIR AND PENDENTIVES. BUT WHEN THE WORK WAS COMPLETED FIVE YEARS LATER, THE TWO WERE BITTER RIVALS.

IT IS QUITE OBVIOUS THAT DOMENICHINO STOLE AGOSTINO CARACCI'S IDEA FOR HIS PAINTING OF THE LAST JUDGMENT OF SAINT JEROME.

WHAT? ALL ARTISTS BORROW IDEAS FROM EACH OTHER. BESIDES, I PAINTED THAT PIECE NEARLY TEN YEARS AGO. LANFRANCO'S ACCUSATION IS OBVIOUSLY MOTIVATED BY JEALOUSY.

GUERCINO COLLABORATED WITH AGOSTINO TASSI ON MULTIPLE ROMAN FRESCOES.

TOGETHER THEY FRESCOED THE *AURORA* ONTO CARDINAL LUDOVICO LUDOVISI'S VILLA CEILING, ANOTHER GRAND DECORATIVE CASINO, EMBELLISHED WITH AGOSTINO'S ILLUSIONS OF ARCHITECTURE.

BUT THERE WAS ONE ARTIST WHO DID NOT GET THE COMMISSIONS HE DESIRED—ORAZIO GENTILESCHI. IN 1621 HE SAID GOODBYE TO ARTEMISIA AGAIN AND, ALONG WITH HIS SONS, MOVED TO GENOA TO WORK FOR THE SAULI, WHO HAD PREVIOUSLY HIRED ORAZIO'S BROTHER, AURELIO LOMI.

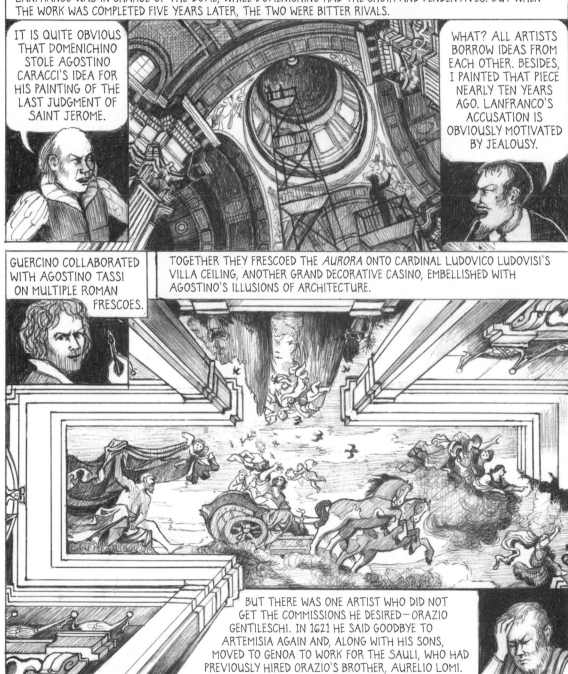

NOW IN HER NATIVE CITY AS AN ADULT WITHOUT HER FATHER, ARTEMISIA HAD TO FACE AGOSTINO TASSI ON HER OWN. SHE MUST HAVE ENDURED SEEING HIM ON A SEMI-REGULAR BASIS. HOW DID ARTEMISIA AND AGOSTINO INTERACT NOW, EIGHT YEARS AFTER THE TRIAL?

AGOSTINO'S SUCCESS WAS UNDENIABLE, BUT HIS TROUBLE WITH WOMEN CONTINUED. AFTER ARTEMISIA LEFT IN 1612, HE STAYED WITH COSTANZA AND THE TWO OF THEM TOOK IN A SICK, YOUNG PROSTITUTE CALLED OFERTIA.

AFTER OFERTIA DIED, HE BEGAN LIVING WITH AN ART DEALER NAMED COSIMO RUGGERO AND A COURTESAN NAMED ALESSANDRA CUCCHIARINA. AGOSTINO AND RUGGERO WERE KNOWN FOR THEIR QUESTIONABLE INVOLVEMENT IN THE ART MARKET.

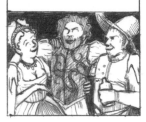

WHEN ALESSANDRA SOLD SOME OF THEIR ART, RUGGERO SUED HER AND SHE WAS EXILED. AGOSTINO WAS FURIOUS WITH RUGGERO AND THREATENED TO RETALIATE.

BUT IN 1619 RUGGERO RENEWED THE INCEST CHARGE AGAINST AGOSTINO FROM 1610, AND HE WAS BACK IN COURT ARGUING WITH THE MAGISTRATES AGAIN.

HOW MANY TIMES DO I HAVE TO TELL YOU? I DID NOT SLEEP WITH MY SISTER-IN-LAW!

HE WAS PARDONED ONCE MORE AND ESCAPED PUNISHMENT.

BY THE TIME ARTEMISIA ARRIVED IN ROME, AGOSTINO LIVED WITH THE COURTESAN CECILIA DE DURANTI, AND POSSIBLY OWNED A BROTHEL. IN 1622 CECILIA AND HER MAID, ASSENZIA, TESTIFIED AGAINST AGOSTINO FOR HIS VIOLENT BEHAVIOR.

...Your Lordship, when I refused to sleep with Signor Agostino Tassi he punched me, bit me, tore my clothing, and pointed a loaded gun at my pregnant belly.

He also threatened me with a gun and threw a stone at me...

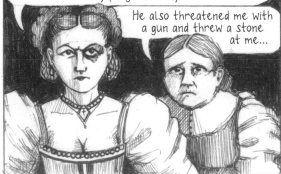

HE WAS CONFINED TO HOUSE ARREST IN THE PALACE OF ONE OF HIS PATRONS. BUT HE WAS CAUGHT OUTSIDE AT NIGHT WITH CECILIA AGAIN, AND WHEN HIS PATRON DISCOVERED THAT HE WAS BRINGING COURTESANS INTO THE PALACE, HE WAS EXPELLED.

AGOSTINO TASSI, YOU AND CECILIA ARE UNDER ARREST.

LET HER GO!

Fuck you! You'll end up fucking my ass with your nose!

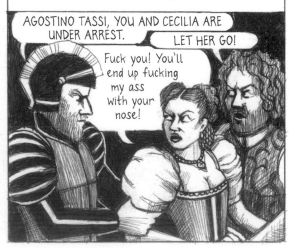

WHAT COULD ARTEMISIA CONTRIBUTE TO THIS MALE-DOMINATED WORLD OF FRESCOES? SHE CONTINUED TO PAINT ONLY PRIVATE GALLERY PICTURES FOR THE WEALTHY ELITE, SUCH AS THIS *LUCRETIA*, BASED ON A ROMAN MYTH FROM 509 B.C. IN THE STORY, TARQUINIUS COLLATINUS BRAGS TO HIS FELLOW SOLDIERS ABOUT HIS WIFE LUCRETIA'S CHASTITY. HE TELLS THE MEN TO GO SPY ON THE WIVES. WHEN THEY DO AS HE SAYS, THEY DISCOVER THAT WHILE THEIR WIVES ARE OUT PARTYING, LUCRETIA IS INNOCENTLY SPINNING WOOL AT HOME. THE KING'S SON, SEXTUS TARQUINIUS, TRIES TO RAPE HER, BUT SHE RESISTS EVEN WHEN HE THREATENS TO KILL HER. SO HE THREATENS TO KILL A SERVANT TOO AND PLACE HIS BODY NEXT TO HERS, IN ORDER TO ACCUSE HER OF ADULTERY. FINALLY, HE SUCCEEDS IN RAPING HER. AFTERWARDS, SHE CONFESSES TO HER HUSBAND AND COMMITS SUICIDE. ARTEMISIA PAINTED A STRONG CARAVAGGESQUE LUCRETIA HOLDING THE DAGGER AS SHE CONTEMPLATES AN HONORABLE DEATH VERSUS A DISHONORABLE LIFE.

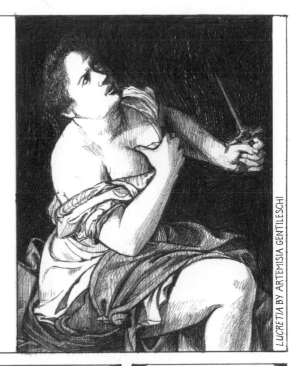

LUCRETIA BY ARTEMISIA GENTILESCHI

YET ARTEMISIA REALIZED THAT IF SHE WERE TO OBTAIN THE LUDOVISI'S FAVOR, SHE WOULD HAVE TO CHANGE HER TACTICS. IN 1622 SHE REVISITED THE STORY OF SUSANNA AND THE ELDERS. BUT THIS TIME SUSANNA LOOKED UP TOWARD HEAVEN, SURROUNDED BY A TYPICAL GARDEN SETTING AND SUGGESTIVE FOUNTAIN.

I MUST ASK FOR GUERCINO'S ASSISTANCE WITH THIS NEW PAINTING OF SUSANNA.

WHAT? ARTEMISIA, NO! HE'S BUSY AND FAMOUS. BESIDES, HE'S WORKING WITH THAT CRAZY IMBECILE AGOSTINO TASSI! IT'S TOO DANGEROUS TO COMPETE WITH THESE MEN!

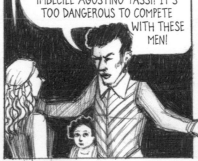

NONSENSE. I AM NOT AFRAID. I MUST OBTAIN THE SECRETS OF THE BOLOGNESE. I NEED A LANDSCAPE FOR THIS PAINTING. I MUST FIND "THE SQUINTER."

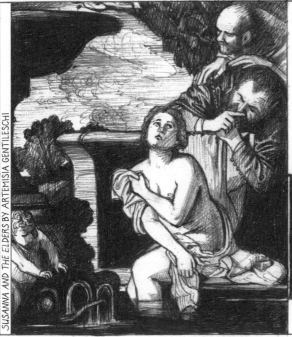

SUSANNA AND THE ELDERS BY ARTEMISIA GENTILESCHI

STRONG EVIDENCE SHOWS THAT ARTEMISIA WAS AIDED BY ANOTHER HAND FOR THIS PIECE. CERTAIN AREAS WERE DRASTICALLY ALTERED FROM THEIR ORIGINAL STATE, ESPECIALLY THE FOUNTAIN. DID GUERCINO ASSIST HER? HE PAINTED A RENDITION OF *JAEL* AND *SISERA* THAT IS REMARKABLY SIMILAR TO ARTEMISIA'S, SO IT IS LIKELY THAT THE TWO INFLUENCED EACH OTHER. IT'S ALSO POSSIBLE THAT SOMEONE ALTERED THE PAINTING LATER, WITH OR WITHOUT ARTEMISIA'S PERMISSION.

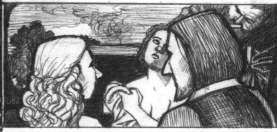

EITHER WAY, THE PAINTING WAS LISTED IN CARDINAL LUDOVICO LUDOVISI'S INVENTORY BY 1623.

IN ADDITION TO HISTORY PAINTING, ARTEMISIA WAS BECOMING FAMOUS FOR HER PORTRAITURE. IN 1622 SHE PAINTED THE *PORTRAIT OF A GONFALONIERE*. HE WAS PROBABLY A KNIGHT OF THE ORDER OF SAINTS MAURICE AND LAZARUS, A CATHOLIC DYNASTIC ORDER LED BY THE DUKES OF SAVOY SINCE 1572.

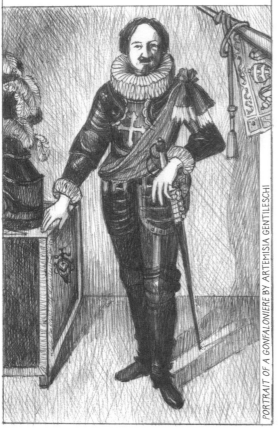

PORTRAIT OF A GONFALONIERE BY ARTEMISIA GENTILESCHI

THE GONFALONIERE IS POSED IN ALL HIS FINERY, BETWEEN HIS PLUMED HELMET AND A HANGING BANNER (THE GONFALONE) THAT HE CARRIED DURING MILITARY PROCESSIONS. BY 1622 THE NORTHERN PROTESTANT UNION WAS DISSOLVED AND CATHOLIC FORCES EVERYWHERE WERE OPTIMISTIC. PERHAPS THAT EXPLAINS THE LIGHTHEARTED EXPRESSION ON ARTEMISIA'S GONFALONIERE. HIS HAND TOUCHES THE TABLE, RELAXED BUT READY FOR ACTION. ARTEMISIA ALSO WENT BACK TO SIGNING HER NAME GENTILESCHI INSTEAD OF LOMI.

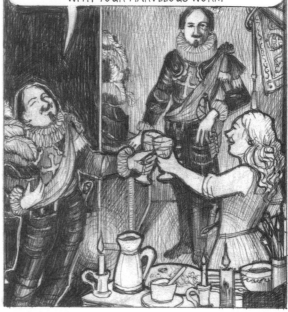

IT'S WONDERFUL, ARTEMISIA! A MIRACLE! YOU HONOR THE ORDER AND ALL OF CHRISTENDOM WITH YOUR MARVELOUS WORK.

AND WHERE IS YOUR HUSBAND?

UM... I DON'T KNOW. OUT, I GUESS.

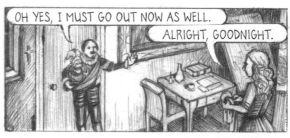

OH YES, I MUST GO OUT NOW AS WELL.

ALRIGHT, GOODNIGHT.

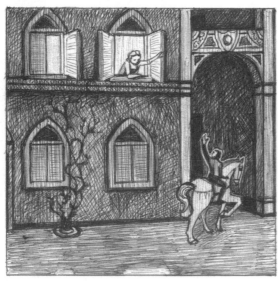

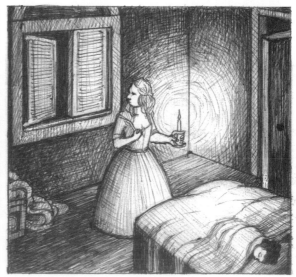

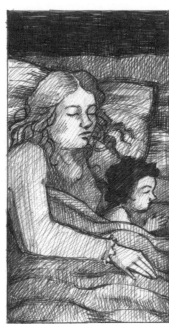

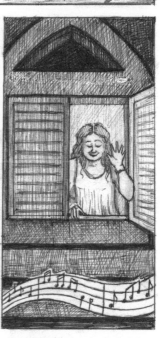
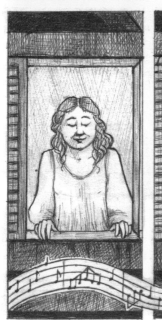
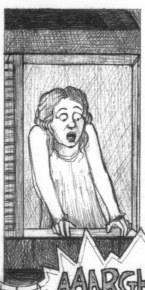
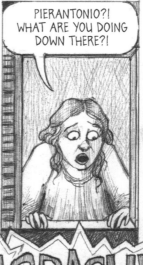
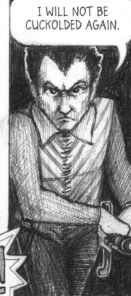

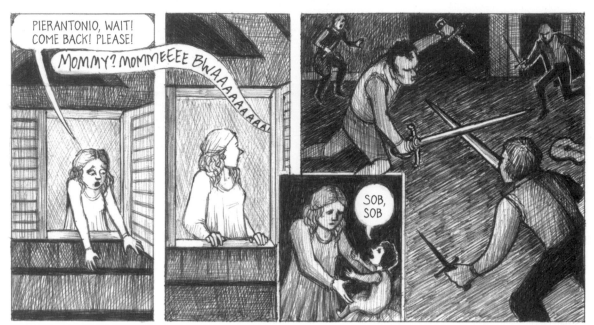

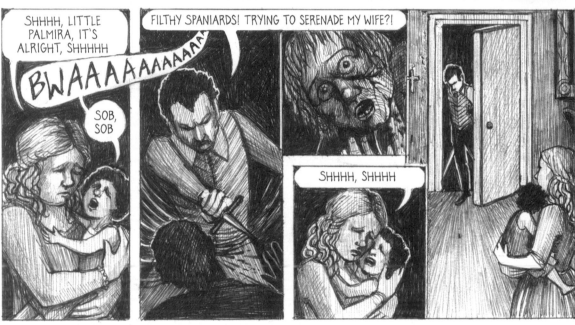

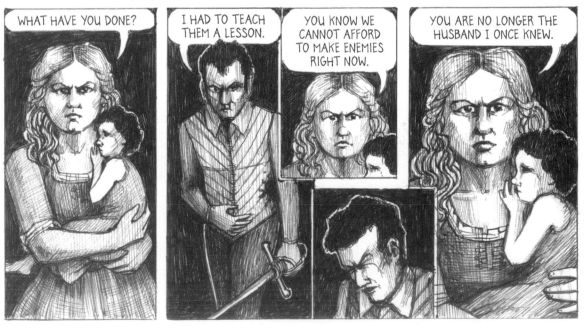

MAMA, WHAT HAPPENED TO DADDY?

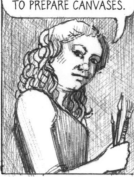
DON'T WORRY ABOUT THAT, MY CHILD, IT'S TIME FOR YOU TO LEARN HOW TO PREPARE CANVASES.

BUT— ENOUGH QUESTIONS. HERE, PUT ON THIS APRON.

THERE'S WORK TO DO, HURRY UP!

IN 1623 POPE GREGORY XV DIED AND WAS REPLACED BY MAFFEO BARBERINI, KNOWN AS URBAN VIII. 1624 MARKED THE RISE OF THE BARBERINI, AND THROUGHOUT THEIR LONG REIGN THEY COVERED ROME WITH THE EMBLEM OF THEIR COAT OF ARMS—THE BARBERINI BEES.

IN 1623 *THE ASSAYER* BY GALILEO WAS PUBLISHED. IT IS A POETIC TREATISE THAT CONTRIBUTED TO THE ONGOING DEBATES ABOUT COMETS, AND EXPOUNDED UPON THE IMPORTANCE OF USING EXPERIMENTAL, SCIENTIFIC METHODS INSTEAD OF BLINDLY ACCEPTING MAINSTREAM OPINIONS. *THE ASSAYER* ALSO SERVED AS A TRIBUTE TO THE BEAUTY OF NATURE, GOD'S CREATION. THERE WAS NO MENTION OF THE FORBIDDEN COPERNICUS. IN 1624 GALILEO TRAVELED TO ROME TO GREET THE NEW POPE, HOPING TO FURTHER HIS CONNECTIONS WITH THE BARBERINI.

GALILEO, I'M SO GLAD TO SEE YOU! HOW ARE YOU?

I AM WELL, ARTEMISIA. I'VE DEDICATED *THE ASSAYER* TO URBAN VIII AND HE LOVES IT! WHAT ABOUT YOU? WHAT HAPPENED TO PIERANTONIO?

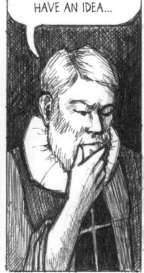

THE SPANIARDS HE ATTACKED HAVE THE PROTECTION OF CARDINAL BORGIA. IT IS TOO DANGEROUS FOR PIERANTONIO TO REMAIN HERE.

GOOD HEAVENS, ARTEMISIA! AND HERE YOU ARE, IN ROME WITH NO PROTECTION!

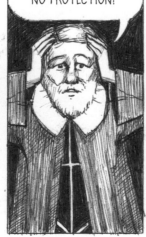

HMMM... I THINK I MAY HAVE AN IDEA...

I SHALL INTRODUCE YOU TO CASSIANO DAL POZZO. HE IS FOND OF CURIOSITIES...

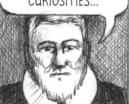

...SUCH AS YOURSELF.

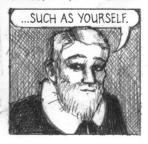

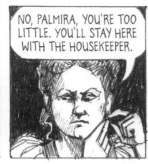

...BUT I WANT TO DRESS UP AND SEE A CABINET OF CURIOSITIES TOO!

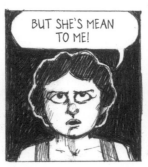

NO, PALMIRA, YOU'RE TOO LITTLE. YOU'LL STAY HERE WITH THE HOUSEKEEPER.

BUT SHE'S MEAN TO ME!

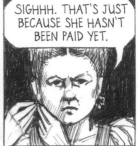

SIGHHH. THAT'S JUST BECAUSE SHE HASN'T BEEN PAID YET.

CASSIANO DAL POZZO ADMIRED GALILEO. BOTH MEN WERE MEMBERS OF THE ACCADEMIA DEI LINCEI, AN ACADEMY CREATED FOR THE STUDY OF POETRY, HISTORY, AND ESPECIALLY NATURAL PHILOSOPHY (SCIENCE). CASSIANO WAS A LEARNED MAN OF LETTERS, KNOWN FOR HIS ARCHEOLOGICAL STUDIES AND HIS COLLECTION OF PLANTS, BIRDS, SKELETONS, ANCIENT ARTIFACTS, AND RARE OBJECTS. HE WAS ALSO THE SECRETARY OF THE CARDINAL NEPHEW—FRANCESCO BARBERINI.

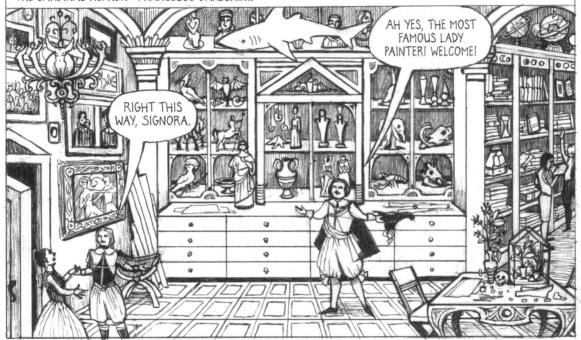

RIGHT THIS WAY, SIGNORA.

AH YES, THE MOST FAMOUS LADY PAINTER! WELCOME!

CASSIANO WAS AN AVID PATRON OF THE ARTS. ONE OF HIS FAVORITE PAINTERS WAS NICHOLAS POUSSIN, WHO HAD JUST ARRIVED FROM FRANCE.

...I can't stand that Caravaggio—he came into the world to destroy art! WE MUST REVIVE ROMAN PAINTING WITH A MORE REFINED, CLASSICAL BEAUTY.

MEANWHILE, AFTER A FEW YEARS IN GENOA, ORAZIO GENTILESCHI WAS SUMMONED TO FRANCE BY QUEEN MARIE DE' MEDICI (THE DECEASED COSIMO II'S COUSIN). SHE WANTED AN ITALIAN ARTIST TO HELP DECORATE THE LUXEMBOURG PALACE.

BUT ORAZIO RAN INTO HIS OLD RIVAL GIOVANNI BAGLIONE, WHO WAS ALREADY WORKING ON NINE CANVASES FOR THE QUEEN MOTHER.

PLUS, THE FLEMISH MASTER PETER PAUL RUBENS ARRIVED IN FRANCE AS WELL, TO WORK ON HIS FAMOUS *LIFE OF MARIE DE' MEDICI* SERIES.

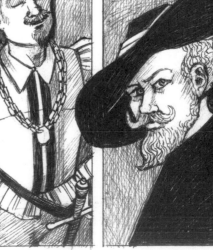

WHILE ORAZIO STRUGGLED IN FRANCE, ARTEMISIA MET ANOTHER ONE OF CASSIANO DAL POZZO'S FRENCH FRIENDS IN ROME—THE PAINTER SIMON VOUET. VOUET HAD BEEN TRAVELING ALL OVER ITALY SINCE 1612, INCLUDING A VISIT TO GENOA AROUND THE SAME TIME THAT ORAZIO WAS THERE. HE DID NOT SHARE POUSSIN'S LOFTY, LITERARY APPROACH TO PAINTING, AND HE PROBABLY WASN'T AS POPULAR, BUT HE DID HAVE THE OFFICIAL BACKING OF THE FRENCH CROWN. HE WAS ALSO A HIGH RANKING MEMBER OF ROME'S ART ACADEMY OF SAN LUCA. AROUND 1625 HE PAINTED A PORTRAIT OF ARTEMISIA.

IN THIS PORTRAIT, A GALLANT THIRTY-TWO-YEAR-OLD ARTEMISIA WEARS A GOLD CHAIN WITH A MEDALLION FEATURING THE TOMB OF MAUSOLUS, WITH THE INSCRIPTION "MAUSOLEION." THE MEDAL REFERS TO THE ANCIENT QUEEN ARTEMISIA OF HALICARNASSUS. AFTER HER HUSBAND, MAUSOLUS, DIED SHE CONSTRUCTED A SPECIAL TOMB—THE MAUSOLEUM. APPARENTLY, SHE ALSO DRANK WINE MIXED WITH MAUSOLUS'S ASHES. IN THE SEVENTEENTH CENTURY, THIS ANCIENT QUEEN WAS REVERED AS AN EXAMPLE OF HONORABLE WOMANHOOD AND ENDURING LOVE.

CASSIANO DAL POZZO HAS REQUESTED THIS PORTRAIT OF YOU, SO HOLD STILL.

I'M NOT USED TO BEING ON THE OTHER SIDE OF A PORTRAIT.

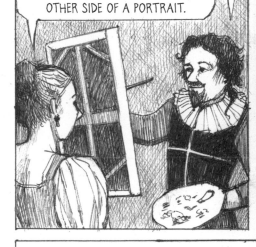

PORTRAIT OF ARTEMISIA GENTILESCHI BY SIMON VOUET

VOUET RAN A BIG WORKSHOP FULL OF UP-AND-COMING ARTISTS, MANY OF WHOM WERE INVOLVED WITH URBAN VIII'S TREMENDOUS EFFORT TO FINALLY COMPLETE ST. PETERS. VOUET PAINTED THE ALTARPIECE FOR THE CHAPEL OF THE CANONS. BUT NO ARTIST COULD COMPETE WITH THE POPE'S FAVORITE—GIAN LORENZO BERNINI, WHO WAS BEGINNING WORK ON THE FAMOUS BALDACCHINO.

PERHAPS IT WAS THROUGH VOUET'S WORKSHOP THAT ARTEMISIA MET ANOTHER FRENCH ADMIRER—PIERRE DUMONSTIER. IN 1625 HE MADE THIS DRAWING OF ARTEMISIA'S HAND WITH THE INSCRIPTION: "THE WORTHY HAND OF THE EXCELLENT AND LEARNED ARTEMISIA, ROMAN GENTLEWOMAN... THE HANDS OF AURORA ARE PRAISED FOR THEIR RARE BEAUTY. BUT THIS ONE HERE IS WORTHY OF A THOUSAND TIMES MORE PRAISE FOR KNOWING HOW TO MAKE THOSE MARVELS THAT RAVISH THE EYES OF THE MOST DISCERNING."

THE BEGINNING OF POPE URBAN VIII'S REIGN COINCIDED WITH THE RISE OF THE FRENCH KING'S CHIEF MINISTER—CARDINAL RICHELIEU. FRANCE WAS TECHNICALLY CATHOLIC, BUT RICHELIEU WAS LESS CONCERNED WITH RELIGION THAN WITH PREVENTING THE HAPSBURGS FROM TAKING OVER ALL OF EUROPE. URBAN VIII WAS NOTORIOUSLY PRO-FRENCH, BUT HE FACED POLITICAL PRESSURE FROM BOTH FRANCE AND SPAIN.

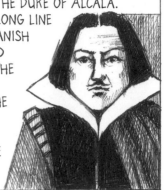

PHILIP IV, THE SPANISH HAPSBURG KING, SENT AN AMBASSADOR TO ROME TO CONVINCE URBAN VIII TO PROVIDE MORE SUPPORT FOR SPAIN'S WAR EFFORTS. THE NEW SPANISH AMBASSADOR WAS A NOBLEMAN NAMED FERNANDO ENRIQUEZ AFAN DE RIBERA, ALSO KNOWN AS THE DUKE OF ALCALA. HE CAME FROM A LONG LINE OF SCHOLARLY SPANISH ARISTOCRATS. HE'D BEEN ADDING TO THE LIBRARY AND ART COLLECTION OF THE FAMILY PALACE— THE CASA DE PILATOS—SINCE HE WAS A TEENAGER.

LIKE MANY OF THOSE BORN INTO NOBILITY, HE MARRIED EARLY AT THE AGE OF FOURTEEN TO A DAUGHTER OF A POWERFUL CLOSE ADVISOR TO PHILIP II. THIS HELPED GUARANTEE HIS FUTURE POSITION AT COURT. BUT HE WAS UNFAITHFUL TO HIS WIFE, PRODUCING FIVE ILLEGITIMATE CHILDREN.

DESPITE HIS LOYALTY TO THE SPANISH CROWN, MANY OF HIS POLITICAL ASPIRATIONS WERE UNSUCCESSFUL. AFTER A DISMAL TERM AS VICEROY OF CATALONIA IN 1618, THE DUKE OF ALCALA GLADLY ACCEPTED HIS POST IN ITALY, WHERE HE EAGERLY SOUGHT OUT GREAT WORKS OF ART. IT MUST HAVE BEEN HERE THAT HE MET CASSIANO DAL POZZO.

...I THINK YOU'LL BE SURPRISED BY HER.

WHAT? THAT WOMAN ARTIST WITH THE FUNNY NAME?

YES. ARTEMISIA.

HER TECHNIQUE IS QUITE GOOD. YOU'LL SEE...

IT'S TRUE THAT SPAIN HAS FAVORED THE DELICATE FEEL OF WOMEN'S WORK FOR LITTLE STILL-LIFES AND PRETTY PORTRAITS...

...BUT I AM A MAN ACCUSTOMED TO THE GENIUS OF VELÁZQUEZ AND RIBERA. I'D LIKE TO MEET THIS BERNINI FELLOW EVERYONE SPEAKS OF.

LET'S MAKE THIS A BRIEF VISIT TO THE LADY'S STUDIO. I'M VERY BUSY AND—

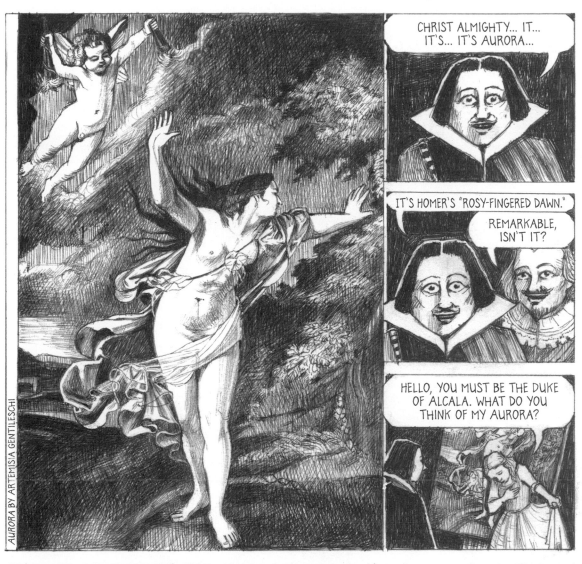

AURORA BY ARTEMISIA GENTILESCHI

CHRIST ALMIGHTY... IT... IT'S... IT'S AURORA...

IT'S HOMER'S "ROSY-FINGERED DAWN."

REMARKABLE, ISN'T IT?

HELLO, YOU MUST BE THE DUKE OF ALCALA. WHAT DO YOU THINK OF MY AURORA?

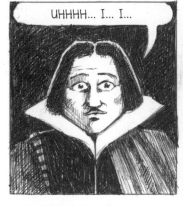

UHHHH... I... I...

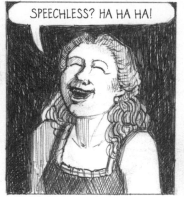

SPEECHLESS? HA HA HA!

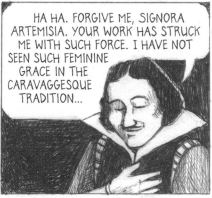

HA HA. FORGIVE ME, SIGNORA ARTEMISIA. YOUR WORK HAS STRUCK ME WITH SUCH FORCE. I HAVE NOT SEEN SUCH FEMININE GRACE IN THE CARAVAGGESQUE TRADITION...

AND I SEE YOU'VE NOT FORGOTTEN THE CARACCI. AND THE COLORS REMIND ME OF GUIDO RENI. MARVELOUS!

YOU'VE DONE IT ALL. I SIMPLY CANNOT BELIEVE MY EYES. I'D LIKE TO COMMISSION MORE WORK FROM YOU AT ONCE.

I WOULD BE HONORED.

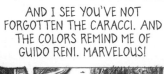

THE DUKE OF ALCALA BECAME ONE OF ARTEMISIA'S MOST SIGNIFICANT PATRONS. HE PUT HER TO WORK IMMEDIATELY ON SEVERAL COMMISSIONS, INCLUDING THIS *CHRIST BLESSING THE CHILDREN* AND A *DAVID WITH A HARP* (NOW LOST).

HE ALSO COMMISSIONED A NEW PENITENT MARY MAGDALENE. SHE LOOKS EXHAUSTED WITH HER HEAD RESTING ON ONE HAND AND DROOPING POSTURE. YET THIS GESTURE TRADITIONALLY REPRESENTED MELANCHOLY AND MEDITATION— THE VISIONARY, INTROSPECTIVE SADNESS OFTEN ASSOCIATED WITH ARTISTS.

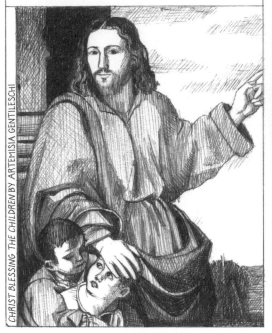

CHRIST BLESSING THE CHILDREN BY ARTEMISIA GENTILESCHI

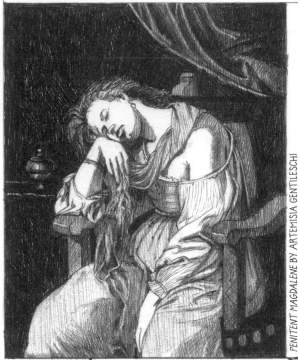

PENITENT MAGDALENE BY ARTEMISIA GENTILESCHI

...A STRANGE SORT OF WOMAN ISN'T SHE, CASSIANO?

YES. HER HUSBAND LEFT SEVERAL YEARS AGO.

WHAT? NO HUSBAND? HOW DOES SHE GET ON?

I DON'T KNOW. SHE HAS SOME VERY POWERFUL FRIENDS.

PRUDENZIA! GET BACK HERE AND CLEAN THAT UP THIS INSTANT!

SHE LOOKS DIRECTLY INTO MY EYES. NORMALLY I WOULD BE OFFENDED, BUT HER BEAUTY MATCHES THE BEAUTY OF HER WORK. SHE SEEMS SO COURAGEOUS.

I WONDER IF SHE COULD BE PERSUADED TO WORK FOR SPAIN. HOW DOES THE POPE FEEL ABOUT HER?

INDIFFERENT.

...AND YOU. GO FETCH SOME WATER. HURRY!

AND PUT THOSE RAGS AWAY TOO!

INDIFFERENT? SHIT. THAT'S HOW HE FEELS ABOUT EVERYONE EXCEPT HIS FAMILY.

HE'S STILL CATERING TO THAT FRENCH MONSTER, CARDINAL RICHELIEU, WHO PUSHED ASIDE THE PAPAL TROOPS IN THE VALTELLINE AND SHAKES HANDS WITH PROTESTANTS ALL OVER EUROPE.

EASY, FERNANDO ENRIQUEZ, YOU MUST BE PATIENT WITH HIS HOLINESS. HE IS SENDING HIS NEPHEW, FRANCESCO, TO NEGOTIATE WITH FRANCE.

HA! WE'LL SEE WHAT GOOD THAT WILL DO. EVEN A MERE WOMAN LIKE ARTEMISIA COULD DO MORE FOR THE CATHOLIC CHURCH THAN THAT USELESS FRANCESCO BARBERINI.

URBAN VIII LIKED HIM WELL ENOUGH, BUT THE DUKE OF ALCALA WAS UNABLE TO CONVINCE THE POPE TO RECONSIDER HIS POLITICAL POLICIES INVOLVING SPAIN.

I ADMIT, I FEEL LIKE A FAILURE.

IN 1626 THE DUKE OF ALCALA WAS SUMMONED BACK TO MADRID, BACK TO HIS WIFE AND FAMILY.

NO, DON'T SAY THAT. YOU'LL HAVE OTHER OPPORTUNITIES.

YES, AND MEETING YOU MADE THIS TRIP WORTHWHILE.

YOUR WORK WILL BE ONE OF THE NEW HIGHLIGHTS OF MY PALACE. I KNOW HIS HIGHNESS PHILIP IV WILL BE AMAZED. SPAIN WILL GIVE YOU THE RECOGNITION YOU DESERVE.

SPAIN WILL MAKE YOU A RICH WOMAN. I'LL FIND YOU AGAIN. I'LL COME BACK FOR YOU, ARTEMISIA. WILL YOU PAINT SOMETHING SPECIAL FOR ME TO TAKE BACK? SOMETHING SENSUAL, SOMETHING...

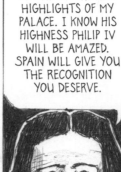

...EROTIC...

...SOMETHING TO HELP ME REMEMBER THE SMOOTHNESS OF YOUR SKIN, THE STRENGTH OF YOUR HANDS, THE CURVES OF YOUR BODY...

ARTEMISIA PAINTED DANAE, THE MYTHICAL GREEK PRINCESS. THERE WAS A PROPHECY THAT HER CHILDREN WOULD GROW UP TO KILL HER FATHER, KING ACRISIUS OF ARGUS, SO HE LOCKED HER UP. BUT ZEUS TRANSFORMED HIMSELF INTO A SHOWER OF GOLD COINS THAT MAGICALLY IMPREGNATED HER, DESPITE THE KING'S RESTRICTIONS.

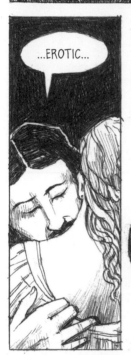

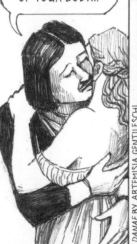

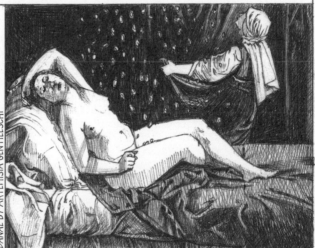

DANAE BY ARTEMISIA GENTILESCHI

ARTEMISIA PAINTED CLEOPATRA, THE ANCIENT ROMAN QUEEN. AFTER HER LOVER, MARK ANTONY, WAS DEFEATED BY OCTAVIAN'S FORCES, SHE COMMITTED SUICIDE WITH A POISON ASP.

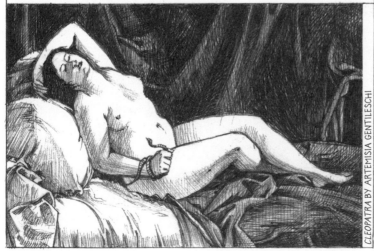

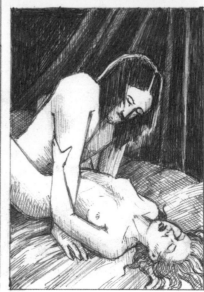

CLEOPATRA BY ARTEMISIA GENTILESCHI

AFTER HIS ATTEMPTS TO NEGOTIATE WITH RICHELIEU IN FRANCE, THE CARDINAL-NEPHEW FRANCESCO BARBERINI WAS SENT ON ANOTHER DIPLOMATIC MISSION TO MADRID. THIS TIME, HE TOOK CASSIANO DAL POZZO WITH HIM. NOW ARTEMISIA'S PRIMARY SUPPORTERS WERE GONE AND SHE WAS STILL STRUGGLING WITH DEBT. SO SHE LEFT, TOO, AND WENT TO VENICE, THE GATEWAY BETWEEN ITALY AND THE SPANISH AND AUSTRIAN HAPSBURG TERRITORIES. THERE MAY HAVE ALSO BEEN POLITICAL REASONS FOR HER MOVE. IN MANTUA, NEAR VENICE, THE FORTUNE OF THE RULING FAMILY—THE GONZAGAS—WAS RUNNING OUT, MOSTLY DUE TO A DECLINE IN THE SILK TRADE. NOW ALL THE GREAT POWERS OF EUROPE HOPED TO SEIZE CONTROL OF THE GONZAGA DYNASTY, INCLUDING THEIR ART COLLECTION. THIS WAS NOT JUST ANY ART COLLECTION. IT CONTAINED WORK BY CARAVAGGIO, CORREGGIO, TITIAN, RAPHAEL, AND LEONARDO DA VINCI. IT BECAME A SYMBOL OF POWER, WEALTH, AND CULTURE. MANY OF EUROPE'S MONARCHS USED THE ARTISTS, POETS, AND MUSICIANS OF THEIR COURTS AS DIPLOMATS AND SPIES. DID CASSIANO DAL POZZO SEND ARTEMISIA NORTH TO EVALUATE THE MANTUAN ART COLLECTION ON BEHALF OF THE BARBERINI? OR DID THE DUKE OF ALCALA SEND HER THERE ON BEHALF OF SPAIN?

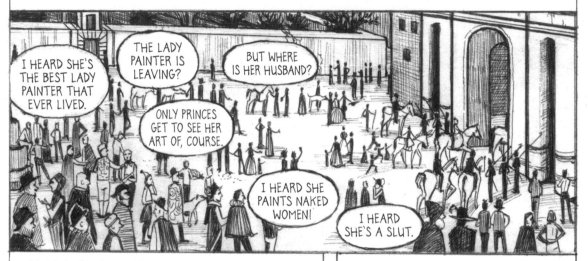

I HEARD SHE'S THE BEST LADY PAINTER THAT EVER LIVED.

THE LADY PAINTER IS LEAVING?

BUT WHERE IS HER HUSBAND?

ONLY PRINCES GET TO SEE HER ART OF, COURSE.

I HEARD SHE PAINTS NAKED WOMEN!

I HEARD SHE'S A SLUT.

BEFORE ARTEMISIA LEFT SHE PAINTED ANOTHER VERSION OF JUDITH AND ABRA FOR AN UNKNOWN PATRON. THE PLAY OF CANDLELIGHT SHOWS ARTEMISIA'S CONNECTION TO SIMON VOUET'S WORKSHOP. HE AND OTHER NORTHERN ARTISTS PUSHED CARAVAGGIO'S CHIAROSCURO A STEP FURTHER BY EXPERIMENTING WITH DRAMATIC CANDLELIT NIGHTTIME SCENES.

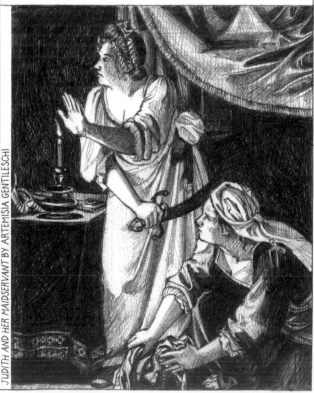

JUDITH AND HER MAIDSERVANT BY ARTEMISIA GENTILESCHI

SIMON VOUET ALSO LEFT ROME AND RETURNED TO FRANCE AROUND 1626. AT THE SAME TIME, ORAZIO GENTILESCHI WAS LEAVING FRANCE. IN 1625 THE FRENCH PRINCESS HENRIETTA MARIA (DAUGHTER OF MARIE DE' MEDICI) MARRIED THE ENGLISH KING CHARLES I. ORAZIO WAS PART OF THE CATHOLIC ENTOURAGE THAT HENRIETTA MARIA BROUGHT TO ENGLAND, WITH THE ASSISTANCE OF CHARLES I'S INFAMOUS ADVISOR, THE DUKE OF BUCKINGHAM. DESPITE WHISPERINGS OF CATHOLIC INTRIGUE, ADHERENCE TO THE PROTESTANT ANGLICAN CHURCH WAS STRICTLY ENFORCED IN ENGLAND. THUS, ARTEMISIA'S FATHER AND BROTHERS WERE ON THEIR WAY TO A HOSTILE LAND THOUSANDS OF MILES AWAY.

183

WHEN ARTEMISIA ARRIVED IN VENICE, SHE WAS IMMEDIATELY CONNECTED TO A GROUP OF STUDENTS AND GRADUATES ASSOCIATED WITH THE UNIVERSITY OF PADUA'S PROFESSOR OF PHILOSOPHY—CESARE CREMONINI. GALILEO AND CREMONINI HAD BEEN RIVALS IN THE 1590S, BUT THEY WERE UNITED ON ONE IMPORTANT ISSUE—THEIR CRITICISM OF THE JESUITS' NEWER UNIVERSITY, WHICH PROVIDED A MORE STRUCTURED, THEOLOGY-BASED EDUCATION. THE UNIVERSITY OF PADUA, ON THE OTHER HAND, WAS UNDER SCRUTINY FROM PAPAL ROME BECAUSE OF ITS ADMISSION OF PROTESTANT STUDENTS FROM OUTSIDE ITALY, AND BECAUSE OF CREMONINI'S PEDAGOGY. HE FOSTERED A MORE CASUAL APPROACH, WITH PRIVATE TUTORING AND OPEN DISCUSSIONS ON CONTROVERSIAL—EVEN DANGEROUS—TOPICS, LIKE THE IMMORTALITY OF THE SOUL AND THE ROLE OF ARISTOTLE WITHIN CATHOLIC DOCTRINE.

VENICE'S GRAND COUNCIL PROTECTED CREMONINI AND THE UNIVERSITY OF PADUA FROM PAPAL SCRUTINY. THE JESUITS WERE BANISHED FROM VENICE IN 1606, CREATING A NEW FREEDOM OF IDEAS.

...MOST WISE AND JUST COUNCIL MEMBERS, THE GRAFFITI SLANDERING THE JESUITS WAS WRITTEN BECAUSE THEY ARE AGGRESSIVE OUTSIDERS WHO DIVIDE OUR YOUTH AND THREATEN THE VERY STRUCTURE OF OUR GREAT REPUBLIC...

VENICE'S RELATIONSHIP WITH THE PAPACY WAS ALSO STRAINED BECAUSE OF ITS CLOSE TIES TO PROTESTANT ENGLAND. THE ROMAN INQUISITION PLACED SPIES THROUGHOUT VENICE. THE ATMOSPHERE WAS CHARGED WITH SECRECY AND DISSIMULATION. PEOPLE WORE MASKS, BOTH LITERALLY AND FIGURATIVELY.

...MY DEAR STUDENTS, think what you like, but say what is expected of you...

THERE WAS ALSO TENSION AMONGST THE NOBLES, WHO ACQUIRED VARIOUS POSITIONS WITHIN VENETIAN GOVERNMENT. RENIERO ZENO, A MEMBER OF THE COUNCIL OF TEN, REALIZED THAT THE REPUBLIC WAS DIVIDED INTO TWO GROUPS—THE GREAT WEALTHY FAMILIES AND EVERYONE ELSE. HE CULTIVATED A SMALL FOLLOWING, BUT HE WAS ASSAULTED BY ASSASSINS.

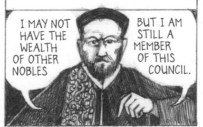

I MAY NOT HAVE THE WEALTH OF OTHER NOBLES

BUT I AM STILL A MEMBER OF THIS COUNCIL.

OTHER WRITERS, LIKE THE BOLOGNESE LUDOVICO ZUCCOLO, SUPPORTED ZENO'S IDEA THAT VENETIAN CIVIL SOCIETY HAD BECOME TOO DIVIDED BY CLASS.

...inequality between citizens is the beginning and source of all seditions and revolutions; Equality by contrast is the source of union and love...

ONE OF ZENO'S FOLLOWERS, A "POOR" NOBLE NAMED MARCO TREVISANO, EMBODIED THIS STRUGGLE WHEN HE BEFRIENDED THE WEALTHIER NOBLE NICCOLO BARBARIGO. IN 1618 NICCOLO WAS THE SUBJECT OF NEGATIVE RUMORS, AND MARCO STOOD UP FOR HIM DESPITE HIS OWN INFERIOR STATUS. BY 1625 THE TWO FRIENDS WERE LIVING TOGETHER AND IN THEIR WILLS THEY PLEDGED ALL OF THEIR BELONGINGS TO EACH OTHER.

THEIR STRONG BOND BECAME A PUBLIC EXAMPLE OF A TRUE, HONORABLE FRIENDSHIP, UNTAINTED BY CLASS DISTINCTIONS AND SELFISH MONETARY CONCERNS—THE PERFECT MODEL FOR AN IDEAL GOVERNMENT. IN ONE OF ZUCCOLO'S DIALOGUES HE WROTE THAT TREVISANO EVEN STOOD UP TO A POWERFUL SENATOR, WHO WAS LATER ELECTED DOGE AND SENT TREVISANO INTO EXILE.

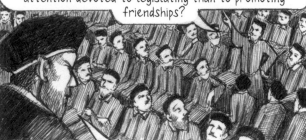

...Signor Molino, if friendship is the necessary prerequisite for justice, why is so much more attention devoted to legislating than to promoting friendships?

SIT DOWN, TREVISANO. The natural imperfection of Man makes the proper hierarchy necessary. There is no place here for your ignorant utopia.

PORTRAIT OF BARBARIGO AND TREVISANO BY JÉRÔME DAVID BASED ON PAINTING BY NICOLAS RÉGNIER

MOST OF THE PEOPLE IN ARTEMISIA'S NEW CIRCLE WERE SUPPORTERS OF TREVISANO AND BARBARIGO. AT THIS TIME MANY SMALL INFORMAL ACADEMIES WERE FORMING THROUGHOUT ITALY. THESE WERE NOT THE STATE-SPONSORED GIANTS LIKE FLORENCE'S ACCADEMIA DEL DISEGNO, BUT INSTEAD ADHERED TO CREMONINI'S MODEL. MEMBERS GATHERED TOGETHER, USUALLY AT SOMEONE'S HOME, FOR DISCUSSION, DEBATE, READINGS, AND EVEN SMALL-SCALE MUSICAL OR THEATRICAL PERFORMANCES. ARTEMISIA'S FIRST PATRON IN VENICE, ANTONINO COLLURAFI, A SICILIAN WRITER AND TUTOR, WAS THE FOUNDER OF ONE OF THESE ACADEMIES—THE ACCADEMIA DEGLI INFORMI.

HIS ACADEMY SERVED AS A TYPE OF PREP SCHOOL FOR VENICE'S UP-AND-COMING ARISTOCRATS, MANY OF WHOM WOULD BECOME THE FORERUNNERS OF ITALY'S LITERARY SCENE AND THE CREATORS OF OPERA.

ARTEMISIA, I'D LIKE YOU TO DESIGN OUR IMPRESA—THE LOGO FOR THE INFORMI! I ALREADY HAVE AN IDEA...

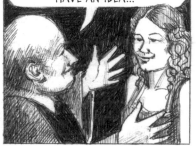

COLLURAFI INTRODUCED ARTEMISIA TO THE EMERGING LEADER OF THIS GROUP—NINETEEN-YEAR-OLD GIAN FRANCESCO LOREDAN. HE WAS ALREADY BECOMING FAMOUS, HAVING PUBLISHED HIS FIRST BOOK AT THE AGE OF FIFTEEN.

I'M ALSO PART OF ANOTHER ACADEMY—THE ACCADEMIA DE' DESIOSI.

YOU'RE INVITED TO COME TO OUR NEXT MEETING, AS WE SOMETIMES ALLOW WOMEN TO ATTEND AS GUESTS. WE'RE OPEN TO WRITERS, MUSICIANS, COMPOSERS, AND PAINTERS OF COURSE. TRY TO COME PREPARED WITH A SHORT, CLEVER SONG OR POEM... IF YOU'RE ABLE TO.

BOTH COLLURAFI AND LOREDAN WROTE LOVING VERSE TO ARTEMISIA.

IS THIS A CHALLENGE? OF COURSE I'LL BE THERE.

AT THE SAME TIME ARTEMISIA REALIZED THAT SHE WAS PREGNANT AGAIN. THE FATHER WAS SOMEONE WHO COULD BE CONSIDERED THE OPPOSITE OF CREMONINI AND HIS RADICAL FOLLOWERS—THE DUKE OF ALCALA.

THE GROUP THAT FORMED AROUND LOREDAN ARE OFTEN REFERRED TO AS LIBERTINES. THEY WERE CRITICAL OF THE PAPACY, THE INQUISITION, SPAIN, AND THE HAPSBURGS. THEY WERE ALSO VERY PROUD OF THE FACT THAT VENICE WAS ONE OF THE FEW ITALIAN CITY-STATES GOVERNED BY A REPUBLIC RATHER THAN AN ABSOLUTE MONARCHY. ONE OF THEIR DISCUSSION TOPICS WAS THE "QUERELLE DES FEMME," ALSO KNOWN AS THE DEBATE ABOUT WOMEN. HOW DID ARTEMISIA INFLUENCE THIS GROUP AND HOW DID THEY INFLUENCE HER? SHE RECEIVED COMMISSIONS FROM SEVERAL OF LOREDAN'S FRIENDS, AND THERE WERE OTHER WOMEN GUESTS.

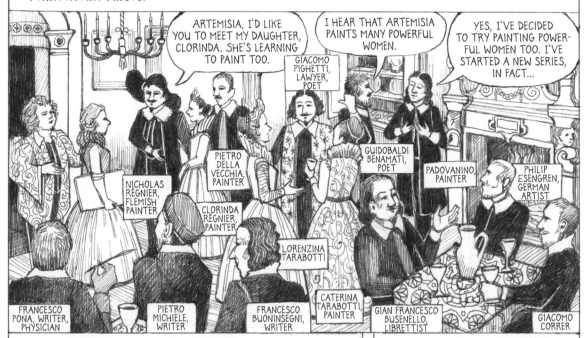

ARTEMISIA, I'D LIKE YOU TO MEET MY DAUGHTER, CLORINDA. SHE'S LEARNING TO PAINT TOO.

I HEAR THAT ARTEMISIA PAINTS MANY POWERFUL WOMEN.

YES, I'VE DECIDED TO TRY PAINTING POWERFUL WOMEN TOO. I'VE STARTED A NEW SERIES, IN FACT...

GIACOMO PIGHETTI, LAWYER, POET

PIETRO DELLA VECCHIA, PAINTER

NICHOLAS RÉGNIER, FLEMISH PAINTER

CLORINDA RÉGNIER, PAINTER

LORENZINA TARABOTTI

GUIDOBALDI BENAMATI, POET

PADOVANINO, PAINTER

PHILIP ESENGREN, GERMAN ARTIST

FRANCESCO PONA, WRITER, PHYSICIAN

PIETRO MICHIELE, WRITER

FRANCESCO BUONINSEGNI, WRITER

CATERINA TARABOTTI, PAINTER

GIAN FRANCESCO BUSENELLO, LIBRETTIST

GIACOMO CORRER

ARTEMISIA SHOCKED THIS GROUP IN VENICE WITH HER DEPICTION OF EITHER THEOXENA OF THESSALY OR MEDEA, TWO WOMEN OF THE ANCIENT WORLD WITH SIMILAR ICONOGRAPHY. WHILE THEOXENA SACRIFICED HER SON SO THAT HE WOULDN'T BE TAKEN AS A PRISONER, MEDEA KILLED HER CHILDREN AFTER THEIR FATHER ABANDONED THEM. BOTH WOMEN WERE UNCOMMON SUBJECTS. THEY WERE CONSIDERED EVIL AND UNNATURAL.

YET THIS IMAGE FITS INTO LOREDAN'S WRITING AND IDEAS. HE COULD BE VERY SERIOUS, BUT ALSO FUNNY AND OUTRAGEOUS. HE LOVED SHOCKING CONTROVERSY, MYSTERY, AND COMPETITIONS OF WIT.

HOW... HOW COULD A WOMAN PAINT SUCH AN IMAGE?

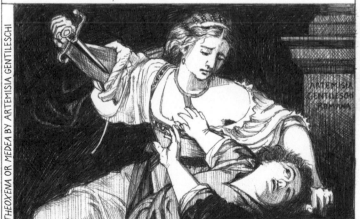

THEOXENA OR *MEDEA* BY ARTEMISIA GENTILESCHI

...WAIT... ARTEMISIA...

THAT IS THE MOST HIDEOUS CHILD I'VE EVER SEEN.

BAHH HA HA HA! I LOVE IT!

IN ORDER TO QUALIFY AS A NOBLE IN VENICE, ONE HAD TO HAVE SOLID EVIDENCE OF THE NOBILITY OF BOTH PARENTS. DUE TO THE CONSTANT INFLATION OF DOWRIES, AND THE UNRELENTING PREOCCUPATION WITH KEEPING THE UPPER CLASSES "PURE," NOBLE PARENTS COULD NOT AFFORD TO MARRY OFF ALL OF THEIR CHILDREN. OFTEN ONLY ONE SON COULD CLAIM HIS INHERITANCE, GET MARRIED, AND CARRY ON THE FAMILY NAME. LIKEWISE, ONLY ONE DAUGHTER COULD GET MARRIED AND PROVIDE THE REQUIRED DOWRY. THEREFORE, WHILE THE LARGE QUANTITY OF BACHELORS FUELED THE FLOURISHING SEX TRADE, CAROUSING WITH COURTESANS IN THE OPERA BOXES, THE SUBSTANTIAL NUMBER OF UNMARRIED WOMEN WERE FORCED INTO CONVENTS. SINCE THE EARLY SIXTEENTH CENTURY, THE CONVENTS OF VENICE WERE STRICTLY ENCLOSED, WALLED OFF FROM THE OUTSIDE WORLD AND RIGOROUSLY REGULATED WITHIN.

MANY OF THESE CONVENTS WERE LIKE PRISONS. HUNDREDS OF WOMEN WERE LOCKED UP.

BUT ONE OF THEM REFUSED TO BE SILENCED...

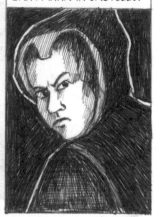

...THE THIRD TARABOTTI SISTER — ARCANGELA OF THE CONVENT OF SANT'ANNA IN CASTELLO.

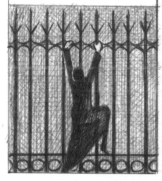

SHE WAS ONE OF LOREDAN'S LIFELONG FRIENDS AND RIVALS.

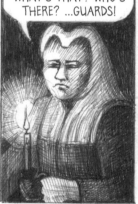

WHAT'S THAT? WHO'S THERE? ...GUARDS!

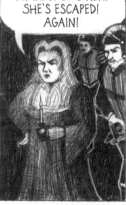

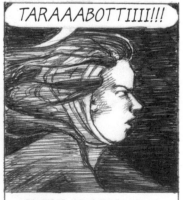

GUARDS! IT'S HER! SHE'S ESCAPED! AGAIN!

TARABOTTI! GET BACK HERE! NOW!

SHE WAS ONLY SEVERAL YEARS OLDER THAN LOREDAN, WHO WOULD SOON BECOME HER PUBLISHER.

SHE WROTE PASSIONATELY AGAINST THE FORCED MONASTICIZATION OF WOMEN.

TARAAABOTTIIII!!!

HER PIECE *CONVENT LIFE AS HELL* WAS CENSORED. SHE WAS FORCED TO RECANT AND REWRITE IT.

PHEW!

ARCANGELA! WHERE IS YOUR CANE? YOU KNOW YOU AREN'T SUPPOSED TO RUN LIKE THAT!

AHH, THE LAME LITTLE NUN HAS FINALLY ARRIVED.

DON'T YOU START WITH ME, LOREDAN!

OH, THERE YOU ARE, THE ONE I CAME TO SEE! I HAD TO SEE YOU AGAIN, LUCREZIA.

LUCREZIA MARINELLA WAS ANOTHER FAMOUS VENETIAN WRITER.

BOTH LUCREZIA AND MODERATA FONTE WROTE ABOUT WOMEN'S RIGHTS. MODERATA DIED WHILE GIVING BIRTH IN 1592, SO HER PIECE *THE WORTH OF WOMEN* WAS PUBLISHED POSTHUMOUSLY. WHEN GIUSEPPE PASSI'S MISOGYNIST TREATISE, *ON FEMININE DEFECTS*, WAS PUBLISHED IN 1599, LUCREZIA WROTE A COUNTER ATTACK — *ON THE NOBILITY AND EXCELLENCE OF WOMEN AND THE DEFECTS AND VICES OF MEN*, PUBLISHED IN 1600. WHEN ARTEMISIA MET HER SHE WAS IN HER SIXTIES AND HAD PRODUCED A SIGNIFICANT BODY OF WORK. SHE WAS INFLUENCED BY HER FATHER AND BROTHER, BOTH DOCTORS WHO ALLOWED HER TO MARRY LATER THAN USUAL.

ARCANGELA, YOUR SHARP TONGUE REMINDS ME OF THE FIRE I HAD WHEN I WAS YOUR AGE.

MY FRIENDS, BEFORE LUCREZIA TELLS US ABOUT HER NEXT EPIC HISTORICAL POEM, ARTEMISIA WOULD LIKE TO INTRODUCE A VERY SPECIAL GUEST TONIGHT...

THANK YOU. I'D LIKE YOU ALL TO MEET...

...MY DAUGHTER, PRUDENZIA. SHE'S JUST TURNED TEN YEARS OLD.

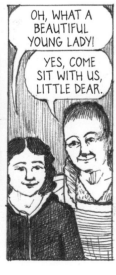
OH, WHAT A BEAUTIFUL YOUNG LADY!

YES, COME SIT WITH US, LITTLE DEAR.

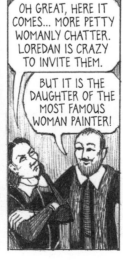
OH GREAT, HERE IT COMES... MORE PETTY WOMANLY CHATTER. LOREDAN IS CRAZY TO INVITE THEM.

BUT IT IS THE DAUGHTER OF THE MOST FAMOUS WOMAN PAINTER!

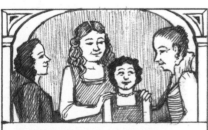
SO ARTEMISIA AND PRUDENZIA FOUND THEMSELVES IN THE SAME CIRCLE AS SOME OF THE MOST IMPORTANT WOMEN WRITERS OF THEIR TIME. IN HER PAINTINGS, ARTEMISIA USED MANY OF THE SAME BIBLICAL AND ANCIENT HEROINES THAT ARCANGELA AND LUCREZIA WROTE ABOUT TO FURTHER THEIR CAUSE.

SOMETIME IN 1626 OR 1627, ARTEMISIA HAD HER LAST CHILD—ANOTHER DAUGHTER REFERRED TO AS ELENA CASSANDRA (CARCANGELA'S NAME FROM BEFORE SHE TOOK HER VOWS).

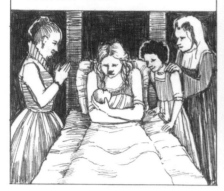

ARTEMISIA, PROMISE ME THAT YOU WILL NOT LOCK UP YOUR DAUGHTERS. YOU MUST PROVIDE DOWRIES FOR BOTH OF THEM.

MY LADIES, YOU CAN COUNT ON ME. MY DAUGHTERS WILL NOT BE MARRIED OFF AS CHILDREN OR FORCED INTO CONVENTS. THEY WILL BE PLACED INTO GOOD MARRIAGES WHEN THE TIME IS RIGHT. I WILL GUARD THEIR HONOR WITH MY LIFE.

DURING THE 1620S, THE ENGLISH KING CHARLES I MADE MULTIPLE DISASTROUS ATTEMPTS TO WIN CONTROL OF THE PALATINATE, FUELED BY HIS OBLIGATION TO SUPPORT HIS SISTER (WHO WAS MARRIED TO THE DISPLACED FREDERICK V) AND THE PROTESTANT CAUSE. THEN, IN 1627 HE SENT HIS RIGHT-HAND MAN, THE DUKE OF BUCKINGHAM, TO A SMALL FRENCH ENCLAVE OF PROTESTANT (HUGUENOT) REBELS IN THE COASTAL TOWN OF LA ROCHELLE. THE GOAL WAS TO SUPPORT THE HUGUENOTS AND REASSERT ENGLISH CONTROL OF THE SURROUNDING SEAS. BUT THE MISSION WAS DESTINED TO FAIL UNLESS CHARLES I COULD OBTAIN THE MONEY TO SEND REINFORCEMENTS. INSTEAD, THE GREAT MONARCH TURNED HIS ATTENTION TO THE GONZAGA'S ART COLLECTION IN MANTUA. IN 1627 AND 1628 HE SENT HIS AGENTS—NICHOLAS LANIER AND ARTEMISIA'S BROTHERS—TO VENICE TO NEGOTIATE THE PURCHASE OF THE MANTUAN COLLECTION.

ALTHOUGH FRANCESCO AND GIULIO GENTILESCHI HAD STARTED FAMILIES BACK IN GENOA, CONTINUOUS TRAVEL THROUGH DANGEROUS LANDS HAD HARDENED THEM.

THE DUKE OF BUCKINGHAM HAS GENEROUSLY PROVIDED FOR US IN ENGLAND.

BUT STILL YOU WOULDN'T BELIEVE THE HOSTILITY TOWARD US CATHOLICS.

WHILE IN ENGLAND, ORAZIO AND HIS SONS HAD BEEN CHALLENGED BY BALTHAZAR GERBIER, ANOTHER COURT PAINTER, ART DEALER, AND AGENT.

FATHER GOT INTO AN ARGU-MENT WITH BALTHAZAR OVER THE QUALITY OF SOME ART, AND BALTHAZAR HAS BEEN AFTER US EVER SINCE. HE THREATENED TO THROW US OUT OF THE KINGDOM, AND HE HAD FRANCESCO ARRESTED ON FALSE CHARGES OF DEBT...

...BUT I WASN'T GOING TO LET THAT BALTHAZAR SCARE ME! I STRUCK A FEW GOOD BLOWS AT HIM WITH MY SWORD. HE GATHERED A GANG OF MEN TO ASSIST HIM, AND MARCO RUSHED TO MY DEFENSE. BUT MY HAND WAS WOUNDED AND WE ALL ENDED UP IN PRISON.

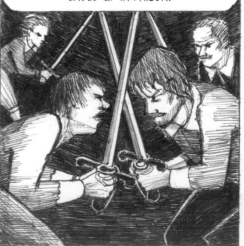

YOU GUYS, PLEASE BE CAREFUL! YOU MUST TAKE CARE OF FATHER.

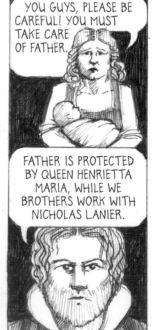

FATHER IS PROTECTED BY QUEEN HENRIETTA MARIA, WHILE WE BROTHERS WORK WITH NICHOLAS LANIER.

NICHOLAS LANIER WASN'T JUST AN AGENT, HE WAS ONE OF THE MOST FAMOUS ENGLISH COURT MUSICIANS OF HIS TIME. LIKE THE CACCINIS IN FLORENCE, HIS MUSICAL FAMILY SANG AND PLAYED FOR THE RULING MONARCHS OF THEIR LAND FOR GENERATIONS.

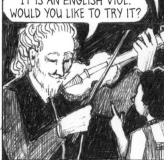

WHAT IS THAT, SIGNOR NICHOLAS?

IT IS AN ENGLISH VIOL. WOULD YOU LIKE TO TRY IT?

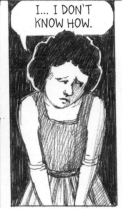

I... I DON'T KNOW HOW.

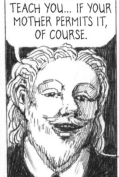

PERHAPS I CAN TEACH YOU... IF YOUR MOTHER PERMITS IT, OF COURSE.

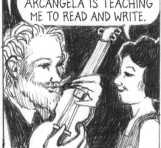

HAVE YOU EVER SEEN A SHEET OF NOTES?

ONLY A FEW TIMES. BUT ARCANGELA IS TEACHING ME TO READ AND WRITE.

EXCELLENT! READING NOTES IS KIND OF LIKE READING WORDS.

SIGNOR NICHOLAS, WON'T YOU JOIN MY FRIENDS AND ME TONIGHT AT THE NEXT MEETING OF THE ACCADEMIA DE' DESIOSI? THERE ARE MANY MUSICIANS IN THE GROUP, YOU'D FIT RIGHT IN.

HOW COULD I SAY NO?

ARTEMISIA'S PLACE WITHIN THE DESIOSI WAS ACKNOWLEDGED WITH JÉRÔME DAVID'S ENGRAVING OF HER BASED ON A SELF-PORTRAIT (NOW LOST). AN INSCRIPTION BELOW THE OVAL CLAIMS THAT SHE IS "MORE EASILY ENVIED THAN IMITATED."

...LADIES AND GENTLEMEN, YESTERDAY I WAS NEARLY RUN OVER BY A COURTESAN AND HER FLOCK OF MAIDSERVANTS. THIS WHORE EMERGED FROM HER GONDOLA WEARING, I KID YOU NOT, EIGHT-INCH PLATFORM SHOES IN AN ATTEMPT TO ELEVATE HERSELF...

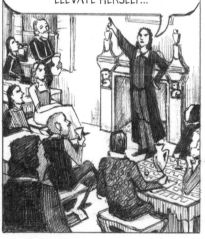

...THIS DISGUSTING DISPLAY OF FEMININE EVIL WAS SHAMELESSLY DISPLAYED FOR ALL TO SEE. IT'S AN EXAMPLE OF WOMEN'S STUPID OBSESSION WITH FRIVOLOUS CLOTHING AND ORNAMENTATION.

BUT IT IS MEN WHO PROVIDE FOR THESE COURTESANS— EVEN AS YOUR WIVES STARVE!

SHE'S RIGHT. PLUS, TAKE A LOOK AT WHAT MEN ARE WEARING THESE DAYS.

Aristotle taught you vain creatures, with your idiotic ruffs and boots, that women are the imperfect, irrational side of humanity; but you have completed your likeness to irrational beasts by twirling each side of your mustaches upward like devil horns.

ARTEMISIA'S PAINTING OF THE BIBLICAL STORY OF ESTHER BEFORE AHASUERUS MAY REFLECT HER INVOLVEMENT IN THESE DEBATES. THE JEWISH HEROINE ESTHER MARRIES THE PERSIAN KING AHASUERUS, BUT THE KING'S MINISTER HAMAN DEVISES A PLOT TO DESTROY ALL THE JEWS. THE KING SIGNS HAMAN'S EDICT, UNAWARE THAT THE QUEEN IS JEWISH. SHE ADVISES THE JEWS TO FAST FOR THREE DAYS AND VOWS TO TELL HER HUSBAND, EVEN THOUGH ENTERING HIS CHAMBER UNINVITED IS PUNISHABLE BY DEATH. WHEN SHE ARRIVES SHE FAINTS AS A RESULT OF FASTING AND FEAR.

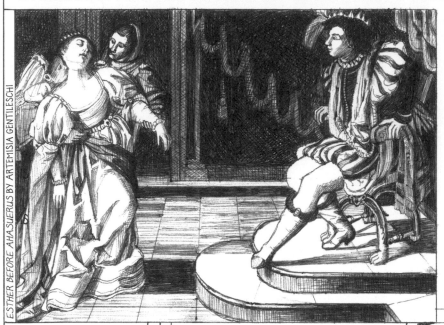

ESTHER BEFORE AHASUERUS BY ARTEMISIA GENTILESCHI

WITH THE HELP OF GOD, THE KING IS NOT ANGRY, BUT INSTEAD TAKES PITY ON HER. ARTEMISIA RENDERED THE MOMENT THAT HE JUMPS UP FROM HIS THRONE TO ASSIST HER. WHILE ARTEMISIA'S ESTHER IS REGAL AND WISE, EVEN AS SHE SWOONS, THE KING IS PORTRAYED AS A JUVENILE DANDY WEARING OUTDATED AND FRIVOLOUS CLOTHING.

MEANWHILE, THE DUKE OF ALCALA AND CASSIANO DAL POZZO HAD NOT FORGOTTEN ARTEMISIA. NEWS OF HER TALENT SPREAD TO SPAIN. THE SPANISH KING PHILIP IV SENT AN AGENT TO BUY HER PAINTING OF HERCULES AND OMPHALE (NOW LOST).

GIOVANNA GARZONI WAS ANOTHER FEMALE PAINTER WORKING FOR CASSIANO DAL POZZO AND THE DUKE OF ALCALA. SHE MADE A NAME FOR HERSELF PAINTING SMALL, ORNATE NATURE STUDIES. SHE TRAVELED A LOT AND WAS IN VENICE ALONGSIDE ARTEMISIA.

STILL-LIFE WITH MELON AND FLY BY GIOVANNA GARZONI

...I'M AFRAID I'LL HAVE TO GO TO NAPLES TO WORK FOR SPAIN. THOSE MEN WILL SEND ME ALL OVER THIS BLASTED LAND BEFORE LETTING ME GO BACK TO WHERE I BELONG—IN ROME WITH MY LADY ANNA COLONNA, TADDEO BARBERINI'S WIFE.

I, TOO, AM IN THE SERVICE OF CASSIANO AND THE DUKE OF ALCALA.

OF COURSE. THEY'RE FOND OF WOMEN, ESPECIALLY THAT SLEAZY DUKE. YOU'VE FALLEN INTO HIS WEB TOO? YOU KNOW HE'S MARRIED, RIGHT?

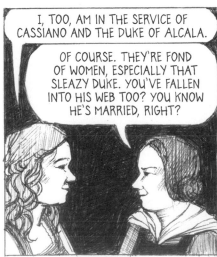

I SHOULD'VE KNOWN.

MY HUSBAND WAS BRIEFLY INVOLVED WITH THAT LOREDAN AND HIS CIRCLE TOO. BUT, LIKE YOU, I'M NOW ESTRANGED FROM MY HUSBAND. UNLIKE YOU, HOWEVER, GOD HAS NOT GIVEN ME DAUGHTERS. YOU'LL HAVE TO PROVIDE DOWRIES FOR THEM. YOU'LL NEED THE HELP OF VERY RICH MEN. THAT'S HOW IT ALWAYS IS FOR US.

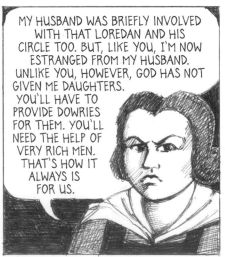

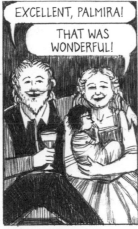

EXCELLENT, PALMIRA!

THAT WAS WONDERFUL!

NOW IT'S TIME FOR BED.

BUT— NOW.

ALRIGHT, ALRIGHT.

GOODNIGHT!

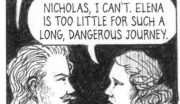

ARTEMISIA GAVE HERSELF PERMISSION TO HAVE AN AFFAIR WITH NICHOLAS LANIER.

IN 1628 THE DUKE OF BUCKINGHAM WAS ASSASSINATED, AND CHARLES I GAVE UP ON WINNING THE PALATINATE. LA ROCHELLE SURRENDERED TO CARDINAL RICHELIEU. CHARLES I KEPT SENDING PAYMENTS THROUGH NICHOLAS FOR THE MANTUAN COLLECTION.

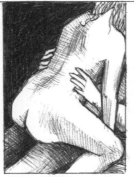

ARTEMISIA, YOU'LL COME BACK TO ENGLAND WITH ME, RIGHT?

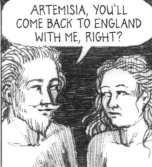

YOUR BROTHERS ARE WASTING KING CHARLES'S MONEY ON THEIR TRAVEL EXPENSES AND THEY ARE CONTINUALLY DISOBEYING ME. *YOU* WOULD MAKE A BETTER AGENT. YOU KNOW THE ART WORLD WELL.

NICHOLAS, I CAN'T. ELENA IS TOO LITTLE FOR SUCH A LONG, DANGEROUS JOURNEY.

I'M SURE WE CAN ARRANGE A SAFE PASSAGE. YOUR FATHER IS ALREADY THERE.

BUT... MY BROTHERS SAY THEY'VE BEEN MISTREATED.

BAH! I HATE TO TELL YOU THIS, BUT YOUR BROTHERS ARE THUGS. THEY DON'T KNOW HOW TO BEHAVE.

NO! THEY ARE ITALIANS. I AM ITALIAN. ROMAN CATHOLIC ITALIAN.

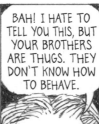

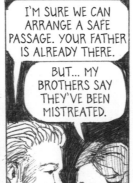

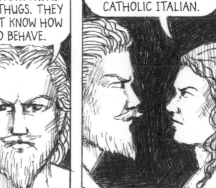

BOTH GUIDO RENI AND GUERCINO REFUSED INVITATIONS TO GO TO ENGLAND. I, TOO, CANNOT LIVE IN A LAND OF HERETICS.

HOW CAN YOU SAY THAT? DON'T I MEAN ANYTHING TO YOU? DON'T YOU CARE ABOUT YOUR FATHER?

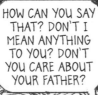

SIGHHH. THE DUKE OF ALCALA HAS ASKED FOR MY ADVICE ON WHICH PAINTINGS TO BUY FOR SPAIN.

SPAIN? SHIT!

ARTEMISIA KNEW THAT GIOVANNA GARZONI WAS RIGHT.

MUSIC LESSONS ARE GREAT FOR MY DAUGHTERS, BUT I NEED MONEY FOR THEM, NICHOLAS.

IN 1629 THE DUKE OF ALCALA WAS APPOINTED VICEROY OF NAPLES, WHICH HAD BEEN RULED BY SPAIN SINCE THE EARLY SIXTEENTH CENTURY. THIS WAS THE MOST PRESTIGIOUS POSITION A SPANISH NOBLE COULD HOPE FOR. NORMALLY PHILIP IV'S PRIME MINISTER RESERVED SUCH OFFICES FOR MEMBERS OF HIS OWN FAMILY, BUT THIS TIME HE DECIDED TO GIVE ARTEMISIA'S PATRON A CHANCE. THE DUKE OF ALCALA'S SUPPORT FOR ARTEMISIA WAS UNWAVERING, AND CASSIANO DAL POZZO MAY HAVE WANTED HER TO PROVIDE A POSITIVE LINK BETWEEN THE BARBERINI AND SPAIN. SO, IN 1629 THESE POWERFUL MEN SENT ARTEMISIA TO NAPLES.

GOODBYE, LUCREZIA, WE'LL MISS YOU.

I'VE SENT WORD TO MY FRIENDS IN THE ACCADEMIA DEGLI OZIOSI THAT YOU'RE COMING. YOU'LL LIKE THEM I'M SURE.

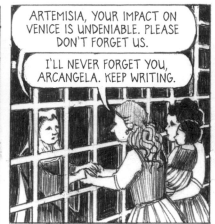

ARTEMISIA, YOUR IMPACT ON VENICE IS UNDENIABLE. PLEASE DON'T FORGET US.

I'LL NEVER FORGET YOU, ARCANGELA. KEEP WRITING.

ARCANGELA! THE SANT'ANNA VISITING HOURS ARE OVER. GET BACK HERE!

NICHOLAS LANIER WASN'T THE ONLY MAN WHO WAS HURT BY ARTEMISIA'S DEPARTURE — GIAN FRANCESCO LOREDAN WAS ALSO UNIMPRESSED WITH HER SPANISH FINERY.

YOU'RE A TRAITOR.

I'M LEAVING THE DESIOSI AND FORMING A NEW ACADEMY — THE ACCADEMIA DEGLI INCOGNITI. I'M GOING TO PUBLISH AUTHORS FROM ALL OVER THE WORLD. WE WILL ALWAYS QUESTION THE TYRANNY OF SPAIN AND ROME, AND THEIR SELFISH RULERS AND CORRUPT INQUISITIONS.

I THOUGHT YOU WERE ONE OF US. I THOUGHT YOU HAD INTEGRITY. BUT YOU THROW IT ALL AWAY. YOU THROW MY LOVE AWAY.

ARTEMISIA AND HER DAUGHTERS EMBARKED ON THEIR JOURNEY ABOARD A ROYAL CARRIAGE DRAWN BY SIX HORSES AND PROPERLY SECURED WITH GUARDS AND SERVANTS. THEIR TIMING WAS PERFECT...

...SHORTLY AFTER THEIR DEPARTURE, THE FIRST OUTBREAKS OF PLAGUE HIT VENICE IN 1630. THE DUKE OF ALCALA AND CASSIANO SENT A TERRIFIED GIOVANNA GARZONI TO NAPLES ALSO.

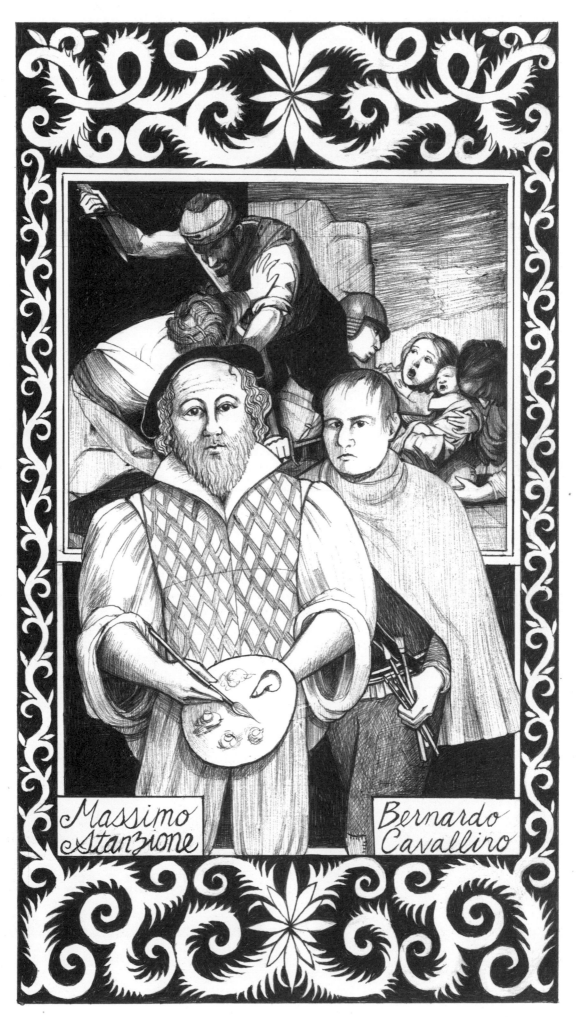

Massimo
Stanzione

Bernardo
Cavallino

AFTER A LONG AND DANGEROUS JOURNEY, ARTEMISIA AND HER DAUGHTERS ARRIVED IN THE CAPITAL OF SOUTHERN ITALY—NAPLES, THE SECOND LARGEST CITY IN EUROPE (AFTER PARIS). PEOPLE WERE DRAWN TO NAPLES FOR MANY REASONS—WHILE SPAIN'S EVER-INCREASING TAXES AFFECTED EVERYONE, RESIDENTS OF THE CAPITAL PAID LESS THAN THOSE IN THE PROVINCES; THE WARM MEDITERRANEAN CLIMATE PRODUCED AN ABUNDANCE OF FRUITS AND OTHER GOODS; THE UNIVERSITY AFFILIATED WITH THE MONASTERY OF SAN DOMENICO NURTURED PROGRESSIVE SCIENTIFIC AND LITERARY THOUGHT—PLUS, THE CITY FEATURED ONE OF EUROPE'S MOST IMPORTANT TRADING PORTS. THE INFLUX OF WEALTHY NOBLES AND MERCHANTS IN THE CAPITAL PROVIDED A VARIETY OF OPPORTUNITIES FOR ARTISTS. YET, ONLY ONE OUT OF EVERY SIX PEOPLE WAS EMPLOYED. OUTSIDE OF THE WEALTHY DISTRICTS, CROWDED MASSES OF PEOPLE—THE "LAZZARONI"—LIVED IN DIRE POVERTY.

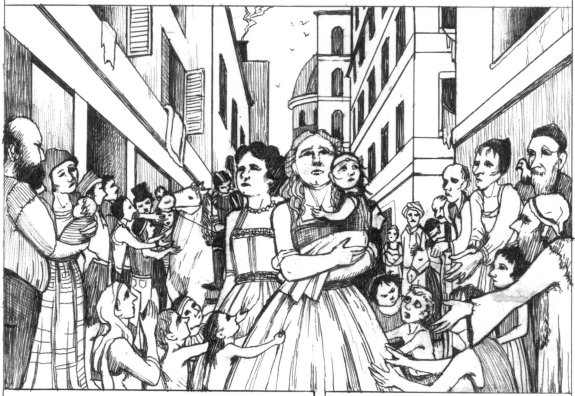

NAPLES WAS RULED BY A SERIES OF SPANISH VICEROYS, ALONGSIDE A NEAPOLITAN BUREAUCRACY WITH FIVE REPRESENTATIVES OF THE OLD, TRADITIONAL ARISTOCRACY AND ONE REPRESENTATIVE OF THE PEOPLE—THE ELETTO DEL POPOLO. IN 1548 THE VICEROY DECLARED THAT FROM THEN ON ONLY THE VICEROYS COULD CHOOSE THE ELETTO DEL POPOLO, SUPPRESSING THE VOICES OF WORKERS AND MERCHANTS. IN 1585 FOOD SHORTAGES LED TO A REVOLT. THE ELETTO DEL POPOLO WAS SEEN AS AN INCOMPETENT SPOKESPERSON FOR THE SPANISH MONARCHY. HE WAS PUBLICLY HUMILIATED AND BRUTALLY MURDERED.

IN THE FOLLOWING YEARS VARIOUS ATTEMPTS AT REFORM WERE MADE, BUT THESE MOVEMENTS WERE SEVERELY REPRESSED. MANY OF THE FEUDAL BARONS RESENTED THE CONTINUOUS TRANSFER OF SOUTHERN ITALY'S MONEY AND RESOURCES TO SPAIN, AND THEY CRUSHED THE LOWER CLASSES' ATTEMPTS TO SET MINIMUM WAGES. FROM 1616 TO 1620 THE VICEROY COLLABORATED WITH THE JURIST GIULIO GENOINO ON A CONSPIRACY TO REFORM THE GOVERNMENT SO THAT COMMON PEOPLE COULD BE REPRESENTED EQUALLY ALONGSIDE NOBILITY.

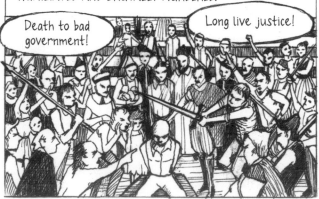

Death to bad government!

Long live justice!

IT SAYS HERE IN SUMMONTE'S *HISTORY OF NAPLES* THAT IT IS SOMETIMES NECESSARY FOR PEOPLE TO STRIKE BACK AGAINST OPPRESSIVE SOVEREIGNS.

BUT WHEN GENOINO WAS DISCOVERED, HE WAS SENT TO A PRISON FORTRESS IN AFRICA.

WHEN PHILIP IV TOOK THE SPANISH THRONE IN 1621, HE DID NOT HESITATE TO USE NAPLES AND THE SURROUNDING PROVINCES TO ASSIST SPAIN DURING THE THIRTY YEARS' WAR. WHEN ARTEMISIA ARRIVED IN THIS METROPOLIS, IT WAS EVEN MORE COMPETITIVE THAN ROME. BUT SHE SAW SOME FAMILIAR FACES AMONG THE ARTISTIC ELITE. IN 1630 DOMENICHINO WAS INVITED TO WORK ON THE CATHEDRAL OF NAPLES.

MASSIMO STANZIONE ALSO LEFT ROME IN 1630 AND ARRIVED IN NAPLES TO WORK ON THE CERTOSA DI SAN MARTINO. A YOUNGER GENERATION OF PAINTERS FLOCKED TO HIS STUDIO TO LEARN, INCLUDING BERNARDO CAVALLINO.

MAESTRO STANZIONE, WHY SHOULD WE CARE ABOUT SOME CHICK PAINTER?

SHE HAS STUDIED IN ROME, FLORENCE, AND VENICE. THEY SAY THAT NO ONE CAN MATCH THE CELESTIAL BEAUTY OF HER COLORS, AND THAT NO MAN CAN EQUAL HER MASTERY OF THE FEMALE FORM. SHE IS ALSO PROTECTED BY OUR VICEROY, THE DUKE OF ALCALA.

IN NAPLES ARTEMISIA PAINTED THIS *ANNUNCIATION*, HER FIRST ALTARPIECE FOR AN UNKNOWN CHURCH. IT FEATURES THE MOMENT WHEN THE ANGEL GABRIEL TELLS THE VIRGIN MARY THAT SHE WILL BEAR THE SON OF GOD. THROUGH CARAVAGGESQUE BLACKNESS, THE WHITE LILY IS A SYMBOL OF MARY'S CHASTITY. THIS WAS ARTEMISIA'S ATTEMPT TO EMBRACE THE SPANISH TASTE FOR FEMININE GRACE AND PIETY.

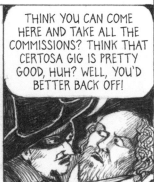

ANNUNCIATION BY ARTEMISIA GENTILESCHI

STANZIONE AND DOMENICHINO'S POPULARITY DID NOT SIT WELL WITH ANOTHER GROUP OF PAINTERS, WHO NOT ONLY ADHERED TO CARAVAGGIO'S PAINTING STYLE BUT ALSO TO HIS AGGRESSIVE, UNPREDICTABLE LIFESTYLE. THEY WERE KNOWN AS THE CABAL.

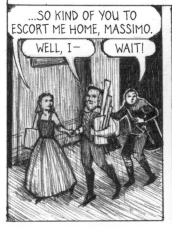

...SO KIND OF YOU TO ESCORT ME HOME, MASSIMO.

WELL, I—

WAIT!

DID YOU HEAR SOMETHING?

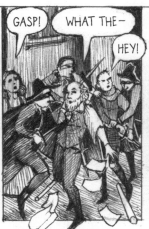

GASP!

WHAT THE—

HEY!

THINK YOU CAN COME HERE AND TAKE ALL THE COMMISSIONS? THINK THAT CERTOSA GIG IS PRETTY GOOD, HUH? WELL, YOU'D BETTER BACK OFF!

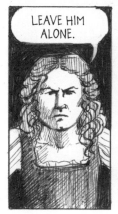

LEAVE HIM ALONE.

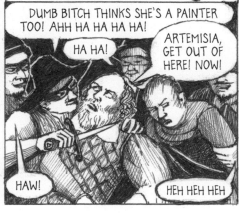

DUMB BITCH THINKS SHE'S A PAINTER TOO! AHH HA HA HA HA!

HA HA!

HAW!

ARTEMISIA, GET OUT OF HERE! NOW!

HEH HEH HEH

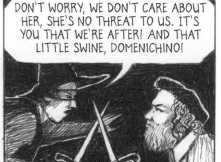

DON'T WORRY, WE DON'T CARE ABOUT HER, SHE'S NO THREAT TO US. IT'S YOU THAT WE'RE AFTER! AND THAT LITTLE SWINE, DOMENICHINO!

IN 1630 ARTEMISIA WROTE TO CASSIANO DAL POZZO. SHE REQUESTED THAT THE PAPAL AMBASSADOR PROVIDE HER ASSISTANT WITH A LICENSE TO CARRY WEAPONS FOR HER PROTECTION.

SIGNOR MASSIMO STANZIONE?

ARTEMISIA!

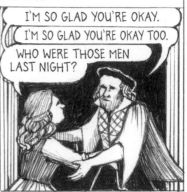

I'M SO GLAD YOU'RE OKAY.

I'M SO GLAD YOU'RE OKAY TOO.

WHO WERE THOSE MEN LAST NIGHT?

IT WAS JUSEPE DE RIBERA AND HIS FOLLOWERS. YOUR PATRON, THE DUKE OF ALCALA, SUPPORTS THEM ALSO.

BUT WHERE ARE YOU GOING? AND WHO IS THIS CHILD?

THIS IS ONE OF MY DAUGHTERS, ELENA. WE ARE GOING TO SEE THE DUKE OF ALCALA NOW...

THE DUKE OF ALCALA WAS STRUGGLING WITH HIS POSITION AS VICEROY OF NAPLES...

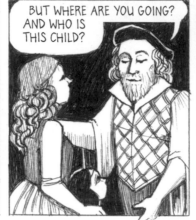

OH HELLO, ARTEMISIA, WHAT DO YOU WANT?

WELL... I'D LIKE YOU TO MEET YOUR DAUGHTER. SHE'S THREE YEARS OLD AND HER NAME IS—

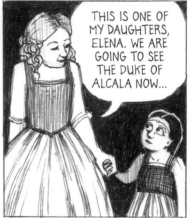

YES, YES, VERY WELL. NOW GET THIS CHILD OUT OF HERE. LISTEN, I NEED YOU TO HELP ENTERTAIN HIS HIGHNESS PHILIP IV'S SISTER, THE INFANTA MARIA ANNA. SHE'S STOPPING HERE ON HER WAY TO VIENNA.

BUT—

PLEASE. I ALREADY HAVE THE BEST SPANISH ARTISTS PAINTING PORTRAITS OF HER LADIES OF THE COURT. BUT I NEED YOUR FEMININE CHARM AND GRACE TO MAKE A GOOD IMPRESSION.

BUT I HAVE LITTLE EXPERIENCE WITH ROYAL COURTS.

YOU CAN WRITE TO CASSIANO IF YOU NEED ANYTHING, LIKE LITTLE GIFTS OR WHATEVER TO PLEASE THE LADIES. AND MAKE SURE TO LET CASSIANO KNOW IF MARIA ANNA HAS ANY ANTI-BARBERINI LEANINGS, OKAY?

BUT—

I'M SORRY, BUT I'M VERY BUSY, MY DEAR. IF I COULD DANCE AROUND COLLECTING ART ALL DAY, I WOULD, BUT I CAN'T.

THESE NEAPOLITANS ARE IMPOSSIBLE! THE ARISTOCRACY HAS WAY TOO MUCH POWER, THEY REFUSE TO COOPERATE! AND NOW THE CITY LAWYERS ARE REFUSING TO PROVE THEIR CREDENTIALS TO ME LIKE I ... THERE'S THAT ... KE OF ALB ... WHY

... FAIR!

NOT A I CAN'T

SO ARTEMISIA FOUND HERSELF PLAYING THE ROLE OF FEMALE COURTIER, AN HONORARY MEMBER OF THE SPANISH HAPSBURG COURT.

OOOH, THE LADY PAINTER!

I JUST LOVE ITALY!

TELL US, HOW DID YOU LEARN?

WITH THE EXCEPTION OF THE MEDICI'S BRIEF FEMALE REGENCY, ARTEMISIA HAD MOSTLY BEEN INVOLVED WITH PRESTIGIOUS CIRCLES OF MEN, NOT WOMEN.

LADIES, I BROUGHT EACH OF YOU A NEW PAIR OF GLOVES.

OH, HOW LOVELY.

HOW DO THEY LOOK?

SPLENDID!

SHE MAY HAVE FELT OVERSHADOWED BY THE ILLUSTRIOUS SPANISH COURT PAINTER DIEGO VELÁZQUEZ, WHO WAS ALSO PAINTING FOR MARIA ANNA ON HIS FIRST TRIP TO ITALY.

HOLD STILL NOW. HIS HIGHNESS, YOUR BROTHER, WANTS AN EXCELLENT LIKENESS OF YOU SO THAT HE CAN REMEMBER YOU.

JUSEPE DE RIBERA! WE'VE HEARD ALL ABOUT YOU.

I SAW SOME PAINTINGS YOU DID OF SOME DISGUSTING, DISAGREEABLE OLD MEN!

HEY, WAIT A MINUTE...

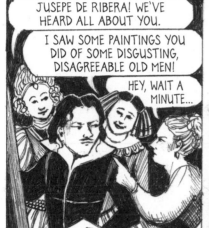

I RECOGNIZE YOU FROM THE STREET THE OTHER EVENING.

JUSEPE DE RIBERA, YOU COWARD! YOU'D BETTER LEAVE ME AND MY FRIENDS ALONE. YOU'RE NOT THE ONLY ONE WITH THE VICEROY'S PATRONAGE AND PROTECTION. I SWEAR IF YOU EVER TRY TO—

WHEN MARIA ANNA WAS A TEENAGER, CHARLES I HAD ATTEMPTED TO MARRY HER. BUT SHE WAS STAUNCHLY CATHOLIC AND REFUSED TO MARRY THE PROTESTANT PRINCE.

ARTEMISIAAAAAAAHH! WON'T YOU TEACH US TO PAINT TOOO?

NOW SHE WAS ON HER WAY TO MARRY THE KING OF HUNGARY, THE SOON-TO-BE NEW HOLY ROMAN EMPEROR. THE FACT THAT HE WAS HER COUSIN WAS CONSIDERED NORMAL, ESPECIALLY FOR THE HAPSBURGS.

LADIES, THE DUKE OF ALCALA HAS JUST INFORMED ME THAT OUR STAY HERE IN NAPLES HAS BEEN, AHEM, TOO EXPENSIVE.

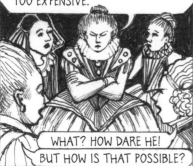

WHAT? HOW DARE HE! BUT HOW IS THAT POSSIBLE?

SOME CRACKS WERE FORMING IN THE HAPSBURG STRONGHOLD. RICHELIEU SENT QUEEN MARIE DE' MEDICI INTO EXILE ONCE AND FOR ALL, ELIMINATING FRANCE'S MAIN HAPSBURG SYMPATHIZER. WITH RICHELIEU'S UNBRIDLED POWER, TENSION BETWEEN SPAIN AND FRANCE GREW. HE FORMED AN ALLIANCE WITH THE SWEDISH GUSTAVUS ADOLPHUS, A NEW PROTESTANT FORCE BLAZING THROUGH EUROPE. SWEDISH TROOPS OCCUPIED POMERANIA. THEN, WITH SAXONY ON HIS SIDE, GUSTAVUS ADOLPHUS LED OVER 40,000 SOLDIERS TO CRUSH CATHOLIC AND IMPERIAL FORCES AT THE BATTLE OF BREITENFELD, AND HEADED INTO THE LOWER PALATINATE BY 1631.

IN 1631 THE DUKE OF ALCALA WAS SENT BACK TO SPAIN AND REPLACED BY MANUEL DE ZÚÑIGA Y FONSECA, ALSO KNOWN AS THE COUNT OF MONTERREY. LIKE THE DUKE OF ALCALA, THE COUNT HAD SPENT TIME IN ROME AS A SPANISH AMBASSADOR, AND HE WAS AN AVID PATRON OF THE ARTS.

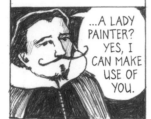

...A LADY PAINTER? YES, I CAN MAKE USE OF YOU.

HE CONTINUALLY SENT ITALIAN ART BACK TO SPAIN TO DECORATE BOTH HIS OWN AND PHILIP IV'S LAVISH BUILDING PROJECTS.

YOU HAVE NOTHING TO FEAR. I SHALL TAKE OVER THE DUKE OF ALCALA'S ROLE AS YOUR PATRON AND PROTECTOR. I THINK IT FITTING THAT—

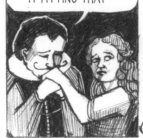

THEN, SUDDENLY A NEW TERROR HIT NAPLES. THE GREAT VOLCANO MOUNT VESUVIUS, THE "MOUTH OF HELL," TOWERED ABOVE THE CITY ABOUT SIX MILES TO THE SOUTH. IT HAD ERUPTED AS EARLY AS A.D. 79 WHEN PLINY THE YOUNGER WROTE ABOUT ITS EXPLOSIVE HORRORS.

WAIT... DID YOU HEAR SOMETHING?

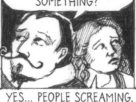

YES... PEOPLE SCREAMING.

ON DECEMBER 16, 1631, THE SKY TURNED OMINOUSLY BLACK.

WHAT... OH MY LORD, OH GOD NO... IT CAN'T...

GASP!

A STEADY RAINFALL BEGAN, FOLLOWED BY A SERIES OF EARTHQUAKES.

I HAVE TO GO!

THE NEXT DAY MOUNT VESUVIUS ERUPTED. TORRENTS OF ASH, SULFUR, AND CHOKING VAPORS CASCADED DOWN THE ANCIENT MOUNTAIN TOWARD THE SEA, KILLING EVERYTHING IN ITS PATH, FOLLOWED BY A TSUNAMI. 4,000 TO 6,000 PEOPLE DIED.

ARTEMISIA LIVED NEAR VIA TOLEDO, NOT FAR FROM THE SPANISH QUARTER AND THE ROYAL PALACE. LUCKILY, HER AREA WAS AFFECTED LESS THAN SOUTHERN NAPLES.

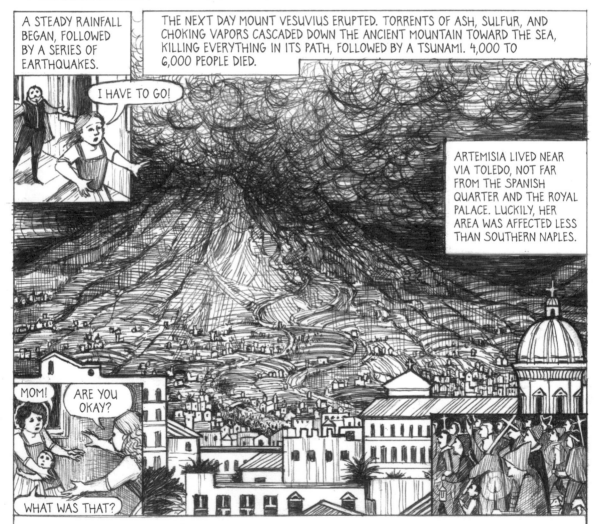

MOM!

ARE YOU OKAY?

WHAT WAS THAT?

ON DECEMBER 19TH, A RESCUE TEAM MANAGED TO SAVE A FEW PEOPLE, BUT THE CITY'S MAIN DEFENSE CONSISTED OF PRAYERS TO SAINT JANUARIUS. BACK IN THE YEAR 305, THE PAGAN RULER TIMOTHEUS HAD CONDEMNED JANUARIUS AND HIS CHRISTIAN FOLLOWERS TO DEATH. BUT JANUARIUS MIRACULOUSLY SURVIVED BEING THROWN INTO A FIERY FURNACE. NOW, DURING THE ERUPTION, PEOPLE HAD VISIONS OF JANUARIUS IN THE SKY AMIDST THE GLOOM, STOPPING THE FLOW OF LAVA. THE CHURCH FATHERS LED PROCESSIONS THROUGH THE STREETS WITH TORCHES AND RELICS. PEOPLE SAW THE ERUPTION AS PUNISHMENT FROM GOD, A WARNING TO NAPLES OF DIFFICULT TIMES AHEAD.

NOT ONLY DID ARTEMISIA SURVIVE, SHE CONTINUED TO PAINT. IN 1632 SHE COMPLETED THIS *CLIO, MUSE OF HISTORY*, AN ALLEGORY WITH A CROWN OF LAUREL, A TRUMPET, AND A BOOK (THE TRADITIONAL ATTRIBUTES SPECIFIED IN THE POPULAR *ICONOLOGIA* BY CESARE RIPA). THE BOOK IS OPEN, DISPLAYING ARTEMISIA'S SIGNATURE AND THE DATE, IN ADDITION TO A DEDICATION TO "THE ILLUSTRIOUS M. IN MEMORY OF ROSIERES." THIS PROBABLY REFERS TO THE DUKE OF GUISE, WHOSE MAITRE D'HOTEL, ANTOINE DE ROSIERES, DIED IN 1631.

THE DUKE OF GUISE, RULER OF LORRAINE, SUPPORTED MARIE DE' MEDICI, AND WHEN RICHELIEU BANISHED HER FROM FRANCE, THE DUKE OF GUISE FLED TOO. HE ENDED UP IN TUSCANY IN 1631. PERHAPS ARTEMISIA'S OLD TUSCAN FRIEND GALILEO REFERRED THE DUKE OF GUISE TO HER FOR THIS MEMORIAL OF ROSIERES. BY PUTTING HER OWN NAME IN THE BOOK, SHE ALSO MEMORIALIZED HERSELF.

CLIO, MUSE OF HISTORY BY ARTEMISIA GENTILESCHI

BUT GALILEO WAS ABOUT TO EMBARK ON HIS OWN STRUGGLE WITH THE FRENCH-LEANING BARBERINI IN ROME. IN 1632 HIS *DIALOGUE ON THE TWO CHIEF WORLD SYSTEMS* WAS PUBLISHED, A RETURN TO COPERNICAN THEORY DESPITE ITS BAN. IN THE DIALOGUE, THE IGNORANT, MISINFORMED "SIMPLICIO" WAS SEEN AS SUSPICIOUSLY SIMILAR TO POPE URBAN VIII HIMSELF. IN 1633 GALILEO WAS CALLED TO ROME TO FACE THE INQUISITION.

MEANWHILE, ARTEMISIA WAS WORKING WITH MASSIMO STANZIONE ON A SERIES OF PAINTINGS DEPICTING THE LIFE OF ST. JOHN THE BAPTIST FOR PHILIP IV'S BUEN RETIRO PALACE IN SPAIN. SHE WAS ASSIGNED TO ONE PIECE OF THE SERIES (*THE BIRTH OF ST. JOHN*) WHILE STANZIONE WAS ASSIGNED TO THE OTHER FOUR. ALL THE MOST FAMOUS ARTISTS CONTRIBUTED TO THE BUEN RETIRO, INCLUDING DOMENICHINO, POUSSIN, RUBENS, VAN DYCK, AND VELAZQUEZ.

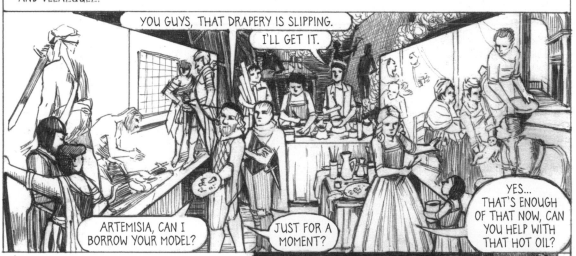

IN THE BIBLE THE ELDERLY PRIEST ZACHARIAS IS TOLD BY AN ANGEL THAT HIS WIFE WILL GIVE BIRTH TO A SON. WHEN ZACHARIAS EXPRESSES DOUBT, THE ANGERED ANGEL REMOVES HIS ABILITY TO SPEAK. WHEN THE BABY IS BORN, ZACHARIAS WRITES ON A PIECE OF PAPER, "HIS NAME IS JOHN." IN HER PAINTING ARTEMISIA WROTE HER OWN NAME ON A SCRAP OF PAPER STRATEGICALLY PLACED ON THE FLOOR. ZACHARIAS IS SHOWN ON THE FAR LEFT, SO THAT THE FOCUS IS ON THE MIDWIVES CIRCLED AROUND THE NEWBORN INFANT. THUS, ARTEMISIA PAID A TRIBUTE TO THE WORKING WOMEN WHO HAVE DELIVERED BABIES THROUGHOUT THE AGES—THE WOMEN CALLED BY THE MAGISTRATES TO EXAMINE HER DURING THE TRIAL MANY YEARS AGO, THE WOMEN WHO HELPED DELIVER HER OWN CHILDREN.

THE BIRTH OF ST. JOHN THE BAPTIST BY A. GENTILESCHI

ARTEMISIA ALSO ATTENDED MEETINGS OF THE ACCADEMIA DEGLI OZIOSI, WHICH WAS SIMILAR TO THE VENETIAN ACCADEMIA DE DESIOSI AND LOREDAN'S ACCADEMIA DEGLI INCOGNITI.

I'M TORQUATO ACCETTO. I HEAR YOU'VE MET THE FAMOUS GIAN FRANCESCO LOREDAN? WE ALL ADMIRE HIS WORK. WHAT IS THE VENETIAN REPUBLIC LIKE COMPARED TO—

I'M SORRY, SIGNOR TORQUATO, BUT THAT IS NOT APPROPRIATE SUBJECT MATTER. ARTEMISIA, ONE OF OUR RULES HERE AT THE OZIOSI IS THAT WE DO NOT SPEAK OF POLITICS OR THEOLOGY. IT KEEPS THE ATMOSPHERE MUCH MORE PLEASANT, YOU'LL SEE.

ARTEMISIA! MY NAME IS GIROLAMO FONTANELLA. I'VE HEARD ALL ABOUT YOU! I AM NO PAINTER, BUT I GREATLY ADMIRE THE VISUAL ARTS. I BELIEVE THAT POETRY AND PAINTING ARE SISTER ART FORMS—PAINTING IS MUTE POETRY, WHILE POETRY IS SPOKEN PAINTING!

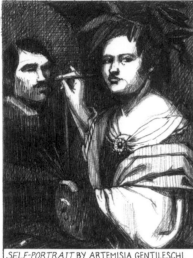

GIROLAMO FONTANELLA WROTE POETRY ABOUT ARTEMISIA'S BEAUTY AND SKILL, AND COMMISSIONED PAINTINGS FROM HER. IT'S POSSIBLE THAT THIS SELF-PORTRAIT WAS FOR HIM. IN IT, A WISE FORTY-YEAR-OLD ARTEMISIA LOOKS DIRECTLY OUT AT THE VIEWER, CROWNED IN LAUREL, WHICH WAS OFTEN A SYMBOL FOR POETRY AND IMMORTALITY. SHE'S IN THE MIDDLE OF PAINTING AN UNKNOWN MAN, PERHAPS THE PATRON.

SELF-PORTRAIT BY ARTEMISIA GENTILESCHI

ARTEMISIA ALSO BECAME ACQUAINTED WITH VIVIANO CODAZZI, WHO ARRIVED IN NAPLES IN 1634, AND DOMENICO GARGIULO, WHO WAS KNOWN AS MICCO SPADARO SINCE HIS FATHER WAS A SWORDSMITH. THESE TWO PAINTERS SPECIALIZED IN LANDSCAPE, ARCHITECTURE, AND BATTLE SCENES. BUT THERE WAS NO SINGLE GLORIFIED HERO IN THEIR BATTLE SCENES, ONLY THE CHAOS AND BRUTALITY OF WAR.

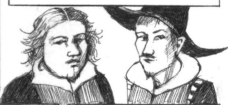

...I JUST GOT BACK FROM ROME, WHERE I MET THE MOST FANTASTIC LANDSCAPE PAINTER YET—AGOSTINO TASSI! HE'S REALLY INSPIRED ME. HAVE YOU HEARD OF HIM?

UMM... NO, NEVER HEARD OF HIM.

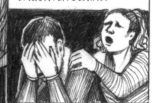

IN 1634 DOMENICHINO ABANDONED HIS WORK AND FLED TO FRASCATI BECAUSE OF CONTINUOUS THREATS FROM JUSEPE DE RIBERA'S CABAL. HE HAD TO LEAVE HIS WIFE AND DAUGHTER BEHIND.

BUT THE OTHER GREAT FOLLOWER OF THE CARACCI, GIOVANNI LANFRANCO, ARRIVED IN NAPLES IN 1634 UNDAUNTED BY RIBERA'S CABAL.

ARTEMISIA GENTILESCHI IS STILL HERE? I CAN'T BELIEVE THE NOBILITY PAY SO MUCH FOR WOMEN'S WORK.

MASSIMO STANZIONE, THE RISING ART STAR OF NAPLES, WAS UNFAZED BY LANFRANCO'S DISMISSIVE ATTITUDE TOWARD WOMEN ARTISTS—HE TOOK ON ANOTHER APPRENTICE—DIANA DE ROSA, KNOWN AS ANNELLA.

ANNELLA WAS A YOUNG MOTHER MARRIED TO AGOSTINO BELTRANO. BOTH HER HUSBAND AND UNCLE WERE PAINTERS IN NAPLES, FOLLOWERS OF STANZIONE AND ARTEMISIA.

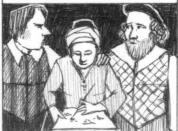

ARTEMISIA, PLEASE DO NOT THINK OF ME AS COMPETITION! I COULD NEVER REACH SUCH GLORY AND FAME AS YOURSELF. I AM YOUR HUMBLE SERVANT.

WHEN ANNELLA VISITED ARTEMISIA'S STUDIO, SHE WAS WORKING ON ANOTHER RENDITION OF CLEOPATRA. UNLIKE THE WARM, SENSUAL VERSION SHE PAINTED FOR THE DUKE OF ALCALA, THIS COLD, PALE CLEOPATRA IS ALREADY DEAD. THE POISONOUS ASP THAT BIT HER IS STILL ON THE BED, AND HER TWO MAIDSERVANTS HAVE JUST DISCOVERED THEIR DEAD QUEEN.

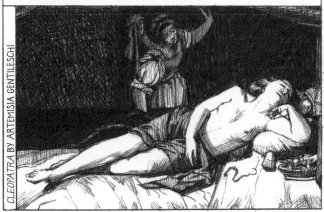

CLEOPATRA BY ARTEMISIA GENTILESCHI

IN 1634 THE ENGLISH TRAVELER BULLEN REYMES VISITED ARTEMISIA AND REPORTED THAT PALMIRA PLAYED THE SPINET FOR HIM.

...ABSOLUTELY WONDERFUL! EXCELLENT! DOES THE REST OF THE GENTILESCHI FAMILY KNOW HOW TALENTED YOUR DAUGHTER IS? YOU SIMPLY MUST COME TO ENGLAND!

MOTHER?

MOTHER—

YOU'RE FAMILIAR WITH THE STORY OF SAMSON AND DELILAH, RIGHT?

DELILAH WAS A PHILISTINE WHO TRICKED HER LOVER SAMSON, TSK. SHE DISCOVERED THAT HIS HAIR WAS THE SOURCE OF HIS POWER, SO SHE CUT IT OFF WHILE HE SLEPT. THEN THE—

MOTHER!

WHAT?

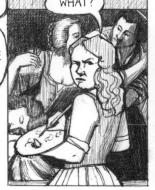

FRANCE HAS ATTACKED THE SPANISH NETHERLANDS.

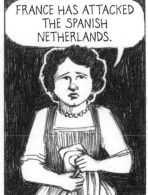

WHERE DID YOU HEAR THAT?

I OVERHEARD THAT ENGLISHMAN TALKING ABOUT IT. AND I HEARD THE SERVANT MENTION IT TOO. PEOPLE ARE WORRIED ABOUT THE VICEROY INCREASING TAXES FOR SPAIN'S DEFENSE. EVEN THE RICH BARONS ARE SELLING THEIR LANDS IN THE PROVINCES.

I'VE HEARD YOU COMPLAIN ABOUT OUR LACK OF MONEY TOO. BUT I NEED A HUSBAND. I NEED A DOWRY. PEOPLE ARE TALKING ABOUT ME.

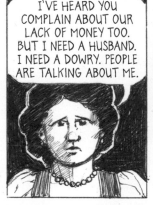

SIGHHH. DON'T WORRY. FORGET ABOUT WHAT PEOPLE SAY.

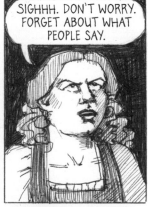

OUR JOB IS TO PAINT! AND—

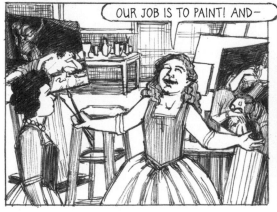

NO, MOM. I'M SEVENTEEN YEARS OLD. I CAN'T STAY HERE AND BE YOUR ASSISTANT FOREVER.

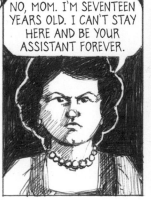

THE COUNT OF MONTERREY WAS SOON TO BE SENT BACK TO SPAIN. WOULD ANOTHER VICEROY SUPPORT ARTEMISIA? IN 1636 AND 1537 HER LETTERS BECAME MORE DESPERATE. IN ONE LETTER TO CASSIANO DAL POZZO IN ROME, SHE ASKED IF HER HUSBAND, PIERANTONIO STIATTESI, WAS STILL ALIVE. SHE REACHED OUT TO POTENTIAL PATRONS OUTSIDE OF NAPLES. HER BROTHER FRANCESCO ARRIVED TO RETRIEVE PAINTINGS TO DELIVER TO THE BARBERINI IN ROME, THE MEDICI IN FLORENCE, AND FRANCESCO I D'ESTE IN MODENA.

SISTER, I WISH YOU'D GET OUT OF THIS MESS BETWEEN SPAIN AND FRANCE, AND COME JOIN US IN ENGLAND. IT'S PEACEFUL THERE NOW. FATHER HAS LOTS OF WORK.

SHE WROTE TO GALILEO, WHO WAS UNDER HOUSE ARREST AT HIS HOME IN ARCETRI. HE HAD MANAGED TO ESCAPE DEATH BY RECANTING AND DENYING HIS HERETICAL VIEWS. ARTEMISIA WROTE TO HIM ASKING FOR HELP, AND EXPRESSED RELIEF THAT HE WAS ALL RIGHT. SHE ALSO MENTIONED THAT HE COULD CORRESPOND WITH HER THROUGH FRANCESCO MARIA MARINGHI, SO SHE WAS STILL CONNECTED TO HER OLD FLORENTINE FLAME.

I'M GOING TO BE A PRETTY PRINCESS!

YOU ARE NOT, ELENA.

YES I AM! MY DADDY WAS A VICEROY!

AT THE SAME TIME, ARTEMISIA EMBARKED ON ONE OF HER MOST LUCRATIVE COMMISSIONS—THE CHOIR ALTARPIECES IN THE DUOMO OF THE POZZUOLI CATHEDRAL ABOUT SIX MILES OUTSIDE OF NAPLES. AGAIN SHE WORKED ALONGSIDE STANZIONE AND OTHERS, INCLUDING AGOSTINO BELTRANO. THE CENTER OF ARTEMISIA'S DEVOTIONAL IMAGERY WAS A GRAND SAINT JANUARIUS. NOT ONLY DID JANUARIUS SURVIVE THE FIERY FURNACE, HE ALSO MIRACULOUSLY SURVIVED BEING THROWN INTO AN AMPHITHEATER FULL OF WILD BEASTS. MICCO SPADARO AND VIVIANO CODAZZI HELPED PAINT THE AMPHITHEATER, WHICH IN REALITY EXISTED IN RUINS ONLY UP TO THE FIRST LEVEL. THE PIECE SHOWCASES ARTEMISIA'S EXPERTISE WITH FIGURES AND FABRICS, AND SPADARO'S KNACK FOR PAINTING NUMEROUS SMALL FIGURES WITHIN CODAZZI'S ARCHITECTURAL SETTINGS. ARTEMISIA ALSO PAINTED THE *SAINTS PROCULUS AND NICEA* WITH SPADARO AND CODAZZI'S HELP. PROCULUS, THE DEACON OF POZZUOLI, AND HIS MOTHER, NICEA, WERE AMONG JANUARIUS'S FOLLOWERS, MARTYRED ALONG WITH HIM WHEN KING TIMOTHEUS BEHEADED THEM ALL. CODAZZI'S LOGGIA IN THE BACKGROUND THROUGH THE ARCH CREATES THE ANCIENT ROMAN CONTEXT. ARTEMISIA'S FINAL POZZUOLI PIECE WAS A TRADITIONAL *ADORATION OF THE MAGI*, WHERE THE SOLEMN VIRGIN PRESENTS THE CHRIST CHILD TO THE THREE VISITING KINGS.

SAINTS PROCULUS AND NICEA BY ARTEMISIA GENTILESCHI

SAINT JANUARIUS IN THE AMPHITHEATER BY ARTEMISIA GENTILESCHI

ADORATION OF THE MAGI BY ARTEMISIA GENTILESCHI

ARTEMISIA ALSO COLLABORATED WITH SPADARO AND CODAZZI ON ANOTHER BIBLICAL THEME SHE WOULD RETURN TO MANY TIMES—THE STORY OF DAVID AND BATHSHEBA. WHILE OUT ON HIS BALCONY, KING DAVID SPIES BATHSHEBA, WIFE OF THE HITTITE SOLDIER URIAH, AND FALLS IN LOVE WITH HER AS SHE BATHES. DAVID EVENTUALLY SENDS URIAH FURTHER INTO BATTLE WHERE HE DIES, ENABLING DAVID TO TAKE BATHSHEBA FOR HIMSELF. SPADARO PAINTED THE SMALL, DISTANT DAVID WITHIN CODAZZI'S BACKGROUND ARCHITECTURE AND ASSISTED WITH THE FOLIAGE.

IN THE 1630S AND '40S, ARTISTS IN NAPLES GRADUALLY MOVED AWAY FROM CARAVAGGIO'S STARK NATURALISM TOWARD A MORE CLASSICAL BOLOGNESE MANNER, WITH HINTS OF VENETIAN COLOR. EVEN JUSEPE DE RIBERA'S HARSH TENEBRISM BECAME SOFTER AND MORE COLORFUL IN THE 1630S. ARTEMISIA WAS IN THE MIDST OF THIS TRANSITION. HER TECHNIQUES WERE INFLUENTIAL—ESPECIALLY HER BLUE, WHITE, AND OCHRE TONES.

THANK GOD YOU'RE HERE! I REALLY NEED YOUR ASSISTANCE WITH THIS FIGURE, I CAN'T SEEM TO GET IT.

HMMM. I SEE THIS IS A MUCH LARGER SCALE FOR YOU TOO.

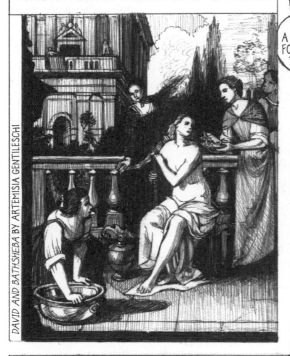

DAVID AND BATHSHEBA BY ARTEMISIA GENTILESCHI

LOT AND HIS DAUGHTERS BY ARTEMISIA GENTILESCHI

HER APPROACH TO RENDERING WOMEN ALSO INFLU- ENCED MANY OF HER CONTEMPORARIES, ESPECIALLY STANZIONE AND CAVAL- LINO. SOME- TIMES HER PAINTINGS ARE CONFUSED WITH THEIRS. SHE PAINTED ALL THE POPULAR BIBLICAL STORIES OF HER TIME, LIKE LOT AND HIS DAUGHTERS. WHEN GOD DESTROYS SODOM AND GOMORRAH, LOT AND HIS DAUGHTERS HIDE IN A CAVE. THE DAUGHTERS REALIZE THAT IN ORDER TO KEEP THEIR RACE ALIVE, THEY MUST HAVE INTERCOURSE WITH THEIR FATHER. UNLIKE OTHER DEPICTIONS OF THIS STORY, IN ARTEMISIA'S VERSION LOT'S DAUGHTERS AREN'T OVERLY EROTIC AND SEDUCTIVE, BUT HUMBLY RESIGNED TO THEIR TASK.

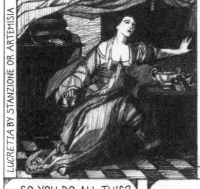

LUCRETIA BY STANZIONE OR ARTEMISIA

...SO YOU DO ALL THIS? EVEN WITH CHILDREN? AND NO HUSBAND?

WELL... YES.

BUT I DON'T GET PAID AS MUCH AS MEN. AND I STILL DON'T HAVE PRUDENZIA'S DOWRY! THE COST OF LIVING IS INCREASING FASTER THAN I CAN KEEP UP. I MIGHT HAVE TO LEAVE.

BUT YOU'RE AN INSPIRATION TO EVERYONE HERE! I'M ABOUT TO GIVE BIRTH TO MY FIFTH CHILD, BUT YOU'VE INSPIRED ME TO KEEP PAINTING.

THANK YOU, ANNELLA. BUT I'M NOT SO SURE. IT'S SO DANGEROUS HERE. HOW ARE WE SUPPOSED TO RAISE OUR CHILDREN? I SEE PALMIRA GAZING OUT THE WINDOW THE WAY I DID WHEN I WAS HER AGE.

IN THE LATE 1630S ARTEMISIA PERFECTED HER REPUTATION AS A COLORIST WITH PAINTINGS LIKE *CHRIST AND THE SAMARITAN WOMAN*, WITH ITS VIVID BLUE, RED, AND WHITE.

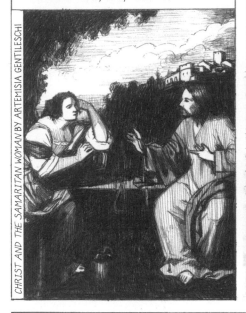

CHRIST AND THE SAMARITAN WOMAN BY ARTEMISIA GENTILESCHI

SHE WASN'T LIMITED TO BIBLICAL AND MYTHOLOGICAL SUBJECTS EITHER. *CORISCA AND THE SATYR* SHOWS ACT TWO, SCENE SIX OF GIOVANNI BATTISTA GUARINI'S SIXTEENTH-CENTURY PLAY *IL PASTOR FIDO*. CORISCA, THE LASCIVIOUS COUNTERPART TO THE CHASTE AMARYLLIS, IS CAPTURED BY A SATYR. HE GRABS HER BY THE HAIR AND JUST AS HE'S ABOUT TO SNAP HER NECK, HE SEES THAT SHE'S WEARING A WIG. SHE ESCAPES HIS GRASP, LEAVING THE WIG STILL IN HIS HAND.

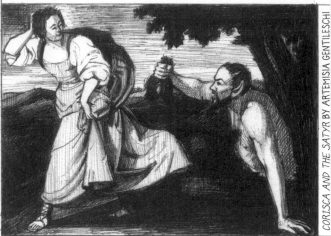

CORISCA AND THE SATYR BY ARTEMISIA GENTILESCHI

BUT ALL OF ARTEMISIA'S CLEVER PORTRAITS, DAZZLING COLOR COMBINATIONS, AND MULTI-FIGURE CANVASES DID NOT PROVIDE ENOUGH FOR HER TO SURVIVE IN NAPLES, ESPECIALLY WITH PRUDENZIA'S DOWRY LOOMING AHEAD. INDIRECT STATE TAXES WERE INCREASINGLY LEASED TO PRIVATE CONTRACTORS WHO PROFITED FROM EXCISES ON SILK, OIL, FLOUR, SALT, AND OTHER GOODS. THIS PAVED THE WAY FOR THE CORRUPT EX-MERCHANT BARTOLOMEO D'AQUINO (AND THE FINANCIAL SPECULATORS WORKING FOR HIM) TO ACQUIRE A MONOPOLY ON THE STATE'S FINANCIAL RELATIONSHIP WITH ITS CITIZENS. MANY SOUTHERN ITALIANS WERE ALSO FORCED TO JOIN SPANISH TROOPS FIGHTING IN THE NORTH. IN 1636 ELENA'S FATHER, THE DUKE OF ALCALA, WAS INVITED TO AN OFFICIAL MEETING IN AUSTRIA TO NEGOTIATE AN END TO THE THIRTY YEARS' WAR. BUT A YEAR LATER HE FELL ILL IN VILLACH AND DIED. THE WAR RAGED ON.

SOMEHOW ARTEMISIA FINALLY ARRANGED PRUDENZIA'S MARRIAGE TO SOMEONE. WHO? PERHAPS ANOTHER ARTIST? IN 1638 THE COUNT OF MONTERREY RETURNED TO SPAIN, BUT ARTEMISIA DID NOT WAIT TO FIND OUT ABOUT THE NEXT VICEROY—SHE DECIDED TO GO TO ENGLAND.

ELENA, YOU'LL STAY HERE IN NAPLES WITH PALMIRA.

YOUR SISTER AND HER NEW HUSBAND WILL KEEP YOU SAFE WHILE I'M AWAY.

WHAT?! MAMA, NOOOO! NO NO!!! DON'T GO! DON'T ABANDON US!! TAKE ME WITH YOU!

MY BEAUTIFUL CHILD, I'M SORRY, BUT MY JOURNEY IS TOO DANGEROUS FOR YOU. YOU'RE TWELVE NOW, A GROWN WOMAN. YOU'VE GOT TO BE BRAVE. AND OUR FRIENDS WILL STILL BE HERE WITH YOU. YOU'LL STILL HAVE MASSIMO AND BERNARDO AND ANNELLA.

NOOOO MAMA! NOOO, DON'T GO! DON'T GO!

HUSH, ELENA. YOU AND I WILL STILL BE TOGETHER.

I'LL BE BACK. I'M NOT SURE WHEN. IT MAY BE A LONG TIME, BUT I WILL RETURN.

BE CAREFUL.

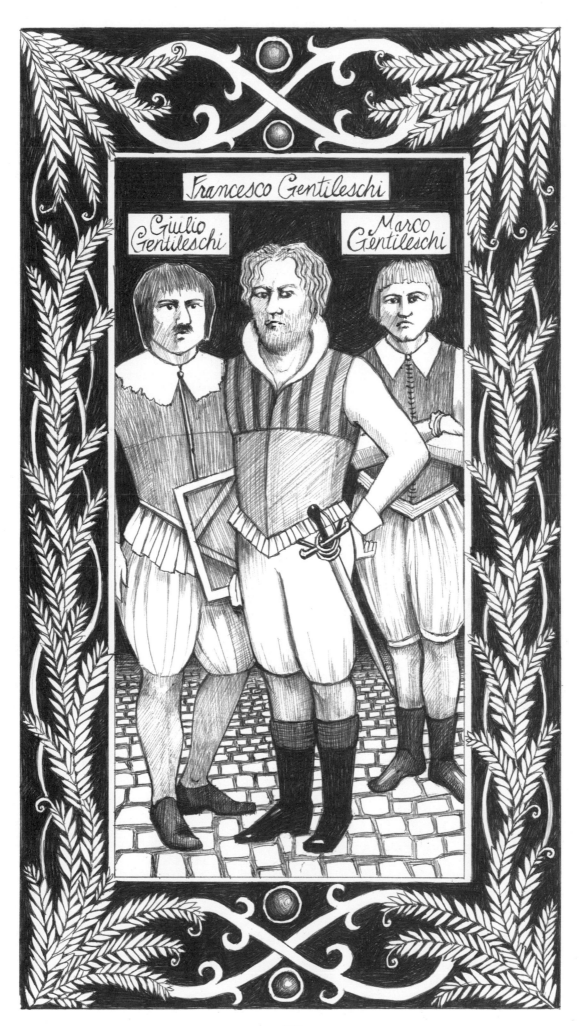

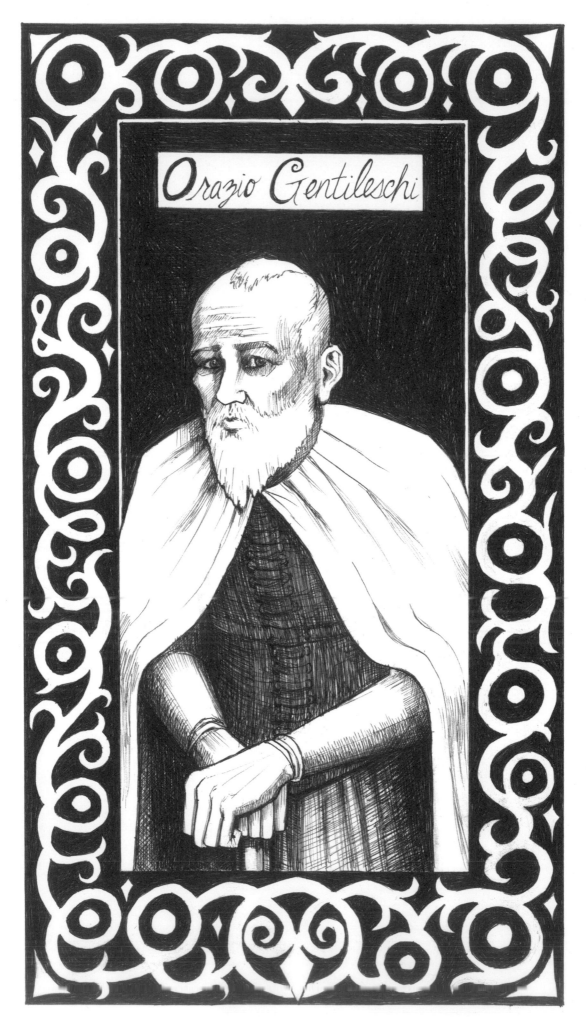

Orazio Gentileschi

THE JOURNEY TO ENGLAND WAS THE LONGEST, MOST DIFFICULT JOURNEY ARTEMISIA HAD EVER TAKEN. SHE MUST HAVE SPENT MANY WEEKS ON A SHIP, OR SEVERAL DIFFERENT SHIPS, OR MONTHS ON HORSEBACK THROUGH WAR-TORN LANDS IN THE NORTH.

AROUND THE SAME TIME, THE OLD EXILED FRENCH CATHOLIC, MARIE DE' MEDICI, WENT TO ENGLAND TO REUNITE WITH HER DAUGHTER, QUEEN HENRIETTA MARIA. THE YOUNG QUEEN WANTED TO CONVERT HER HUSBAND, KING CHARLES I, TO CATHOLICISM AND WAS IN CLOSE CONTACT WITH THE POPE. BUT THE ENGLISH PROTESTANTS, ESPECIALLY THE PURITANS, WERE COMMONLY SUSPICIOUS OF CATHOLICS. THE PURITANS SAW PAINTING AS FRIVOLOUS PAPIST LUXURY.

AS FOR CHARLES, HE HAD NO INTENTION OF CONVERTING. WHILE MANY SCOFFED AT HIS WIFE'S CATHOLIC FINERY (INCLUDING HER OWN CHAPEL AT SOMERSET HOUSE), CHARLES SAW NO PROBLEM WITH THE FACT THAT HIS WIFE PRACTICED A DIFFERENT RELIGION.

SINCE THE TUMULT OF THE 1620s, CHARLES HAD RULED OVER HIS LAND PEACEFULLY, CONTENT TO STUDY, HUNT, AND GAZE AT HIS ENORMOUS WORLD-RENOWNED ART COLLECTION. IT INCLUDED WORK BY THE FAMOUS PETER PAUL RUBENS. IN 1630 RUBENS HAD NEGOTIATED THE TREATY OF MADRID, WHICH SECURED ENGLAND'S PEACE WITH SPAIN.

IN ENGLAND RUBENS WAS KNIGHTED AND LAVISHED WITH JEWELS, AND IN THE FOLLOWING YEARS HIS MOST PROMISING STUDENT, ANTHONY VAN DYCK, BECAME THE OFFICIAL COURT PAINTER. BUT RUBENS SENSED THE TENSION BETWEEN CHARLES AND THE PARLIAMENT. SINCE 1629 CHARLES HAD RULED AS AN INDEPENDENT MONARCH WITHOUT CALLING FOR THE STANDARD MEETINGS OF THE PARLIAMENT, AND SO HE LOST TOUCH WITH THE LEADING MEN OF HIS LAND.

...whereas in other courts negotiations begin with the ministers and end with the royal word and signature, here they begin with the king and end with the ministers. I am very apprehensive about the English temperament...

THE NORMAL LEVYING OF TAXES ON SEA PORTS TO AID THE NAVY EXPANDED TO A GENERAL LAND TAX, WHICH MADE THE GENTRY EVEN MORE RESENTFUL. WHEN ARTEMISIA ARRIVED IN 1638, CHARLES WAS IN THE PROCESS OF IMPOSING A NEW PRAYER BOOK. HE SENT TROOPS INTO SCOTLAND, HOPING TO SECURE THE CHURCH OF ENGLAND AGAINST PURITANS, CALVINISTS, AND PRESBYTERIANS. IN 1639 THE EARL OF STRAFFORD BECAME THE KING'S MOST POWERFUL ADVISOR. STRAFFORD WAS A RUTHLESS ROYALIST. HIS PLAN WAS TO RALLY AN IRISH ARMY TO CRUSH RELIGIOUS REBELS AND PUSH THE COUNTRY TOWARD CIVIL WAR.

IN 1631 ORAZIO'S RIVAL, BALTHAZAR GERBIER, HAD LEFT ENGLAND TO ACCEPT A POST AS AN AGENT IN THE SPANISH NETHERLANDS, LEAVING THE GENTILESCHIS IN PEACE AT LAST. IN 1633 GERBIER GRUDGINGLY ADMITTED THAT MARIE DE' MEDICI, AND THE ARCHDUCHESS ISABELLA OF THE SPANISH NETHERLANDS, BOTH LOVED ORAZIO'S WORK. ORAZIO MAY HAVE BEEN INVOLVED IN POLITICAL INTRIGUE ON BEHALF OF ISABELLA. YET, IN THE 1630s HE WAS TRYING TO GET OUT OF ENGLAND. HE WROTE LONGINGLY TO HIS OLD SUPPORTERS IN TUSCANY AND OFFERED PAINTINGS TO PHILIP IV IN SPAIN, BUT HE WAS UNSUCCESSFUL. NOW IN 1638, HE WAS SEVENTY-FOUR YEARS OLD. ARTEMISIA WAS FORTY-FIVE. THEY HADN'T SEEN EACH OTHER IN EIGHTEEN YEARS.

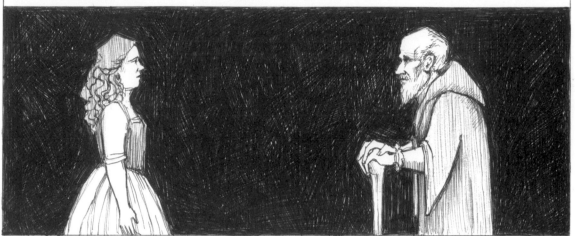

THE LIGHTER, MORE COLORFUL BOLOGNESE AND VENETIAN TRENDS HAD INFLUENCED ORAZIO'S PAINTINGS TOO. HIS EARLY CARAVAGGISM WAS REPLACED WITH AN ELEGANT, REFINED STYLE FIT FOR ALL THE KINGS AND QUEENS OF EUROPE.

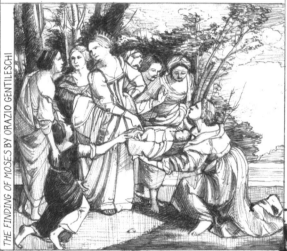

THE FINDING OF MOSES BY ORAZIO GENTILESCHI

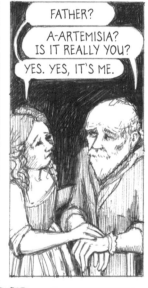

FATHER?

A-ARTEMISIA? IS IT REALLY YOU?

YES. YES, IT'S ME.

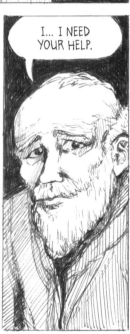

I... I NEED YOUR HELP.

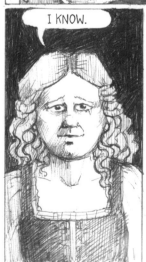

I KNOW.

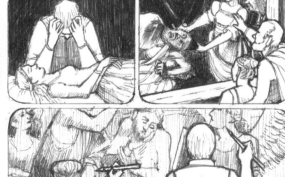

YOU—Y-YOU'RE A... A PAINTER? YES?

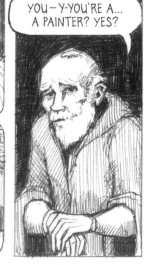

210

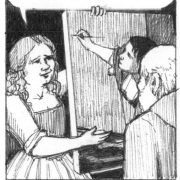

LOOK, FATHER, THIS IS A SELF-PORTRAIT I DID FOR KING CHARLES—I AM THE ALLEGORY OF PAINTING, SEE? I'VE BEEN A PAINTER ALL MY LIFE...

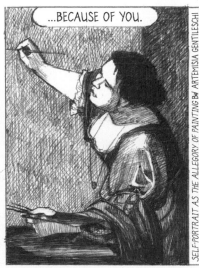

...BECAUSE OF YOU.

SELF-PORTRAIT AS THE ALLEGORY OF PAINTING BY ARTEMISIA GENTILESCHI

ORAZIO'S FINAL UNDERTAKING WAS THE ENORMOUS CEILING OF THE GREAT HALL OF THE QUEEN'S HOUSE AT GREENWICH. THE PIECE WAS TITLED *AN ALLEGORY OF PEACE AND THE ARTS UNDER THE ENGLISH CROWN*, AND CONSISTED OF NINE PAINTINGS PUT TOGETHER. LIKE ARTEMISIA'S ALLEGORY OF PAINTING, THE IMAGERY CONFORMS TO CESARE RIPA'S *ICONOLOGIA*. THE FIGURE IN THE CENTER WITH THE OLIVE BRANCH REPRESENTS PEACE, SURROUNDED BY ALLEGORIES OF VICTORY, STRENGTH, AND CONCORD. THE OUTSIDE IMAGES ARE PERSONIFICATIONS OF THE LIBERAL AND VISUAL ARTS, INCLUDING PAINTING, SCULPTURE, ARCHITECTURE, AND MUSIC. SUCH A LARGE, ELABORATE COMMISSION WAS TOO MUCH FOR ORAZIO TO HANDLE ON HIS OWN. HIS CHILDREN PROBABLY HAD A HAND IN ITS PRODUCTION.

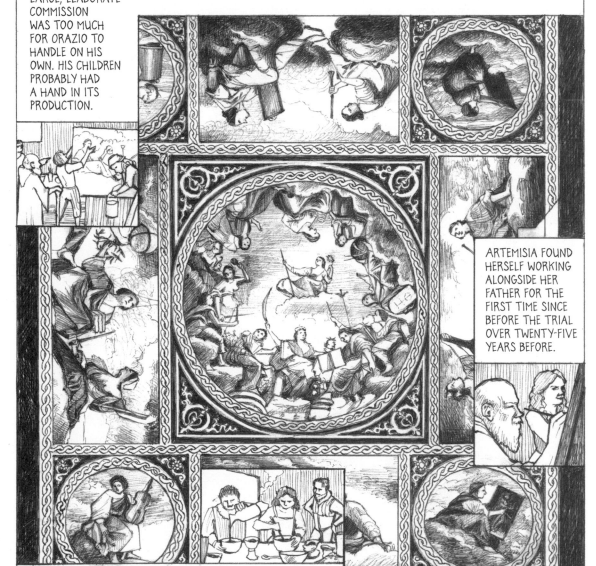

ARTEMISIA FOUND HERSELF WORKING ALONGSIDE HER FATHER FOR THE FIRST TIME SINCE BEFORE THE TRIAL OVER TWENTY-FIVE YEARS BEFORE.

THE GENTILESCHI FAMILY WAS TOGETHER AGAIN.

BUT THE FAMILY DID NOT STAY TOGETHER FOR LONG. ORAZIO DIED IN FEBRUARY 1639. HE WAS BURIED IN THE QUEEN'S CHAPEL, LIKE ALL CATHOLICS IN THE SERVICE OF HENRIETTA MARIA. HIS SONS FRANCESCO AND GIULIO WERE THE ONLY CHILDREN LISTED IN HIS WILL. ARTEMISIA WAS LEFT OUT SINCE ORAZIO HAD ALREADY PAID HER DOWRY. THE REASON FOR MARCO'S EXCLUSION IS UNKNOWN. AT THE FUNERAL ORAZIO'S CHILDREN BOWED THEIR HEADS IN MOURNING. A LARGE CRUCIFIX BY RUBENS HUNG ABOVE THEM.

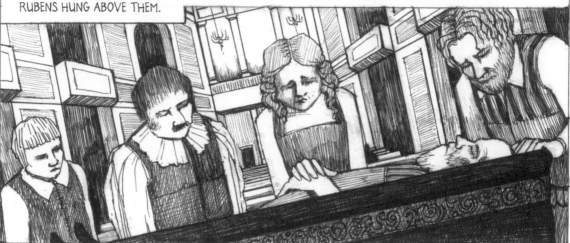

IN 1640 FRANCESCO RUSHED BACK TO ROME, CLAIMING TO THE BARBERINI THAT HE WAS IN THE SERVICE OF HENRIETTA MARIA. BUT ARTEMISIA STAYED IN ENGLAND.

FRANCESCO, WAIT! YOU DON'T EVEN HAVE A LETTER FROM THE QUEEN TO DELIVER!

WAS SHE INVOLVED IN HENRIETTA AND MARIE DE' MEDICI'S SECRET COMMUNICATION WITH THE BARBERINI POPE? WERE THESE WOMEN TRYING TO CONVERT THE ENGLISH KING TO CATHOLICISM?

DID ARTEMISIA MAKE CONTACT WITH HER OLD LOVER FROM EIGHT YEARS PRIOR, NICHOLAS LANIER? HE WAS LIVING PRIMARILY IN ENGLAND WITH HIS WIFE. A DEVOTED FOLLOWER OF THE KING, LANIER WAS EVENTUALLY FORCED INTO EXILE IN ANTWERP.

IN 1640 CHARLES I FINALLY SUMMONED THE PARLIAMENT, BUT ITS MEMBERS REFUSED TO PROVIDE MONEY FOR CIVIL WAR AND CONDEMNED STRAFFORD TO DEATH FOR TREASON. CHARLES WAS LOSING FAVOR QUICKLY AND MOB VIOLENCE ESCALATED. THE PARLIAMENT PASSED MULTIPLE BILLS THAT HINDERED THE MONARCHY'S POWER. CHARLES MARRIED OFF HIS NINE-YEAR-OLD DAUGHTER TO THE DUTCH STADHOLDER'S SON, HOPING TO GAIN DUTCH SUPPORT. BUT IN 1641 THERE WAS A CATHOLIC UPRISING IN IRELAND. THOUSANDS OF PROTESTANTS WERE KILLED AND THE PARLIAMENT'S ACTIONS AGAINST CHARLES BECAME INCREASINGLY DRASTIC. CHARLES GATHERED A ROYALIST PARTY AND TRIED TO ARREST HIS OPPONENTS, BUT THEY ESCAPED. FINALLY, THE ROYAL FAMILY WAS FORCED TO FLEE. ARTEMISIA KNEW SHE HAD TO LEAVE TOO.

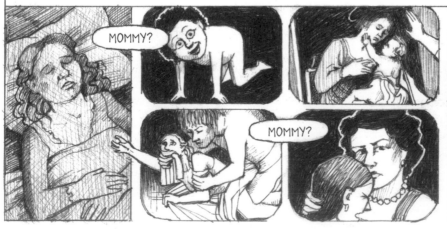

MOMMY?

MOMMY?

IN 1641 SHE WAS ON HER WAY BACK TO NAPLES.

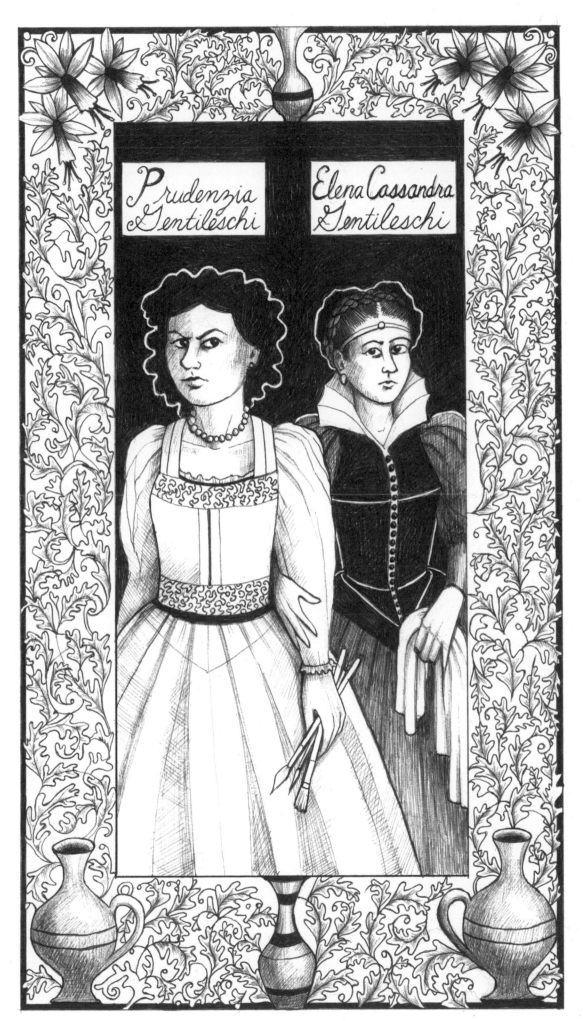

Prudenzia Gentileschi

Elena Cassandra Gentileschi

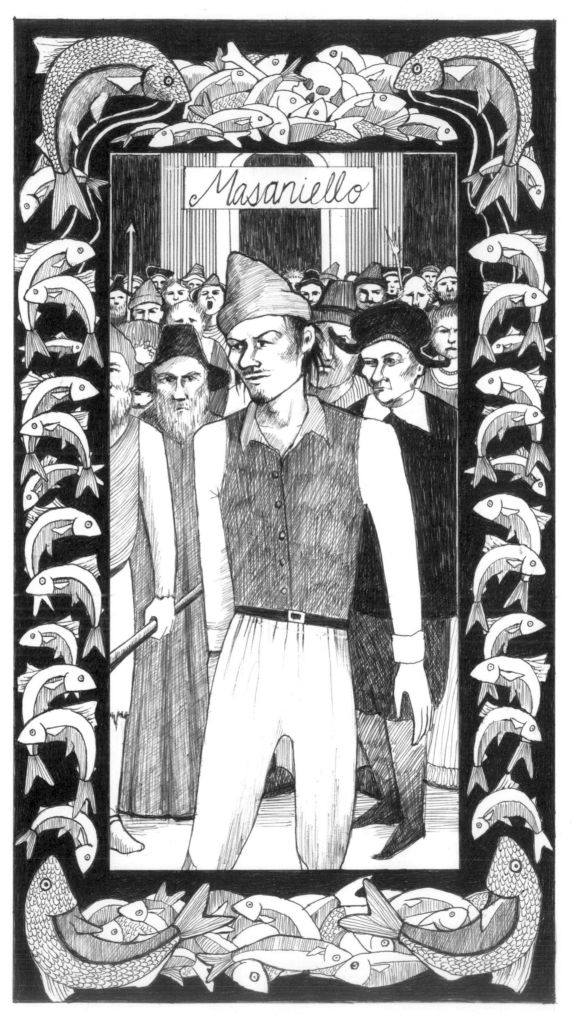

MEANWHILE, THE KINGDOM OF NAPLES HAD FALLEN INTO A FINANCIAL CRISIS. BARTOLOMEO D'AQUINO NOW CONTROLLED ALMOST ALL TAXES IMPOSED UPON THOSE IN NAPLES AND THE PROVINCES. HIS COMMISSIONS GREW DRAMATICALLY. HE WAS NOW THE RICHEST MAN IN NAPLES. THE VICEROYS PREVENTED ANY OPPOSITION TO D'AQUINO SO THAT HIS TAX REVENUE CONTINUED TO FLOW TO SPAIN'S WAR EFFORTS. WHILE SOME NOBLES STROVE TO WORK WITH D'AQUINO, MOST WERE FURIOUS. D'AQUINO'S RISE TO POWER CHALLENGED THE VERY CONCEPT OF NOBILITY. THE FEUDAL BARONS CLUNG TO WHATEVER POWER THEY HAD LEFT, OFTEN AT THE EXPENSE OF THOSE BELOW THEM.

FOR EXAMPLE, THE COUNT OF CONVERSANO OWNED A FIEF IN PUGLIA CALLED NARDO. THE MAYOR OF NARDO ATTEMPTED TO RALLY FOR A ROYAL GOVERNOR AS OPPOSED TO A FEUDAL MINISTER. WHEN THE COUNT OF CONVERSANO FOUND OUT, HE SIMPLY HIRED SOMEONE TO MURDER THE MAYOR. THEN HE HAD THE ASSASSIN STRANGLED IN A CHURCH TO CONCEAL THE EVIDENCE.

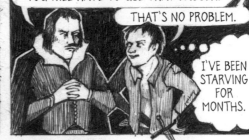

...YOU'VE BEEN A BANDIT FOR THREE YEARS?

YES, SIGNOR.

EXCELLENT. I HAVE A JOB FOR YOU THAT WILL PAY MORE THAN ANY OTHER. BUT YOU WILL HAVE TO USE THAT DAGGER.

THAT'S NO PROBLEM.

I'VE BEEN STARVING FOR MONTHS.

THE VICEROY TRIED TO DISSUADE THE COUNT OF CONVERSANO FROM RESORTING TO SUCH EXTREME MEASURES.

...YOU'VE MURDERED EIGHT PEOPLE? TEN? THAT'S ENOUGH NOW.

BUT HE SOON REALIZED THAT TO CONFRONT THE COUNT OF CONVERSANO WAS TO CONFRONT AN ENTIRE CLAN OF FEUDAL NOBILITY.

...THEN AGAIN, MAYBE WE CAN WORK SOMETHING OUT BETWEEN YOU AND PHILIP IV.

WHEN D'AQUINO ATTEMPTED TO MARRY THE COUNT OF CONVERSANO'S SISTER, THE VICEROY HELPED REMOVE HER FROM THE CONVENT OF SAN MARCELLINO TO SIGN A MARRIAGE CONTRACT.

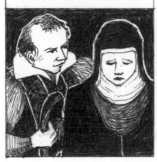

BUT D'AQUINO WAS NOT A PROPER NOBLE, SO THE COUNT OF CONVERSANO DEFIANTLY HIRED AN ARMY OF MEN TO STORM THE PALACE WHERE SHE WAS STAYING. HE MANAGED TO PREVENT THE MARRIAGE AND MOVE HER TO ANOTHER CONVENT IN BENEVENTO.

THAT D'AQUINO MAY BE THE RICHEST MAN, BUT HE IS NOT A NOBLE AND HE NEVER WILL BE! THERE IS NOT A SINGLE DROP OF NOBLE BLOOD IN HIS VEINS!

THERE WERE RUMORS THAT THE COUNT OF CONVERSANO WAS CONSPIRING WITH THE FRENCH AND WITH THE BARBERINI IN ROME.

 ARTEMISIA REALIZED THAT SHE HAD LEFT THE TUMULT OF ONE COUNTRY FOR THE CHAOS OF ANOTHER.

MOM, YOU HAVE TO UNDERSTAND THE SITUATION HERE...

 THERE ARE FAMILIES IN THE PROVINCES THAT ARE SELLING THEIR CHILDREN IN ORDER TO REMAIN UNDER ROYAL JURISDICTION. ALL OF THE BIG TRADING COMPANIES ARE BANKRUPT. EVEN MY HUSBAND IS AFRAID TO GO OUT SOMETIMES, AND WE DON'T ALWAYS HAVE ENOUGH TO EAT.

 BUT I WON'T STARVE BECAUSE I'LL MARRY A RICH MAN! MY DADDY WAS A VICEROY AND HE'S GOING TO PAY MY DOWRY.

 ELENA...

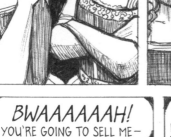 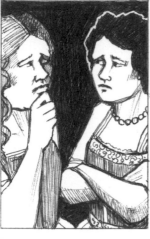

ELENA, YOUR FATHER IS DEAD. I'M SORRY.

I DIDN'T HAVE THE HEART TO TELL HER.

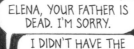 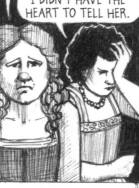 WHAT?

NOOO! NO! YOU'RE GOING TO SELL ME, AREN'T YOU?!

BWAAAAAAH! YOU'RE GOING TO SELL ME—

NO! NO, ELENA, NEVER.

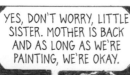 NOW, YOU LISTEN TO ME. LONG AGO I SWORE THAT I WOULD PROVIDE GOOD MARRIAGES FOR BOTH OF YOU, AND I WILL NOT GIVE UP.

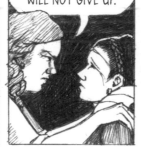 WE WILL SUPPORT OURSELVES THE WAY WE ALWAYS HAVE— BY PAINTING. I NEED BOTH OF YOU TO HELP ME IN THE STUDIO.

 WE WILL PAINT FOR MONEY. WE WILL PAINT WHATEVER THEY ASK FOR. IN HONOR OF MY FATHER, WE WILL KEEP PAINTING.

YES, DON'T WORRY, LITTLE SISTER. MOTHER IS BACK AND AS LONG AS WE'RE PAINTING, WE'RE OKAY.

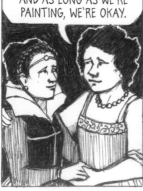 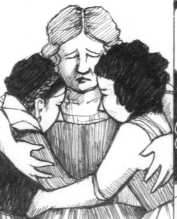 I HEARD A RUMOR THAT GIULIO GENOINO IS BACK FROM THE PRISON FORTRESS IN AFRICA.

 WHAT? THAT OLD REFORMER FROM YEARS AGO? WHO TOLD YOU THAT?

216

AT THIS POINT THERE WERE NO FUNDS FOR NAPLES' DEFENSE. PEOPLE WERE ALREADY AFRAID OF A TURKISH INVASION, AND IN 1640 NEWS OF AN APPROACHING FRENCH FLEET CAUSED SUCH PANIC THAT THE VICEROY ALLOWED THE PEOPLE TO FORM THEIR OWN MILITIA WITH THEIR OWN OFFICERS. THIS FURTHER INFURIATED THE FEUDAL NOBILITY BECAUSE THEY KNEW WHAT COULD HAPPEN IF THE OPPRESSED COMMON PEOPLE ORGANIZED THEIR OWN FORCES. BUT THE FRENCH NEVER ENTERED NAPLES—THEY ONLY WANTED TO BLOCK NAPLES' AID TO SPAIN.

TORQUATO ACCETTO, A MEMBER OF THE ACCADEMIA DEGLI OZIOSI, WROTE A TREATISE CALLED *HONEST DISSIMULATION*. IT WAS ABOUT HOW DISSIMULATION, ALTHOUGH IT SHOULD BE AVOIDED, WAS SOMETIMES NECESSARY FOR SURVIVAL IN THIS WORLD OF ABSOLUTISM AND NEO-FEUDALISM. HE DIFFERENTIATED BETWEEN "HONEST DISSIMULATION" AND THE HYPOCRISY OF COURTIERS AND MINISTERS OF STATE. AFTER THE TREATISE WAS PUBLISHED IN 1641, ACCETTO MYSTERIOUSLY DISAPPEARED FROM THE RECORDS. THE OZIOSI DISBANDED IN 1645 AFTER THE DEATH OF ITS FOUNDER.

WHERE IS ACCETTO?! HM? WHERE IS HE?!

CALM DOWN NOW, ARTEMISIA.

BY 1641 DOMENICHINO, WHO HAD RETURNED TO NAPLES, WAS GONE TOO. HIS WIFE SWORE THAT HE'D BEEN POISONED.

IT WAS THAT JUSEPE DE RIBERA'S CABAL, THEY WERE ALWAYS AFTER HIM!

ARTEMISIA STRUGGLED TO MAKE NEW WORK, BUT SHE NO LONGER HAD THE SUPPORT OF THE VICE REGENCY.

COUGH COUGH

HER NEW LUCRETIA WAS A VULNERABLE BEAUTY RAISING A PALE WEAK ARM AGAINST HER ATTACKER.

RAPE OF LUCRETIA BY ARTEMISIA GENTILESCHI

HER NEW VERSIONS OF BATHSHEBA WERE MORE CONVENTIONAL AND TITILLATING THAN ANY BEFORE. HER VIOLENT CARAVAGGESQUE HEROINES WERE DEEPLY BURIED IN THE PAST.

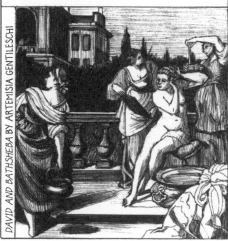

DAVID AND BATHSHEBA BY ARTEMISIA GENTILESCHI

EVENTUALLY THE COUNT OF CONVERSANO WAS SUMMONED TO SPAIN BY PHILIP IV. WHEN HE RETURNED TO NAPLES, HE WAS NO LONGER INVOLVED IN ANTI-SPANISH CONSPIRACIES, AND PHILIP IV GRANTED HIM MORE POWER OVER HIS FIEFS. IN 1644 A NEW VICEROY INVESTIGATED BARTOLOMEO D'AQUINO—THE MOST CORRUPT TAX FARMER IN SOUTHERN ITALY WAS FINALLY ARRESTED, BUT HIS CASE WAS UNRESOLVED FOR OVER TEN YEARS. IN 1646 PHILIP IV REPLACED THE VICEROY AGAIN, BUT NO ONE KNEW HOW TO OBTAIN THE STAGGERING FUNDS THAT THE SPANISH KING DEMANDED.

...THIS BATHSHEBA IS SIMILAR TO THE LAST ONE I SAW YOU DO.

COUGH COUGH

LISTEN, MASSIMO, I LOST MY HONOR AT A YOUNG AGE, BUT THAT WILL NOT HAPPEN TO ANY DAUGHTER OF MINE. THEY MUST BOTH BE HAPPILY MARRIED.

I'LL DO AS MANY SEXY BATHSHEBAS AS IT TAKES. ANNELLA WOULD UNDERSTAND. WHERE IS SHE?

SHE...

...SHE'S DEAD.

NO.

NO! NO NO NO NO NO!!

SHE WAS... STABBED BY HER HUSBAND. HE WAS JEALOUS.

HER HUSBAND—AGOSTINO BELTRANO—YOUR STUDENT!?! HOW COULD THIS HAPPEN?!

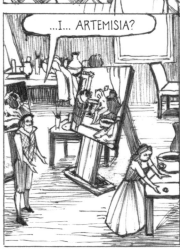

...I... ARTEMISIA?

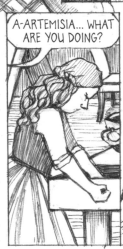

A-ARTEMISIA... WHAT ARE YOU DOING?

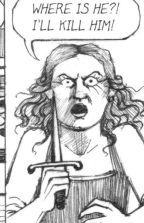

WHERE IS HE?! I'LL KILL HIM!

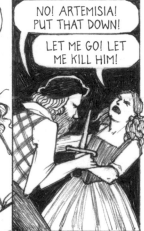

NO! ARTEMISIA! PUT THAT DOWN!

LET ME GO! LET ME KILL HIM!

I ALMOST KILLED THAT TRAITOR AGOSTINO TASSI IN MY YOUTH! I WILL KILL *THIS* AGOSTINO NOW!

NO, ARTEMISIA. HE HAS FLED NAPLES, AND NEITHER YOU NOR I HAVE THE STRENGTH TO TRAVEL ANYMORE.

COUGH

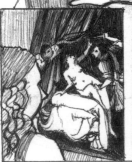

AROUND THE SAME TIME THAT ANNELLA DIED IN THE MID 1640s, AGOSTINO TASSI DIED IN ROME AFTER A SUCCESSFUL CAREER IN PAINTING, FRESCOING, AND ETCHING. HE WAS IN HIS MID-SIXTIES AND IN A LONG-TERM RELATIONSHIP.

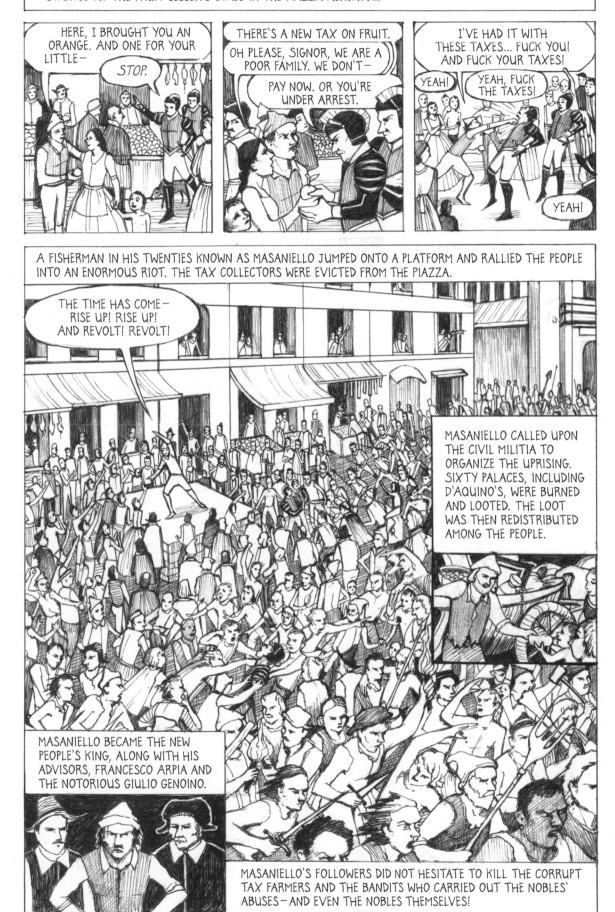

AS THE REVOLT SPREAD THROUGHOUT SOUTHERN ITALY, THE VICEROY HID IN THE PALAZZO REALE IN TERROR. SOME OF THOSE WHO RELIED ON HIS SUPPORT HID WITH HIM, LIKE JUSEPE DE RIBERA.

ON JULY 10, 1647, ONE OF THE MOST INFAMOUS NOBLES ORGANIZED A PLOT TO KILL MASANIELLO, BUT HE WAS DISCOVERED AND IMMEDIATELY BEHEADED.

THE NEXT DAY, MASANIELLO DRESSED UP, RODE TO THE VICEROY'S PALACE, AND DEMANDED THAT HE OVERTURN THE TAXES AND UNBURDEN THE PEOPLE OF SOUTHERN ITALY.

GIULIO GENOINO AND OTHER MORE MODERATE REFORMERS ASKED MASANIELLO TO DISARM THE CIVIL MILITIA AND RENOUNCE HIS LEADERSHIP POSITION.

THIS HAS GOTTEN OUT OF HAND, MASANIELLO. THIS VIOLENCE CANNOT CONTINUE!

NO. I WILL NOT LET GO OF THE MILITARY. IF THE PEOPLE WANT ME TO REMAIN KING, THEN I WILL REMAIN KING. THIS WILL NOT BE A REPEAT OF YOUR WEAK OLD REFORMS, THIS WILL BE A REVOLUTION!

MASANIELLO, STOP! YOU'VE GONE MAD! COME BACK! NOW!

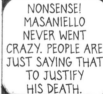

ON JULY 16TH, NINE DAYS AFTER THE INITIAL RIOT IN THE PIAZZA, GENOINO AND OTHER POLITICAL LEADERS ORGANIZED THE ASSASSINATION OF MASANIELLO.

BUT THIS DID NOT SUBDUE THE PEOPLE, AND THEIR MARTYR WAS GIVEN A LARGE MILITARISTIC FUNERAL WITH A PROCESSION PAST THE PALACE.

...A FISHERMAN BECOMING KING FOR A WEEK? HOW COULD THIS BE POSSIBLE?

THEY SAY HE WENT CRAZY. HIS SIMPLE MIND WAS NOT FIT TO RULE.

THIS IS THE KIND OF CHAOS THAT IS INEVITABLE WHEN A PEASANT STEPS OUT OF THE PROPER ORDER. IT IS THE DEVIL SPEAKING.

NONSENSE! MASANIELLO NEVER WENT CRAZY. PEOPLE ARE JUST SAYING THAT TO JUSTIFY HIS DEATH.

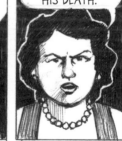

THE CHURCH FATHERS TRIED TO QUELL THE "EVIL SPIRIT OF THE PEOPLE."

Why are you organizing such zealous processions now that attempts are made to unburden the city? There were none when we were burdened with taxes.

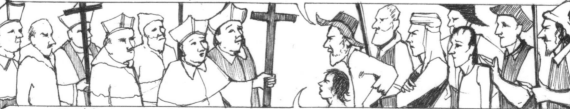

Yeah! Cardinals should order public and private prayers for the current needs of the city and kingdom... the way it was every day when Masaniello was alive!

BUT, UNLIKE THE REVOLT OF 1585, THE PEOPLE REFUSED TO BACK DOWN. THE UPHEAVAL CONTINUED FOR NINE MONTHS. GENOINO WAS EXILED AGAIN. SOME PEOPLE WANTED A NEW REPUBLIC, OTHERS PUSHED FOR FRENCH RULE, OTHERS INSISTED ON A REFORMED SPANISH MONARCHY.

ONE OF ARTEMISIA'S COLLABORATORS, MICCO SPADARO, PAINTED DETAILED IMAGES OF THE UPRISING. HE SHOWED THE CHAOTIC FRENZY OF THE PEOPLE AS THEY DROVE CARTS OF BOOTY, GATHERED STICKS FOR BURNING, CARRIED THE GREEDY NOBLES' HEADS ON SPIKES, AND CHEERED FOR MASANIELLO.

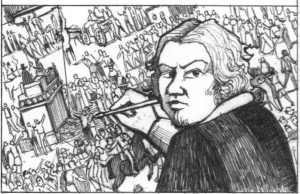

AT SOME POINT ANOTHER NEAPOLITAN PAINTER NAMED ONOFRIO PALUMBO BEGAN HELPING AT ARTEMISIA'S STUDIO. LITTLE IS KNOWN ABOUT HIM, BUT TWO PORTRAITS OF MASANIELLO ARE ATTRIBUTED TO HIM.

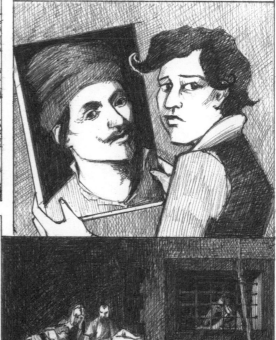

FINALLY, PHILIP IV'S ILLEGITIMATE SON, DON JUAN JOSÉ OF AUSTRIA, STEPPED IN TO REINFORCE SPANISH DOMINATION. IN APRIL OF 1648, A NEW VICEROY WAS INSTATED, BUT HE REFUSED TO INSTITUTE SPAIN'S TAX SYSTEM WITHOUT THE SUPPORT OF THE PEOPLE'S ORGANIZATIONS. MEANWHILE, THE PEACE OF WESTPHALIA SIGNALED THE OFFICIAL END OF THE THIRTY YEARS' WAR IN THE NORTH, ALSO IN 1648. RICHELIEU WAS DEAD. THE NEW FRENCH HEIR WAS TOO YOUNG TO RULE, AND THE TEMPORARY REGENCY WEAKENED FRANCE'S MILITARY MIGHT. THE HOLY ROMAN EMPEROR MADE PEACE WITH FRANCE, WHICH SUBDUED THE AUSTRIAN HAPSBURGS. NATIONALISM, RATHER THAN RELIGION, BECAME THE DRIVING FORCE BEHIND EUROPE'S BATTLES.

THE BEHEADING OF ST. JOHN THE BAPTIST BY CARAVAGGIO

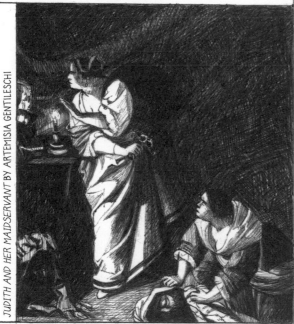

JUDITH AND HER MAIDSERVANT BY ARTEMISIA GENTILESCHI

ARTEMISIA WAS STILL PAINTING IN NAPLES AND TRYING TO RAISE MONEY FOR ELENA'S DOWRY. SHE TURNED BACK TO HER OLD HEROINES—JUDITH, ABRA, AND SUSANNA. _JUDITH AND HER MAIDSERVANT_ WAS PAINTED FOR THE LUMAGA, A VENETIAN MERCHANT FAMILY WITH STRONG TIES TO NAPLES. BUT THE FIGURES SEEM DISTANT, ALMOST COMPLETELY SWALLOWED UP BY DARKNESS.

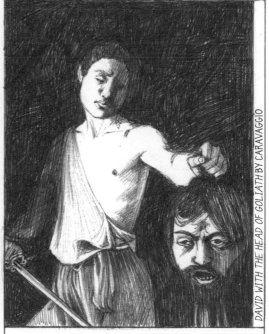

DAVID WITH THE HEAD OF GOLIATH BY CARAVAGGIO

THERE IS A STRONG CHIAROSCURO, REMINISCENT OF CARAVAGGIO'S LATER WORKS LIKE _DAVID WITH THE HEAD OF GOLIATH_ OR _THE BEHEADING OF ST. JOHN THE BAPTIST_ IN MALTA. THESE ARE GRIM DEPICTIONS OF BLOOD AND BLACKNESS, TENSE AND SORROWFUL.

ANOTHER PAINTING OF SUSANNA FROM AROUND 1649 CONTAINS ELEMENTS OF ARTEMISIA'S PREVIOUS DEPICTIONS OF THE INNOCENT WOMAN FENDING OFF THE LECHEROUS MAN.

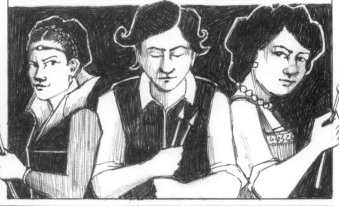

BUT HER STUDIO ASSISTANTS PROBABLY PLAYED A GREATER ROLE IN THE PRODUCTION OF THESE LATER PAINTINGS.

SUSANNA AND THE ELDERS BY ARTEMISIA GENTILESCHI

IN 1649 ELENA WAS FINALLY MARRIED TO A KNIGHT OF THE ORDER OF ST. JAMES. THIS PRESTIGIOUS CATHOLIC ORDER ORIGINATED IN TWELFTH-CENTURY SPAIN AND PORTUGAL. MEMBERS WERE HIGH-RANKING MEN WITH NOBLE LINEAGES FROM BOTH PARENTS. ARTEMISIA'S OLD PATRON, THE COUNT OF MONTERREY (VICEROY DURING THE LATE 1630s), WAS A MEMBER. ELENA'S DOWRY MUST HAVE BEEN A CONSIDERABLE SUM.

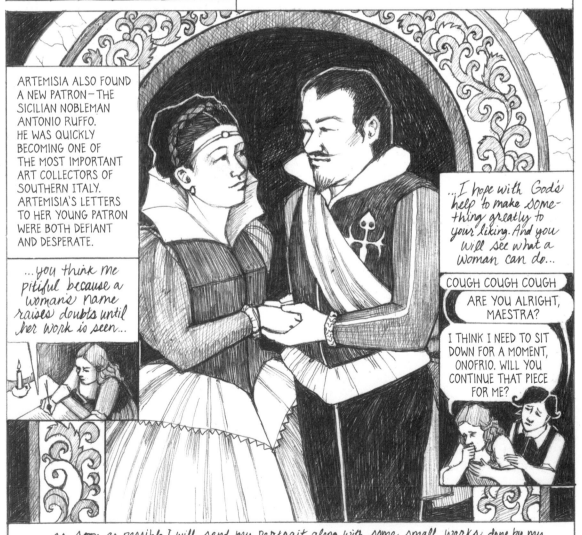

ARTEMISIA ALSO FOUND A NEW PATRON—THE SICILIAN NOBLEMAN ANTONIO RUFFO. HE WAS QUICKLY BECOMING ONE OF THE MOST IMPORTANT ART COLLECTORS OF SOUTHERN ITALY. ARTEMISIA'S LETTERS TO HER YOUNG PATRON WERE BOTH DEFIANT AND DESPERATE.

...you think me pitiful because a woman's name raises doubts until her work is seen...

...I hope with God's help to make something greatly to your liking. And you will see what a woman can do...

COUGH COUGH COUGH

ARE YOU ALRIGHT, MAESTRA?

I THINK I NEED TO SIT DOWN FOR A MOMENT, ONOFRIO. WILL YOU CONTINUE THAT PIECE FOR ME?

...as soon as possible I will send my portrait, along with some small works done by my daughter, whom I have married off today to a knight of the order of Saint James. This marriage has broken me. For this reason if there are any opportunities for work in your city, I ask your Lordship to assist me with your usual benevolence, and to keep me informed because I need work very badly. I am bankrupt...

...Further, I want Your Most Illustrious Lordship to promise me that as long as I live you will protect me, as if I were a lowly slave born into your household. I have never seen Your Lordship but my love and my desire to serve you are beyond imagination. I shall not bore you anymore with this womanly chatter. The works will speak for themselves...

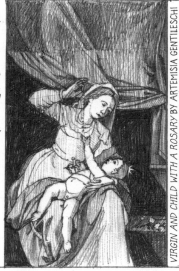

VIRGIN AND CHILD WITH A ROSARY BY ARTEMISIA GENTILESCHI

...I will say no more, except for what I have on my mind—that I think Your Most Illustrious Lordship will not suffer any loss with me, and that you will find the soul of Caeser in this soul of a woman.

ARTEMISIA, WHAT'S WRONG?

I'VE BEEN CHEATED.

I sent my drawings of the souls in purgatory to that bishop of St. Gata like he requested. But he commissioned another artist to do the painting based on MY drawings!

WELL, AT LEAST HE LIKED THE DRAWINGS.

NO NO, ONOFRIO, IT IS A SERIOUS INSULT.

If I were a man, I cannot imagine it would have turned out this way.

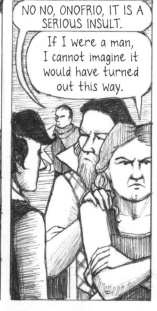

When the concept has been realized and defined with lights and darks and established by means of planes, the rest is a trifle. I will never send my drawings again.

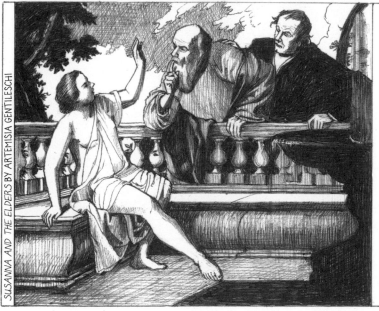

SUSANNA AND THE ELDERS BY ARTEMISIA GENTILESCHI

ARTEMISIA'S PAINTINGS OF THE EARLY 1650s WERE SOFT AND SOMBER. HER LAST SUSANNA IS SENSUAL, WITH MUTED COLORS. SUSANNA LIFTS HER HAND AGAINST THE ELDERS, BUT SHE DOESN'T SEEM SHOCKED OR TERRIFIED. HER THIN CHEMISE SHOWCASES BOTH THE BODY BENEATH AND ARTEMISIA'S MASTERY OF PAINTING DRAPERY. THIS PIECE WAS IN THE MEDICI'S PALAZZO MEDICI RICCARDI IN FLORENCE BY THE LATE SEVENTEENTH CENTURY. PERHAPS THIS SUSANNA RECONCILED THE FADING MEDICI DYNASTY WITH THE WOMAN WHO PAINTED THE INFAMOUS *JUDITH SLAYING HOLOFERNES* SO LONG AGO.

BY 1653 ARTEMISIA WAS SIXTY YEARS OLD. SHE HAD NO HUSBAND. SHE WAS A SURVIVOR OF SEXUAL ASSAULT. SHE LIVED IN ONE OF THE LARGEST, OLDEST, MOST DANGEROUS CITIES OF EUROPE. SHE HAD MANAGED TO MARRY OFF TWO DAUGHTERS, ONE TO A HIGH-RANKING KNIGHT, IN ADDITION TO SURVIVING A VOLCANIC ERUPTION AND A VIOLENT UPRISING. SHE'D RAISED HER CHILDREN AND CONTINUED TO PAINT.

IN 1653 HER NAME APPEARED IN A BOOK OF MOCK EPITAPHS BY HER OLD VENETIAN FRIEND, GIAN FRANCESCO LOREDAN. THE BOOK, CO-WRITTEN BY PIETRO MICHIELE, CONSISTS OF RIBALD, HUMOROUS EPITAPHS FOR ALL KINDS OF PEOPLE, INCLUDING ANCIENT AUTHORS AND QUEENS, AS WELL AS FAMOUS FIGURES SUCH AS MASANIELLO, AND STOCK PERSONAS LIKE "CHEATING SERVANT" OR "SPANISH THIEF." AT THE TIME OF ITS PUBLICATION, FORTY-SIX-YEAR-OLD LOREDAN WAS A WELL-ESTABLISHED ARISTOCRAT WHO CONTROLLED NEARLY ALL OF VENICE'S PUBLISHING. HIS ACCADEMIA DEGLI INCOGNITI WAS FAMOUS AND SUCCESSFUL. YET, THE INCOGNITI'S PRIMARILY ANTI-SPANISH, ANTI-BARBERINI, ANTI-INQUISITION STANCE ENDANGERED MANY OF ITS MEMBERS, EVEN AS THE VENETIAN GOVERNMENT TRIED TO PROTECT THEM.

THE WRITERS OF THE INCOGNITI OFTEN USED HIDDEN MESSAGES AND MYSTERIOUS CONTRA-DICTIONS TO OBSCURE THEIR MORE RADICAL VIEWS. THEIR MOTTO WAS "EX IGNOTO NO-TUS" – "THE KNOWN FROM THE UNKNOWN" – AND THEIR LOGO WAS THE ELUSIVE NILE RIVER, WHOSE SOURCE WAS UNKNOWN AT THE TIME.

ONE OF LOREDAN'S FOLLOWERS, FERRANTE PALLAVICINO, WAS CONSTANTLY RUNNING FROM THE INQUISITION AND THE INDIGNANT CARDINAL FRANCESCO BARBERINI. IN 1642 THE WORKERS WHO PRINTED PALLAVICINO'S BOOKS WERE KILLED, THEIR REMAINS HUNG ON DISPLAY AS EXAMPLES. PALLAVICINO WAS FORCED TO HIDE IN LOREDAN'S HOME.

IN 1644 PALLAVICINO WAS LURED TO FRANCE, WHERE HE WAS FINALLY CAPTURED AND BEHEADED. HIS EXE-CUTION SHOCKED AND DEVASTATED THE INCOGNITI, LEAVING LOREDAN WEAKENED AND DISILLUSIONED.

BUT ONE OF HIS WRITERS NEVER GAVE UP – ARCANGELA TARABOTTI. SOME OF FERRANTE'S WRITING WAS OPENLY MISOGYNISTIC, AND ARCANGELA WROTE ARGUMENTS AGAINST HIS SEXISM. IN 1653, WHILE LOREDAN AND MICHIELE PUT OUT THEIR JOKE BOOK, ARCANGELA HAD JUST RELEASED HER FOURTH BOOK – *WOMEN ARE NO LESS RATIONAL THAN MEN*, FOLLOWED BY *PATERNAL TYRANNY*.

ARTEMISIA PROBABLY HADN'T BEEN TO VENICE IN OVER TWENTY YEARS, BUT TWO EPITAPHS TO HER ARE INCLUDED IN LOREDAN'S MOCK EPITAPH BOOK (*IL CIMITERIO: EPITAFI GIOCOSI*).

...YOU REMEMBER THAT CHICK PAINTER, WHAT WAS HER NAME AGAIN?

AHH, ARTEMISIA, I HAD A CRUSH ON HER.

ME TOO!

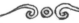

Painting the faces of this man and that in this world I acquired infinite merit; but in carving the horns of a cuckold for my husband I put down the brush and took up the chisel.

I was tender allure for the hearts of whoever could see me in this Blind World; now I hide myself beneath the marbles and am made tender bait for the worms.

WHAT LOREDAN DIDN'T REALIZE WAS THAT ARTEMISIA WAS STILL ALIVE. SHE DIDN'T ACTUALLY DIE UNTIL 1655 OR 1656, MOST LIKELY DUE TO A PARTICULARLY HORRIFIC OUTBREAK OF BUBONIC PLAGUE THAT SWEPT THROUGH NAPLES, KILLING ABOUT HALF OF THE POPULATION. THE PLAGUE, ALSO KNOWN AS THE BLACK DEATH, WAS A PERSISTENT THREAT DURING ARTEMISIA'S TIME. WITHOUT REALIZING THAT RATS SPREAD THE DISEASE, AND WITH LITTLE SCIENTIFIC PROGRESS, PEOPLE SIMPLY GUESSED AT REMEDIES. VICTIMS WERE QUARANTINED AND TRAVEL WAS BANNED IN A FUTILE ATTEMPT TO STOP THE SPREAD OF THE DEADLY CONTAGION. SURVIVORS, BOTH NOBLE AND PLEBIAN, SOUGHT REFUGE IN THE CHURCH OF S. MARIA DI CONSTANTINOPOLI. JUST AS SAINT JANUARIUS HAD BEEN INVOKED WHEN MOUNT VESUVIUS ERUPTED, THE MADONNA OF CONSTANTINOPLE PROVIDED A SPIRITUAL OUTLET FOR PEOPLE DURING THE PLAGUE. THE BLACK DEATH TOOK THE LIVES OF MANY ARTISTS IN ARTEMISIA'S CIRCLE, INCLUDING MASSIMO STANZIONE AND BERNARDO CAVALLINO. THUS, 1656 MARKED THE END OF AN ERA. WHETHER OR NOT ARTEMISIA'S DAUGHTERS SURVIVED IS UNKNOWN.

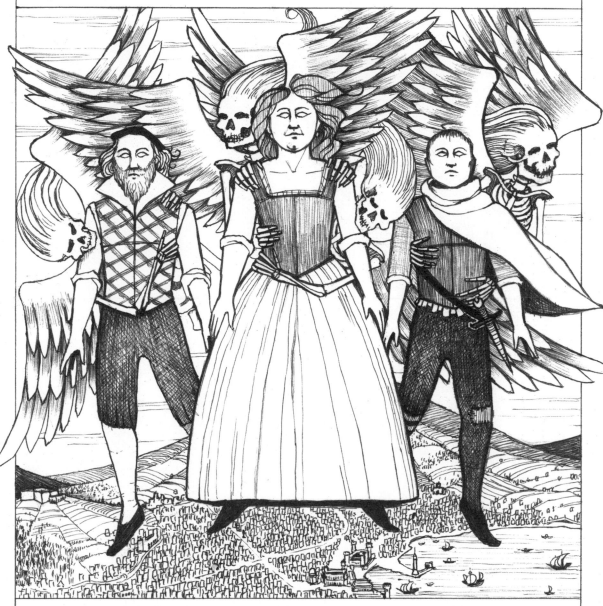

THE EIGHTEENTH-CENTURY SCHOLAR AVERARDO DE' MEDICI (WHO OWNED ARTEMISIA'S LAST SUSANNA OF 1652) WROTE THAT WHEN THE CHURCH OF S. GIOVANNI DEI FIORENTINI WAS RESTORED IN THE 1780S, A MARBLE SLAB WITH THE WORDS "HEIC ARTEMISIA" WAS FOUND. AVERARDO AND OTHERS THOUGHT THAT THIS WAS THE TOMBSTONE OF ITALY'S GREATEST FEMALE PAINTER. THE WORDS TRANSLATE TO THE SIMPLE "HERE LIES ARTEMISIA." SUCH BRIEF INSCRIPTIONS WERE COMMON, BUT NORMALLY A WOMAN WAS LISTED AS THE WIFE OF SOMEONE. ARTEMISIA'S NAME, HOWEVER, WAS NOT ATTACHED TO ANY MAN'S, BUT STOOD ON ITS OWN. YET, ITS PLACEMENT IN THE FLORENTINE CHURCH OF NAPLES ALLUDED TO HER FAMILY'S TUSCAN HERITAGE, ESPECIALLY TO ORAZIO AND THE LOMI ARTISANS WHO PAVED THE WAY FOR ARTEMISIA. THE TOMBSTONE WAS BROKEN OR BURIED UNDER THE NEW FLOOR DURING THE RESTORATION OF THE CHURCH, AND THE BUILDING WAS EVENTUALLY DEMOLISHED IN THE 1950S. NONETHELESS, ARTEMISIA'S FAME GROWS, AS NEW GENERATIONS OF ARTISTS DISCOVER HER AND ARE INSPIRED BY HER STORY.

Artemisia Gentileschi

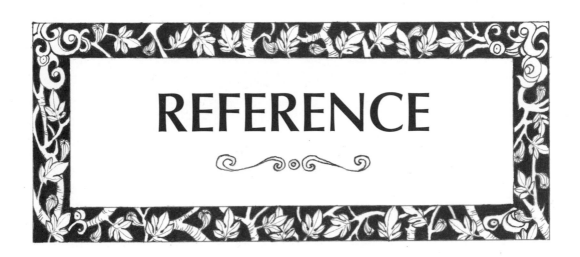

REFERENCE

NOTES

TO PUT ARTEMISIA into context for this graphic novel, I had to summarize large political and social happenings, historical landmarks, and biographical information about characters. At times, it seemed impossible to condense into a few panels the philosophy of Giordano Bruno, or Gustavus Adolphus' war efforts, or the beginning of the English Civil War. But the ease and enjoyment of the reader must take first priority, as any historical fiction writer or graphic novel artist knows. Thankfully, I had the opportunity to include much of this contextual information in these notes.

For most of the main characters, I created their likeness based on their self-portraits or portraits of them by others. I often slightly exaggerated certain features, so the reader could more easily differentiate between people. I also had to invent the appearance of some characters entirely, like Tuzia Medaglia, Francesco Maria Maringhi, Arcangela Tarabotti, Lucrezia Marinella, Giulio Genoino, Bartolomeo d'Aquino, the Count of Conversano, Artemisia's brothers and daughters, and both of the Stiattesis. In Artemisia's time, the names of places and people were spelled inconsistently. Artemisia spelled her own name in different ways. I chose to spell people and place names the same way that they appear in my sources.

The world of scholarship on Artemisia is ever-changing, full of endless debate and passion. While one can see from the Bibliography that I consulted a variety of sources, there are a few books that especially shaped *I Know What I Am*. A handful of scholars brought Artemisia to life, and without their research I never would have completed this book. Some of these writers have had multiple pieces published. When I refer to the following authors in the notes, I'm referring to their writing within the following titles (unless otherwise noted in parenthesis).

Artemisia Gentileschi: The Image of the Female Hero in Italian Baroque Art, by Mary Garrard (1989)

Aided by the feminist movement of the seventies and eighties, Garrard brought Artemisia out of the shadows with this groundbreaking monograph, which includes an easily readable English translation of the trial of 1612 and a selection of

Artemisia's letters. When I refer to the trial of 1612 in these notes, I am referring to it as it appears in Garrard's monograph (see the beginning of notes for Part 2). Garrard has been writing about Artemisia with the same unapologetic feminist voice for over twenty years, but there has been a backlash against her "gendered" approach. Feminist scholars have been accused of taking Artemisia out of context and neglecting information that doesn't fit into their preconceived notions. It's important not to project our modern psychological ideas onto historical figures too much, but I don't think that feminist assertions are inherently anachronistic, and I've returned to Garrard's scholarship regularly. I always will.

Orazio and Artemisia Gentileschi, edited by Keith Christiansen and Judith W. Mann (2001)

This Metropolitan Museum exhibition catalogue provides pictures of a large quantity of paintings by Artemisia and Orazio, as well as a timeline and essays analyzing each segment of Artemisia and Orazio's careers.

Artemisia, by Alexandra Lapierre (1998)

This is my favorite fictionalized account of Artemisia's life. I took a similar approach to Lapierre's — stringing historical documents together with fiction, staying as true to historical accuracy as possible, and including a notes section so the reader can see which parts were invented and why. Although she used her scholarship to write a novel, Lapierre's discoveries in the Italian archives changed and enriched our understanding of Artemisia as much as any nonfiction approach.

The Revolt of Naples, by Rosario Villari, translated by James Newell and John A. Marino (1993)

In the introduction, Peter Burke describes Villari as "a southerner, a Marxist, and a European historian who specializes in the early modern period. He was born in Calabria in 1925, and he has always been passionately concerned with the problems of the Italian South" (vi). Compared with the North,

the study of Southern Italian history has been neglected. Most of the scholarship isn't translated into English. Artemisia's Neapolitan period has always been the most perplexing, her later work consistently seen as inferior. I turned to Villari's book frequently, not just because it feels like the only one of its kind available — but also because it helped me get a sense of both the structure of seventeenth-century Neapolitan society and the hardships people then faced. The legacy of these struggles is still felt in the present.

Artemisia Gentileschi: The Language of Painting, by Jesse Locker (2015)

This work was crucial for developing Artemisia's Venetian and Neapolitan periods. Locker has analyzed seventeenth and eighteenth-century writing about Artemisia to piece together her involvement in literary and musical circles, early modern perceptions of Artemisia and her art, and her connections to "proto-feminism." Instead of fueling the backlash against feminist interpretations of Artemisia, Locker tactfully uses his own research to dig deeper into Artemisia's potential relationship with the *querelle des femmes*.

Artemisia Gentileschi in a Changing Light, edited by Sheila Barker (2017)

This is the latest collection of essays on Artemisia, highlighting a recently discovered *Mary Magdalene*. It contains new work by a familiar group of Artemisia scholars including Mary Garrard, Jesse Locker, and Judith W. Mann. Especially pertinent is the new scholarship by Sheila Barker about Artemisia's Florentine period. This book was published after my graphic novel was completed, but I've addressed some of these new ideas in this notes section.

❀ ❀ ❀

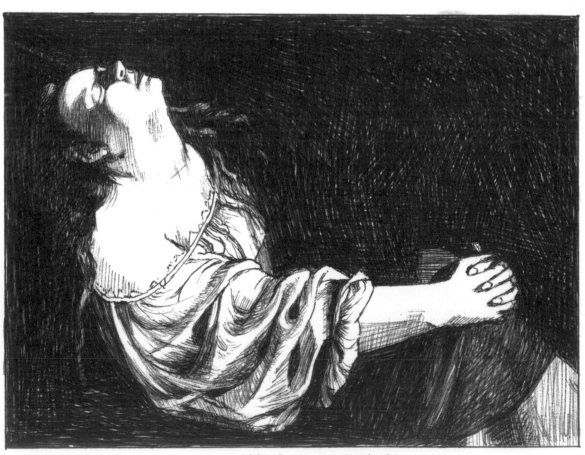

Mary Magdalene by Artemisia Gentileschi

PART ONE

PAGE 3: The map is based on the one from Lapierre's *Artemisia*.

PAGE 4: The drawings behind Giordano Bruno are copied from Francis Yates' *Giordano Bruno and the Hermetic Traditon*. These are all woodcuts made by Bruno, published in three of his pieces: *On the Triple Minimum; 120 Articles Against Mathematicians and Philosophers*, dedicated to the Hapsburg emperor Rudolph II in 1588; and *On the Immense and Numberless*, published in Frankfort in 1591. These mysterious geometric designs make it clear that Bruno saw poetry, art, science, math, and spirituality as interconnected, functioning together as a whole.

PAGE 5: Both Giordano Bruno's protests and the magistrates' (Roberto Bellarmine and Santaro di Santa Severina) sentence against him are summarized from documents in the Vatican Archives, transcribed and translated by Michael White in *The Pope and the Heretic*. The panel on the lower left features Giordano Bruno's famous last words. The hooded figures in the last panel represent the Brothers of the Company of Saint John the Beheaded, whose job was to accompany condemned people during their final hours before death. They prayed with, consoled, and escorted prisoners to the location of their execution. They generally carried torches, crosses, and small plaques depicting crucifixes and other emblems of the suffering Christ. There is a picture of one of the Brothers in Corrado Ricci's *Beatrice Cenci*. For the last panel, I drew a screaming Giordano Bruno, but actually he was muzzled.

PAGE 6: The castle on the lower right is based on the graphic reconstruction of the Petrella Castle in Corrado Ricci's *Beatrice Cenci*. Beatrice Cenci's contempt for the court is evident in Ricci's quotes from her testimony.

PAGE 7–8: Many sources claim that Beatrice was raped by her father. As a last effort to save the Cenci, lawyer Prospero Farinaccio turned their case to the issue of incest. He claimed that Beatrice was acting in self-defense. Corrado Ricci (*Beatrice Cenci*), however, argues against the assertion that Beatrice was raped. He also disputes popular rumors that she was tortured for hours.

Scholars researching both the Cenci and Caravaggio continuously grapple with avissi, which were basically the equivalent of newspaper tabloids. Just as a lot of modern news media tends to distort facts, so did the *avissi*. Yet, they represented the public's overall sentiment, snippets of the gossip of the time.

PAGE 9: This gruesome event was so crowded, hot, and frenzied that a few spectators died. Behind the platform looms the Castel Sant'Angelo, an ancient castle and Renaissance prison. Young Bernardo Cenci was eventually pardoned, left the galleys, and managed to live a somewhat normal life.

PAGE 11: I decided to focus on only two of Caravaggio's pals — Onorio Longhi and Mario Minitti. But there were others, such as Ottavio Leoni, whose portraits serve as a record of many men in the Roman art scene of the time, as well as Cecco Boneri, another young model, assistant, and possibly lover.

PAGE 12: The panel on the lower left features a plague doctor. The strange mask and beak held herbs and fragrances that were believed to ward off the plague and prevent the doctor from inhaling the infection that burdened his patients.

PAGE 13: Caravaggio was known for putting just as much care and detail into his still-lifes as he did for his history paintings, even though still-life was considered the lowest painting genre, as opposed to the "high art" of history painting (see notes for Part 3 p. 145).

Basket of Fruit by Caravaggio

Caravaggio was stopped by police numerous times. I've combined several of those interactions for the sequence in the upper right. Alexandra Lapierre touches on seventeenth-century Italian insults:

The endless bad language used by Tassi and Orazio Gentileschi — both spoken and written — and all the obscenities uttered by those in the artistic milieu, particularly Cosimo Quorli, are an integral part of the way men communicated in seventeenth-century Italy. The high incidence of swear words in their language may

not seem very different from the words that pepper modern speech, but they were conforming to a 'code of practice' for insults, a ritual governing verbal attacks that is virtually forgotten today. Contemporary Englishmen doing the Grand Tour expressed their amazement as they noted down the eight blasphemous terms that Romans, Venetians, and Neapolitans could get away with. They even drew up a catalogue of Italian insults. (368)

PAGE 14: Peter Robb (*M*) implies that Caravaggio was primarily attracted to younger men, while Andrew Graham-Dixon (*Caravaggio: A Life Sacred and Profane*) accepts that Caravaggio's sexuality was more fluid. During Caravaggio's time, sex was an activity one engaged in, but it wasn't part of one's identity.

PAGE 19: The scandalous poetry is taken from translations of the trial published in Lapierre's *Artemisia* and Robb's *M*. Mao Salini actually interrogated Filippo Trisegni, but I drew Giovanni Baglione in the bottom three panels instead.

PAGES 20–23: This trial is the only remaining record of Caravaggio's own words, as recorded by the notary. They serve as a simplified explanation of his painting philosophy. Orazio and Caravaggio's dialogue (as well as Onorio Longhi's exclamations in the upper left panel on p. 23) is summarized from translations in Lapierre's *Artemisia* and Robb's *M*. Robb cites Gian Alberto Dell'Acqua and Mia Cinotti's *Il Caravaggio e le sue grandi opere da San Luigi dei Francesi* (Milan 1971), while Lapierre cites the *Archivio di Stato di Roma* (*Tribunale Criminale del Governatore*). Since the Corte Savella prison no longer exists, its entrance on page 22 is based on other similar buildings.

PAGE 24: Artemisia is standing inside the transept of San Giovanni in Laterano, one of the only parts of the church that hasn't been significantly altered since Artemisia's time. Pope Clement VIII commissioned many artists to collaborate on the frescoes behind her, including her father and Cavalier d'Arpino.

PAGE 29: The tavern in the upper right panel is based on the Old Bear Inn, built in the late-fifteenth century on Via del Orso.

PAGE 32: The beach scene (middle panel) was inspired by Angelo Longoni's film *Caravaggio*. Most scholars agree that Caravaggio died from natural causes in Port Ercole, and Andrew Graham-Dixon (*Caravaggio: A Life Sacred and Profane*) adds that Caravaggio probably never fully recovered from the attack in Naples. Yet, there are other

theories about his death, discussed on this page by Agostino Tassi, Cosimo Quorli, and Orazio. By the time he died, Caravaggio was famous, his influence already spreading throughout Europe. Although I invented this conversation at the bar, it's likely that artists were talking about Caravaggio and trying to figure out his mysterious death.

PAGE 33: I invented this conversation between Cosimo and Agostino.

PAGES 34–35: I invented the dialogue between Artemisia and Tuzia's daughter. They were friends though, as Tuzia described during the trial of 1612.

PAGE 36: The Quirinal Palace, featured here, has changed a lot since Artemisia's time, and I tried to recreate its appearance before Bernini's (see Part 3 p. 177) additions of the mid 1600s. In the bottom left two panels, Artemisia looks at the recently completed *Annunciation* by Guido Reni (see Part 3 p. 169), whose fame was steadily growing. (The chapel with the *Annunciation* appears again on p. 38.) This trip to Monte Cavallo, the hill where the Quirinal Palace stands, is based on Tuzia and Artemisia's testimonies during the trial of 1612. Apparently, Artemisia and Costanza were friends. They played some type of croquet game together after dinner at Cosimo's house.

PAGES 41–43: I invented this scene between Artemisia and Cosimo, but throughout the trial of 1612 both Artemisia and Giovanni Battista Stiattesi claimed that Cosimo attempted to rape Artemisia multiple times. Cosimo's language may seem extreme, but such slander was common (see notes for p. 13).

PAGE 46: This scene is based on Artemisia's testimony from the trial of 1612. Mary Garrard explains, "Because *sverginata* is a more precise term than rape, indicating as it does that the victim was a virgin, it is here represented by the archaic English 'deflowered.' Artemisia is frequently described as *zitella*, which can mean either an unmarried woman or a virgin" (410). The word deflowered is considered the closest English equivalent of the seventeenth-century word for rape, since at that time forced intercourse was only considered a crime if the victim was a virgin beforehand. If the victim was married, the crime was adultery. The other early modern Italian term for rape was *stuprum*, which also implied that the victim was a virgin. The word *raptus* meant only the violent theft of property.

PAGES 48–50: This sequence is based on Artemisia's testimony from the trial of 1612, especially the

dialogue on page 49, but I invented Agostino and Cosimo interrupting and harassing her.

PAGE 53: In the original painting, Artemisia's name and the year 1610 are painted in the shadow beneath Susanna's right leg.

PAGE 54: I invented Cosimo introducing Giovanni Battista Stiattesi. We don't know exactly how and when this circle of friends, relatives, and rivals met one another.

Detail of *Suzanna* by A. Gentileschi

PAGES 56–57: This scene is based on Agostino's testimony during the trial of 1612, though the dialogue is my invention. It's likely that Artemisia yearned for a husband, since the society she lived in left women with few options, and also because marriage would keep her honor intact (see notes for Part 2 p. 123, Part 3 pp. 172–174).

PAGE 58: In Artemisia's day, daughters were often a burden to their families due to the ever-increasing cost of dowries that honorable fathers had to pay. Orazio may have delayed finding Artemisia a husband for financial reasons. Perhaps it was easier for him to have her help with the family business instead. (For more on Artemisia's marriage, see notes for Part 3 p. 140.) There's scholarly debate about what was painted by Artemisia and what was painted by Orazio, especially when they lived together and occupied the same studio, but it's my impression that they worked together on many of these paintings.

There is also debate about when Orazio's *Judith and Her Maidservant*, on the lower left, was painted. Many scholars place it in his 1610–12 phase, and some even suppose that it's the stolen painting mentioned in the trial of 1612 (see notes for Part 2 pp. 79–80). Keith Christiansen (*Orazio and Artemisia Gentileschi*) thinks that Orazio painted it between 1621 and 1624 in Genoa. There's also a copy of it that some claim Artemisia painted.

PAGE 60–65: This sequence is based on Artemisia's description given during the trial of 1612. She also said that Agostino made fun of the fathers retrieving the communion cards, boasting that he could beat them up. Artemisia probably added that detail to emphasize Agostino's careless disregard for the Catholic Church, the institution that Italians were legally bound to.

PART TWO

Mary Garrard's *Artemisia Gentileschi: The Image of the Female Hero in Italian Baroque Art* contains the most thorough English translation of the rape trial of 1612. It is a combination of translations by Efrem G. Calingaert and Anna Modigliani and also references Eva Menzio's 1981 translation. The original transcript of the trial is in the *Archivo di Stato* in Rome. The magistrates' questions are in Latin, while the answers are in Italian. The trial was recorded by a notary, who listened to the testimonies and recorded them quickly without punctuation. Yet, the notary seems remarkably thorough, even recording details like Agostino's loud, angry outburst, and Artemisia repeating "it's true, it's true" over and over again. The document is now old, worn, and missing pieces, which has added to the endless controversy about the trial. Garrard's translation, like the original, is dense and full of filler words, redundant passages, and confusing contradictions. Therefore, I adjusted, reworded, paraphrased, summarized, and removed many sections. When I summarized testimonies, I tried to remain as faithful to their overall meaning as possible. I used some of the witnesses' descriptions of events to illustrate those same events in Part 1. If an event described by a witness was portrayed in Part 1, I did not include that part of the witness's testimony in Part 2.

PAGES 69–70: Orazio moved his family many times. Initially, they lived on Via del Babuino. By February 1611, they were living on Via Margutta (in the house referenced by several witnesses during the trial of 1612). In April, they moved to Via della Croce, and in July they moved to Santo Spirito in Sassia, probably to be closer to Agostino Tassi, Orazio's co-worker at the time. (Christiansen, Mann)

PAGES 71–74: My first priority here was to remain as true to Artemisia's words as possible, even if her testimony seems awkward or overly technical.

PAGE 74: In Garrard's translation of the trial, there is a footnote that defines the term "foolishness" as "presumably meaning unfaithfulness on her [Artemisia's] part" (416).

PAGE 77: Carnival was a joyous, festive time, but it also coincided with an increase in criminal activity. Most of the parades took place on Via del Corso, a road that was less developed in Artemisia's time. I drew one building that was there — the Hospital of the Incurables, on the left side of the street in the large top panel. This was the hospital for those with syphilis, an increasingly common, incurable disease associated with prostitution, often referred to as the "French Disease."

PAGES 79–80: In *Orazio and Artemisia Gentileschi* (Christiansen, Mann), several authors claim that this *Judith and Her Maidservant* was the stolen painting referred to in the trial of 1612. The back of the canvas bears the inscription "Piz," which may be a reference to the trial notary Tranquillo Pizzuti.

PAGES 83–91: I invented this sequence. How Orazio discovered the affair between Artemisia and Agostino is still debated. Alexandra Lapierre's conclusion is that Giovanni Battista Stiattesi broke the news to Orazio and set the trial in motion, seeking revenge against Cosimo. Elizabeth Cohen ("The Trials of Artemisia Gentileschi") suggests that Orazio knew about the affair all along and thought that Agostino probably seemed like a decent potential husband. Cohen proposes that some disagreement between Agostino and Orazio, perhaps work-related, set them against each other. I lean more toward Lapierre's theory, mainly

because it seems that during the trial of 1612 many witnesses alluded to keeping the affair secret.

On page 91, I included a slightly shortened version of Orazio's letter, as it appears in Garrard's *Artemisia Gentileschi: The Image of the Female Hero in Italian Baroque Art*, translated alongside the trial of 1612 by Efrem G. Calingaert. Lapierre concludes that this letter was actually written by Giovanni Battista Stiattesi, who served as Orazio's lawyer, because it's in his handwriting (he probably also advised Artemisia on her testimony).

(For more on the *Casino of the Muses* on p. 83, see notes for Part 3 p. 217.)

PAGE 101: Agostino's sonnet and letters, submitted to the court by Giovanni Battista Stiattesi, are included in Mary Garrard's *Artemisia Gentileschi: The Image of the Female Hero in Italian Baroque Art*, translated along with the trial of 1612 (see beginning of notes for Part 2).

PAGE 102: In the bottom panels, Agostino refers to Grand Duke Ferdinando I de' Medici (1549–1609). Rowing on the galleys was a common punishment in Renaissance Italy. It's possible that Agostino did not row voluntarily for the Grand Duke, but was actually a galley slave serving time for crimes he had committed.

Agostino Tassi as a galley slave

PAGE 105: I invented this funeral scene and its location — Santa Maria del Popolo, the church where Prudenzia's funeral took place.

PAGES 109–111: This scene was constructed according to the testimony of Porzia, Giovanni Battista Stiattesi's wife, who accompanied her husband on this visit to Corte Savella (see notes for p. 120).

PAGES 115–117: The *sibille* was considered less severe than other forms of torture. This method of extracting the truth was deemed suitable for Artemisia's gender and social status.

PAGES 118–119: Agostino actually addressed his questions to the magistrates, who read them to Artemisia. When she answered, she alternated between addressing Agostino and the authorities.

PAGE 120: In their testimonies, both Giovanni Battista Stiattesi and his wife, Porzia, described the night that they visited Agostino at Corte Savella, but their descriptions are slightly different from each other. Although I left Porzia out, I used her testimony to construct pages 109–111, while showing Giovanni Battista give his testimony on this page.

PAGE 123: The concept of "honor" and "dishonor" referred to a person's behavior, class, and status. For a man to be considered honorable, he had to protect the women in his family. For a woman, maintaining an honorable reputation required chastity and sexual purity (see notes for Part 3 pp. 172–174). However, the term "honest" was also associated with prostitution. A wealthy courtesan who slept with only high-ranking nobles or cardinals was considered an "honest courtesan," above the status of a lowly prostitute (see notes for Part 3 pp. 180–181).

PAGES 125–129: Many witnesses testified on behalf of both Orazio and Agostino, but only some of them are represented here. In Garrard's translation of the trial, after June 9, 1612, the testimony is paraphrased in a section titled "Synopsis of Testimony" by Efrem G. Calingaert. I used the "Synopsis of Testimony" for the witnesses' words here. The notary recorded the name of each witness, followed by a brief description of them, which I used here. Sometimes the witness' occupation or age is included, and the women are usually referenced in relation to their husbands or fathers. Pietro Hernandes is described simply as "a Spaniard."

The "Synopsis of Testimony" states that Olimpia "related that she and her brother Agostino were sometimes on bad terms but made up, and that once she brought suit against him for incest with his sister-in-law. She gave more details about her relationship with Agostino" (485). Calingaert does not elaborate on those "details." Therefore, on the last panel of page 129, I invented Olimpia's statement " … but we've made up … I think … "

PAGE 132: With X-radiography (X-raying a painting to expose the underpainting), art historians have detected "pentimenti," marks that painters made on their canvases as they planned their compositions. "Pentimenti" signifies the early stages of a painter's process of mapping out the placement of forms, shapes, and structures, similar to a preliminary drawing. An abundance of "pentimenti" was found in Artemisia's first *Judith Slaying Holofernes*, especially around the entangled arms, revealing her struggle with such a complex composition.

PAGE 133: This first rendition of *Judith Slaying Holofernes* has been damaged throughout the years. At some point, it was trimmed on the upper left side. It must have originally looked more like Artemisia's later Florentine version, with more of Holofernes' legs showing (see Part 3 p. 167).

PART THREE

PAGE 137: The portion of Orazio's letter in the upper right panel is from Ward Bissell's *Artemisia Gentileschi and the Authority of Art*. Bissell cites Leopoldi Tanfani-Centofanti's transcription in *Notizie di artisti tratte dai documenti Pisani* (1897).

The fifteenth-century Pitti Palace, shown here and on page 151, was purchased in 1550 by Eleonara de' Toledo, Cosimo I's wife. The building soon became the Medici's primary residence, with the Vasari Corridor connecting it to the Palazzo Vecchio, the seat of government. Throughout the late sixteenth century, architect Bartolomeo Ammanati widened the building, and added the back wings, the courtyard, and the grotto below. I've attempted to recreate the Pitti Palace as it appeared in Artemisia's time, without the two lateral projecting pavilions added by the Lorraine family in the early 1800s. My main source was a 1599 painting of the Pitti by Giusto Utens, published in the exhibition catalogue *The Medici, Michelangelo, and the Art of Late Renaissance Florence*. However, I invented the interior since it has changed a lot since Artemisia's time.

PAGE 140: The marriage of Artemisia and Pierantonio, in the middle right panel, took place in the Church of Santo Spirito. Orazio agreed to pay a large dowry of 1,000 *scudi* — 500 up front, the other 500 to be paid five years later with interest (Barker). Sheila Barker ("Artemisia's Money") states that "In an arrangement that was not unheard of among the lower tiers of the merchant and artisan classes, the marriage contract permitted Pierantonio to employ the principal of the dowry in his business investments, on the condition that those business investments were made with his wife's approval. This critical last clause established Artemisia's power over the use of the

money and made her a *de facto* business partner with her husband when it regarded the investment of her dowry" (60). (For more on the marriage, see notes for pp. 158–160, 161–165, 172–174.)

PAGE 141: It was recently discovered that Artemisia obtained the favor of Cosimo II sooner than previously thought — she completed three paintings for him by 1614 (Barker). Cosimo II's mother was French and his wife was Austrian due to the Medici's attempts to forge alliances with other great world powers through marriage, common during the Renaissance. These two women are often dismissed as religious fanatics who argued and wasted the Medici's dwindling fortune. But Kelly Harness' *Echoes of Women's Voices* and Suzanne Cusick's *Francesca Caccini at the Medici Court* illuminate Christine of Lorraine and Maria Maddalena's control of the marriage market and their use of feminist imagery and music to promote their leadership, especially throughout the 1620s.

On the lower left panel, the dialogue comes from a letter written by Maria Maddalena, discussed by Cusick:

> The grand duchesses' ongoing responsibility to protect other women in bad marriages extended beyond the princesses' class. In early November 1628, Magdalena [sic] wrote the Auditore of Siena about the ill treatment suffered by one of her former donne: 'We cannot nor should we tolerate that gentildonne who have served us and been married from our household should find themselves unhappy and distressed because of their husbands. It displeases us infinitely therefore to hear that this happens in that city, and to the person of Ippolita Agostini, because of her husband Bolgherini's evil ways, whence he has wanted to beat her and throw her out of the house, without the slightest regard for her merit.' Magdalena [sic] wanted the auditore to remedy the situation, first by talking to Bolgherini. Specifically, he was to tell him that if the beatings did not stop 'we will make him aware of his error, and in such a way that he will have the memory of it forever, and be an example to others.' (51)

Maria Maddalena also wrote to the widowed duchess of Mantua, her sister-in-law Caterina de' Medici (see notes for p. 155), threatening to imprison Bolgherini.

PAGE 142: For the bottom left panel I summarized an argument between Galileo and his rival, Ludovico delle Colombe, analyzed by Mario Biagioli (*Galileo, Courtier*).

PAGE 143: I invented this scene. It's my guess that the Tuscan Lomi and Allori families knew one another. Cristofano Allori was the godfather of Artemisia's son, Cristofano (see p. 146), and collaborated with Francesca Caccini and Michelangelo the Younger on several Medici court spectacles.

It's unclear when Galileo met Orazio and Artemisia, but Artemisia's 1635 letter to Galileo implies that he was one of her long-term supporters. The letter, translated by Efrem G. Calingaert from the transcription in *Le Opere di Galileo Galilei* (Florence 1929–39), is published in Mary Garrard's *Artemisia Gentileschi: The Image of the Female Hero in Italian Baroque Art*. Galileo was in Rome in 1611 to promote the telescope and to become an official member of the scientific *Accademia dei Lincei* (Lyncean Academy) (see p. 176), founded in 1603 by Federico Cesi. It's possible that Galileo met the young Artemisia in Rome in 1611. Livia Carloni ("Orazio Gentileschi Between Rome and the Marches") writes, "In 1615, [Orazio] Gentileschi's neighbor Nicolo Tassi wrote to Galileo, implying a special relationship with Orazio … Clearly, Galileo's admiration for [Orazio] Gentileschi was not due solely to their common origins (like Galileo, Orazio was born in Pisa, though he always called himself a Florentine). Nor was it nurtured solely by the scientist's great open-mindedness. Rather, it must have derived from Galileo's recognition of the extraordinary visual precision, modernity, and elegance of the painter's work" (122–123).

Galileo became a member of the *Accademia del Disegno* around 1613. When he was young, he wanted to be an artist but was dissuaded by his father, Vincenzio, who encouraged his son to enter the medical field instead.

Accademia dei Lincei Coat of Arms, one of many examples of a Renaissance designer drawing an animal they have never actually seen before—in this case, the lynx.

PAGE 144: It's likely that Francesca Caccini and Artemisia were friends, or at least knew each other, since both were in the same circle and worked closely with Michelangelo the Younger. I invented Galileo introducing Artemisia to Michelangelo the Younger. (For more on Artemisia's ties to music, see notes for p. 151.)

PAGE 145: I invented this scenario to show Artemisia's Florentine community coming together. The current location of this *Self-Portrait as the Allegory of Painting* is unknown, but there is a picture of it in Jesse Locker's *Artemisia Gentileschi: The Language of Painting*. It's not certain that it's a self-portrait, but the figure's gaze and the position of her hand seem to portray an artist observing herself in a mirror. The allegory of painting is one of many allegories described in Cesare Ripa's *Iconologia*. Artemisia's figure conforms to Ripa's description — messy, dark hair, paintbrush, and a pendant with a mask representing imitation (see notes for pp. 210–212). This may be the painting referenced in Alessandro Biffi's 1637 inventory, along with another small circular *Allegory of Poetry* by Artemisia (now lost), eluding to her affiliation with literary arts (Locker).

Artemisia is listed in the *Accademia del Disegno*'s roster in 1614, but only in reference to unresolved debts (see notes for pp. 158–160). This may be evidence that Artemisia was involved with the academy before she was an official member. In the middle right panel everyone exclaims, "A woman history painter?" because it was so unusual at the time. Portraits and still-lifes were considered the traditional realm of women, as these were lower in the hierarchy of artistic practices.

PAGE 146: According to Filippo Baldinucci's short biography of Artemisia (published posthumously in 1728), the figure in Artemisia's *Allegory of Inclination* was originally nude, but later covered with drapery. Lionardo, Michelangelo the Younger's nephew, commissioned Baldassare Volterrano to add the drapery (Garrard 1989). Thus, I invented what the figure looked like underneath the drapery in the upper left panel. Originally, she also held a compass, "with two small pulleys at her feet, indicating quickness and facility of mind" (Garrard 1989, 498).

Mary Garrard ("Artemisia's Hand") argues that the hands of Artemisia's female figures exude a unique, dynamic energy and strength. The weakness of the figure's hand in the *Self-Portrait as a Martyr* led Garrard to question its attribution to Artemisia. While the face of the martyr adheres to Artemisia's style and resembles other self-portraits by her, the hand looks uncharacteristically flimsy, even slightly out of proportion. Jesse Locker makes the case that Artemisia, and other uneducated artists of the time (e.g., Cavalier d'Arpino and Guido Reni), learned about literature primarily through popular music and theatre (see notes for p. 155).

The name Gentileschi was not only the last name of Orazio's mother, it was also the last name of Orazio's uncle, with whom he stayed when he first moved to Rome from Tuscany. This uncle was Captain of the Guards of Castel Sant'Angelo, perhaps another incentive for adopting his name.

Initially, Artemisia moved in with the Stiattesis, a large Tuscan family of mostly tailors. In fact, Pierantonio's father, Vincenzo, probably oversaw the production of luxurious garments that Artemisia wore and incorporated into her paintings. He may have also connected Artemisia with his own clients. (Barker)

There is little information on the births of Artemisia's children, besides the dates of their baptisms and burials (see notes for pp. 161–165). For the lower left panel, I omitted the "birthing chair" commonly provided by Italian midwives, described by Nadia Maria Filippini ("The Church, the State and Childbirth").

PAGE 149: *La Guerra D'Amore* was written by Andrea Salvadori and Paolo Grazi. The music was composed by Giovanni del Turco, Jacopo Peri, and Francesca's husband Giovanni Battista Signorini, who was known for his good looks. Jacopo Peri and Andrea Salvadori were Francesca Caccini's rivals, and Suzanne Cusick (*Francesca Caccini at the Medici Court*) describes Francesca's conflicts with Salvadori in particular. *La Guerra D'Amore* is one example of the many performances, or "masques," put on by the Medici. I assumed that Artemisia and Francesca would've been there, especially since Francesca's husband was involved in its production.

PAGE 150: Little is known about Francesco Maria Maringhi, but he inherited 6,000 gold scudi and several pieces of property, so he was quite wealthy (Straussman-Pflanzer). He was descended from the famous Francesco Maringhi who commissioned the *Coronation of the Virgin* altarpiece by Filippo Lippi in the fifteenth century. I invented this scenario, as there is no evidence that he was involved with equestrian ballets, although many members of the Medici court were passionately enthusiastic about fancy, expensive horses throughout the ages.

PAGE 151: Artemisia may have been a musician as well as a painter. Women playing instruments are featured in multiple paintings by Artemisia and Orazio. The Medici court diarist, Cesare Tinghi, wrote that in Francesca Caccini's 1615 performance of the *Balle delle Zingare* (*Dance of the Gypsy Women*) in the Pitti Palace, a "Sig.ra Artimisia" [sic] sang the part of one of the gypsy women. Artemisia Gentileschi's artisan class background made her a good candidate for the role. Noblewomen were only allowed to perform in more private events if at all. There was another Artemisia in the Medici court — Artemisia Torre (or Tozzi), but she was a noblewoman, so it would have been dishonorable for her to participate in the *Dance of the Gypsy Women*. (Locker)

Jesse Locker refers to the self-portrait in the lower left panel as the *Self-Portrait as a Gypsy*, linking it to the *Dance of the Gypsy Women* performance. Locker explains the similarities between this particular self-portrait and other images of gypsies. The dress she wears in the painting coincides with Tinghi's description of costumes worn for the performance. In fact, there may be multiple paintings by Artemisia associated with Medici court spectacles. Tinghi wrote that the actors playing the gypsies appeared in blackface. Locker explains that Artemisia does not appear in blackface in her *Self-Portrait as a Gypsy* because the black facemask "would have been necessary in a theatrical performance but extraneous in a painting and foreign to the pictorial tradition" (140). Since people of color and gypsies were thought to be more sexual and immoral, I wonder if Artemisia's cleavage (notably more prominent here than in her other self-portraits) was part of the costume, another detail representing the stereotype of these minorities (see notes for p. 217).

(For more on the Pitti Palace, see notes for p. 137.)

PAGE 152: I invented this scene based on a handful of recently discovered love letters from Artemisia to Maringhi, along with letters from Pierantonio to Maringhi, from around 1620 (see notes for pp. 155, 158–160, 161–165). The letters were transcribed by Francesco Solinas and published in 2011, but they haven't been fully translated into English. Elizabeth Cohen's "More Trials for Artemisia Gentileschi" provided a much-needed analysis of the letters, quoting sections of them in English. She explains that they are more than love letters — they reveal Artemisia and Pierantonio's attempts to maintain their business, with Maringhi's assistance. Pierantonio knew about the affair between his wife and Maringhi but, as Locker writes, he "turned a blind eye" to it. Yet, Sheila Barker ("Artemisia's Money") recently revealed that Artemisia probably became more independent after joining the *Accademia del*

Disegno, even claiming full control of her dowry, and that Pierantonio was often absent from Florence after 1616.

PAGE 153: Scholars debate about the left-hand strip of Artemisia's *Penitent Magdalene*, which includes the gold signature on the chair. Some think that this strip of canvas was added later, perhaps by someone other than Artemisia, although it was common for artists to save money by piecing together canvases. Orazio's father, Giovanni Battista Lomi, was a Florentine goldsmith. Judith W. Mann ("Identity Signs") proposes that Artemisia's elaborate gold signature references her Lomi heritage, a link to her goldsmith grandfather.

Galileo went to Rome around 1615–16. Artemisia needed powerful allies to advocate for her, so I decided that Galileo summoned Orazio in Rome to grant Artemisia's access to the *Accademia del Disegno*. In the upper right panel, Galileo writes his famous letter to Christine of Lorraine, derived from a debate at a dinner party hosted by Christine herself. Eventually, the letter was published in 1636 as an appendix to Galileo's *Dialogue Concerning the Two Chief World Systems*. The excerpt in the word balloon is from Jean Dietz Moss's "Galileo's Letter to Christina." Moss's translation of the letter comes from Stillman Drake's *Discoveries and Opinions of Galileo*. Drake translated the letter from *Le Opere di Galileo Galilei*, twenty volumes edited by Antonio Favaro, aided by Thomas Salisbury's 1661 translation.

Detail of *Penitent Magdalene* by A. Gentileschi

PAGE 154: In the upper right panel, I summarized a small portion of the Florentine ambassador Piero Guicciardini's report on Orazio. Alexandra Lapierre's *Artemisia* contains a translation of the letter. She cites Anna Maria Crino's "More Letters from Artemisia Gentileschi," which features Andrea Cioli's request for information about Orazio; and Anna Maria Crino and Benedict Nicolson's "Further Documents Relating to Orazio Gentileschi," which features Guicciardini's reply to Cioli. Lapierre and others speculate that a vindictive Agostino Tassi influenced Guicciardini's hostility toward Orazio. In 1613 Tassi worked on Cardinal Montalto's villa just outside of Rome. He was commissioned to work on the Sala Regia in the Quirinal Palace soon after, one of his largest undertakings (see notes for p. 217).

Although Giovanni Battista Stiattesi was in Florence from 1616–19, it's unclear whether Orazio went to Florence in 1616 (see notes for p. 153). Lapierre discusses how the phrase "ratified by the father" appears alongside Artemisia's registration in the *Accademia del Disegno* records. After comparing Artemisia's registration to others, Lapierre discovered that this phrase appears only a few times and "seems to apply only to young artists. Does this perhaps mean that before minors could be admitted, their fathers had to give their agreement? Or is the phrase simply a reminder that the father — or uncle in some cases — was already a member of the academy himself?" (403).

Karen Barzman (*The Florentine Academy and the Early Modern State*) concludes that "the presence of a woman among the academy's professional members seems to have had little, if any, impact on the institution's affairs. Her name appears in several documents in the academy's archives, but they concern mundane matters of business settled in the academy's court, rather than the activities of the academy's school or confraternity" (84). There is evidence of two other women among the ranks of the *Accademia del Disegno* in the seventeenth century — Rosa Maria Settermi paid taxes to the academy between 1662 and 1668, and Caterina Corsi Pierozzi became an academician in 1684 (Straussman-Pflanzer). (For more on Artemisia's entry into the academy, see notes for p. 152.)

PAGE 155: Artemisia's *Saint Catherine* may have coincided with Caterina de' Medici's marriage to the Duke of Mantua in 1616 (see notes for p. 141) — a celebratory gift or a commission. It might also be a self-portrait, as the saint's extended left arm could be analogous to Artemisia's painting arm, as seen in a mirror. Michael Fried (*The Moment of Caravaggio*) makes a similar claim that Caravaggio's early paintings of dark-haired, sensual men are self-portraits — mirror images of the

artist at work, the paintbrush and easel replaced with musical instruments or floral bouquets.

Elizabeth Cropper ("New Documents for Artemisia's Life in Florence") writes, "Between May 1616 and June 1616, Artemisia ran up debts with a pharmacist *alla Carraia* for all manner of laxatives and sweet meats" (760). Artemisia's debt is documented in the *Accademia del Disegno* records in the *Archivo di Stato* in Florence (see notes for pp. 158–160).

Artemisia's letters to Maringhi (see notes for p. 152) contain numerous references to Petrarch and Ovid, two well-known, commonly read authors during Artemisia's time. Although the letters prove that Artemisia was more literate than previously thought (during the trial of 1612 she mentioned that she could not write and could only read a little), they also show "Artemisia's want of a proper period education" (Straussman-Pflanzer 25). Jesse Locker quotes Francesco Solinas's description of Artemisia's letters: "Incorrect but profound, ungrammatical but cultured" (7). Even if Artemisia was new at reading and writing, she was familiar with popular authors simply from hearing their works recited or referenced out loud in poetry, music, and theatre. Locker stresses the importance of Italian oral culture throughout the early modern era (see notes for p. 146).

PAGE 156: In addition to attempting to work on St. Peters in Rome, Orazio also tried to work in Venice for Giovanni de' Medici, Cosimo I's illegitimate son. The Medici court *guardaroba*, Bernardo Migliorati, was responsible for a libellous sonnet about Artemisia's scandalous love life. Sheila Barker ("Artemisia's Money") recently proposed that Orazio sent his son, Giulio, to Florence

to take Artemisia back to Rome, as her increasingly negative reputation threatened the family's honor (see notes for pp. 161–165).

Artemisia and Giulio

PAGE 157: This map is based on maps in Alexandra Lapierre's *Artemisia* and Will and Ariel Durant's *The Story of Civilization Part VII*. The fifty scudi advance from Cosimo II was actually for two paintings (Barker), but Elizabeth Cohen ("More Trials for Artemisia Gentileschi") describes Artemisia's struggle to create one last painting for Cosimo II, to send back to Florence after she left (see notes for p. 152). Artemisia expected Maringhi to visit her in Rome and take the painting back to Florence with him, but he never came (Cohen 2015).

PAGES 158–160: I invented these domestic scenes based on the letters between Artemisia and Maringhi (see notes for p. 152). Lisabella was named after one of her godparents, Jacopo Cicognini's wife. Cicognini was another writer and producer of Medici festivities, alongside Michelangelo the Younger and Francesca Caccini. He was loosely involved with the *Accademia del Disegno* and committed suicide in 1633. Lisabella's other godparent, Iacopo di Bernardo Soldani, was a poet and early defender of Galileo.

On page 159, Artemisia's words during her first appearance in court on June 5, 1619, are derived from her letter to Cosimo II, who advised the academy's court for her case. The academy reduced Artemisia's debt to two carpenters — Bartolomeo Pocelli and Salvestro Susini. Elizabeth Cropper ("New Documents for Artemisia's Life in

Florence") summarizes Artemisia's words during these trials, including her letter to Cosimo II, which is in the *Accademia del Disegno* records in the *Archivo di Stato* in Florence. Recently discovered sources indicate that this debt was contracted prior to the financial independence Artemisia gained with her entry into the academy's guild (see notes for p. 152).

Sheila Barker ("Artemisia's Money") recently provided a compelling reassessment of Artemisia's finances in Florence. Many scholars agreed that since much of Artemisia and Pierantonio's debt was under his name, he was primarily responsible, but actually Artemisia controlled the couple's business decisions: "Artemisia's recourse to her husband … to formalize her contracts and to collect payments can be ascribed in large part to the laws requiring women to employ a male proxy known as a *mondualdo* for their contractual business arrangements" (64). Also, in various documents, Pierantonio is referred to as an *aromatarium*, an apothecary owner, more frequently than he is listed as a *pittura*, or painter. Therefore, he "could have helped in the acquisition and preparation of Artemisia's pigments, glues, linseed oil, mineral spirits, and varnishes" (61).

Barker has also illuminated the "culture of credit." Recent research shows that buying items on credit was common and not inherently dishonorable. A merchant allowing an artisan to purchase goods on credit meant that the artisan was trustworthy. The artisan often pledged valuable personal items—in Artemisia's case, expensive jewelry and dresses—to ensure that the debt would be paid off. In this context, Artemisia's frequent use of credit to obtain luxury items was a normal part of self-fashioning that enhanced her status. The fancier Artemisia appeared (her hair, jewelry, clothes, and home), the more she could purchase on credit, and the more likely she was to obtain the favor of wealthy patrons. Plus, unlike bankers, merchants did not charge interest, and the amount owed was often reduced. Another artist that made huge purchases to make himself appear upper class was none other than Agostino Tassi. According to his eighteenth-century biographer, Giovanni Passeri (see notes for pp. 180–181, 202), he was never able to pay off his debt; while it appears that Artemisia mostly did (Barker). Yet, Artemisia took longer to pay lower-class serving women and manual workers, which was also common (see notes for p. 176).

PAGES 161–165: According to Elizabeth Cohen ("More Trials for Artemisia Gentileschi"), Cristofano "died of *bachi*, a pernicious dysentery" (263). Did this disease, or something similar, kill the other children too? It was recently discovered that in 1614 Artemisia gave birth to another

daughter, Agnola, who died before she was baptized (Barker). Infants and children died so frequently in early modern times that many scholars have proposed that parents then did not grieve the way that twenty-first-century parents grieve in such circumstances. This interpretation about the psychological impact of death echoes similar debates about the impact of rape. Which feelings are instinctively human and which feelings are the product of society?

Just as children died more frequently, so did women (especially while giving birth) and men. Simon Schama (*Rembrandt's Eyes*) describes how devastated Peter Paul Rubens (see pp. 176, 209) felt when his brother, Philip, died at age 37 in 1611, and when his wife, Isabella Brant, died at age 35 in 1626:

How do you feel when your best friend dies? How do you feel when he is also your brother, and when your brother is all that remains, besides yourself and your infant daughter, of a family that once numbered nine? Historians like to tell us that we can know nothing of such things; that seventeenth-century grief is as remote from our sensibility as the mourning rituals of ancient Sumeria; that the ubiquitousness of plague and dysenteric diseases made for necessarily callused sensibilities. They caution us that a sudden passing that would render us distraught was accepted by our ancestors as the unchallengeable decree of the Almighty. And of course they are right, to some degree, in warning against projecting our own emotional sensibilities onto cultures still innocent of the raptures and torments of Romantic sentiment. Sometimes, though, they protest too much against the shock of recognition, the peculiar familiarity we register intuitively across the centuries. Historians, after all, have a vested interest in insisting that the past is a foreign country, since they like to claim a monopoly on translating its alien tongues. But sometimes they aren't needed. Sometimes the culturally conditioned response cracks apart and an emotion immediately recognizable to modern sensibilities makes itself felt. (145)

Schama goes on to quote Rubens's letter to Pierre Dupuy regarding Isabella Brant:

I have no pretensions about ever attaining a stoic equanimity; I do not believe that human feelings so closely in accord with their object are unbecoming to man's nature, or that one can be equally indifferent to all things in this world … truly I have lost an excellent companion whom one could love—indeed had to love with good reason—as having none of the faults of her own sex. She had no capricious moods and

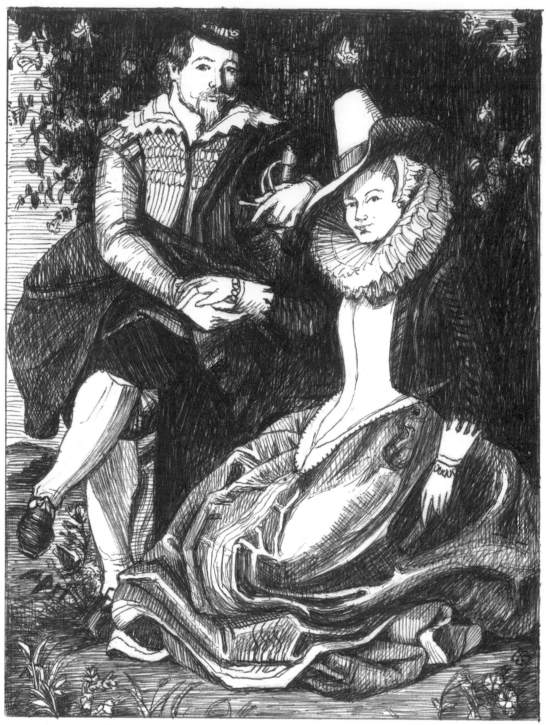

The Honeysuckle Bower, a self-portrait with Isabella Brant by Peter Paul Rubens

no feminine weakness but was all goodness and honesty. And because of her virtues she was loved by all in her lifetime and mourned by all at her death. Such a loss seems to me worthy of deep feeling. (145)

Rubens's words indicate how people thought about death, and the prevailing attitudes toward women at the time. Schama cites *The Letters of Peter Paul Rubens*, edited and translated by Ruth Saunders Magurn.

Artemisia's letters of 1620 illuminate her grief. The quotes from both Artemisia and Pierantonio's letters on page 164, as well as Pierantonio's letter in the bottom middle panel on page 163, are all translated by Cohen in "More Trials for Artemisia." Cohen cites *Lettere de Artemisia* (Rome, 2011) edited by Francesco Solinas. Artemisia and Pierantonio's exit from Florence, their arguments with Orazio and the Gentileschi brothers, and Artemisia's breakdown are all based on Cohen's analysis of the letters (see notes for p. 152).

For page 161, I invented Giovanni Battista Stiattesi and Maringhi's frustration with Artemisia. It seems that she was unable to complete paintings on time (see notes for p. 167), but artists often haggled with patrons over deadlines, money, and subject matter. Even Michelangelo's letters to patrons are full of heated ongoing negotiations.

In 1620, Artemisia requested 1.5 ounces of ultramarine from Cosimo II to complete a painting for him, perhaps the *Judith Slaying Holofernes* on page 167. She offered some of her household goods as collateral. Later, Maringhi wrote to Cosimo II guaranteeing that she would complete the painting in six months and if not, he would cover the cost himself. After Artemisia's departure, Maringhi bought what was left in her studio and paid some of her remaining debt. He also secured Artemisia and Pierantonio's living arrangements in both Florence, within the Piazza Frescobaldi, and in Rome with Luigi Vettori on Via Soria. I invented Maringhi loaning the horses for travel, based on his record of unwavering generosity. (Straussman-Pflanzer)

Drawing from recently discovered documents and the 1620 letters (see notes for p. 152), Sheila Barker ("Artemisia's Money") put forth a different version of Artemisia and Pierantonio's exit from Florence. Barker contends that Orazio may have sent Artemisia's brother, Giulio, to Florence to take Artemisia back to Rome: "Artemisia and her brother were apprehended in Prato, at which point Pierantonio was summoned by government officials and commanded to keep his wife in Florence, or pay a steep fine. In response, Artemisia beseeched the grand duke for permission to go to Rome for a short spell, citing an urgent family matter" (69). Barker doesn't think that a financial crisis forced the couple to flee, but rather the slanderous gossip and libelous sonnets (see notes for p. 156). Eventually, Pierantonio filed a lawsuit against Orazio, demanding the remaining portion of Artemisia's dowry (see notes for p. 140). If Artemisia and Pierantonio were not living together in Florence, Orazio would not have had to pay the remaining 500 scudi (see notes for p. 152). Whether or not he paid is unknown. He may have given the couple real estate in Pisa instead. In Artemisia's letter to Andrea Cioli from 1636, she mentions selling some land in Pisa (see notes for p. 197).

PAGE 166: I invented this scene. There is little information about what kind of parent Artemisia was, but there are signs that she was a decent mother. She went through a lot of trouble to raise dowries for her daughters (see p. 222). Prudenzia played the spinnet (see notes for p. 203), and Artemisia mentions some "small works" by her daughter in a letter (see p. 222), revealing that she tried to create opportunities for her children — the ability to play an instrument, along with writing, drawing, and painting, could raise a young woman's social standing and enhance her dowry (see Part 1 p. 26).

It was not unusual for mothers to abandon their children, especially illegitimate ones. Daughters were more likely to be abandoned — unlike sons, who would eventually bring money into the family, daughters took money away because of the required dowry. Even entering a convent cost a small sum. Sandra Cavallo and Simona Cerutti ("Female Honor and the Social Control of Reproduction") describe the abandonment of babies in the seventeenth and eighteenth centuries. State-funded hospitals were so frequently burdened by abandoned children that, by the eighteenth century, separate institutions took responsibility for unwanted children secretly dropped off at night. Yet, even though she could've easily abandoned them, Artemisia took responsibility for her daughters, even the illegitimate one.

For the last panel on the bottom right, I was thinking of Judith Mann's "Identity Signs." Mann points out that this is the only known instance where Artemisia used the word "ego" alongside her signature, one of her boldest statements of authorship.

PAGE 167: Similar to the screaming face on the pommel of Judith's sword in the painting on page 156, the pommel of Sisera's sword also has a grotesque face. While the aggressive face on Judith's sword resembles Medusa, the face on Sisera's discarded weapon is sillier, perhaps even mocking the fallen man. (For more on Artemisia's *Jael and Sisera*, see notes for p. 171.)

According to Eve Straussman-Pflanzer (*Violence and Virtue*), the Florentine female regency seems to have reacted negatively to Artemisia's *Judith Slaying Holofernes*:

Despite Orazio's initial contact with Grand Duchess Christine of Lorraine, it does not appear that the Medici grand duchesses, either Christine or her successor Maria Maddalena of Austria (1589–1631), ever harbored intentions of actively patronizing Artemisia Gentileschi. Artemisia was an outsider who likely carried a dubious reputation due to the Roman trial, her extramarital affair with a Florentine nobleman, and her inability to finish pictures in a timely manner. Without question, the Medici family was status-conscious, the grand duchesses in particular. Rather than capitalizing on her shared gender with the grand duchesses, as did many women of artistic ability, such as the Bolognese

Detail of *Judith & Her Maidservant* by A. Gentileschi

Detail of *Jael & Sisera* by A. Gentileschi

painter Elisabetta Sirani (1638–1665) or the Marchigian portrait painter Camilla Guerrieri Nati (1628–after 1693), Artemisia appears to have placed greater emphasis on engaging with the male members of the court circle, as her correspondence with Galileo and Michelangelo Buonnaroti the Younger attests. Notably, the last known person Artemisia contacted at the Florentine court, with a letter dated July 20, 1635, was Grand Duke Ferdinando II, not his wife, Grand Duchess Vittoria della Rovera (1621–1694), with whom many seventeenth-century women of talent were in contact. (28–29)

This dynamic also inspired the scene on page 198, when Artemisia admits her inexperience upon entering the Hapsburg court of Maria Anna of Austria. Of the known letters by Artemisia, not one is addressed to a woman.

It's easy to connect Grand Duchess Christine's negative reaction to Artemisia's *Judith Slaying Holofernes* with the reaction of the last Medici Grand Duchess, Maria Luisa (1667–1743). Her younger brother, Giangastone, the last Medici Grand Duke, died in 1737, and both the Austrian

empire and the House of Lorraine took over Tuscany once and for all. They allowed Maria Luisa to spend the rest of her days in the Pitti Palace. In return, she gave up the Medici's property, art, and treasure, accumulated over many generations, to the House of Lorraine, but she insisted that all of it remain in Florence. However, Artemisia's *Judith Slaying Holofernes* was too much for her. Straussman-Pflanzer mentions what Marco Lastri wrote in his history of Tuscan painting, *L'Etruria Pittrice* (1795): "Such is the horror inspired by the truncated neck of Holofernes gushing blood on the white linens of the bed, and the proud attitude of the heroine, that it was necessary to condemn this picture to a dark corner of the aforementioned Royal Gallery, in order not to offend the sensibility of our deceased sovereign, Maria Luisa, who had on many occasions displayed disgust upon viewing it" (29). Filippo Baldinucci (see notes for p. 146) also mentioned Artemisia's bloody *Judith*. Even though he praised the painting, he wrote that it caused "not a little terror" (Christiansen, Mann 348).

Jesse Locker explores eighteenth and nineteenth-century reactions to Artemisia's paintings. It was not just the graphic violence that shocked and disgusted the English feminist art historian Anna Brownwell Jameson (1794–1860), it was the fact that it was painted by a woman. Jameson sympathized with the story of Judith, but she didn't understand how Artemisia could paint such an image, and she wished "for the privilege of burning it to ashes" (Locker 174). Locker quotes from Jameson's *Characteristics of Women, Moral, Poetical, and Historical* (1832).

PAGE 169: I invented the words of Domenichino and Lanfranco to summarize the competitive atmosphere surrounding Domenichino's *Last Communion of Saint Jerome*, analyzed in Elizabeth Cropper's *The Domenichino Affair*.

The chronology in *Orazio and Artemisia Gentileschi* (Christiansen, Mann) lists data on Artemisia from two Roman censuses taken during Lent of 1622 and 1624. The 1622 census lists Artemisia living on Via del Corso with her husband, her daughter, servants, and her brothers, Francesco and Giulio. The 1624 census lists Artemisia as the head of her household with her daughter Prudenzia and servants, still on Via del Corso. Mary Newcome ("Orazio Gentileschi in Genoa") contends that from 1621–1624 Francesco was in Genoa helping Orazio, despite the 1622 Roman census. Newcome also states that the brothers started their own families while living in Genoa and nearby Sampierdarena—Francesco from 1628–1641, Giulio from 1630–1656. Newcome cites *La Berio* (1976) by Luigi Alfonso, but Francesco and Giulio are also documented in

London in the late 1620s and early 1630s (see p. 190). Orazio's sons were couriers and assistants for both Orazio and Artemisia. Perhaps the brothers started families in Genoa, but were often absent as they traveled constantly on behalf of their father and sister. Marco is excluded from many documents and remains Artemisia's most mysterious brother.

PAGE 170: Patrizia Cavazzini ("Artemisia and the Other Women in Agostino Tassi's Life") found records of the events summarized here in the *Archivo di Stato di Roma* and *Tribunale Criminale del Governature*. Despite Agostino's aggression toward Cecilia de Duranti, the two defended each other in court. Cavazzini writes, "Cecilia said they had been caught only because the head of the police hated Agostino, while the painter pretended to be shocked by the insults she had received from the police and firmly defended her against the accusation of having shouted to the *sbirri* [cops], 'You will end up fucking my ass with your nose'" (44).

The maidservant Assenzia's claim that Agostino threw a rock at her may seem trivial, especially compared to being threatened with a gun. But Robert C. Davis ("The Geography of Gender in the Renaissance") describes how groups of young men dominated public spaces in Italy, their rough antics creating a dangerous environment for the few women who ventured outside, particularly lower-class women. Davis describes an instance where a washerwoman was hit in the head by a rock and died.

PAGE 171: Mary Garrard (*Artemisia Gentileschi Around 1622*) addresses multiple theories about how and why this *Susanna and the Elders* was repainted. Garrard thinks that someone else repainted it later without Artemisia's permission to make the piece conform to traditional, patriarchal expectations. Garrard concludes, "The alterations are likely to have been motivated less by the opinion that the original version was offensive than by the belief that it could be improved, along lines that would better represent the 'Artemisia' whom the art world welcomed" (108).

Guercino's *Jael and Sisera* looks similar to Artemisia's version on page 167.

(For more on Artemisia's *Lucretia*, see notes for pp. 180–181.)

PAGES 172–174: No one knows exactly who this Gonfaloniere is. The little crest painted on the side of the table has not been identified, even after the painting was cleaned in 1964. I invented this scene between the artist and the model.

The scuffle between Pierantonio and the serenading Spaniards is listed in the chronology in *Orazio and Artemisia Gentileschi* (Christiansen,

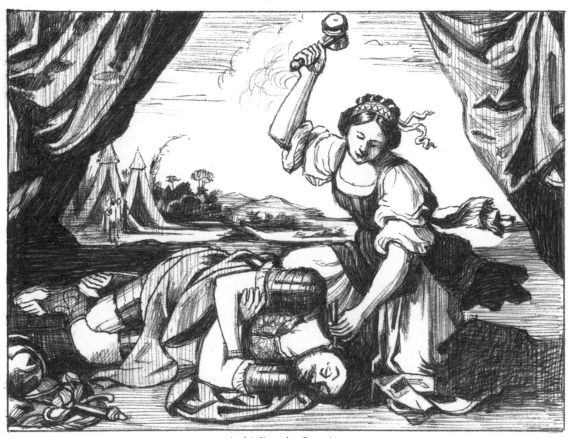

Jael & Sisera by Guercino

245

Mann), which also lists data on Artemisia from two Roman censuses taken during Lent in 1622 and 1624. The 1622 census lists Artemisia living with her husband, while she's listed in the 1624 census as head of the household with no mention of her husband. The circumstances of the couple's separation are debatable, but I don't think it's a coincidence that Pierantonio disappeared from the records so soon after a violent outbreak. Jesse Locker connects the serenading Spaniards with Artemisia's increasing affiliation with Spanish patrons. Patrizia Cavazzini ("Artemisia and the Other Women in Agostino Tassi's Life") mentions that Pierantonio's victims were protected by the Borgias (a powerful noble family with Spanish ties), another likely reason for Pierantonio's disappearance.

Some scholars claim that Pierantonio and Artemisia separated earlier (see notes for pp. 152, 161–165), while others remain open to the possibility that Pierantonio was still around through the 1620s. Locker states that Pierantonio may have accompanied Artemisia to Venice, but he was definitely estranged from his wife by the time she asked Cassiano dal Pozzo for information on her husband in a letter from 1637 (see notes for pp. 198–199). Sheila Barker ("Artemisia's Money") acknowledges that Artemisia's husband "shielded her from charges of *mala fama* [dishonor], which in the case of women could be triggered by even the mere appearance of promiscuity" (61). Alexandra Lapierre addresses the theory that Artemisia asked Cassiano dal Pozzo to get rid of her husband, explaining, "It was common practice in those days to find a woman a husband just for show and then relieve her of him later—a prerogative of the powerful" (410–411).

PAGE 175: I invented this interaction between Artemisia and Prudenzia. I believe Prudenzia was trained to help in the studio at a young age (see notes for p. 166).

I also invented this scene with Galileo (see notes for pp. 172–174), but Judith W. Mann ("Identity Signs") states that "Francesco Solinas [see notes for p. 152] has recently argued that the identification of Artemisia as a Lomi was how Cassiano dal Pozzo, the famed Roman collector and antiquarian, became aware of the artist" (89). Mary Garrard stresses that Cassiano dal Pozzo and the Duke of Alcalá were interested in Artemisia because they considered her a "curiosity," an exception to the norm. However, Consuelo Lollobrigida ("Women Artists in the Casa Barberini") recently shed light on the Barberini's patronage of women artists. Apparently, during the Barberini's rein there was a distinct rise in the number of women artists in Rome, which then tapered off by 1660.

PAGE 176: I invented this interaction between Artemisia and Prudenzia. Patrizia Cavazzini ("Artemisia and the Other Women in Agostino Tassi's Life") explains that when Pierantonio and Artemisia moved back to Rome they hired a servant named Domenico, then Dianora Turca, an innkeeper's wife. When Domenico tried to collect his payment, Artemisia and Pierantonio refused and threatened to kill him. Pierantonio assaulted him and "was consequently brought to justice by the servant" (41). Cavazzini states that after Pierantonio left, Artemisia "repeatedly refused to settle her accounts with her new servant, Dianora Turca" (42). Cavazzini cites the *Archivo Storico del Vicariato* in Santa Maria del Popolo and the *Archivo di Stato di Roma*. The court ordered Artemisia to pay Dianora twenty scudi (Lapierre). Dianora insisted that it was thirty scudi, but the court claimed that Artemisia had already paid the remaining ten scudi in "various forms of payment" (Lapierre 413). Lapierre also cites the Archivo di Stato di Roma. (For more on Artemisia's debt, see notes for pp. 158–160.)

I invented the appearance of Cassiano's "cabinet of curiosities," based on "The dal Pozzo Collection Again" by Donatella L. Sparti, *Curiosity and Enlightenment* by Arthur MacGregor, and *Cabinets of Curiosities* by Patrick Mauriès.

Poussin's words are my summary of his general opinion of Caravaggio. Peter Robb (*M*) quotes Giovanni Pietro Bellori's *Lives of the Modern Painters, Sculptors, and Architects* (1672): "Monsieur Poussin couldn't bear M [Caravaggio] at all, and said he'd come into the world to destroy painting" (13). Bellori was another unreliable early modern art historian, alongside Filippo Baldinucci (see notes for p. 146) and Bernardo de Dominici (see notes for pp. 197, 202).

PAGE 177: Jesse Locker touches on the large quantity of Simon Vouet paintings owned by Cassiano dal Pozzo, including Vouet's portrait of Artemisia, which Cassiano may have requested.

PAGES 178–179: I invented the Duke of Alcalá's astonished delight upon seeing the *Aurora*. Jesse Locker maintains that he met her, probably through Cassiano dal Pozzo, at a high point in her career.

PAGES 180–181: There are two known versions of this *Penitent Magdalene*—one commissioned by the Duke of Alcalá in the Cathedral of Seville's Sala del Tesoro, and one in a private collection in France. In the Seville rendition, there is extra drapery painted around the Magdalene's neck, covering the top edge of her breast. With X-radiography, it is evident that the extra drapery was added later. Mary Garrard (*Artemisia*

Gentileschi Around 1622) thinks that the drapery was added to censor the piece before its inclusion into the Cathedral, similar to the censorship of Artemisia's *Allegory of Inclination* (see notes for p. 146). Garrard asserts that both renditions of the *Penitent Magdalene* are by Artemisia, and that the French version was copied from the pre-censored Spanish version. I've attempted to show the pre-censored Spanish version here. By comparing this *Penitent Magdalene* to similar paintings by other Renaissance artists, Garrard argues that it represents the melancholy associated with artistic genius.

I invented this conversation between Artemisia's patrons on page 180 to touch on the political feeling of the time. The Barberini were known for their nepotism and their anti-Spanish, pro-French leanings. Jesse Locker develops the theory that the Duke of Alcala and Cassiano dal Pozzo possibly fostered Artemisia's career in the late 1620s to form a link between Spain and the Barberini. The Duke of Alcala compares Artemisia's beauty to the beauty of her paintings, a common trope of the time. Almost every poet who wrote about Artemisia made this connection between her appearance and her work. While Garrard points out the inherent sexism of this comparison, Locker explains its relation to the popular style of lyric poetry, influenced by the famous Baroque poet, Giambattista Marino.

A combination of sources led me to invent the affair between the Duke of Alcala and Artemisia, leading to Artemisia's last pregnancy. A Roman census taken during Lent in 1624 lists Artemisia as living with only one daughter, Prudenzia (see

notes for pp. 169, 172–174). Therefore, Elena must have been conceived after 1624. Alexandra Lapierre confirms the existence of Artemisia's second daughter: "Artemisia bemoans the fact that she has had to take responsibility twice over for getting a daughter settled, once in 1637, and again in 1649. If Prudenzia had been widowed and had remarried in 1649, her mother would not have been responsible for paying the dowry. Artemisia writes that the wedding in 1649 has ruined her [see p. 222]. So I agree with Mary Garrard in thinking that it cannot be the same daughter" (419–420). Lapierre also explains why she thinks the Duke of Alcala might be the father: "The duke [of Alcala] had the reputation of being a lady's man and of having fathered a string of illegitimate children. He assumed power in Naples at exactly the same time she [Artemisia] arrived there. And the highly prestigious Neapolitan marriage she negotiated for one of her daughters, with a knight of the Order of San Giacomo … made me think that the girl's father must have been of high rank" (413). Lapierre adds, "The Knights of the Order of San Giacomo could only marry into families claiming four quarters of nobility. So a lot of quarters would have been needed to outweigh the Gentileschi's obscure background, or that of the Stiattesis. But I cannot be certain of this" (420).

Lapierre discovered more evidence in the *Archivo di Stato di Roma* that Artemisia may have engaged in extramarital affairs in Rome in the 1620s. While Artemisia lived on Via del Corso, she subleased two other rooms for herself. One lease, signed June 20, 1625, was for a flat on "Via Rasella, known as Via dei Serpenti, a rather seedy street in a part of Rome that was quite a long way from the artists' district. We can only speculate about what she was going to do there" (412).

Is there a chance that Artemisia was a sex worker? Women had few opportunities to make money, so it was more difficult for them to support themselves. Court records show that numerous prostitutes and courtesans were not ashamed when speaking of their profession to magistrates. Some sex workers were defined as lowly prostitutes, and others as "honest," respectable courtesans highly regarded within intellectual circles (see notes for Part 2 p. 123). Despite the papal authorities' attempts to control the sex trade, the practice was never completely banned or criminalized. (Story)

Artemisia had already lost her honor and had a questionable reputation (see notes for p. 163). Patrizia Cavazzini ("Artemisia in Her Father's House") explains that "Giovanni Battista Passeri [see notes for pp. 158–160, 202] understood what sort of character Agostino [Tassi] was and condemned him in every instance except the one of the rape. He wrote that Artemisia would have been praiseworthy for her paintings if she

had been more virtuous, and that Agostino was acquitted in the trial, even though he may have been guilty" (287). Artemisia may have felt that she had nothing to lose by supplementing her income with sex work. Likewise, Andrew Graham-Dixon (*Caravaggio: A Life Sacred and Profane*) proposes that Caravaggio was perhaps a pimp, which would help explain his nighttime scuffles, constant trouble with the law, numerous paintings of prostitutes, and maybe even his battle with Ranuccio Tomassoni, who was a pimp himself. Yet, Artemisia and Caravaggio's involvement in the sex trade is highly speculative.

My attribution of the *Cleopatra* and *Danae* (on p. 181) to Artemisia, and my placement of these paintings at this point in her career, is controversial. I'll address the *Cleopatra* first. A *Cleopatra* was in the Gentile family collection in Genoa, starting with Pietro Maria I Gentile in 1640–41 (Christiansen, Mann). In his guidebook of Genoa published in 1780, Carlo Giuseppe Ratti mentions a *Lucretia* (probably the one now attributed to Artemisia on p. 171), a *Sacrifice of Isaac*, a *Judith*, and a *Cleopatra* in the collection of Pietro Maria III Gentile, all of them attributed to Orazio. The Gentile inventory of 1811 lists the same paintings, attributed to Orazio again.

Many scholars reattributed this *Cleopatra* to Artemisia for stylistic reasons. There aren't any female nudes like this in Orazio's oeuvre. The unidealized naturalism, Caravaggesque tone, tightly clenched fist, dark red and black, and the handling of the paint all seems more characteristic of Artemisia. Garrard originally placed this *Cleopatra* in Artemisia's second Roman period of the 1620s, but most scholars now place it in Artemisia's (or Orazio's) early Roman period of 1611–12, which coincides with the rape and trial. But why would Artemisia (or Orazio) paint such an openly erotic image at the same time that she (and Orazio) tried to prove her innocence and chastity? Regardless of whether or not the figure in the *Cleopatra* resembles Artemisia, I cannot believe that she painted it while trying to express her virtue and honor to both the magistrates and the public (see notes for pp. 172–174, Part 2 p. 123). Furthermore, I think the *Cleopatra* fits with Artemisia's Caravaggesque Roman work of the 1620s, alongside the *Lucretia* (see p. 171) probably in the same Gentile collection, and the *Aurora* (see p. 179). Plus, this *Cleopatra* is similar to Artemisia's *Judith Slaying Holofernes* of 1620 (see p. 167), especially the faces of Judith and Cleopatra.

Mary Newcome ("Orazio Gentileschi in Genoa") lends credence to this conjecture: "Recently, [Piero] Boccardo has suggested that Gentile bought the *Lucretia* in the sale in Genoa in 1637 of the collection of the Duke of Alcala. The matter remains very problematic, but

Detail of *Judith Slaying Holofernes* by A. Gentileschi

Detail of *Cleopatra* by A. Gentileschi

Gentile's *Cleopatra*, thought on grounds of style to date from before Orazio's arrival in Genoa, could also have been purchased through the sale" (166). If the *Cleopatra* is by Artemisia, it would make sense for it to be in the Duke of Alcala's collection since he was her patron. Some scholars (i.e., Keith Christiansen) have compared the *Cleopatra* to Jusepe de Ribera's work, and the Duke of Alcala was one of Ribera's patrons too. Pietro Maria Gentile I's purchase of the *Cleopatra* at the 1637 sale would coincide with the painting's first appearance in the Gentile inventory of 1640–41.

Judith W. Mann (*Orazio and Artemisia Gentileschi*) adds a caveat: "Boccardo's conjecture that the Gentile may have purchased the painting from the Duke of Alcala, who would presumably have bought the work in Rome or Naples, must be treated with caution, since no such work occurs in the inventories of his collection" (362). But since the piece is so blatantly erotic and seductive, perhaps it was not listed in the Duke of Alcala's inventories to protect his honor, especially if he had had an affair with its creator. If

Spanish authorities censored Artemisia's *Penitent Magdalene* on page 180, how could they accept the *Cleopatra*? I can picture Pietro Gentile I gazing upon the deceased Duke of Alcala's collection and stumbling upon a secret image made by the Duke's favorite female painter, known for her beauty and questionable background. Eventually, the Gentileschi's art could have been lumped into one group attributed to Orazio, the leading man of the Gentileschi clan.

There is less information on the provenance of the *Danae* on copper on page 181. It was discovered in a private collection in 1986 and attributed to Orazio. As with the *Cleopatra*, multiple scholars have reattributed this *Danae* to Artemisia, lumping it into her early Roman 1611–12 phase. Judith W. Mann (*Orazio and Artemisia Gentileschi*) claims that the *Danae* "displays the subtle variations in skin tone and the tightly composed format that are characteristic of Artemisia's Roman work and cannot sustain a placement in the early 1620s, a dating that originally developed from a belief (now discredited) that Artemisia must have visited Genoa with her father at that time. Most important, the picture was done in the period during which Artemisia painted in the workshop of her father, employing the techniques that he had taught her, which are evident in the handling of pigment and glazes in the skin tones" (308). But Artemisia utilized her father's techniques throughout her life, so I don't see his influence as proof of the earlier 1611–12 date for the *Danae*.

Jeanne Morgan Zarucchi ("The Gentileschi 'Danae'") links this *Danae* to prostitution — there are falling coins on the displayed woman's body, and the other woman fits the role of procuress, with her maidservant headdress and outstretched garment collecting the coins. If this image is a nod to prostitution, that would be another reason for placing it later in Artemisia's career, rather than during the trial of 1612 when Agostino Tassi and his allies tried to portray Artemisia as a prostitute. Orazio could only prosecute Agostino if his daughter were an honorable virgin when the rape occurred. Why would Artemisia (or Orazio) paint an image of prostitution during the trial, especially since the nude figure in the *Danae* — possibly a prostitute — might resemble Artemisia?

PAGE 182: The Mantuan Collection (see notes for p. 193) was curated by Peter Paul Rubens (see pp. 176, 209). (For more on Artemisia serving as a diplomat for Cassiano and the Duke of Alcala, see notes for pp. 180–181.)

Georges La Tour, Gerrit van Honthorst, and Adam Elshiemer are examples of Northern artists that pioneered the dramatic, candlelit night scenes that influenced Artemisia's *Judith and Her Maidservant* on this page. As with the *Allegory of Inclination* (see p. 146) and the *Penitent Magdalene* (see p. 180), light drapery was painted over the top of the breasts (see notes for pp. 146, 180–181), likely another example of censorship. I attempted to recreate the piece as it appeared before the added drapery.

PAGE 184: Arcangela Tarabotti's appearance is based on an engraving of a Benedictine nun featured in *Arcangela Tarabotti: A Literary Nun in Baroque Venice* edited by Elissa Weaver. The engraving, by Arnold van Westerhout (after Andrea Orazi), is from a catalogue of religious orders by Filipo Bonanni published in 1723. Bonanni gave special attention to the unique attire of the Venetian Benedictine nuns (Zarri). However, Edward Muir (*The Culture Wars of the Late Renaissance*) states that "although she respected her vows, she [Arcangela] rebelled by refusing to cut her hair or wear the habit of her order" (103).

PAGES 185–186: According to Jesse Locker, Loredan's letters to Artemisia indicate that she was in Padua, "which suggests she was more closely connected with Cremonini's Paduan circle than previously suspected" (51). The University of Padua provided about sixty to seventy lectures per year, while the Jesuits' college boasted of providing 300 lectures per year. Cremonini's words in the middle right panel on page 185 are my paraphrase of his defense of the University of Padua against the Jesuits, as described by Edward Muir (*The Culture Wars of the Late Renaissance*). The Jesuits were banished until 1657, when Venice needed the Papacy's help fighting the Turks.

Cremonini's words in the lower left panel of page 185 are also from Muir's *Culture Wars*: "His student Gabriel Naude exported Cremonini's erudite Libertine views to France. Naude noted Cremonini's favorite maxim, '*Intus ut libet, foris ut moris est*' ('Think what you like, but say what is expected of you' or 'inwardly according to your will, outwardly according to social convention'), the supreme expression of the Libertine habit of living inside a mask, of remaining 'unknown,' as the *Accademia degli Incogniti*, founded in Venice by Cremonini's students, proclaimed to be their goal" (56). For the quote of Naude, Muir cites Domenico Bosco's *Cremonini e le origini del libertinismo*.

I used Peter Miller's "Friendship and Conversation in Seventeenth-Century Venice" to paraphrase Renier Zeno in the bottom middle panel on page 185. Ludovico Zuccolo's writing in the last panel of page 185 is from Miller's quotes of Zuccolo's dialogue *Della Citta Felice*, part of the larger volume *Considerationi Politichi*, published in 1621 and 1625. The upper right panel on page 186 is based on Miller's analysis of Zuccolo's dialogues,

Della Citta Felice and *Della amicitia scambievole fra'cittadini* (Of Reciprocal Friendship Among Citizens):

'Thus,' noted Zuccolo, linking his preliminary, didactic exposition to the dramatic dialogue that followed, 'discoursed some years ago in Venice in a salon of nobles and great minds, the most prudent and learned Senator Domenico Molino.' At the end of his lecture all assembled were silent except Trevisano—of all people!—who asked, with Aristotle's definition of friendship ringing in his ears, why, if friendships were the necessary prerequisite for justice, was so much more attention devoted to legislating than to promoting friendships? The responsibility of the legislature, Molino answered gravely, was not to give laws to those already friends, 'but to order the city well, in its fashion, and to arrange the interests of the citizens in such a way that they have good will toward each other' ... When Trevisano still refused to concede, Molino concluded by proclaiming that friendship was all well and good for people who were well and good, but 'because of the imperfection of man, who, drawn after his passions,' cannot remain on the right path, the 'reins of justice' were necessary to control him. How appropriate for Zuccolo to have made Molino, later one of Zeno's enemies and eventually doge, the spokesman for political friendship founded in inequality and Trevisano the defender of perfect friendship as the solution to a republic's social schism. The dialogue does not appear in the 1621 edition, perhaps because Trevisano's identity as the 'heroic friend' had not yet been established. But even in 1625, only a clairvoyant could have foreseen that life would follow art and this debate become a matter of state, or that Molino would be the one to condemn Trevisano to exile six years later. In the decades that followed, elsewhere in Europe, Molino's claim that the natural imperfection of man vitiated Trevisano's utopian nostalgia would be developed into a compelling portrait of society by Pascal, Nicole, and La Rochefoucauld. (15)

The Council of Ten was a branch of Venetian government whose members investigated and prosecuted treason, corruption, espionage, and, by the 1600s, state expenditures and foreign affairs. Elite Council members maintained painstakingly elaborate rules and rituals to prevent any single man, even the doge, from gaining too much power. The Republic never had the huge revolts and warring factions that plagued other Italian city-states in the Renaissance (hence, the "Myth of Venice"), but their oligarchy still had its problems. Zeno recovered from the assassins' attack and continued to criticize self-interested ministers

of state, like France's Richelieu, Spain's Olivares, and England's Buckingham. Cremonini was wise to caution young rebels by encouraging dissimulation—Galileo's friend Paolo Sarpi was stabbed on the Venetian bridge in 1607, and Giulio Vanini was burned at the stake for atheism in 1619.

Guidubaldo Benamati (see p. 187) wrote *Il Trevisano* (1630), a poetic defense of Barbarigo and Trevisano. Benamati argued in favor of "heroic friendships," including those of the ancient world. He described a painting by Artemisia of the ancient Roman friends Petronius and Coelius. This painting is now lost, or it may be a fictional element of Benamati's treatise, but Locker remains open to its existence since it is described with specific details.

Artemisia must have been involved with the *Accademia de' Desiosi* since it is referenced in Jérôme David's engraving of her (see p. 191), but there were multiple Italian academies called Desiosi. Locker and Ward Bissell (*Artemisia Gentileschi and the Authority of Art*) maintain that Artemisia was involved with the Venetian *Desiosi*, since Jérôme David was in Padua at the same time that she was (he also made the engraving of Barbarigo and Trevisano on p. 186), and because she was connected to *Desiosi* member Giovan Francesco Loredan. Alexandra Lapierre thinks that Artemisia was involved with a Roman *Accademia de' Desiosi* founded in 1625–26, comprised of Galileo's followers.

In a letter to Artemisia from Collurafi, he explains that the impresa for the *Accademia degli Informi* should depict a mother bear licking her young. Collurafi stressed that it should be rough and unpolished, the bear cubs gradually taking shape, as if the mother were licking them to life. The idea was rooted in Titian's impresa symbolizing an artist's ability to transform materials into art, a metaphor for the *Informi*. The *Informi*'s motto was "*Dam Mobilis Aetas*" ("While their age is still pliant"), a phrase from Book III of Virgil's

Georgics, which refers to training calves while they're young and impressionable. The motto symbolized a parental figure's ability to transform youths into adults. Locker notes that "Lapierre has suggested that the emblem that appears on the frontispiece of the academy's inaugural address may be the very one that Artemisia designed. As one of the few to have actually seen the frontispiece, Lapierre remarks it 'will never go down in the annals of emblem making'" (53).

(For more on Artemisia's last pregnancy, see notes for pp. 180–181.)

PAGES 187: Jesse Locker provided the links that connect everyone in the big panel: Guidubaldo Benamati (see notes for pp. 185–186) wrote poetry about Artemisia. Giacomo Correr commissioned a *Head of Athena* (now lost) from Artemisia and a portrait of Giacomo Pighetti from Nicolas Regnier. Regnier's daughter, Clorinda, married Pietro della Vecchia, Padovanino's student. Padovanino married Caterina Tarabotti, Arcangela's sister. Padovanino, Pietro della Vecchia, and Artemisia painted images of *donne forti* (powerful/exceptional women). Giacommo Pighetti commissioned a *Sleeping Love* from Artemisia, probably the *Sleeping Baby Jesus* shown in *Artemisia Gentileschi in a Changing Light* (Barker). The painting is reminiscent of Caravaggio's *Sleeping Cupid* of 1608.

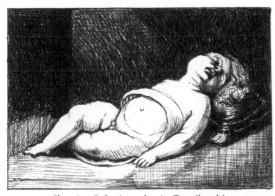

Sleeping Baby Jesus by A. Gentileschi

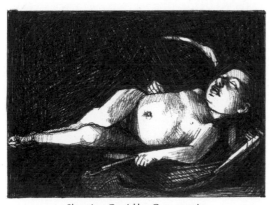

Sleeping Cupid by Caravaggio

Locker also analyzes the mysterious painting of Theoxena or Medea. He thinks that the painting is from Artemisia's Venetian period, coinciding with Loredan's sense of humor (see notes for p. 224).

PAGE 188: I invented this scene to show how radical Arcangela was, but it's more likely that people visited her in the convent, rather than her escaping. Loredan and Giovanni Francesco Busenello visited her, and probably her brother-in-law Giacomo Pighetti (see p. 187), who "encouraged Arcangela to publish" (Locker 73). Anyone who denies the existence of early modern feminism (or "proto-feminism") should read Tarabotti's *Paternal Tyranny* (see notes for p. 191).

There are two strains of feminist thought about the role of early modern convents. On one hand, the convent could be a sanctuary where women could pursue a variety of occupations unattainable in the outside world. *La Crocetta*, a Florentine convent cultivated by Christine of Lorraine, is a good example of this. Many notable women retired there, including Francesca Caccini. On the other hand, the convent could also be severely limiting and brutally oppressive, especially in Venice during the Counter-Reformation. Plus, Tarabotti differentiated between women who were forced into convents, and those that had a "true calling" and wanted to join. The convent of Sant'Anna was demolished and rebuilt by Francesco Contarini in the early 1630s, right after Artemisia left. Therefore, I attempted to draw the old convent building as it appears on a map from 1500 by Jacopo de' Barbari. Jeff Cotton's website, *The Churches of Venice*, shows a close-up of the map where the old Sant'Anna stood.

PAGE 189: Little is known about Lucrezia Marinella. There is no evidence that she was a guest at this academy, although her writing is similar to that of the people in this circle.

Loredan's play, *La Forza D'Amore* (1662), encompasses the *Incogniti* debates about gender roles and sexuality, also prevalent in Venetian opera. I fashioned the *Desiosi* meetings after the *Incogniti* meetings. The two academies were similar and shared many members, but there is more information about the *Incogniti*. Jesse Locker describes a letter from Loredan to Artemisia where he "expresses his chagrin at having poorly improvised a poem in Artemisia's presence the previous day, and in the letter he provides a more polished version to allay his embarrassment" (50). Locker also describes anonymous poems to Artemisia, probably by Loredan or someone in his circle. One of the anonymous letters praises Artemisia's "*canto*," which could refer to verse or song (see notes for p. 151). (For more on Loredan and the *Incogniti*, see notes for p. 224.)

There is no evidence that Artemisia took her daughter to one of these meetings. I invented this scenario to illustrate time passing, the child growing up, the possible unity of the women, and the sentiments of the men in the group. In the second-to-last panel, Francesco Buoninsegni disparages the women in the group, while Francesco Pona sympathizes with them (see p. 187). Buoninsegni's 1644 *Contro 'l Lusso Donnesco* (*Against Feminine Luxury*) was written in the same vein as Giuseppe Passi's 1599 *On the Defects of Women* (Locker). Arcangela's feminist statements made Buoninsegni defensive, and he wrote "virulent rebuttals" (Locker 71) against her and women in general. On the other hand, Francesco Pona wrote *Della eccellenza et perfettione ammirabile della donna* (1653) in defense of women. Locker suggests that Pona's description of Judith, who is referenced as an example of a good woman, might derive from one of Artemisia's renditions of the heroine, possibly the one in the Lumaga family collection (see p. 221). Buoninsegni and Pona are shown here over fifteen years before their arguments were published, so I only hinted at the attitudes expressed in their later writing.

PAGE 190: I invented the circumstances of this birth (see notes for pp. 180–181). This daughter's name has not been discovered yet. Alexandra Lapierre calls her Francesca after Francesca Caccini. I chose Elena Cassandra after Arcangela Tarabotti's maiden name, to place this birth closer to Artemisia's Venetian period, rather than her Florentine period.

Noel Sainsbury's "Artists' Quarrels in Charles I's Reign" features a transcription of the letter from Orazio ("Horace" in English) to Lord Dorchester, Secretary of State, detailing the strife between himself, his sons, and Balthazar Gerbier. (For more on the Mantuan Collection, see notes for pp. 182, 193.)

PAGE 191: I invented this scene between Artemisia, Prudenzia, and Nicolas Lanier. Lanier's involvement with the *Desiosi* is also my invention. Prudenzia could play music though (see notes for p. 203), so I decided that Lanier taught her how. There is no evidence that Arcangela taught Prudenzia to read or write, but Artemisia probably encouraged her children to play music and paint—perhaps she included reading and writing (see notes for p. 166).

Although I invented this debate at the *Desiosi* meeting, it falls in line with what was discussed by the *Incogniti* (see notes for p. 189). Robert C. Davis ("The Geography of Gender in the Renaissance") examines the impressions of Italy written by travelers on the Grand Tour. "Whore towns," areas where prostitutes worked, were among the

few public spaces controlled and dominated by women. Platform shoes, known as *zoccoli* ("chapines" or "croponi" in English), were popular in Venice. Travelers reported that they could be over a foot tall, and not just for courtesans—noblewomen frequently wore them to church. Since they could barely walk, they were assisted by maidservants, as they displayed themselves on the slow journey, almost like a royal procession. Cesare Vecellio's *Habiti Antichi et Moderni*, a sixteenth-century treatise on fashion from all over the world, includes an image of a Venetian courtesan wearing platforms called *pianelle*, the soles of which could be adjusted to varying heights. Venetian law severely confined women, and they were often criticized for wearing platforms. But Davis points out that the platforms provided a way to reclaim predominantly male space, allowing the woman to tower above men in a status-enhancing display of femininity and wealth.

In the second-to-last panel, Lucrezia and Arcangela's responses are derived from their writing. Stephanie Jed ("Archangela Tarabotti and Gabriel Naude") analyzes and quotes Archangela's *Antisatira* (1644), a response to Francesco Buoninsegni's *Contro 'l Lusso Donnesco* (*Against Feminine Luxury*) (see notes for p. 189): "In the Antisatira, Tarabotti shows how economies depend on economic relations between the sexes, or, more particularly, how men balance their budgets with lust, avarice, and vanity, keeping their wives plain and their courtesan's adorned: ... 'They would like their wives to dress after the fashion of our first Mother, so that they can more easily squander in the adornment of their prostitutes'" (137). The Tarabotti quote is from *Francesco Buoninsegni, suor Arcangela Tarabotti, Satira e Antisatira* edited by Elissa Weaver (Rome 1998).

Jesse Locker connects Marinella's stance on men's fashion with Artemisia's *Esther Before Ahasuerus* (see p. 192), quoting Marinella's *The*

Nobility and Excellence of Women (see p. 189), edited and translated by Anne Dunhill:

To the king's outmoded ensemble Artemisia added two elements that seem to be of her own invention: Ahasuerus's remarkable, white, fur-trimmed and gem-studded boots, and the supremely affected, and seemingly unnecessary, purple scarf trimmed with gold that drapes loosely around the king's neck and over his shoulders. These unusual elements in particular bring to mind Lucrezia Marinella's extended mockery of men who adorn themselves excessively, an ironic reversal of criticism traditionally leveled at women. Indeed, Marinella dedicates a whole chapter to the subject, citing countless examples of ancient and modern men "who make great efforts to appear handsome and appealing, not only by putting on clothes made of silk and cloth of gold as many do." She asks, "What should we say of the medallions they wear in their caps, the gold buttons, the pearls, the pennants and plumes ... and the great number of liveries that bring ruin on their houses?" In her list she includes numerous rulers, such as Sardanapalus and Commodus, who were so absorbed in vanity and self-adornment that they neglected the care of their subjects. Particularly relevant here is her indictment of the Roman emperor Heliogabalus (Marcus Aurelius Antoninus) who, she writes, "wore pearls, necklaces, jewelry, priceless rings, and clothes made of silk and cloth of gold decorated with pearls and other precious gems. He had priceless stones even on his shoes." (80–81)

Tarabotti's words in the last panel are from *Paternal Tyranny* (1654), edited and translated by Letizia Panizza. After giving examples of how "Christ treated women, his most faithful disciples, as equals of men," Tarabotti continues:

And what is your response, you liars, to these truths — not fables — of sacred history, as time and again you contemptuously devise to rob us of our deserved dignity and respect? To accomplish your purpose better, you have buried some of us within a convent's four walls, knowing that had we been free and assisted by an education, we would have made known to the world all your tyranny's treacheries with truthful tongue and faithful pen! You give the name of "imperfect animal" to the woman, driven by spiteful envy far more than by the simple truth. On the other hand, you yourselves grow hair on your faces, thus imitating wild animals not just by your rough skins, but more precisely by your savage manners. You have made your likeness to irrational horned beasts complete by carefully twirling each side of your moustaches upward, you vain creatures, to look like two horns, anxious to brand above your mouths rather than above your heads a sign that marks you as perfect animals! (133)

Tarabotti, Marinella, Loredan, and their colleagues were probably discussing these issues out loud before, during, and after they were published (Locker). (For more on Loredan and the *Incogniti*'s attitude toward women, see notes for p. 224.)

PAGE 192: X-radiography reveals that Artemisia repainted *Esther Before Ahasuerus* numerous times. It was initially a busier, multi-figure composition with an African servant or page (see notes for p. 217) and a growling dog, but they were painted over. Mary Garrard and Jesse Locker point out Artemisia's reversal of traditional gender roles — the wise, regal Esther versus the frivolous, juvenile king. (For more on *Esther Before Ahasuerus*, see notes for p. 191.)

I invented Artemisia's interaction with Giovanna Garzoni, but both women were in Venice at the same time. The two women were mistaken for one another by eighteenth-century writers Girolamo Gualdo and Filippo Baldinucci (see notes for p. 146). Ward Bissell (*Artemisia Gentileschi and the Authority of Art*) suggests that Artemisia may have introduced Garzoni to Cassiano dal Pozzo and the Duke of Alcalá. Locker writes that "Garzoni's letters to Cassiano make it clear that she came into the service of the viceroy [the Duke of Alcalá] unwillingly. In them she complains vigorously of her dislike of Naples and of the Spanish and indicates her desire to return to Rome where she could work for her primary patron, Anna Colonna, wife of Taddeo Barberini" (24). Giovanna Garzoni and Tiberio Tinelli were married for two years until they separated because her father suspected that Tinelli practiced some sort of magic (Fortune). Locker mentions Tinelli's involvement with Loredan's *Incogniti*. Garzoni was invited to Turin by the Duchess of Savoy from 1632–1637 and painted for the Florentine court of Ferdinando II de' Medici and Vittoria della Rovera from 1642 until the early 1650s. She then returned to Rome, where she had been a member of the *Accademia di San Luca* since the 1630s, but she still maintained close ties to the Medici.

PAGE 193: I invented these scenes with Lanier. Orazio mentioned Lanier's work with the Gentileschi brothers in his letter to Lord Dorchester (see notes for p. 190). Richard Symonds, the English traveler, wrote in his journal (now in the British Library in London) that Lanier was "in love with Artemisia Gentileschi, who was a good painter" (Lapierre, 415–416). King

Charles I's Swiss physicist, Theodore Turquet de Mayenne, wrote a scientific exploration of artists' techniques. Jesse Locker explains that, according to Mayenne, "Artemisia told Lanier that she used an amber varnish, the same kind used by lute makers, mixed with walnut oil and painted over the under painting. The color was then directly applied to the wet varnish, making the colors softer, more vibrant, and in short more harmonious" (116). In Lapierre's novel, Artemisia helps Lanier (and art dealer Daniel Nyes) acquire the Mantuan Collection for England (see notes for p. 182).

However, I think Artemisia was helping Spain more than England at this point. Locker explains how her style conformed to Spanish sensibilities. The second-to-last panel is based on Locker's assertion that "Artemisia seems to have served as an artistic advisor of sorts to the viceroy [the Duke of Alcala], counseling him on what paintings he should purchase in Venice—a position, as far as I know, unprecedented for a woman" (25). This could be another sign of her closeness to the Duke of Alcala (see notes for pp. 180–181).

PAGE 194: Edward Muir (*The Culture Wars of the Late Renaissance*) describes the *Incogniti*'s anti-Spanish leanings, so I assumed that Loredan would resent Artemisia working for Spain. Jesse Locker acknowledges the romantic nature of Loredan's poetry for Artemisia at this early stage. Elizabeth Cropper's "Life on the Edge" features a lengthy quote from one of Loredan's letters:

> I will not say you are a woman in order not to cast doubts on the vitality of your thoughts. I will not say you are a goddess so that you will not doubt the sincerity of my voice. I will not say you are beautiful so as not to associate you with the qualities of every simple woman. I will not say that you make miracles with your brush for me so as not to deprive you of glory. I will not say you give birth to marvels with your tongue because only you are worthy of celebrating them. I will just say that the singularity of your virtue requires my mind to invent new words worthy of the greatness of your gifts and expressive of my devotion. (279)

Cropper cites Ward Bissell's *Artemisia Gentileschi and the Authority of Art*, which contains N. Ivanoff's 1965 transcription from *Gian Francesco Loredan e l'ambiente artistico a Venezia nel seicento*.

Alexandra Lapierre posits that the Duke of Alcala provided the luxurious coach for the journey to Naples. I assumed Lucrezia Marinella was connected to the *Accademia degli Oziosi*, since *Oziosi* member Girolamo Fontanella wrote about her (see p. 202).

PAGE 195: *The Massacre of the Innocents*, painted in the 1630s by Stanzione, appears behind Cavallino and Stanzione.

PAGE 196: For the lower left panel, I considered Rosario Villari's assertion that "The cry of 'Death to bad government and long live justice!' which rose from the crowd in front of the viceroy's palace, had a general political meaning. Moreover, some demanded the abolition of the new taxes (*gabelle*), a demand which, in a rudimentary way, implied opposition to the monarchy and the privileged bourgeoisie. Such opposition was made more explicit by the reappearance of the threatening request for the equalization of the votes of aristocratic and popular representatives of the city" (26). For the cries of the crowd Villari cites M. Schipa's "*La mente di Masaniello*" in *Archivo Storico per le province napoletane* (1913–14). The execution of the *Eletto del Popolo*, Giovan Vincenzo Starace, in 1585, was "no simple explosion of savage fury. On the contrary: the rioters made their feelings and intentions felt through a ritual which they followed with rigorous precision" (24). Starace was supposed to join a delegation to the viceroy, but instead an angry mob took him to the headquarters of the people's assembly, the monastery of Sant'Agostino. They removed his hat and forced him to sit backwards on his sedan chair (a fancy mini-carriage for the wealthy elite, carried by servants) in front of the monastery. This signaled the beginning of the revolt—Starace was killed, his

body dragged through the streets and mutilated.

In the last panel, Giulio Genoino summarizes elements of Giovanni Antonio Summonte's *History of Naples* published in 1602, then posthumously in 1640 and 1643. It was both a mythical and factual account of Naples' history, ending with a description of the 1585 revolt. It contained radical and reformist ideas, such as the people's right to rise against their sovereigns when necessary, and the right of the *Seggio* (subdivisions

of aristocracy representing the five districts of Southern Italy) to take their grievances directly to the Spanish king, even bypassing the viceroy. Summonte was imprisoned and forced to make corrections to the book which, Villari conjectures, hastened his death.

PAGE 197: Information on the Cabal is inconsistent. In addition to Ribera, two other painters may have been part of the group — Giovanni Battista Caracciolo (also known as Battistello) and Belisario Corenzio. Alexandra Lapierre writes:

> The famous Guido Reni [see p. 169] was invited to Naples to decorate one of the chapels in the Cathedral and, after several anonymous letters and a number of death threats carved on his door with a knife, he found his manservant riddled with stab wounds on the threshold of his studio. Between his groans, the man delivered a message that the attack on him was only a warning. Reni had packed up and left. Sometime later a ship was chartered by the monks of the Cathedral for the transportation of a number of Bolognese painters whose work they looked forward to seeing in Naples; it sank, with all lost, off the island of Ischia. As for scaffoldings, which the bravest of the foreign artists persisted in climbing, these would come crashing down, taking them and their assistants with them. The works of the Florentine fresco painters would mysteriously flake, their outlines and colors fade. Everyone in Naples knew the source of these attacks: the "Cabal." Three painters, bound by family ties — fathers-in-law or brothers-in-law — had sworn that no foreigner would work in the shadow of Vesuvius. The members of this fearsome triumvirate were not, however,

Neapolitans. The most inspired and famous of the group claimed Spanish nationality. His name was Jusepe de Ribera, and he was known as *Lo Spagnoletto*. (323–324)

Haldane MacFall (*A History of Painting Volume 3*) describes an incident where "Stanzione had painted a *Pieta* above the principle entrance to [Certosa] S. Martino, and the picture having darkened, Ribera persuaded the monks into allowing him to clean it, whereon he so ruined it with corrosive liquid that Stanzione refused to restore it, desiring that the scandalous act of treachery might stand as witness to all who passed by" (63).

Gabriele Finaldi ("A Documentary Look at the Life and Works of Jusepe de Ribera") explains:

> [Joachim von] Sandrart [one of Rubens's apprentices who traveled, wrote, and visited Artemisia in Naples] states that Ribera accompanied him to visit Stanzione's studio ... There were two painters, however, with whom Ribera seems not to have got on well: Domenichino and Caracciolo. The poor relationship with the former is attested to only in the secondary sources; the documents say nothing about it. As for relations between Ribera and Caracciolo, Cosimo del Sera, the Tuscan agent in Naples, wrote to the Grand Duke's secretary in 1618 stating that if the secretary wanted to have an opinion of Ribera's talent he should not ask "a certain hunchbacked painter from these parts called Giovambattistello [Caracciolo]," who happened to be in Florence at that moment, since "there is no love lost between them and this Spaniard is envied by everyone." Perhaps Ribera's relationship with Caracciolo would be better described as one of rivalry rather than enmity, since eight years later they stood together as witnesses to the marriage of [Giovanni] Do. (4–5)

Finaldi translates and quotes A. Parronchi's transcription of Sera's letter in *Sculture e progetti di Michelangelo Naccherino in Prospettiva* 20 (1980). The "secondary sources" Finaldi refers to are a familiar handful of seventeenth and eighteenth-century historians — Filippo Baldinucci (see notes for p. 146), Giovanni Pietro Bellori (see notes for p. 176), and Bernardo de Dominici (see notes for p. 202). It seems that the rumors about the Cabal can be traced back to de Dominici's *Vite de' pittori, scultori ed architetti Napoletani* (1742).

In his preface to *Painting in Naples 1606–1705* (Whitfield, Martineau), Harold Acton describes the Cabal's antagonism toward Stanzione and Domenichino. Acton adds, "With Belisario Corenzio and Battistello Caracciolo — the former Greek, the latter a true blue Neopolitan — Ribera formed a tyrannical cabal. We know little that is

nice about the personalities of this triumvirate. Bernardo de Dominici, the Neapolitan version of Vasari, was prone to embellish his anecdotes, but they undoubtedly contain a foundation of truth since they have been corroborated by others. According to him, no painter could execute any major commission in Naples without the trio's consent" (16).

Since there's no evidence of Artemisia's interactions with the Cabal, my guess is that she wasn't taken seriously enough to pose as a threat. It's also possible that she fought them off somehow. I chose to use a physical attack on Stanzione and his friends to represent both the Cabal and the violent atmosphere of Naples. In 1636 Artemisia wrote to Andrea Cioli, the Medici secretary, "I have no further desire to stay in Naples, both because of the fighting, and because of the hard life and the high cost of living" (386). Artemisia's letters to Cioli are published in Mary Garrard's *Artemisia Gentileschi: The Image of the Female Hero in Italian Baroque Art*, translated by Efrem G. Calingaert (edited by Garrard) from Anna Maria Crino's transcription in "More Letters from Orazio and Artemisia Gentileschi" (1960). The original letters are in the *Archivo di Stato* in Florence.

PAGES 198–199: I invented the scenes on page 198, but both Alexandra Lapierre and Jesse Locker describe the Duke of Alcala sending Artemisia to the Infanta Anna Maria alongside the Spanish painters. (For more on Artemisia's lack of experience, see notes for p. 167.) I invented the Duke of Alcala's dismissive attitude toward Elena. His failure as viceroy is outlined in "The Duke of Alcala: His Collection and Its Evolution" by Jonathan Brown and Richard L. Kagan. Telling the Infanta Anna Maria that her visit was too expensive was a grave mistake, and there was tension between the Duke of Alcala and the previous viceroy, the Duke of Alba. I invented Artemisia's reaction to Ribera (see notes for p. 197).

In 1630 Artemisia requested from Cassiano dal Pozzo a license to carry arms for her protection. The license was intended for her household cleric Diego Campanili. Artemisia also wrote, "I would serve you immediately if I didn't have to do some paintings for the Empress (*Imperatrice*) [Anna Maria], which must be finished by the middle of September" (377). She also explained, "I must beg you to send me by messenger six pairs of the finest gloves, because I need gifts for some of the ladies" (378).

These letters to Cassiano dal Pazzo are published in Mary Garrard's *Artemisia Gentileschi: The Image of the Female Hero in Italian Baroque Art*, translated by Efrem G. Calingaert (edited by Garrard) from Giovanni Gaetano Bottari and Stefano Ticozzi's transcription in the

eight-volume *Raccolta di lettere sulla pittura, scultura ed architettura scritte da' piu celebri personaggi dei secoli* (1822–25). The original letters are now lost. Garrard explains that, "Cassiano's volumes of correspondence containing artists' letters, used by Bottari in preparation for his first volume (published in 1754), were apparently looted during the Napoleonic invasions but largely recovered by an heir to the Albani family. They were probably in the hands of Leon Dufourny until the sale of 1824, after which they must have been widely scattered" (376).

I had to invent the Royal Palace interior on page 198, since it has changed since Artemisia's time, but the outside of the palace, shown on page 199, is basically the same as it once was. In the 1700s some of the big arches were filled in and new stables were added, along with a new apartment on the east side. The Carthusians added to the Certosa di San Martino (see notes for p. 197) throughout the seventeenth century, employing dozens of artists. The famous Neapolitan architect, Cosimo Fanzago (see notes for p. 221), spent thirty years working on this monastic complex. The upper left panel on page 198 features what was then Fanzago's new work on the Certosa, without his later embellishments.

PAGE 200: *Parthenope's Splendor* (Chenault, Munshower) was especially helpful for this page, as it contains early modern maps and images of the region's "natural curiosities."

Bullen Reymes (see notes for p. 203) wrote that he visited Artemisia after visiting the brothels on Via Toledo, and before visiting the Concezione Church to hear nun's singing. Thus, Artemisia lived somewhere between Via Toledo and the Concezione Church. (Lapierre)

PAGE 202: Although the *Oziosi* was a literary academy, artists were also involved. Jesse Locker writes that Stanzione, Caracciolo (see notes for p. 197), Aniello Falcone (who influenced Micco Spadaro and was famous for painting battle scenes), and Giovan Bernardo Azzolino "were known to the academy's members" (103). Helen Langdon (*Salvatore Rosa*) mentions that Cesare, Francesco Fracanzano, and Salvatore Rosa (see p. 221) were involved too.

There's no evidence that Artemisia met Torquato Accetto (see notes for p. 217), although her connections to the *Oziosi* are described by Locker. Loredan's Venetian *Incogniti* influenced the more formal, elite *Oziosi*. Yet, the *Oziosi*'s rule against discussing politics or theology points to the bourgeoisie's growing fear of opposition and revolt. Girolamo Fontanella's words are my paraphrase of his views, as described by Locker. My summary of Artemisia's self-portrait on this page is also based on Locker's analysis.

I invented the scene where Viviano Codazzi asks Artemisia if she's heard of Agostino Tassi. Mary Garrard describes Codazzi as a follower of Tassi. It's unclear whether or not people knew about Agostino and Artemisia's past. Locker writes that "none of the early sources mention it [the rape and trial]. While two early authors, Giulio Mancini and Giovanni Passeri [see notes for pp. 158–159, 180–181], mention the rape, they do so in passing in their biographies of Agostino Tassi and, more importantly, without reference to Artemisia's art. Moreover, neither of these texts was published until over a century after the events occurred" (11).

I paraphrased Lanfranco's words from Patrizia Cavazzini's "Artemisia Gentileschi and the Other Women in Agostino Tassi's Life":

> Her seventeenth-century contemporaries did not quite know what to make of Artemisia, or of women painters in general. The ambivalent attitude toward them is well demonstrated in one of Giovanni Lanfranco's letters. In 1637 Lanfranco was working in Naples, where he sold a painting to Ippolito Vitelleschi, a Roman patron, for fifty-eight scudi. Vitelleschi had been very insistent in asking for it, although apparently he was not very discerning in his judgement of the work. When he returned to Rome, he was teased for having bought a mediocre picture, perhaps a workshop piece or even "the work of a woman." Therefore, he wanted to return the canvas to the artist and to be reimbursed. Lanfranco had been aware of the painting's inferior quality, and had only sold it because the customer wanted it so badly. Nevertheless, the artist thought Vitelleschi had gotten a bargain, as even copies of Lanfranco's paintings sold for a hundred scudi. He was therefore reluctant to return the money, but eventually did so. But if it were indeed the work of a woman, he asked, would not the painting be worth three times as much, bad as it was? Were the Roman *cognoscenti*, who had denigrated Vitelleschi's purchase suggesting it was by a female painter, thinking of Artemisia — also living in Naples at the time — as the author of this mediocre picture? (41)

Cavazzini translated Lanfranco's letter from the same eight volumes by Bottari and Ticozzi that contain Artemisia's correspondence with Cassiano dal Pozzo (see notes for pp. 198–199).

Artemisia's interactions with Annella are my invention. Riccardo Lattuada ("Artemisia and Naples, Naples and Artemisia") writes, "At this time, too, it is not possible to go beyond merely suggesting that there is an analogy between the biography of Artemisia and that of Annella de Rosa (b. 1602), Pacecco de Rosa's niece. Considered one of Stanzione's most brilliant pupils … It is also notable that, according to de Dominici (our principal seventeenth-century source for Neapolitan painting) [see notes for p. 197], there were other women in Naples who followed Annella's example and, 'motivated by a virtuous envy, took up painting'" (389).

Locker explains, "Evidence also suggests that the Neapolitan court had a more open attitude toward women in general than other Italian courts. The seventeenth-century Spanish writer María de Zayas y Sotomayor (renowned like Artemisia for her portrayals of vengeful women) remarked that the court of Naples was far more liberal than

other Italian courts in allowing women to participate in festivities: 'It was the custom in Naples for maidens to attend parties and soirees given in the viceroy's palace and in other private homes of the nobility.' She adds that 'this practice isn't considered proper in other parts of Italy'" (25). Locker quotes from María de Zayas y Sotomayor's *The Enchantments of Love: Amorous and Exemplary Novels* (1637), translated by H. Patsy Boyer in 1990. Both Locker and Lattuada admit that there hasn't yet been an in-depth exploration of the links between Artemisia and either Annella de Rosa or María de Zayas y Sotomayor.

(For more on the Cabal and Domenichino see notes for pp. 197, 217.)

PAGE 203: Jesse Locker and Alexandra Lapierre write that Bullen Reymes visited Artemisia twice and recorded that Prudenzia painted and played the spinnet (see notes for p. 200). I invented this scene between Prudenzia and Artemisia. I decided to use Artemisia's daughters to represent the overall feeling of their time and place (see notes for pp. 204, 216, 219–220).

PAGE 204: Artemisia's letters, mentioned in the top two panels, are published in Mary Garrard's *Artemisia Gentileschi: The Image of the Female Hero in Italian Baroque Art* (see notes for pp. 161–165, 172–174, 197, 198–199). I invented the dynamic between Artemisia and Francesco, and between Elena and Prudenzia. The Duke of Alcala, Elena's father (see notes for pp. 180–181), belonged to the upper-class, while Pierantonio Stiattesi,

Prudenzia's father, had more humble origins. Prudenzia and Elena's contrasting perspectives are based on their fathers' backgrounds and also on their age difference — Elena was probably about nine years younger than Prudenzia at the time (see notes for pp. 203, 216, 219–220).

The Pozzuoli Cathedral caught on fire in 1964. Miraculously, Artemisia's paintings survived, although they were damaged. The *Saint Januarius* was cleaned after the fire, but areas of the *Adoration of the Magi* are difficult to discern, especially the darker right side where the black magus once was (see notes for p. 217).

PAGE 205: In his *Vite de pittori scultori ed architetti Napoletani* (1742), Bernardo de Dominici (see notes for pp. 197, 202) wrote that Artemisia collaborated with Viviano Codazzi and Micco Spadaro on this *David and Bathsheba* (see notes for p. 217).

The painting that Cavallino struggles with in the upper right panel is *The Triumph of Galatea*, originally attributed to Artemisia or a collaboration of artists. However, Christopher R. Marshall ("An Early Reference and New Technical Information for Bernardo Cavallino's 'Triumph of Galatea.'") attributes the painting to Cavallino, while acknowledging Artemisia's influence.

I invented Artemisia's interaction with Annella de Rosa (see notes for p. 202) to convey the desperation revealed in Artemisia's letters (see notes for pp. 197, 198–199, 210–212). Artemisia generally made less than her male colleagues, but there are many factors to consider, such as the type of commission, supplies needed, subject matter, and the social status and spending habits of both patron and artist (Spear 2003, 2005) (see notes for p. 202). (For more on Artemisia's spending habits, see notes for pp. 158–160.)

PAGE 206: Mary Garrard suggests that Artemisia could relate to Corisca, the victimized object of the Satyr's lust in *Il Pastor Fido*. However, seventeenth-century fans of the play were unsympathetic to Corisca — in *The Nobility and Excellence of Women* (see p. 189), Lucrezia Marinella refers to Corisca as a bad example of women (Locker).

I invented the goodbye scene between Artemisia and her daughters. So far there is no record of whether or not they accompanied her to England.

PAGE 209: No one knows the route Artemisia took to London. The ship in the upper left panel is based on Peter Bruegel the Elder's (1525–1569) engravings of ships, featured in *Graphic Worlds of Peter Bruegel the Elder* edited by H. Arthur Klein. Alexandra Lapierre suggests that Artemisia traveled by land to The Hague, where she boarded a ship with Marie de' Medici's entourage. Orazio,

and possibly Artemisia, already had connections with the exiled French queen (Garrard).

Rubens's word balloon in the bottom left panel is from Pauline Gregg's *King Charles I*: "Rubens remarked that 'Whereas in other courts negotiations begin with the ministers and end with the royal word and signature, here they begin with the king and end with the ministers.' He felt that he was negotiating on two levels and remarked sadly that he was 'very apprehensive as to the stability of the English temperament'" (193). Gregg cites W. N. Sainsbury's *Original Unpublished Papers Illustrative of the Life of Sir Peter Paul Rubens* (1859) and R. S. Magurn's *The Letters of Peter Paul Rubens* (1955).

Anthony Van Dyck arrived in England in 1632. He had probably already met Orazio when they were both in Genoa. Van Dyck made a drawing of Orazio for his *Icononography*, a collection of portraits. Simon Schama (*Rembrandt's Eyes*) explains that the *Iconography* portrayed not just artists, but "statesmen, generals, and princes" (33). Schama continues, "This miscellany was a deliberately loaded statement. It said that painters, *northern* painters, were no longer to be thought of as mere craftsmen, but rather like *Sir* Peter Paul Rubens (and Sir Anthony Van Dyck, as he would be), should be counted a natural nobility, fully the equal of the philosopher, the warrior, and the poet" (33–34). In England, Van Dyck was knighted and received a pension twice as high as Orazio's, but the fact that Van Dyck included Orazio in the *Iconography* reveals that the older Italian made an impression on him. Van Dyck's *Iconography* was never completed, and it was only partially published after his death in 1641.

Self-portrait with Sunflower by Van Dyck

PAGES 210–212: Little is known about Artemisia's trip to England, and scholars are divided on whether or not Artemisia worked on the *Allegory of Peace and the Arts Under the English Crown*. She must have made the journey between her letter from Naples in 1637 and her letter from London

in 1639. Jesse Locker posits that she left Naples soon after the Count of Monterrey left in 1637, as she expressed anxiety about his departure in a 1635 letter to Medici secretary Andrea Cioli (see notes for p. 197). Yet, Gabriele Finaldi and Jeremy Wood ("Orazio Gentileschi at the Court of Charles I") insist that Artemisia arrived after the *Allegory of Peace* was installed in October of 1638. Some see her absence from Orazio's will as evidence that she wasn't in England when he died, but Judith W. Mann (*Orazio and Artemisia Gentileschi*, Christiansen) explains that Artemisia was omitted from the will because her dowry served as her inheritance. Artemisia left England just as the English Civil War began. Eventually, Oliver Cromwell's troops crushed the royalists, Charles I was beheaded in 1649, and his family and allies were exiled. The new Commonwealth had to deal with Charles I's collection of over 1,400 pictures and 400 sculptures. The Gentileschi's *Allegory of Peace* survived, later transferred to Marlborough House. It's in terrible condition, but Mary Garrard and Ward Bissell (*Artemisia Gentileschi and the Authority of Art*) still see Artemisia's hand in it.

Alexandra Lapierre explains:

Following the execution of Charles I, the royal collections were dispersed when between October 1649 and November 1651 Cromwell's Commonwealth organized the largest-scale public sale in the history of painting. The kings of France and Spain were secretly to purchase numerous works through their agents, bankers, and ambassadors, shamelessly sharing in what was plundered from their beheaded 'cousin' ... In the course of this sale, Nicholas Lanier would buy his own portrait, executed by Van Dyck, for the sum of ten pounds. Artemisia's self-portrait would go for double this amount to one of the king's creditors, a lawyer named Jackson. When the son of Henrietta Maria, Charles II, brought the monarchy back to power, he would reacquire some of his father's pictures — in particular, the works of Orazio and Artemisia Gentileschi. (362)

A Hampton Court inventory from Cromwell's sale lists an *Allegory of Painting* and a *Self-Portrait* by Artemisia. Therefore, many scholars assume that Artemisia's painting on page 211 is both a self-portrait and an allegory of painting (similar to the circular *Self-Portrait as the Allegory of Painting* on p. 145). The piece conforms to Cesare Ripa's definition of the allegory of painting in his *Iconologia* (see notes for p. 145). Garrard thinks that Artemisia reinvented the traditional allegory by inserting the artist herself in it. However, Ward Bissell ("Artemisia Gentileschi: A New Documented Chronology") claims that the Hampton Court listing refers to two separate

In 1573, Venice officially made peace with the Ottoman ruler, which infuriated the pope, since the Christians had just won the famous Battle of Lepanto against the Turks in 1571. In 1573, the renowned Venetian painter Paolo Veronese (his *Esther and Ahasuerus* probably influenced Artemisia's) was summoned by the Inquisition for his painting of the Last Supper (later re-titled *Feast in the House of Levi*), which features a number of black and brown people. Most of them are servants, but one of them is a well-dressed guest at the table, perhaps one of the Ottoman rulers.

Laura Dianti by Titian

There was a continuous black presence throughout Italy, especially in the South. Alessandro de' Medici's mother was said to be a "moorish" slave, and he ruled Tuscany for seven years until he was assassinated in 1537 (Fletcher). After Duke Giangalleazo Sforza of Milan was assassinated in the fifteenth century, his black bodyguard killed the murderer. Afterwards, Giangalleazo's brother, Ludovico, took the throne until 1499. Ludovico may have been of mixed race ethnicity. His nickname was "Il Moro," and he used African imagery on his coat of arms. Giangalleazo Sforza's wife, Isabella d'Aragona of Naples, and her sister, Eleanora, kept black servants, pages, and entertainers. Eleanora married Duke Ercole d'Este of Ferrara, and the fascination with Africans was passed down to their heir, Alfonso d'Este. In Mantegna's painting of Judith for the d'Este court, Judith's maidservant, Abra, is black.

In the 1520s, Alfonso d'Este commissioned Titian to paint a portrait of his mistress Laura Dianti, an inferior commoner, but Titian painted her with a young black servant looking up at her

in awe. The servant's subordinate place below her enhanced Dianti's status. This painting marked the beginning of a trend — the use of black servants in portraits to emphasis the grandiosity of white subjects. In Orazio and Agostino Tassi's *Casino of the Muses* (see Part 2 p. 82), there is a black slave or servant among the musicians. He gazes up at the woman with the fan, often thought to be Artemisia. Following tradition, Orazio may have intended to use the black figure to enhance his daughter's social standing, although Paul H. D. Kaplan ("Italy 1400–1700") states that there is no evidence that the Gentileschi owned slaves. Artemisia had servants throughout her life, but their ethnicity is unknown and they aren't referred to as slaves in any documents.

After Alfonso d'Este died, Laura Dianti gave money to his black ensign. Ferrara's court poet, Ariosto, rhymed Laura with *maura*, which meant "moorish." Giovanni Battista Giraldi dedicated ten short stories to her in 1565. The seventh story is similar to Shakespeare's *Othello* (1604), a tale in which a black soldier's jealousy destroys his white wife. In *Othello*, the "moor" is a Christian convert from Venice, probably North African, though his origins are debatable. Shakespeare never clearly defines a "moor," and there are no seventeenth-century images of Othello.

Another longstanding artistic tradition featuring people of color involved the biblical tale of the three kings visiting the newborn baby Jesus — the Adoration of the Magi. The kings (also known as wise men or magi) were Old Testament prophets from the gospel of Matthew. Since the thirteenth century, artists usually made one of the three magi

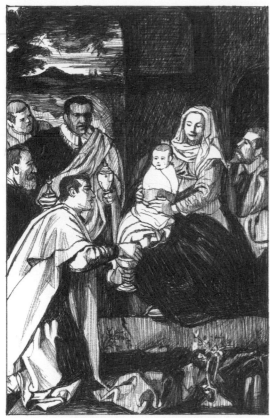

Adoration of the Magi by Velázquez

Detail of *Adoration of the Magi* by Velázquez

black, typically the last and youngest. During the Counter-Reformation, the Catholic Church claimed that it was not historically accurate to portray a black magus, but that didn't stop artists from following the tradition, including Artemisia (see notes for p. 204). As colonialism expanded in the sixteenth and seventeenth centuries, the black magus symbolized the East kneeling to the West — the whitewashing, imperialist aims of European Christianity.

The Kongo, a Christian African kingdom since 1484, was associated with Rome in the 1570s through Duarte Lopez. Once a Portuguese slave trader, Lopez became the Kongo's ambassador to Rome. In 1604, the Kongo's King Alvaro II sent his cousin, Ne Vunda, to Rome as an envoy. In 1608, Pope Paul V welcomed him warmly, but Ne Vunda died shortly after his arrival. There are a handful of images of him, often comparing him to the black magus of the Adoration of the Magi story. He was usually depicted wearing European dress, an early example of assimilation, similar to England's Pocahontas (around the same time, she too traveled to Europe, struggled to assimilate, and didn't survive). Before his death, Ne Vunda was a guest in the new wing of the Quirinal Palace — the Sala Regia, constructed in 1606. In 1616–17, Lanfranco and Agostino Tassi decorated the Sala Regia with frescoes containing several dark-skinned figures, perhaps alluding to Ne Vunda (see p. 154).

There was one seventeenth-century painter whose depictions of Africans stand out — Diego Velázquez (see p. 199). His *Adoration of the Magi* of 1619 features a black magus dressed, like Ne Vunda, in standard European finery. But instead of gazing upon the divine infant, he looks directly out at the viewer. In Velázquez's *Supper at Emmaus*, one of several Eucharist images also from 1619, a young African or mixed-race serving woman is in the foreground, while Christ and his followers are tiny figures in the background. For years, the piece was thought to be a portrait of a "mulatress" — the biblical component is so miniscule that it was invisible until the canvas was cleaned in 1933.

Juan de Pareja by Velázquez

Supper at Emmaus by Velázquez

During his second trip to Italy in 1650, Velázquez painted a portrait of his slave, Juan de Pareja, wearing a Flemish lace collar forbidden in Spain at the time. When Velázquez was accepted into the *Congregazione dei Virtuosi del Pantheon*, his portrait of Pareja was exhibited in the Santa Maria Rotunda, the "Temple of Painting," near Raphael's tomb. Usually artists only painted portraits of high-ranking individuals, so the portrait of the slave was considered practice before Velázquez painted Pope Innocent X's portrait.

In *Velázquez* (Ortiz), Julian Gallego quotes Antonio Palomino's *El museo pictórico y escala óptica* (1724), one of the main sources of information on Velázquez: "Palomino … offers biographical information about Pareja: 'A native of Seville, mestizo by birth, and of odd color. He was the slave of Don Diego Velázquez, and although his master (for the honor of art) never allowed him to assist in anything having to do with painting or drawing, but permitted him only to grind colors and from time to time prime a canvas and do other chores around the studio and house, he performed these with such skill that, unbeknownst to his master, and stealing hours while he was sleeping, he eventually made paintings well worthy of esteem.' As I have written elsewhere … the custom of having a slave apprentice was not unusual; Velázquez's master, Pacheco, had a Turkish slave and Murillo had one of unknown nationality" (228–230). Pareja became an artist in his own right, and Velázquez freed him in 1650. The two returned to Spain in 1651, and Pareja's first signed and dated paintings are from around 1658.

Velázquez may have been familiar with seventeenth-century Spanish writers like Alonso de Sandoval, a Jesuit who wrote against the mistreatment of slaves. Sandoval, whose mother may have been Creole, thought that black and white people were part of God's divine variety, and that baptizing Africans brought out their inner whiteness. Likewise, in 1640 Francesco Quevedo pointed out that while whites saw blacks as the "other," in black communities whites were the "other."

In Italy and Spain there were minorities who were considered exceptional or outside of the norm, similar to Artemisia's reputation as a "curiosity" (see notes for p. 175). Juan Latino, a young slave, arrived in Spain in 1528 and was probably baptized. Like Pareja's secret study of painting, Juan Latino secretly studied his master's books. In 1546, he received a bachelor's degree, in 1556 a law degree, and in 1557 he became a distinguished professor of Latin in Granada. He had a white wife and published several titles before he died around 1594–97. There was also the famous Benedetto Maria Seri, known as Saint Benedict, who was born in Messina in 1524—his mother a free woman, his father a slave. He joined the friars of Santa Maria di Gesù in Palermo in 1562. He died around 1589, was beatified in 1743, and canonized in 1807. The stories of Juan Latino and Saint Benedict were retold throughout the seventeenth century, along with numerous racial stereotypes and clichés. It is often difficult for historians to differentiate the facts from biased folklore. Africans were seen as demonic, unruly, and overly sexual (see notes for p. 151). The Spanish Inquisition had a lengthy catalogue of offenses that could be committed by Africans, accompanied by severe punishments. Offenses included running away from slave owners and/or joining the Morisco cult, a group of Africans who were baptized but officially expelled in 1609.

One other seventeenth-century artist is worth mentioning here—Rembrandt. Simon Schama analyzes Rembrandt's 1626 *Baptism of the Eunuch*, in which the eunuch is an African, shown with

three other black people, an uncommon approach to the subject:

> Just as he scrapped the generic mountain landscape for the palm of a plausible desert oasis, so Rembrandt also disposed of the insipid and tentative 'mooris' physiognomy in favor of an unapologetic authentically described and brilliantly individualized group of African portraits. Only Rubens [see pp. 176, 209] in his intensely sympathetic multiple studies of a single African head, painted around 1616–1617, anticipated Rembrandt's freedom from stereotype. This does not, however, make Rembrandt some sort of early civil rights advocate in the studio. On the contrary, at the back of all these sympathetic sketches is the standard Protestant race theory which made blackness a kind of damnation from which the eunuch's baptism would provide a redemptive bleaching. That Rembrandt should subscribe to the commonplace is hardly surprising. What is truly amazing is that Rembrandt should have had access to African models (were they slaves, house servants in Amsterdam or Leiden?), and that he should have seen their strong, dignified depiction as the key to his storytelling. (235–236)

Elmer Kolfin ("Rembrandt's Africans") mentions that there was a small group of free Africans living in Amsterdam when Rembrandt was there.

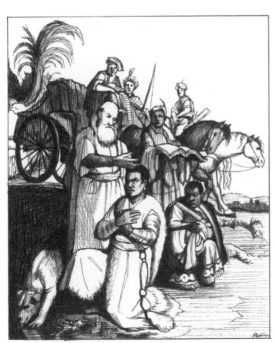

Baptism of the Eunuch by Rembrandt

PAGE 218: I invented this scene. According to Bernardo de Dominici's (see notes for pp. 197, 202) *Vite de pittori, scultori ed architetti Napoletani* (1742), when Stanzione was excited about Annella's

progress he embraced her, but a maidservant reported it to the jealous husband, Agostino Beltrano, who then stabbed Annella to death. De Dominici includes that Beltrano realized his error, but it was too late and he fled. However, many scholars dismiss de Dominici's story, as he was known for writing unreliable gossip. He even listed the wrong year for Annella's death.

Yet, Julia K. Dabbs ("Sex, Lies and Anecdotes") disputes claims that Annella died of natural causes: "The church document cited by Prota-Giurleo does not actually indicate the cause of death" (35). Dabbs goes on to describe seventeenth-century sources confirming that Annella was killed by her husband:

> One of those sources is a manuscript written by Massimo Stanzione himself, and thus one of de Dominici's key texts given that he did not personally know de Rosa or Beltrano. Of course, de Dominici, like most historians of the early modern period, would have turned to literary commonplaces to embellish the narrative, such as that of the vindictive servant woman, who serves as a convenient, lower-class scapegoat in order to exonerate the male artist. The author's simplified rhetoric is appropriate to this genre of writing, which was intended to forcefully impress the reader's sensibilities with examples of the virtue and vice exhibited in the *Vite*. While these literary devices may cloud the modern reader's perceptions, they should not deflect us from the truth that a woman artist's career was cut short by her husband's suspicion and rage due to her interactions with a male colleague. (35)

Alexandra Lapierre writes that Artemisia was glad that Annella died because Annella was

seen as competition, but I gave Artemisia a more sympathetic stance. Bernardo de Dominici also claimed that Stanzione was romantically involved with Artemisia. I alluded to this possibility by showing Stanzione's consistent, but subtle, physical contact with Artemisia on pages 197, 198, 218, and 223.

PAGES 219–220: On page 220 Artemisia's daughters represent opposing views that persist even today (see notes for pp. 203, 204, 216). The idea that Masaniello went crazy has been perpetuated throughout the centuries. In *History Today*'s "Masaniello's Naples Revolt Against Spain" (1997), Richard Cavendish hints at Masaniello's "irrational behavior," stating that the people "grew tired of his novelty." But Rosario Villari insists that Masaniello's madness was fabricated to justify his death (he was beheaded in the Chiesa del Carmine), and that Masaniello's large funeral, alongside the people's agitation after his death, signified their devotion to him. Villari also stresses that "Masaniello participated for only ten days (from July 7th to 16th) in a revolution that lasted about nine months" (154), and that Masaniello's role was to act "as a bridge between the political leadership and the popular protest movement" (158).

The "infamous noble" executed in the top middle panel of page 220 was Don Giuseppe Carafa, whose outlook and behavior was similar to the Count of Conversano's. Usually Masaniello wore only his fisherman's rags, in solidarity with the people, but he dressed up on the day he rode to the palace on behalf of the people. In the upper right panel of page 220, I drew Masaniello wearing the silver jacket and breeches that he wears in Micco Spadaro's painting of this stage of the revolt (see notes for p. 221).

The bottom panel on page 220 comes from Villari:

> It was normal, in moments of great calamity and danger, for the ecclesiastical and religious authorities to organize religious processions and displays with the aim of interrupting the growing violence, exorcizing the 'demonic' spirit which had taken hold of the population, and restoring order. These processions 'were not taken well by a large part of the population' but were brushed aside — as Burke points out ... Rather, an explicit, politically motivated decision prevented the enormous suggestive power of the religious ritual from being used, according to tradition, as a means of disorienting the rebels and subduing the disturbance. At a meeting in the Piazza del Mercato with the cardinals' envoys — who wanted to discover what had provoked the resistance and hostility to the official

religious processions — the people's representatives replied by asking why 'the processions were organized with so much zeal now that attempts were being made to unburden the city,' whereas they had not been held when it was decided, against all protests, to burden it with 'excessive taxes.' They successfully demanded that instead the cardinals issue an order for 'public and private prayers imploring the Divine Majesty to heed the current needs of the city and of the kingdom, as had in fact been done every day up to the death of Masaniello.' (160)

For the quotes of the representatives of the people, Villari cites Allesandro Giraffi's *Le rivolutioni di Napoli* (1714) edited by Paolo Monti. The idea of the demonic or evil spirit of the people was tied to the general attitude that the masses were dangerous and unruly. Christopher R. Marshall ("Causa di Stravaganze") notes, "Cardinal Filomarino used the metaphor of boiling liquid to describe the riotous behavior of the people during the early days of the revolt. The anti-Spanish physician Angelo della Porta interpreted the people's behavior as acts of 'strange madness'" (489). (See notes for p. 221.)

PAGE 221: While Viviano Codazzi fled Naples, Artemisia's other collaborator, Micco Spadaro, stayed. Rosario Villari doesn't hesitate to include artists among the rebels: "Only old prejudices can lead to the conclusion that the fervent solidarity of Salvatore Rosa with the actions inspired by Masaniello was an 'isolated' case" (161).

Salvatore Rosa (1615–1673) was a famous Neapolitan painter, poet, and actor (see notes for p. 202). Lanfranco (see pp. 154, 169, 202) helped kick-start his career. Rosa left Naples around 1635, worked in Rome and Florence, and became famous for his landscapes, which often incorporated bandits and peasants, similar to Spadaro and Codazzi's styles. Rosa was critical of Spain's

control of Naples, sympathetic toward the revolt of 1647, and annoyed with the banality and corruption of royal courts. Yet, Wendy Wassyng Roworth ("The Evolution of History Painting") describes how Salvatore Rosa's participation in the revolt has been exaggerated, especially by nineteenth-century writers. Roworth also touches on Bernardo de Dominici's (see notes for pp. 197, 202) anecdotes about artists' participation in the revolt, even though he was notoriously unreliable:

> De Dominici claimed that 'many painters actually participated in the rebellion under the leadership of the painter Aniello Falcone' [see notes for p. 202]. According to the biographer, Falcone united a group of scholars, friends, and relatives to form the *Compagnia della Morte*, the Confraternity of Death, and these included Domenico Gargiulo [Micco Spadaro], Carlo Coppola, Andrea di Lione, and Salvatore Rosa. De Dominici writes that when Masaniello heard that many of this company were good artists, he requested that the best ones paint his portrait, proposing a prize for the one who would paint him life-size. The author goes so far as to claim that Masaniello actually ruled for thirteen days, not eight as most 'wrongly believe,' in order to justify the large number of portraits he attributes to these painters. (12)

Micco Spadaro's paintings of the revolt stand out, especially when compared to the few other seventeenth-century representations of the uprising. Michelangelo Cerquozzi's *Revolt of Masaniello* was probably created in Rome based on someone else's description of the revolt. Cerquozzi's portrayal of Masaniello feels staged, contrived, and perhaps even humorous. Spadaro's images, on the other hand, are more nuanced. He painted multiple aspects of the revolt with specific details. For example, in his *Piazza del Mercato During the Revolt of Masaniello* (a portion of which is shown in the upper left panel), he included women gathering sticks for setting fires. Multiple scholars mention de Dominici's delighted description of the novelty of women's participation. Spadaro's gruesome depictions are comparable to French artist Jacque Callot's series, *The Miseries of War*, but, as with Callot, the artist's intentions are debatable. (Callot was in Florence at the same time as Artemisia, and he was the same age.)

Spadaro's paintings of the revolt originally belonged to Giovanni Battista Capea Piscicelli, as they're in his inventory of 1690. It was previously thought that Spadaro's paintings of the revolt were intended to accompany his paintings of the eruption of Vesuvius and the plague of 1655. But the latter two paintings weren't in the 1690 inventory,

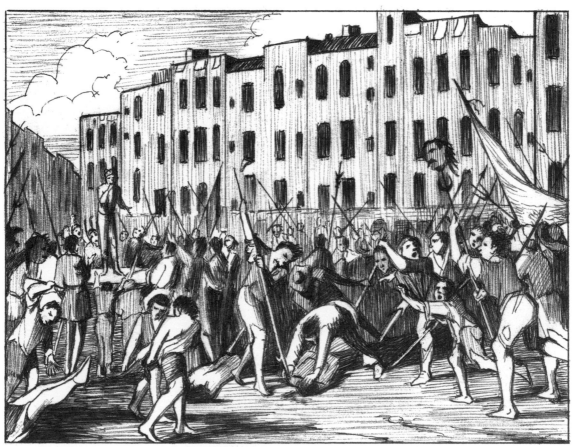

Murder of Don Giuseppe Carafa by Micco Spadaro

so they must have been acquired by the Piscicelli family later. Their collection was unusual since it didn't contain an abundance of religious subjects, and it seems that Giovanni Piscicelli was interested in all sides of the revolt — he commissioned portraits of both Masaniello and Don Juan José of Austria (see p. 224).

Christopher R. Marshall ("Causa di Stravaganze") refutes Villari's claim that Spadaro sympathized with the revolt leaders, since "Piscicelli's fortune perpetuated this system of oppression" (486). Marshall points out that Piscicelli was an aristocrat who benefited from the corrupt tax system that the revolt leaders fought against. In fact, many of Spadaro's patrons, including the infamous Carafa (see notes for pp. 219–220), worked to crush the rebellion.

On July 14, 1647, Masaniello commissioned a monument from architect Cosimo Fanzago (see notes for pp. 198–199). It was supposed to display a list of the people's privileges, with statues of the viceroy, Cardinal Filomarino, and Philip IV celebrating the agreements made between the authorities and the people. But Fanzago couldn't complete the monument because of a "violent uprising that threatened his life and home" (Marshall 489). An unfinished monument appears in the back of Spadaro's *Piazza del Mercato During the Revolt of Masaniello*, while a second unfinished monument from September 1647 appears in the center — a grey stone structure with dead bodies and decapitated heads draped over it. Marshall sees Spadaro's inclusion of the unfinished monuments (both were demolished in 1652) as a symbol of failed law and order. He maintains that Spadaro's work fits within common early modern representations of poor people and the "cosmic disorder" of the masses (see notes for pp. 219–220), another dark portrayal of the mob to entertain the nobles.

A number of Piscicelli's peers were on "a list drawn up by the rebels of palaces to be ransacked during the opening stages of the revolt" (Marshall 486). Yet, Piscicelli himself is not on this list. Marshall admits that "little is known specifically of the political allegiances of Giovanni Piscicelli" (486), and that "our knowledge of the personalities of Neapolitan collectors remains, in many instances, limited by the fact that a comprehensive study of Neapolitan patronage has yet to be written" (486). Can we assume that, since Spadaro worked for patrons who probably wanted to suppress the revolt, the artist himself was unsympathetic toward the revolt leaders? How often did artists agree with the political leanings of their patrons? Many artists simply went where the money was. The sculptor and goldsmith, Benvenuto Cellini, whose famous autobiography serves as a window into the life of a Renaissance

artist, worked for the Medici on and off throughout his career. While on the road, Cellini ran into two men who had been exiled by the Medici. When they mocked Cellini, he responded, "I am a poor goldsmith, who serves whoever pays me; and you are jeering me as though I were a party leader" (Fletcher 238).

Onofrio Palumbo is documented as working in Artemisia's studio in 1653 and 1654 (De Vito). Two portraits of Masaniello are attributed to Palumbo — a picture of one is in Marshall's "Causa di Stravaganze," a picture of the other is in *Painting in Naples 1606–1705* (Whitfield, Martineau). Did Masaniello commission Palumbo's portraits of him? Or was Palumbo painting to amuse wealthy aristocrats like Piscicelli?

Portrait of Masaniello (a.k.a. Tomaso Aniello) attributed to Palumbo

PAGES 222–223: Antonio Ruffo's collection contained paintings by Van Dyck, Poussin, Ribera, Simon Vouet, Guido Reni, Annibale Caracci, Salvatore Rosa, Guercino, and one Dutch stalwart — Rembrandt. Artemisia's letters to Ruffo are published in Mary Garrard's *Artemisia Gentileschi: The Image of the Female Hero in Italian Baroque Art*, but the original letters are lost. Garrard explains that they may have been destroyed during World War I, after they were transcribed by Vincenzo Ruffo and published in 1916, and again in 1919 with his corrections and supplementary material. Efrem G. Calingaert translated the letters from Vincenzo's transcription.

Due to limited space, I combined multiple letters to Ruffo. The panel beginning with "you

think me pitiful" on page 222 is from a letter dated January 30, 1649. The next panel beginning with "I hope with God's help to make something greatly to your liking," is from a letter dated March 13, 1649. I added the line "and you will see what a woman can do" from another letter dated August 7, 1649. The passage beginning with "As soon as possible I will send you my portrait" and ending with "The works will speak for themselves" is also from the March 13th letter. The bit about the "spirit of Caesar" on page 223 is from a letter dated November 17, 1649.

The middle four panels on page 233 are derived from Artemisia's letter to Ruffo dated November 13, 1649: "As for my doing a drawing and sending it, I have made a solemn vow never to send my drawings because people have cheated me. In particular, just today I found myself [in the situation] that having done a drawing of the Souls in Purgatory for the Bishop of Saint Gata, he, in order to spend less, commissioned another painter to do the painting using my work. If I were a man I can't imagine it would have turned out this way, because when the concept [*inventione*] has been realized and defined with lights and darks, and established by means of planes, the rest is a trifle" (398). (The brackets are Garrard's.) The panel on the lower right of page 222 refers to Jesse Locker's assertion that Artemisia endured serious illness in the early 1650s. (For more on Elena's marriage, see notes for pp. 180–181.)

PAGE 224: Mary Garrard sees Loredan's epitaphs as offensive and sexist, but Jesse Locker has carefully reassessed their meaning:

What remains most striking about the epitaphs is the difference in tone between Loredan's early letters [see notes for pp. 189, 194], which humbly and respectfully address Artemisia as an intellectual peer, and these verses, which disparage her virtue in a strikingly crude manner. This paradox is in fact far from an isolated instance but rather is fairly typical of the literary and dramatic production of the *Accademia degli Incogniti* as a whole. It is crucial that the tone of these verses be understood in their context of intentionally provocative satirical barbs and that this tone has nothing to do with Artemisia in particular ... In the case of Loredan, his entire career, not just the writings concerning Artemisia, embodies this paradoxical view of women. Loredan's secretary Antonio Lupis reports that Loredan had a gallery of "*effegie di molte Donne letterate*" with portraits of Vittoria Colona, Veronica Gambara, Violante Vanossa, and many others, and he supported the careers of prominent female artists and writers. At the same time, he was not averse to writing polemics against women or writing crude satires of them. For Loredan, neither of these positions was necessarily sincere (nor insincere), for he like the *Incogniti* in general famously adopted veiled, contradictory, and deliberately shocking positions on every subject, the most shocking of which is Antonio Rocco's *Alcibiades*, a defense of pederasty. From this perspective, questions of whether women were the equals of men — or if they were even human — were merely a pretext for whimsical debate. Indeed, when a furious Arcangela Tarabotti attacked Loredan for authoring a polemic against women, Loredan defended himself by arguing that the theme of the discourse was not his choosing and that he was obligated to follow it. (66–67)

I wonder if this same taste for "whimsical debate" made the patron, Giovanni Piscicelli, insist that Micco Spadaro paint different sides of the 1647 revolt (see notes for p. 221).

PAGE 225: The plague of 1655 killed many artists in Artemisia's circle, including Francesco Guarino, Pacceco de Rosa (Annella's uncle), and Aniello Falcone (see notes for pp. 202, 221). Micco Spadaro survived and continued to paint the various Neapolitan upheavals (see notes for p. 221). Onofrio Palumbo also survived. In *Painting in Naples 1606–1705* (Whitfield, Martineau), the catalogue entry for Palumbo states, "According to de Dominici [see notes for pp. 197, 202] there were works by Palumbo in both public buildings and private collections. However, his activity was apparently cut short when he became embroiled in a court case following a dispute with relatives. They not only turned him away from painting, but sent him mad. Although this sad tale has the air of legend about it, it is still true that we know little of Palumbo's work and few pictures can be certainly attributed to him" (202).

❈ ❈ ❈

BIBLIOGRAPHY

Argan, Giulio Carlo. *The Europe of the Capitals 1600–1700*. Cleveland, OH: The World Publishing Company, 1964.

Arnold, Janet. *Patterns of Fashion*. London: MacMillan Publishers, 1979.

Bal, Mieke, ed. *The Artemisia Files*. Chicago, IL: University of Chicago Press, 2005.

Balchin, Paul N. *Urban Development in Renaissance Italy*. West Sussex, England: John Wiley & Sons, Ltd, 2008.

Bander van Duren, Peter. *Orders of Knighthood and Merit*. Buckinghamshire: Colin Smythe Limited, 1995.

Banti, Anna. *Artemisia*. Translated by Shirley D'Ardia Caracciolo. Lincoln, NE: University of Nebraska Press, 1953.

Barker, Sheila, ed. *Artemisia Gentileschi in a Changing Light*. London and Turnhout, Belgium: Harvey Miller Publishers, 2017.

———. "Artemisia's Money: The Entrepreneurship of a Woman Artist in Seventeenth-Century Florence." In *Artemisia Gentileschi in a Changing Light*, edited by Sheila Barker, 59–88, 2017.

Barzman, Karen. *The Florentine Academy and the Early Modern State: The Discipline of Disegno*. New York: Cambridge University Press, 2000.

Bentley, Jerry. *Politics and Culture in Renaissance Naples*. Princeton, NJ: Princeton University Press, 1987.

Biagolioli, Mario. *Galileo, Courtier*. Chicago: University of Chicago Press, 1993.

Bindman, David and Henry Louis Gates Jr., eds. *The Image of the Black in Western Art Volume 3 Part 1*. Cambridge, MA: Belknap Press/Harvard University Press, 2010.

Bissell, R. Ward. "Artemisia Gentileschi: A New Documented Chronology." *The Art Bulletin* 50, no. 2 (June 1968): 153–168.

———. *Artemisia Gentileschi and the Authority of Art*. University Park, PA: Pennsylvania State University, 1999.

———. "Artemisia Gentileschi: Painter of Still-Lifes?" *Notes in the History of Art o1 32*, no. 2 (Jan. 2013): 27–34.

Blumenfeld-Kosinski, Renate, ed. *The Selected Writings of Christine de Pizan*. Translated by Renate Blumenfeld-Kosinski and Kevin Browlee. New York: W. W. Norton & Company, 1997.

Blunt, Anthony. *Neapolitan Baroque and Rococo Architecture*. London: A. Zwemmer Ltd., 1975.

Bonney, Richard. *The Thirty Years' War 1618–1648*. Oxford: Osprey Publishing, 2002.

Brown, Jonathan and Richard L. Kagan. "The Duke of Alcala: His Collection and Its Evolution." *The Art Bulletin* 69, no. 2 (June 1987): 231–255.

Brown, Judith. *Immodest Acts: The Life of a Lesbian Nun in Renaissance Italy*. New York: Oxford University Press, 1986.

Brown, Judith and Robert C. Davis, eds. *Gender and Society in Renaissance Italy*. Essex, UK: Addison Wesley Longman, 1998.

Butsch, Albert Fidelis. *Handbook of Renaissance Ornamentation*. Mineola, NY: Dover Publications, 1969.

Capo Ferro, Ridolfo. *Italian Rapier Combat*. Edited and translated by Jared Kirby, Ramon Martinez, and Jeanette Acosta-Martinez. London: Greenhill Books, 2004 [1610, 1629].

Carloni, Livia. "Orazio Gentileschi Between Rome and the Marches." In *Orazio and Artemisia Gentileschi*, edited by Keith Christiansen and Judith W. Mann, 116–129. New York: Metropolitan Museum of Art, 2001.

Cavallo, Sandra and Simona Cerutti. "Female Honor and the Social Control of Reproduction in Piedmont Between 1600 and 1800." In *Sex and Gender in Historical Perspective*, edited by Edward Muir and Guido Ruggiero, 73–109. London: Johns Hopkins University Press, 1990.

Cavazzini, Patrizia. "Artemisia in Her Father's House." In *Orazio and Artemisia Gentileschi*, edited by Keith Christiansen and Judith W. Mann, 282–295, 2001.

———. "Artemisia and the Other Women in Agostino Tassi's Life: Attitudes to Women's Improper Sexual Behavior in Seventeenth-Century Rome." In *Artemisia Gentileschi: Taking Stock*, edited by Judith W. Mann, 39–49. Turnhout, Belgium: Brepolis Publishers, 2005.

Cavendish, Richard. "Masaniello's Naples Revolt Against Spain." *History Today* 47, no. 7 (July 1997).

Cellini, Benvenuto. *Autobgiography*. Translated by George Bull. England: Penguin Books, 1996 [1728].

Chamberlin, E.R. *Everyday Life in Renaissance Times*. London: Capricorn Books, 1967.

Cheney, Liana de Girolami. "Review of 'Giovanna Garzoni: Insigne Miniatric 1600–1700' by Gerard Casale." *The Sixteenth Century Journal* 29, no. 1 (Spring 1998): 257–258.

Chojnacki, Stanley. *Women and Men in Renaissance Venice*. Baltimore and London: Johns Hopkins University Press, 2000.

Christiansen, Keith and Judith W. Mann, eds. *Orazio and Artemisia Gentileschi*. New York: Metropolitan Museum of Art, 2001.

Ciavolella, Massimo and Patrick Coleman, eds. *Culture and Authority in the Baroque*. Toronto: University of Toronto Press, 2005.

Cipolla, Carlo. *Faith, Reason, and the Plague in Seventeenth-Century Tuscany*. Translated by Muriel Kittel. New York and London: W. W. Norton & Company, 1981.

———. *Fighting the Plague in Seventeenth-Century Italy*. Madison, WI: University of Wisconsin Press, 1981.

Cohen, Elizabeth S. "The Trials of Artemisia Gentileschi: A Rape as History." *The Sixteenth Century Journal* 31, no. 1 (Spring 2000): 47–75.

———. "More Trials for Artemisia Gentileschi: Her Life, Love and Letters in 1620." In *Patronage, Gender, and the Arts in Early Modern Italy*, edited by Katherine A. McIver and Cynthia Stollhans, 249–272. New York: Italica Press, 2015.

Cohen, Thomas V. and Elizabeth S. Cohen. *Words and Deeds in Renaissance Rome: Trials Before the Papal Magistrates*. Toronto: University of Toronto Press, 1993.

Cole, Janie. *A Muse of Music in Early Baroque Florence: The Poetry of Michelangelo Buonarroti il Giovane*. Florence: Leo S. Olschki, 2007.

Costa, Patrizia. "Artemisia Gentileschi in Venice." *Notes in the History of Art* 19, no. 3 (Spring 2000): 28–36.

Cotton, Jeff. *The Churches of Venice*. 2007–2019. www.churchesofvenice.co.uk.

Crelly, William. *The Painting of Simon Vouet*. New Haven and London: Yale University Press, 1962.

Crino, Anna Maria and Benedict Nicolson. "Further Documents Relating to Orazio Gentileschi." *The Burlington Magazine* 103, no. 697 (April 1961): 144–145.

Croce, Benedetto. *History of the Kingdom of Naples*. Translated by Francis Frenaye. Chicago: University of Chicago Press, 1970.

Cropper, Elizabeth. *The Domenichino Affair*. London: Yale University Press, 2005.

———. "New Documents for Artemisia's Life in Florence." *The Burlington Magazine* 135, no. 1088 (Nov. 1993): 760–761.

———. "Life on the Edge: Artemisia Gentileschi, Famous Woman Painter." In *Orazio and Artemisia Gentileschi*, edited by Keith Christiansen and Judith W. Mann, 262–281, 2001.

Cusick, Suzanne. *Francesca Caccini at the Medici Court*. Chicago: University of Chicago Press, 2009.

Dabbs, Julia K. "Sex, Lies and Anecdotes: Gender Relations in the Life Stories of Italian Women Artists 1550–1800." *Aurora, The Journal of the History of Art Annual* 6 (2005): 17–37.

Damase, Jacques. *Carriages*. Translated by William Mitchell. New York: G.P. Putnam's Sons, 1968.

Dapra, Brigitte. *Micco Spadaro: Napoli ai tempi di Masaniello*. Naples: Electa Napoli, 2002.

Davis, Natalie Zemon. *Women on the Margins: Three Seventeenth-Century Lives*. Cambridge, MA: Harvard University Press, 2001.

Davis, Robert C. "The Geography of Gender in the Renaissance." In *Gender and Society in Renaissance Italy*, edited by Judith Brown and Robert C. Davis, 19–38. Essex, UK: Addison Wesley Longman, 1998.

De Vito, Giuseppe. "A Note on Artemisia Gentileschi and Her Collaborator Onofrio Palumbo." *The Burlington Magazine* 147, no. 1232 (Nov. 2005): 749.

Durant, Will and Ariel. *The Story of Civilization Part VII: The Age of Reason Begins*. New York: Simon & Schuster, 1961.

Ehrlich, Tracy. *Landscape and Identity in Early Modern Rome*. Cambridge, UK: Cambridge University Press, 2002.

Eliav-Feldon, Miriam. *Realistic Utopias: The Ideal Imaginary Societies of the Renaissance 1516–1630*. Oxford: Clarendon Press, 1982.

Evans, Robert and Eric J. Sterling, eds. *The Seventeenth-Century Literature Handbook*. London: Continuum, 2010.

Felton, Craig and William B. Jordan, eds. *Jusepe de Ribera: Lo Spagnoletto*. Seattle, WA: Washington University Press, 1982.

Ferraro, Joanne M. *Marriage Wars in Late Renaissance Venice*. New York: Oxford University Press, 2001.

Finaldi, Gabriele. "A Documentary Look at the Life and Works of Jusepe de Ribera." In *Jusepe de Ribera: 1591–1652*, edited by Alfonso E. Perez Sanchez and Nicola Spinosa, 3–8. New York: The Metropolitan Museum of Art, 1992.

Finaldi, Gabriele and Jeremy Wood. "Orazio Gentileschi at the Court of Charles I." In *Orazio and Artemisia Gentileschi*, edited by Keith Christiansen and Judith W. Mann, 222–231, 2001.

Filippini, Nadia Maria. "The Church, the State and Childbirth: The Midwife in Italy During the Eighteenth Century." In *The Art of Midwifery*, edited by Hilary Marland, 152–175. London and New York: Routledge, 1993.

Findlen, Paula. *Possessing Nature*. Berkeley and Los Angeles: University of California Press, 1994.

Fletcher, Catherine. *The Black Prince of Florence*. New York: Oxford University Press, 2016.

Fortune, Jane. *Invisible Women: Forgotten Artists of Florence*. Florence: The Florentine Press, 2010.

Franco, Veronica. *Poems and Selected Letters*. Edited and translated by Ann Rosalind Jones and Margaret F. Rosenthal. Chicago and London: University of Chicago Press, 1998 [1580, 1575].

Freiberg, Jack. *The Lateran in 1600*. New York: Cambridge University Press, 1995.

Fried, Michael. *The Moment of Caravaggio*. New Jersey: Princeton University Press, 2010.

Garrard, Mary. *Artemisia Gentileschi Around 1622*. Berkeley, CA: University of California Press, 2001.

———. *Artemisia Gentileschi: The Image of the Female Hero in Italian Baroque Art*. New Jersey: Princeton University Press, 1989.

———. "Artemisia's Hand." In *Artemisia Gentileschi: Taking Stock*, edited by Judith W. Mann, 99–120, 2005.

Goodwin, Robert. *Crossing the Continent 1527–1540: The Story of the First African-American Explorer of the American South*. New York: HarperCollins Publishers, 2008.

Grabski, Jozef. "On Seicento Painting in Naples: Some Observations on Bernardo Cavallino, Artemisia Gentileschi, and Others." *Artibus et Historiae* 6, no. 11 (1985): 23–63.

Graham-Dixon, Andrew. *Caravaggio: A Life Sacred and Profane.* New York: W. W. Norton & Company, 2010.

Gregg, Pauline. *King Charles I.* London: J. M. Dent & Sons, 1981.

Hacke, Daniela. *Women, Sex and Marriage in Early Modern Venice.* England and Burlington, VT: Ashgate Publishing, 2004.

Harness, Kelley. *Echoes of Women's Voices: Music, Art, and Female Patronage in Early Modern Florence.* London: University of Chicago Press, 2006.

Harr, Jonathon. *The Lost Painting: The Quest for a Caravaggio Masterpiece.* New York: Random House, 2006.

Harris, Anne Sutherland. "Artemisia Gentileschi and Elisabetta Sirani: Rivals or Strangers?" *Woman's Art Journal* 31, no. 1 (Spring/Summer 2010): 3–12.

Harris, Enriqueta. "Cassiano dal Pozzo on Diego Velázquez." *The Burlington Magazine* 112, no. 807 (June 1970): 364–373.

Haskell, Francis. *Patrons and Painters.* New York: Alfred A. Knopf, 1963.

Hebbert, Benjamin M. "A New Portrait of Nicholas Lanier." *Early Music* 38, no. 4 (Nov. 2010): 509–522.

Heller, Wendy. "La Forza D'Amore and the Monaca Sforzata: Opera, Tarabotti, and the Pleasures of Debate." In *Arcangela Tarabotti: A Literary Nun in Baroque Venice*, edited by Elissa B. Weaver, 141–157. Ravenna, Italy: Longo Editore, 2006.

Herman, Eleanor. *Mistress of the Vatican: The True Story of Olimpia Maidalchini.* New York: HarperCollins Publishers, 2008.

Hibbert, Christopher. *The House of Medici: Its Rise and Fall.* New York: William Morrow and Company, 1974.

Higson, John W. *A Historical Guide to Florence.* New York: Universe Books, 1973.

Hughes, Robert. "A City of Crowded Images." *Time Magazine* 121, no. 13 (March 1983): 68.

Hutson, Lorna, ed. *Feminism and Renaissance Studies.* New York: Oxford University Press, 1999.

Jack, Belinda. *Beatrice's Spell.* London: Pimlico and Random House, 2005.

Jacobs, Frederika. "Woman's Capacity to Create: The Unusual Case of Sofonisba Anguissola." *Renaissance Quarterly* 47, no. 1 (Spring 1994): 74–101.

Jed, Stephanie. "Arcangela Tarabotti and Gabriel Naude: Libraries, Taxonomies, and Ragion di Stato." In *Arcangela Tarabotti: A Literary Nun in Baroque Venice*, edited by Elissa B. Weaver, 129–140, 2006.

Jones, Ann Rosalind. "Labor and Lace: The Crafts of Giacomo Franco's Habiti delle donne venetiane." *I Tatti Studies in the Italian Renaissance* 17, no. 2 (Fall 2014): 399–425.

Kamen, Henry. *Inquisition and Society in Spain in the Sixteenth and Seventeenth Centuries.* London: Weidenfeld & Nicolson, 1985.

Kaplan, Paul H.D. "Italy 1400–1700." In *The Image of the Black in Western Art Volume 3 Part 1*, edited by David Bindman and Henry Louis Gates Jr., 93–190, 2010.

Klein, H. Arthur. *Graphic Worlds of Peter Bruegel the Elder.* New York: Dover Publications, 1963.

Kolfin, Elmer. "Rembrandt's Africans." In *The Image of the Black in Western Art Volume 3 Part 1*, edited by David Bindman and Henry Louis Gates Jr., 271–306, 2010.

Krauss, Johann Ulrich. *Baroque Cartouches for Designers and Artists.* New York: Dover Publications, 1969.

Kristeller, Paul Oskar. *Eight Philosophers of the Italian Renaissance.* Stanford, CA: Stanford University Press, 1964.

Lambert, Gilles. *Caravaggio.* Germany: Taschen, 2004.

Lancaster, Jordan. *In the Shadow of Vesuvius.* London and New York: I.B. Taurus Publishers, 2005.

Langdon, Helen. *Caravaggio: A Life*. Boulder, CO: Westview Press, 1998.

———. *Salvatore Rosa*. London: Paul Holberton Publishing, 2010.

Lapierre, Alexandria. *Artemisia*. New York: Grove Press, 1998.

Lattuada, Riccardo. "Artemisia and Naples, Naples and Artemisia." In *Orazio and Artemisia Gentileschi*, edited by Keith Christiansen and Judith W. Mann, 378–391, 2001.

Laven, Mary. *Virgins of Venice: Broken Vows and Cloistered Lives in the Renaissance Convent*. Middlesex: Viking Press/Penguin Random House, 2002.

Leed, Drea. *Elizabethan Costuming Page*. 2010. www.elizabethancostume.net.

Linscott, Robert N., ed. *Complete Poems and Selected Letters of Michelangelo*. Translated by Creighton Gilbert. Princeton, NJ: Princeton University Press, 1980.

Locker, Jesse. *Artemisia Gentileschi: The Language of Painting*. New Haven and London: Yale University Press, 2015.

Lollobrigida, Consuelo. "Women Artists in the Casa Barberini: Plautilla Bricci, Maddalena Corvini, Artemisia Gentileschi, Anna Maria Vaiani, and Virginia da Vezzo." In *Artemisia Gentileschi in a Changing Light*, edited by Sheila Barker, 119–130, 2017.

Longoni, Angelo, dir. *Caravaggio*. Produced by Titania Produzioni. EOS Entertainment, GMT Productions, 2007.

Loomie, Albert J. "The Destruction of Rubens's 'Crucifixion' in the Queen's Chapel, Somerset House." *The Burlington Magazine* 140, no. 1147 (Oct. 1998): 680–682.

Loughman, Thomas J., ed. *Fierce Reality: Italian Masters from Seventeenth-Century Naples*. Milan: Skira Editore, 2006.

Luchinat, Cristina Acidini, et al. *The Medici, Michelangelo, and the Art of Late Renaissance Florence*. New Haven and London: Yale University Press, 2002.

MacFall, Haldane. *A History of Painting Volume 3: Later Italians and the Genius of Spain*. London: Caxton Publishing Company, 1911.

MacGregor, Arthur. *Curiosity and Enlightenment*. New Haven and London: Yale University Press, 2007.

Madden, Thomas F. *Venice: A New History*. London: Viking Press/Penguin Random House, 2012.

Magnuson, Torgil. *Rome in the Age of Bernini Volume 1*. Stockholm, Sweden: Almquist & Wiksell International, 1982.

Mahone, Sir Denis. *Guercino: Master Painter of the Baroque*. Washington, D.C.: National Gallery of Art, 1992.

Malpezzi-Price, Paola and Christine Ristaino. *Lucrezia Marinella and the "Querrelle des Femmes" in Seventeenth-Century Italy*. Cranbury, NJ: Fairleigh Dickinson University Press, 2008.

Malvasia, Carlo Cesare. *The Life of Guido Reni*. Edited and translated by Catherine and Robert Engass. London: Pennsylvania State University Press, 1980 [1678].

Mann, Judith W., ed. *Artemisia Gentileschi: Taking Stock*. Turnhout, Belgium: Brepolis Publishers, 2005.

———. "Identity Signs: Meanings and Methods in Artemisia Gentileschi's Signatures." *Renaissance Studies* 23, no. 1 (Feb. 2009): 71–107.

Marinella, Lucrezia. *The Nobility and Excellence of Women, and the Defects and Vices of Men*. Edited and translated by Anne Dunhill. Chicago and London: University of Chicago Press, 1999 [1600].

Marland, Hilary, ed. *The Art of Midwifery*. London and New York: Routledge, 1993.

Marshall, Christopher R. "'Causa di Stravaganze': Order and Anarchy in Domenico Gargiulo's Revolt of Masaniello." *The Art Bulletin* 80, no. 3 (Sept. 1998): 478–497.

———. "An Early Reference and New Technical Information for Bernardo Cavallino's 'Triumph of Galatea.'" *The Burlington Magazine* 147, no. 1222 (Jan. 2005): 40–44.

Marshall, David. "A View of Poggioreale by Viviano Codazzi and Domenico Gargiulo." *Journal of the Society of Architectural Historians* 45, no. 1 (March 1986): 32–46.

Martin, John Rupert. *Baroque*. New York: Harper & Row, 1977.

Mauries, Patrick. *Cabinets of Curiosities*. London: Thames & Hudson, 2002.

McIver, Katherine A. and Cynthia Stollhans, eds. *Patronage, Gender, and the Arts in Early Modern Italy: Essays in Honor of Carolyn Valone*. New York: Italica Press, 2015.

McKee, Sally. "Domestic Slavery in Renaissance Italy." *Slavery and Abolition* 29, no. 3 (Sept. 2008): 30–326.

Migiel, Marilyn and Juliana Schiesari, eds. *Refiguring Woman: Perspectives on Gender and the Italian Renaissance*. Ithaca, NY: Cornell University Press, 1991.

Miller, Peter N. "Friendship and Conversation in Seventeenth-Century Venice." *The Journal of Modern History* 73, no. 1 (March 2001): 1–31.

Moraria, Alberto. *Beatrice Cenci*. London: Martin Secker & Warburg Limited, 1965.

Morrissey, Jake. *The Genius in the Design: Bernini, Borromini, and the Rivalry That Transformed Rome*. New York: HarperCollins Publishers, 2005.

Mosco, Marilena. *The Pitti Palace: The Palace and Its Art*. London: Philip Wilson Publishers, 1997.

Moss, Jean Dietz. "Galileo's Letter to Christina: Some Rhetorical Considerations." *Renaissance Quarterly* 36, no. 4 (Winter 1983): 547–576.

Muir, Edward. *The Culture Wars of the Late Renaissance*. Cambridge, MA: Harvard University Press, 2007.

———. *Mad Blood Stirring: Vendetta and Factions in Friuli During the Renaissance*. Baltimore, MD: Johns Hopkins University Press, 1993.

Muir, Edward and Guido Ruggiero, eds. *Sex and Gender in Historical Perspective*. London: Johns Hopkins University Press, 1990.

Murphy, Caroline. *Lavinia Fontana*. London: Yale University Press, 2003.

———. *Murder of a Medici Princess*. New York: Oxford University Press, 2008.

Nagler, A. M. *Theatre Festivals of the Medici 1539–1637*. London: Yale University Press, 1964.

Nettl, Paul and Theodore Baker. "Equestrian Ballets of the Baroque Period." *The Musical Quarterly* 19, no. 1 (Jan. 1933): 74–83.

Newcome, Mary. "Orazio Gentileschi in Genoa." In *Orazio and Artemisia Gentileschi*, edited by Keith Christiansen and Judith W. Mann, 164–171, 2001.

Norwich, John Julius, ed. *The Italians*. New York: Abrams Books, 1983.

Ortiz, Antonio Dominguez, Alfonso E. Perez Sanchez, and Julian Gallego. *Velázquez*. New York: Metropolitan Museum of Art, 1989.

Pawlak, Manfred, ed. *Jacques Callot: Das gesamte Werk in zwei Bänden*. Germany: Verlagsgesellschaft Herrsching, 1970.

Perry, Mary Elizabeth. *Gender and Disorder in Early Modern Seville*. Princeton, NJ: Princeton University Press, 1990.

Porter, Jeanne Chenault and Susan Scott Munshower, eds. *Parthenope's Splendor: Art of the Golden Age in Naples*. University Park, PA: Pennsylvania State University, 1993.

Prose, Francine. *Caravaggio: Painter of Miracles*. New York: HarperCollins Publishers, 2005.

Ray, Meredith K. Daughters of Alchemy: *Women and Scientific Culture in Early Modern Italy*. Cambridge, MA: Harvard University Press, 2015.

Redford, Bruce. *Venice and the Grand Tour*. New Haven and London: Yale University Press, 1996.

Ricci, Corrado. *Beatrice Cenci*. Translated by Morris Bishop and Henry Longan Stuart. New York: Boni & Liverwright, 1925.

Rinne, Katherine Wentworth. *The Waters of Rome: Aqueducts, Fountains, and the Birth of the Baroque City*. New Haven and London: Yale University Press, 2010.

Robb, Peter. *M*. London: Bloomsbury Publishing, 1998.

Robertson, Elizabeth and Christine M. Rose, eds. *Representing Rape in Medieval and Early Modern Literature*. New York: Palgrave Macmillan, 2001.

Rose, Charles J. "Marc Antonio Venier, Renier Zeno, and 'The Myth of Venice.'" *The Historian* 36, no. 3 (May 1974): 479–497.

Rosenthal, Margaret F. *The Honest Courtesan: Veronica Franco, Citizen and Writer in Sixteenth-Century Venice*. Chicago and London: University of Chicago Press, 1992.

Roworth, Wendy Wassyng. "The Evolution of History Painting: Masaniello's Revolt and Other Disasters in Seventeenth-Century Naples." *The Art Bulletin* 75, no. 2 (June 1993): 219–234.

Sainsbury, W. Noel. "Artists' Quarrels in Charles I's Reign." *Notes and Queries* 2, no. 8 (August 1859): 121–122.

Sanchez, Alfonso E. Perez and Nicola Spinosa. *Jusepe de Ribera: 1591–1652*. New York: The Metropolitan Museum of Art, 1992.

Savoy, Daniel. *Venice from the Water: Architecture and Myth in an Early Modern City*. New Haven and London: Yale University Press, 2012.

Schama, Simon. *Rembrandt's Eyes*. New York: Alfred A. Knopf, 1999.

Schleiner, Winfried. *Medical Ethics in the Renaissance*. Washington, D.C.: Georgetown University Press, 2007.

Seward, Desmond. *Caravaggio: A Passionate Life*. New York: William Morrow & Company, 1998.

Signorotto, Gianvittoria and Maria Antonietta Visceglia, eds. *Court and Politics in Papal Rome 1492–1700*. Cambridge, UK: Cambridge University Press, 2002.

Snyder, John R. "Truth and Wonder in Naples Circa 1640." In *Culture and Authority in the Baroque*, edited by Massimo Ciavolella and Patrick Coleman, 85–105, 2005.

Sobel, Dava. *Galileo's Daughter*. New York: Walker & Company, 1999.

Sparti, Donatella L. "The dal Pozzo Collection Again: The Inventories of 1689 and 1695 and the Family Archive." *The Burlington Magazine* 132, no. 1049 (Aug. 1990): 551–570.

Spear, Richard. "Artemisia Gentileschi: Ten Years of Fact and Fiction." *The Art Bulletin* 82, no. 3 (Sept. 2000): 568–579.

———. "Scrambling for Scudi: Notes on Painters' Earnings in Early Baroque Rome." *The Art Bulletin* 85, no. 2 (June 2003): 310–320.

———. "Money Matters: The Gentileschi's Finances." In *Artemisia Gentileschi: Taking Stock*, edited by Judith W. Mann, 147–159, 2005.

Sterling, Charles. "Gentileschi in France." *The Burlington Magazine* 100, no. 661 (April 1958): 112–121.

Stocker, Margarita. *Judith: Sexual Warrior*. New Haven and London: Yale University Press, 1998.

Stoichita, Victor. "The Image of the Black in Spanish Art: Sixteenth and Seventeenth Centuries." In *The Image of the Black in Western Art Volume 3 Part 1*, edited by David Bindman and Henry Louis Gates Jr., 191–234, 2010.

Stortoni, Laura Anna, ed. *Women Poets of the Italian Renaissance: Courtly Ladies and Courtesans*. New York: Italica Press, 1997.

Story, Tessa. *Carnal Commerce in Counter-Reformation Rome*. Cambridge, UK: Cambridge University Press, 2008.

Straussman-Pflanzer, Eve. *Violence and Virtue: Artemisia Gentileschi's "Judith Slaying Holofernes."* Chicago: Art Institute of Chicago, 2013.

Sutherland, Martha. *Regarding the Borgo Pio*. Fayetteville, AR: University of Arkansas Press, 1996.

Tarabotti, Arcangela. *Paternal Tyranny*. Edited and translated by Letizia Panizza. Chicago and London: University of Chicago Press, 2004 [1654].

Talvacchia, Bette. *Taking Positions: On the Erotic in Renaissance Culture*. Princeton, NJ: Princeton University Press, 1999.

Thornton, Peter. *The Italian Renaissance Interior 1400–1600*. New York: Abrams Books, 1991.

Vecellio, Cesare. *The Clothing of the Renaissance World (Habiti Antichi et Moderni)*. Edited and translated by Margaret F. Rosenthal and Ann Rosalind Jones. London: Thames & Hudson, 2008 [1590].

Villari, Rosario. *The Revolt of Naples*. Translated by James Newell and John A. Marino. Cambridge, UK: Polity Press, 1993.

Walker, Jonathan. "Gambling and Venetian Noblemen c. 1500–1700." *Past and Present* no. 162 (Feb. 1999): 28–69.

Weaver, Elissa B., ed. Arcangela Tarabotti: *A Literary Nun in Baroque Venice*. Ravenna, Italy: Longo Editore, 2006.

White, Michael. *The Pope and the Heretic*. New York: HarperCollins Publishers, 2003.

Whitfield, Clovis and Janet Martineau, eds. *Painting in Naples 1606–1705: From Caravaggio to Giordano*. London: Royal Academy of Arts, 1982.

Wilbourne, Emily. "A Question of Character: Artemisia Gentileschi and Virginia Ramponi Andreini." *Italian Studies* 71, no. 2 (2016): 335–355.

Witek, Joseph. *Comic Books as History*. Jackson, MS: University Press of Mississippi, 1989.

Wolfthal, Diane. *Images of Rape: The 'Heroic' Tradition and Its Alternatives*. Cambridge, UK: Cambridge University Press, 1999.

York, Laura. "The 'Spirit of Caesar' and His Majesty's Servant: The Self-Fashioning of Women Artists in Early Modern Europe." *Women's Studies* 30, no. 4 (2001): 499–520.

Zarri, Gabriella. "Venetian Convents and Civic Rituals." In *Arcangela Tarabotti: A Literary Nun in Baroque Venice*, edited by Elissa B. Weaver, 37–56, 2006.

Zarucchi, Jeanne Morgan. "The Gentileschi 'Danae': A Narrative of Rape." *Woman's Art Journal* 19, no. 2 (Autumn 1998–Winter 1999): 13–16.

Zorzi, Alvise. *Venice 692–1797: A City, A Republic, An Empire*. Woodstock, NY: The Overlook Press, 1999.

GINA SICILIANO graduated from Pacific Northwest College of Art in 2007. She is an artist, a bookseller, and the drummer and vocalist for two rock bands. She's been self-publishing her comics for many years, and *I Know What I Am* is her first book published by Fantagraphics. She lives in Seattle, WA.